ARTS OF AFRICA

7000 YEARS OF AFRICAN ART

ARTS OF AFRICA

7000 YEARS OF AFRICAN ART

DISCARD

SKIRA / GRIMALDI FORUM MONACO

ARTS OF AFRICA
7000 YEARS OF AFRICAN ART

July 16 — September 4 2005

Exhibition and Catalogue

Curator
Ezio Bassani

Scientific comittee
Omotoso Eluyemi
Violata I. Ekpo
Hélène Leloup
Jean-Louis Paudrat

The exhibition has been realized with the cooperation of ArtificioSkira, Florence

Graphic design
Salut Public, Bruxelles
Manuela Dechamps Otamendi
Pascale Onraet and Renaud Huberlant

Translations
Translated from Italian into English by Emanuela Noce
Translated from Italian into French by Laurent Cattin and Angela Cristina
Translated from French into English by Nancy G. Duncan Le Diascorn

Scenic artist
Ettore Sottsass and Marco Palmieri
assisted by Monica Lovati and Maurizio Scalzi

Communication
Hervé Zorgniotti, Director of Communication
Nathalie Pinto, Communication Manager
N2D Conseil International
Ruder Finn Arts & Communications Counselors

Cover: Kwele, Gabon, Masque
Former Charles Ratton Collection
© Musée Dapper - M. Carrieri

Grimaldi Forum Monaco

Jean-Claude Riey, President
Sylvie Biancheri, General Director

Catherine Alestchenkoff, Director of Cultural Events
Guy Caruana, Building Director
Gérard Nouveau, Director of Events
Marc Rossi, Administrative and Financial Director
and their staff.

Lætitia de Massy, Cultural Officer
Katia Montironi, Editing assistant
Thierry Vincent, Registrar
Sarah Camara, Assistant

Monaco

His Excellency Mr. Jean-Paul Proust, Minister of State
Mr. Philippe Deslandes, Government Adviser for the Interior
Mr. Franck Biancheri, Government Advisor for Economy and Finance

GRIMALDI FORUM MONACO

10 Avenue Princesse Grace,
MC 98000 Monaco
www.grimaldiforum.com

ACKNOWLEDGMENTS

We wish to express our deepest appreciation to all those institutions and individuals who, each in their own way, have helped guide this project to fruition.

Austria

Museum für Völkerkunde, Vienna
Wilfried Seipel, General Director
Christian Feest, Director
Tina Seyfried, Exhibition Organiser

Belgium

Royal Museum of Central Africa, Tervuren
Guido Gryseels, Director
Anne-Marie Bouttiaux, Head of the Ethnographic Department

Canada

Art Gallery of Ontario, Toronto
Denis Reid, Chief Curator
Marcie Lawrence, Loans Co-ordinator

Denmark

National Museum, Copenhagen
Espen Waehle, Curator of the Ethnographic Collections
Ingegerd Marxen, Head of Ethnographic Department
Barbara Berlowicz, Conservator

France

Musée Dapper, Paris
Christiane Falgayrettes-Leveau, Director

Musée du Quai Branly, Paris
Stéphane Martin, President
Germain Viatte, Head of Inheritance and Collections Department

Musée Picasso, Antibes
Jean-Louis Andral, Chief Curator of the Antibes Museums

Musée national Fernand Léger, Biot
Jean-Michel Foray, Director
Brigitte Hedel-Samson, Chief Curator

Musée d'histoire naturelle et d'ethnographie, Lille
David Verhulst, Head of Ethnographic Department

Musée Calvet, Avignon
Pierre Provoyeur, Curator

Germany

Staatliche Museen zu Berlin, Preussischer Kultur-besitz, Ethnologisches Museum, Berlin
Peter Junge, Head of Africa Department
Viola König, Director

Staatliches Museum für Völkerkunde, Munich
Claudius C. Müller, Director

Stiftung Schleswig-Holsteinische Landesmuseen, Schloss Gottorf
Herwig Guratzsch, Director
Margret Schütte, Head of Painting Department

Stiftung Seebüll Ada und Emil Nolde
Manfred Reuther, Director
Andrea Fluck, Curator

Italy

Armeria Reale, Turin
Fulvio Cervini, Director

Direction of the Historical, Artistic and Ethno-anthropological Inheritance, Turin
Carla-Enrica Spantigati, Director

Municipal Collections of Applied Arts and Prints, Extra-European Collections Sforzesco Castle, Milan
Claudio Salsi, Director

Municipal Museum of Ancient and Medieval Art, Bologna
Massimo Medica, Director

Direction of the Historical, Artistic and Demo-anthropological Inheritance, Bologna
Franco Faranda, Director

National Museum of Anthropology and Ethnology, Section of the Natural History Museum, Florence
Marco Piccardi, Director

Direction of the Historical, Artistic and Ethno-anthropological Inheritance for the Departments of Florence, Pistoia and Prato
Bruno Santi, Director

Gallery and Museum Estense, Modena
Mrs. Esposito, Curator

Direction of the Historical, Artistic and Ethno-anthropological Inheritance for the Departments of Modena and Reggio Emilia
Maria Grazia Bernardin, Director

Museum of Silver and Porcelain, Pitti Palace, Florence
Ornella Casazza, Director

Special Direction for the State Museums of Florence
Antonio Paolucci, Director

National Museum, Ravenna
Monica Zavattaro, Curator

Direction of the Architecture of Ravenna
Anna-Maria Ianucci, Director

Mali

National Museum of Mali, Bamako
Samuel Sidibé, Director

Niger

Institute of Research in Social Sciences, Niamey
Abdoulaye Maga, Director of the Institut
Oumarou Amadou Ide, Head of Art and Archeology Department

Nigeria

National Commission for Museums and Monuments
Omotoso Eluyemi, Director General
Violata I. Ekpo, Director of the Museums

Portugal

Ethnographic Museum of the Society of Geography, Lisbon
Prof. Cat. Luis Antonio Aires-Barros, Director
Manuela Cantinho, Curator

National Museum of Ethnology, Lisbon
Joaquim Pais de Brito, Director
Joana Amaral, Curator

Instituto Portuges de Museus
Manuel Bairrão Oleiro, Director

Sudan

*National Corporation for Antiquities
and Museums, Khartoum*
Hassan Hussein Idriss, Director of the Institut

United Kingdom

The British Museum, London
Brian Durrens, Head of the collections,
Department of Africa, Oceania and the Americas
Fiona Grisdale, Senior Administrator,
Department of Africa, Oceania and the Americas
Iain K. Slessor, National Security Adviser

André Gaillard
Su and Jan Calmeyn
Pieter Coray
Pierre Dartevelle
Philippe Dodier
Bernard Dulon
Liliane & Michel Durand-Dessert
Lance Entwistle
Marc Léo Felix
Christian Goetghebuer
Bernard de Grunne
W. & U. Horstmann
Alexis Kugel
Marc Larock
Hélène and Philippe Leloup
Maître Guy Loudmer
Giancarlo Marsiletti
Daniel Masson
Mario Meneghini
Guy J.P. Onghena
Claude-Henri Pirat
Mrs & Mr François Propper
Marc Restellini
Marceau Rivière
Jean-Jacques Rotthier
Marie-Laure Terrin-Amrouche
René Vanderstraete
Renaud Vanuxem
Jean-Claude Weill

As those which preferred to keep anonymity.

We extend our warmest thanks to all those
who have contributed to this exhibition:

Corinne Bertani, Serena Botti, Frédéric Bouttin,
Dirk de Croes, James Elliot, Bonny Gabin,
Véronique Garrigues, Ulla Harmsen, Dominique
Lacroze, Gabrielle Landry, Tommaso Lamparelli,
Elisabetta Macumelli, Hubert Maheux, Véronique
Martingay, Arne Kirstejn Olsen, Federica Onnis,
Christine Pinault, Maria-Rosa Pocaterra-Schuma-
cher, Damiano Pastore, Catherine Rouvière, Doro
Schäfer, Laura Persico.

A very special thanks goes to Jean-Louis Paudrat,
curator of the 20th century section.

In celebration of its 5ᵗʰ anniversary, the Monaco Grimaldi Forum pays homage to the African continent and affirms its vocation as a meeting place for the patrimony and cultures of the world.

"Arts of Africa" is an unprecedented presentation of the cultural heritage of that continent as seen through the eyes of two great experts of traditional and contemporary african art, Mr. Ezio Bassani and Mr. André Magnin, enhanced by the renown architect and designer Ettore Sottsass who created the exhibition staging.

This exhibition opens the way to an aesthetic appreciation of African culture. The exceptional objects of traditional art presented here, coming from many private collections and from famous museums and institutions, are evidence of this. Not only are these objects the material testimony of a cultural identity, they are above all works of art.

This aesthetic journey continues with the presentation never before shown of commissions and works of African artists coming from the CAAC (Contemporary African Art Collection), a unique collection initiated by Mr. Jean Pigozzi who for over twenty years has been wholeheartedly supporting and promoting more than fifty artists living and creating in their country of origin within Black Africa.

I salute all the talent of the experts who have made it possible through this event to shine an original light upon the history of african art, encompassed in its diversity as well as its contemporaneity, thus giving proof that this patrimony belongs also to the whole of humanity.

CONTENTS

THE TIME IS RIGHT FOR AN AFRICAN ART EXHIBIT

There are endless series of African art exhibitions all over the world. It is therefore only natural to wonder about the need of this, which is organised in the premises of the Grimaldi Forum in Monaco, in collaboration with Filippo Zevi. The curators are myself (with Jean-Louis Paudrat's precious assistance) for the part which for brevity — but to some extent also out of laziness — we have defined as "traditional", and André Magnin for the contemporary part.

I believe that the answer can be affirmative for a number of reasons, which I will try to summarise here. Firstly, a new generation of visitors is increasingly interested in knowing what happens, or happened, outside the borders of the West also in the arts. In recent years, the status of traditional African sculpture has decidedly, if not definitively, risen, receiving new and important acknowledgements. Then, the frequent archaeological finds in every part of the continent, and increasingly widespread and reliable laboratory tests have shown that artistic creation in Africa dates back thousands of years. Moreover, studies on ancient European collecting have revealed that works by black artists were part of the collections of European kings and aristocrats as far back as the Renaissance. Also, the appearance in Europe of African sculptures at the beginning of the last century significantly influenced the course of European art. Lastly, it should be noted that the personalities, the role and the importance of African artists in the past is becoming increasingly clear, while African contemporary art is increasingly successful in an international context, alongside and on equal terms with the works of Western artists, and is being given more space in Europe and America's major exhibitions and institutions.

This initiative in Monaco therefore intends to offer for the first time, in a programmatic and comprehensive form, the opportunity to assess, on one hand the extent of the break with "traditional" African artistic creation, and on the other hand, the hidden continuities, the contaminations which are sometimes evident but more often difficult to identify, between the works of past artists and of those working today in a decolonised, urbanised and globalised Africa, whose changes they reflect whilst at the same time trying not to lose their identity. This is a "present" which, in the light of accelerated development, already seems like a "present perfect" or, in any case, a time of transition.

In the last few decades, a new concept of art has been established in Africa, leading to a radical revision of the language, detached from tradition and no longer bound to the perfection of the form as we were used to seeing, and responding to different expressive canons. This art is decontextualised with respect to the changing realities of the villages, and recontextualised in the new urban environments, and is not immune, in the age of globalisation, to Western influences, in a sort of compensation for the real or presumed loans made to European artists in the early 20th century.

The works exhibited in the section of which I am the curator belong to the African world of the past, a world which has been overturned, in many cases even cancelled, by savage globalisation and economic interests, that have changed the thoughts, religion and customs of Africa's inhabitants, above all in the cities, and

has emptied of meaning the works of art that were the expression of that world. Innumerable events had transformed African societies over the course of the centuries, already before European colonisation of the continent in the late-19th and early-20th centuries. However, the transformation which took place from the mid-20th century onwards was a second revolutionary change, and was also reflected in the way of producing art, no longer at the service of society and religion as it had been for millennia, but of the market. This is completely legitimate, of course, but means increasing alignment with the Western model. Perhaps it is no coincidence that few modern African artists practise sculpture, while the majority prefer expressive media such as painting, engraving and photography. The attributes "traditional" and "modern" therefore do not regard the quality of the works, which may be high or low in either case. Defining an Italian work of art as "Renaissance" does not mean expressing a value judgment but placing it in a particular moment of history. In the same way, defining an African sculpture as "traditional" means stating that it was created before the radical transformation mentioned above. Moreover, it should be warned that the adjective "traditional" attributed to African art, at least for now, covers an undifferentiated historical period, which is not without contaminations, and is used unnaturally as a generic term to refer to widely varying social or cultural contexts. A case in point is artistic creation during the colonial period.

The real risk of devaluation of African art in this phase of transition is not in its expressing itself in modern forms, which is historically inevitable, but in the decline of traditional creation, where this still survives, in the opaque and repetitive production of standardised and lifeless objects and of copies which resemble more or less the original works of art, and are fraudulently fobbed off as such: artistic traditions rarely survive the dissolution of the societies to which they are linked.

The separation between traditional and modern art, as illustrated here, may seem arbitrary, and is certainly simplistic. In reality it is a complex and difficult operation, because the passage from one culture to another, also in Africa as I have mentioned on other occasions, is never clear and contemporaneous throughout the continent, and is linked to the history of the various regions, and to the transformations of the various societies. Above all, it is not a uniform phenomenon, without resistance, retrievals or contaminations, revealing the existence of an incessant dialectic between the past and present, between continuity and innovation. Elements of tradition can be seen in many modern African works of art, in the same way that many works created for traditional uses in the recent past embody elements of modernity.

The new "status" which African art enjoys in the world has caused deep changes in the attitude of many major institutions; in the last twenty years some of the most important European and American ethnographic museums have refurbished their rooms, or organised exhibitions, in which the sculptures are treated as works of art in the fullest sense, and displayed as such. This is also because it is impossible to recreate the original conditions of use, as it is for European pictures and sculptures from past centuries, above all those with religious themes, which are today held in museums. The culmination of these historical transformations and process of promotion was in spring 2000, when the Louvre gave the official seal of approval, so to speak, by opening a new section dedicated to non-European art, the *Pavillon des Sessions*, in which the largest number of works on show are from Africa.

It is not as though African art needs recognition from Western culture to exist, to be considered art without limitations. If anyone, it is we Westerners who need such official approval, if we are to be encouraged to accept with naturalness the contribution to universal art of black artists, and to look at their works with the spirit with which we look at, appreciate, and enjoy the masterpieces of our own artistic heritage, adopting the various criteria of evaluation suggested by the specific nature of the works themselves, without deforming lenses, and without hierarchies.

In fact, what, until recent years, has prevented us from recognising the artistic excellence of African sculpture, if not a residue of cultural racism? Certainly, African art works — at least most of them — arrived in Europe without "certificates of nobility", confused in the undifferentiated mass of what was considered above all, if not solely, the product of an inferior culture.

It is no coincidence that, until a few decades ago, the testimonies of peoples without writing were indiscriminately massed together in museums. Back then, there was no distinction between ethnographic evidence and artistic creation, between art and craft, and no attention was paid to the formal qualities of the works. This is also because Western culture was not ready to accept a different way of interpreting and rendering reality, which some years later would seduce the artists of the avant-garde.

The sculptures were considered works of art but, unlike in the West, they were assigned to the category of "primitive arts", in which the adjective certainly does not have the same meaning as in the expressions "Sienese primitive" or "Flemish primitive". African works, defined dismissively as "idols and fetishes", were considered products of a world outside history, babblings of humanity in an infantile stage of its cultural development, left behind by civilised peoples.

This discrimination continued for many decades, and there was only an attempt to make remedy with the introduction in specialist literature of the terms "tribal", "indigenous", or "ethnic" art and, some years ago, of "arts premiers" (i.e. "of the origins"), or also "other" art. But there is only one artistic universe with its infinite individual, regional, ethnic and temporal variations, in terms of conception, executive techniques, choice of form, and decoration.

Perhaps it is precisely the infinite variety, the result of migrations and contacts, the "pluralisme coherent" (coherent pluralism), as defined by Jean-Louis Paudrat (Kerchache, Paudrat, Stephan 1988, 28), which characterises and enriches African arts, which has disconcerted Western scholars, unable to find their way around this multiform and inexhaustible universe of formal innovations.

While the deformed, geometric, idealised or overturned representation of the sensible world was granted and justified, and even appreciated as a continuous conquest by the artists in the West, thus able to respond to the incessant developments in thought and science, a completely different criterion was adopted for the African world. Intentional deformations, calculated expressive emphasis or abstract and conceptual approaches characterising many sculptures, such as those on show in this exhibition, were not considered expressions of the cultural heritage of the various peoples, or independent choices of the black artists to provide concrete images for the invisible world, but were seen as the result of the artists' incapacity to give a coherent form to their thoughts and expressive needs. As if a century of modern Western art had not accustomed us to deformations, and a lot more besides.

In reality, many of the formal inventions which have marked the path of Western figurative arts, the signs of a conquered and reappropriated expressive freedom, were anticipated in the works of the artists of Black Africa, who redeemed, with their extraordinary wealth of figurative solutions, the apparent thematic poverty of their universe. They moreover demonstrated that religious or social purposes and respect for tradition do not make creativity sterile, as however happened to art in the West and everywhere else in the world.

Sculpture is the form in which the creativity of African artists from the past is above all manifested. There did not exist south of the Sahara constructions comparable in terms of size to the temples in Greece, India, Mexico and the Egypt of the Pharaons (which, unlike Nubia, is part of the Mediterranean world), to the great mosques of the Arab world or to the cathedrals and palaces of Europe. The clay mosques and houses of Sahel, great sculptures pulsing like living organisms, moving in their fragility, the palaces of Cameroon with their decorated portals

and the palaces, now in ruins, of the Kuba sovereigns, built in wood and other perishable vegetable materials, seem modest in comparison to the constructions of the civilisations listed above.

The absence of surfaces suitable for painting, apart from in caves in the prehistoric age, probably prevented this expressive form from becoming widespread in Africa, unlike in Europe. The situation has changed in recent decades, following the processes of urbanisation and globalisation which have affected the continent, encouraging the appearance of new target audiences: the local picture-buying middle classes, and the international market, which is increasingly interested in African artists. The adoption of expressive means adequate to the new situation, with a greater emphasis on colours and less value attributed to plastic arts, has been the inevitable response.

Sculpture was however for centuries the African artistic expression par excellence; the form that first comes to mind, and the human figure was its subject: images of mythical or real ancestors who establish a link with the world of the dead and affirm the owner's right to power or land; images of spirits or particular deities which watch over or protect specific activities of man or the community; so-called "power figures", used in divinatory and propitiatory rites or to hinder the activity of evil individuals and avert evil forces.

The figures seem isolated, without feelings. The identity of those presumably portrayed is indicated by scarifications, hairstyle, attributes, and costume. The function of power figures is suggested by additional elements such as the "loads" of propitiatory or protective materials, and the nails driven by the priest. Independently of stylistic diversification, rigid frontal orientation, symmetry and immobility (or movement barely hinted at) are the distinctive figurative features which give the figures dignity, and a monumentality which goes beyond their actual size.

Unlike in the Western world, masks in Africa have a fundamental role. Max-Pol Fouchet defined them as "manifestations in the pure state of imagination", which often lend a material and visible body to supernatural forces, to the "spirits" which interact with human life. For this function, in which "l'entité considérée change de monde" (the considered entity changes world), Lucien Stephan (Kerchache, Paudrat, Stephan 1988, 239) used the term "présentification", which we could translate as "making present", since the African mask cancels the person wearing it and brings to life the evoked spirit. The deformations and mixtures of human and animal elements which give physical form to these entities, "monsters" inexistent in daily reality, must be recognised and accepted by the community for whom the masks incorporating them are made.

If we consider that wood was the main material and that the works are carved from a single piece, it is not surprising that very few exceed a metre in height, and that the average size is around 50 cm. However, despite this intrinsic limitation, the quality which is most striking in African sculpture is its monumentality, as we hope will be evident from this exhibition.

The predominant use of wood, easy to work with simple tools, does not mean that African artists have not produced extraordinary works with other materials, such as ivory, widely available in past centuries, stone, terracotta, bronze and iron, or that they have not used other expressive means, such as body painting, tattoos or polychrome masks and the decoration of fabrics and carpets.

The preference for wood did not impose any standardisation in form, because form and meaning were linked to the function of the works themselves, to the ideal qualities of the subject represented or to the evocation of the spirit world, according to the cultures of the different African populations expressed by the artists.

Despite the fact that many art galleries over the world exhibit the creations of black sculptors, thus giving official approval of their high quality, in the collective imagination they are still frequently seen as ethnological artefacts. This view is encouraged by the ambiguity with which the works are often presented, emphasising function and meaning (which are sometimes uncertain). Moreover, they are often set in misleading contexts, as we find great masterpieces placed alongside mere functional artefacts lacking any real formal worth.

It is clear that definitions of function and meaning are anything but marginal, because if they should be proved, they would not only enrich the "enjoyment" of the works presented but also explain their forms — often strange or at least unusual and foreign to our culture. The recognition of a work's particular function or meaning helps place it in a particular historical period, in a specific cultural climate and thus facilitates its comprehension also on a formal level.

What, however, is no longer acceptable is for adjectives such as "primitive", "tribal", "ahistorical", "anonymous" to be associated with African sculpture. In reality, nothing is more incorrect and ahistorical: the increasingly numerous finds which come to light in all parts of the continent, the study of ancient documents and the re-examination of the works with attention to their formal qualities, contradict this false vision. They prove that in Africa there have existed since antiquity, and certainly still exist, artists who have consciously created works of art which are in no way inferior to those of other cultures, in terms of originality and formal perfection.

The religious or social purpose of the sculptures — figures or masks — did not suffocate the expressive freedom of real artists nor did it make their task become an anonymous and boring routine. Besides, also in Western society, in the past, the purpose of a work of art was hardly ever the artist's choice, but of the person who commissioned it, who often also suggested the iconography to be used. In reality, such limitations only made the job more difficult, in Europe as in Africa. The artists who emerged were those who possessed an original personality, whose creative ability and conscious search for formal perfection went beyond the purpose of the works themselves.

We should however admit that we do not know whether the sculptures on show here would have been considered the best examples of their kind by the members of the societies from which they originate, or even whether they would have been considered works of art in our sense of the term. These are questions that we have to ask ourselves and which we must try to answer, although we cannot modify the evaluation criteria of our own culture. However, even if we are unable to look at African sculpture with the eyes of those for whom it was made, we can still clearly see the intentional search for formal perfection in these works, which, despite their wealth of figurative approaches, have certain standard elements which immediately set them apart as African.

The exhibition, organised into various sections, intends to do justice to these nameless artists and to the cultures which expressed and nourished them.

The last section is devoted to the relationships between "art nègre" (at the beginning of the 20th century no distinction was made between African art and Oceanic art) and Western modern art.

A deep-rooted opinion, not only in the public in general but also in the field of specialist criticism, attributes African art with a predominant and direct influence on the creation of the avant-garde in Europe and America in the early decades of the last century. Most recent studies tend to reduce this function, or, more precisely, to put it into perspective.

Many protagonists of the renewal of Western art in the early 20th century (Braque, Derain, Picasso, Matisse, Modigliani and Brancusi in France; Carrà and Magnelli in Italy; Pechstein, Kirchner, Heckel, Schmidt-Rottluff, Nolde in Germany; Epstein and Moore in England — to mention only the most important figures) owned or had seen African sculptures, albeit of a different formal worth. At certain moments of their career, their works clearly show some relationship with "art nègre"; however, this relationship, although fascinating, above all regards the outer appearance of the works, and is often mere quoting.

Having clarified this, it should nevertheless be acknowledged that, in various and

different forms, the two cultures have interacted, and the relation between the European artists in the first half of the 20th century and African sculpture deserves to be mentioned. A few particularly important works by these artists, together with the photographs of their studios and the houses of their contemporary arts merchants and friends (Apollinaire, Khanweiler, Guillaume), bear witness to this meeting, which has been studied in detail by Jean Louis Paudrat.

Starting from the fifties the african continent will go through deep changes ; the reasons can be listed hereby:
- Participation of African soldiers in the Second World War
- People's reappropriation of their African identity (*negritude*)
- Decolonisation
- Urbanisation
- Globalisation
- Transformations in the structures of political and economic power
- Progressive abandonment of traditional religions

The second part of the exhibit is dedicated to contemporary African art and testimonies the transition of "traditional Africa" to "modernity". A work of Kane Kwei — a sarcophagus in the shape of a car — symbolises the new values, such as "well-being", those of Western affluence, which are now dominant.

 E. B.

ANCIENT ART

ANCIENT AFRICAN ART

FOR THE AFRICANS

The claim that artistic creation in Africa is stagnant has always been accompanied by ignorance of its historical origins. We often read that certain forms have been handed down "since immemorial time", without Western scholars documenting their presumed antiquity by using dated examples.

The recent recourse to science — due above all to market rules (works of certified antiquity command higher prices than those which are more recent or undated) — has provided information which can help us outline a history of African art, as long as such information is provided by institutions of recognised scientific authoritativeness and reliability.

The European knowledge of sub-Saharan Africa and its culture before the 15th century was certainly limited. For the ancient Romans, the rulers of the Mediterranean coast, the part of the continent in which the works on show in this exhibition were created was the "land of the lions", a vast and hostile expanse, beyond the sands of the desert from where, however, according to Pliny the Elder, "something new" always came. There must certainly have been attempts to reach the sources of that precious "something", but their traces have been lost in legend. Moreover, in the early Middle Ages, between barbaric invasions and famines, European knowledge of trans-Saharan Africa made little progress, although the area was already well-known to the Arabs.

In the 14th century, some news also began to filter through to Europe. The name of Mali appeared in 1339 on the map by Angelino Dulcert; the cities of Gao and Timbuktu are correctly placed in the *Atlas Catalan*, drawn in 1375 by Abraham Cresques for King Charles V of France. The same famous atlas, kept at the National Library in Paris, represents, in all his majesty, the Emperor of Mali, Mansa Musa, famous for his journey to Mecca.

It was, however, not until the mid-15th century that Europeans first established contact with the Africans living south of the desert, with the intention of entering the trans-Saharan markets, circum-routing the bastions of Islamic lands by sea. The Portuguese were the best situated for this move into Black Africa, with their strategic position on the Atlantic. Consequently, starting from the mid-15th century, Portuguese caravels, loaded with maps and nautical instruments, began to push further southwards, in the space of half a century reaching Sierra Leone, the Gulf of Guinea, and the mouth of the Congo. In 1498, they went beyond the southern tip of the continent, which they christened Cape of Good Hope, and sailed into the Indian Ocean.

Once the Portuguese had forged ahead, other European powers — France, England, Holland, Brandenburg, Denmark and Sweden — started to take advantage of the new trade routes, with varying success.

The pilots' books, maps, globes, geography treatises, and the reports of travellers and historians, record with increasing precision the various discoveries. The works of art and the objects collected over the centuries, some of which are on show in this section of the exhibition, are tangible proof of these advances. Ma-

terial proofs from the most ancient civilisations in the continent, and the very existence of such civilisations, remained unknown or were, however, ignored by the West, in some cases until only a few decades ago. Cases in point are the ancient cultures of Nigeria, with the sole exception of Benin, revealed in tragic circumstances.

Certainly we do not have (nor could we expect to) for African sculpture the exact dates to which we are accustomed in studies on Western art, i.e. dates supported by precise documentary evidence, in addition to laboratory tests (although these are still somewhat approximate and unreliable). However, despite these uncertainties and the limitations deriving from the absence of writing in trans-Saharan Africa, the first two sections of the exhibition intend to illustrate, at least in part, the greatness of African art in the past.

The first section opens with a small group of incredible works from the Sudanese civilisations, halfway between ancient Egypt and Black Africa: stylised human figures in stone, and terracotta vases dated from the 5th-4th millennium BC, and heads in stone from the 2nd-3rd century AD from the Meroe civilisation.

It is however Nigeria, the large country on the Atlantic coast, which reveals, in an almost uninterrupted sequence of works, the richest and most convincing panorama at present available of ancient African art: the terracottas of the Nok civilisation, spread out over a millennium, from the 5th century BC to the 5th century AD; the bronzes of the Igbo Ukwu culture from the 1st-10th century AD, astounding for their formal perfection and technical craftsmanship; the bronzes and terracottas from Ife, the sacred city of the Yoruba, from the 12th-15th century AD, works of an absolute beauty, so perfect that Leo Frobenius, amazed, assigned the first examples discovered by him in the early 20th century to the artists of the Mediterranean; the barbaric and majestic bronze figures from Tada and Jebba from the 14th-16th century AD; twenty or so works from the ancient kingdom of Benin, dating back to the 15th-18th century, sumptuous testimonies of a court life with luxurious and complex rituals; terracottas from Owo, dating back to the 15th century, proof of the contemporaneous influence of Ife and Benin on the art of that city; two stones from Esie; and two terracottas from the region of Calabar, the result of excavations still in progress.

For many decades Nigerian art was almost the only testimony of the creative ability of Africans in past centuries, then archaeological research was extended to other countries in the continent. Excavations, motivated by scientific reasons but nourished more prosaically also by the desire for profit, thus brought to light: in Niger, the terracottas of Bura Asinda Sikka from the 3rd-11th century

AD, represented in the exhibition by a figure and an impressive rider; in Mali, the figures from Jenne-Jeno dating back to the 12th-16th century AD. Seven heads in terracotta (not on show), known as the "Lydemburg heads" from the name of the place in Eastern Transvaal where they were found in the late fifties, have been dated between the 6th and 10th century AD.

Stone sculptures, considered together, represent an important part of African art history. Consequently, alongside the works from Esie mentioned above, the panorama is provisionally completed by some steatite figures from Sierra Leone dating back to the 15th-16th century AD, small but, in some cases, of great monumentality. Sculptures in soft stone had been discovered in the late 19th century also among the impressive ruins of Zimbabwe, capital of the Shona kingdom in the 12th-15th century.

The most surprising aspect, in rapid growth with the intensification of carbon-14 dating — even if so far the results obtained have displayed a wide margin of approximation and chance — regards the antiquity of wooden works. The dates obtained in recent decades contradict the widespread conviction that wood is highly perishable in African environments, at least for some regions of the continent.

The most comprehensive data at present regard the sculptures collected in Mali, and in the area of the cliff of Bandiagara. Twenty or so Djennenke, Tellem and Dogon figures from between the 10th and 19th centuries AD testify the continuity of the ascetic and monumental tradition in sculpture, spanning over a millennium if we take into consideration that some styles are present in works collected a few decades ago, and probably sculpted not long before.

But if the wooden works of the Dogon and of the other artists of the cliff are so far the largest group of dated works, no less significant is the fact that some Bamana sculptures, from the same sanctuary, again in Mali, have been dated between the 13th and 17th century AD (Ezra 1988, nos. 25, 27, 30, 34), even if the recent examination of another stylistically similar piece of the same origin would lead us to reconsider the problem and set the date of their creation as later.

Moving southwards through the continent, a group of Mbembe figures from the region of Cross River could date back to the period between the 17th and 18th century AD. And the landscape is continuously being filled in, as the number of laboratory tests intensifies. A Lobi figure from Burkina Faso, and a figure and a Fang reliquary figure from Gabon, for example, have unexpectedly been found to be over two centuries old.

These results may seem insignificant compared with our knowledge of the chro-

nology of European art, but they are only the first promising results in research aimed at dating the works, whose future developments will contribute to outlining the history of African art in its evolution through the centuries.

E. B.

[1] This experience is made possible above all thanks to the generous lending of works by the Director-General of the National Commission for Museums and Monuments of Nigeria, Doctor Chief Omotoso Eluyemi

Foreword

The works exhibited and described have been mentioned and reproduced in writings too numerous to be mentioned in each entry. Those interested in further reading will find the relative titles in the general bibliography.

NUBIA

ANCIENT
NUBIA

Until a few decades ago, Sudanese Nubia —
an important corridor for traffic between the
Mediterranean and central Africa — was
considered a cultural province of Egypt.
Research in recent years has instead proved
that in antiquity Nubian art had, albeit in al-
ternate phases, an independent, African deve-
lopment, with results which must thus be
considered the result of cultural interaction ra-
ther than subordination.
The few finds on show prove the age of the
plastic creation of Nubia, which is increasingly
the subject of attention in Europe.

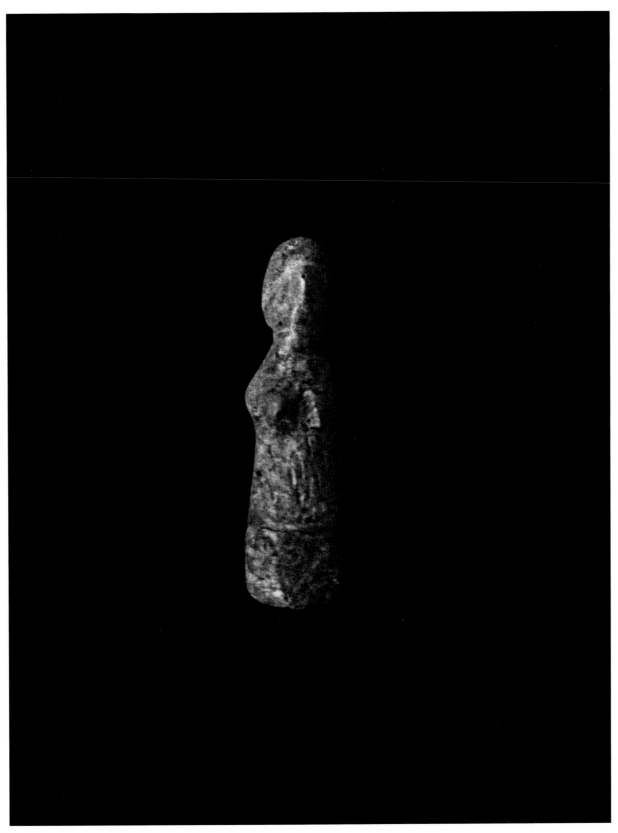

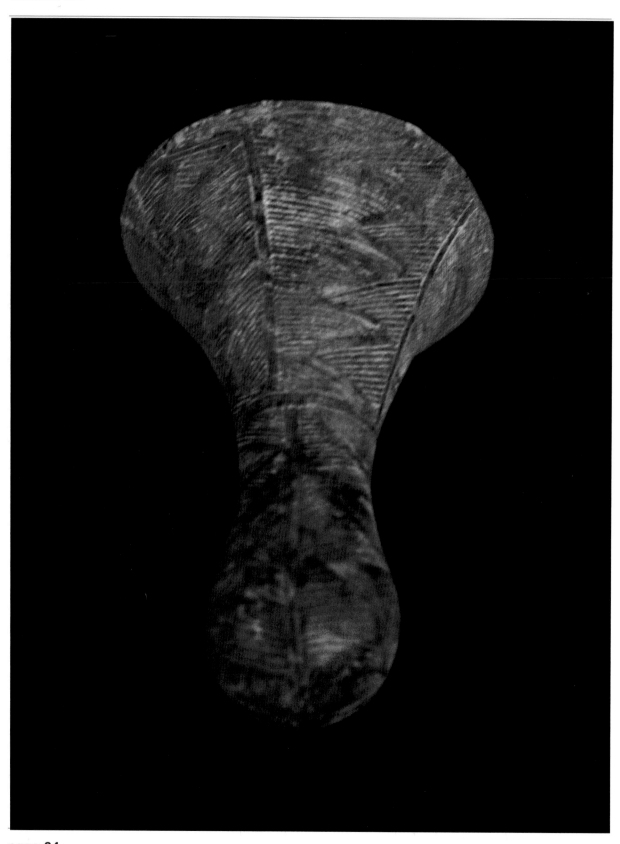

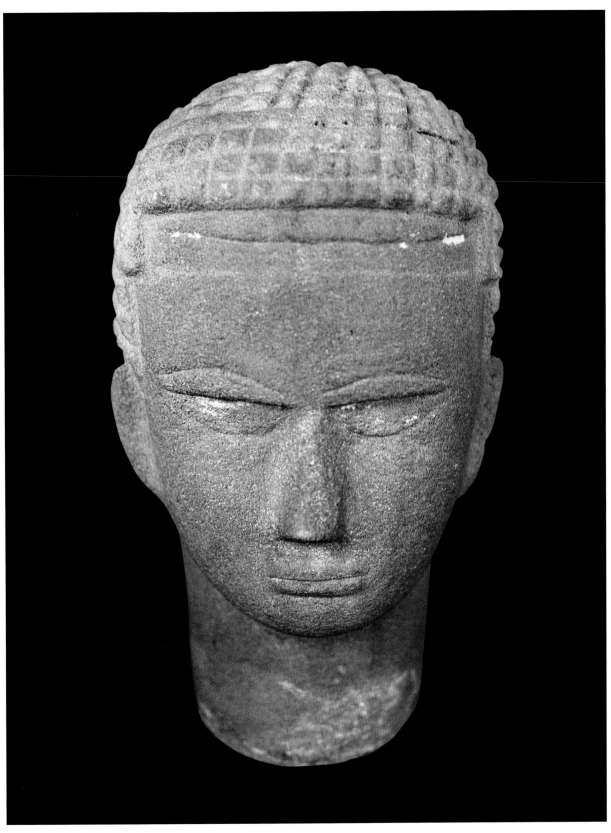

1a　**Neolithic artist, excavations
from the Kadruka Cemetery 21 (Sudan)
Anthropomorphic figure**
First quarter of the 5th millennium BC (?)
Stone, 19.9 cm
Khartoum The National Corporation for Antiquities
and Museums, Sudan (inv. SNM 27335)

The distinctive expressive feature of this small figure is its stylisation of the human form while respecting anatomy: a reduction to the essential forms which presupposes high intellectual awareness on the part of the artist.
The sculptor limited himself to making the subject recognisable with subtle relief work which does not interrupt the fluidity of the overall volume, and exploited the natural veins of the stone to draw a harmonious and vibrant body. This is art which is anything but primitive!

2a.　**Neolithic artist,
excavations from the C cemetery of El-Kadada (Sudan)
Funerary vase "chalice-form"**
Second half of the 4th millenium BC.
Terracotta, 27.6 cm
Khartoum, The National Corporation for Antiquities
and Museums, Sudan (inv. SNM 27138)

3a.　**Neolithic artist,
excavations from the C cemetery of El-Kadada (Sudan)
Vase**
First quarter of the 5th millennium BC
Stone, 27.3 cm
Khartoum, The National Corporation for Antiquities
and Museums, Sudan (inv. SNM 27361)

4a.　**Neolithic artist,
excavations from the C cemetery of El-Kadada (Sudan)
Funerary vase**
First quarter of the 5th millennium BC
Stone, 20 cm
Khartoum, The National Corporation for Antiquities
and Museums, Sudan (inv. SNM 26925)

The perfect equilibrium between the volume and decoration is the proof of the perfection consciously pursued by the ancient Nubian artists in the creation of these beautiful terracotta containers, probably vases for funerary use.
The first piece, which belongs to the so-called "chalice-form" type, is noteworthy for its sophisticated form and for the engraved and painted decoration, perfectly functional to the form itself.

5a. **Artist from the Meroe, Argin**
Head
2ⁿᵈ-3ʳᵈ century AD
Stone, 26.7 cm
Khartoum, The National Corporation for Antiquities
and Museums, Sudan (inv. SNM 13365)

This refined sculpture, created five millennia after the small anthropomorphic figure is, for the moment, one of the many enigmas of Sudanese art.
The simplification of the facial features, limited to the essential, without diminishing their austere expressiveness, has led scholars to hypothesise a relation with African art, in particular with that of ancient Nigeria. This would suggest "interchange, influences or migrations" (F.B. 2002, no. 117), which, however, remain to be proved, between the two areas at the beginning of the first millennium AD.

Author's Note
The captions for the works presented were edited by Ezio Bassani, exept:
6a-30a, 32a-37a, 42a-57a which were edited by Violata I. Ekpo.

NIGERIA

NIGERIA

With a population of over one hundred and forty million people, Nigeria is widely known among the world's cultures for her fine indigenous arts and crafts' technology. The country's artistic traditions stretch back into antiquity and have produced a variety of exquisite artistic works; those known so far are made of terracotta (fired clay), bronze, brass, wood, stone, ivory and other materials. The intricate and exquisite nature of the works made in these media has created a unique cultural identity for Nigeria as a nation.

Wood appears to have been the most widely used sculptural medium in black Africa since earliest times but the duration of such works is put at about one hundred years because they are usually destroyed by the intense heat, humidity and insects. Nigeria, however, is the only known country in sub-Saharan Africa to have produced a large number of ancient artworks in durable and varied media. In addition to this, they are of a quality as high as those produced anywhere else in the world.

The collection and preservation of ancient Nigerian works of art were the work of a number of British officers working in Nigeria in the first half of the 20ᵗʰ century that included K.C. Murray, J.D. Clerck, William Fagg, Bernard Fagg and Thurstan Shaw.

Accidental finds have shed light on many important art cultures in Nigeria. For instance, in 1943, tin-mining operations in the Jos area of *Plateau State* unearthed a unique collection of ancient terracotta sculptures that date back to between 5ᵗʰ century BC and 2ⁿᵈ century AD. The culture that produced them was named Nok after the village where the first sculpture was found.

It was Bernard Fagg who first recognised the historical importance of this early find. Subsequently, over one hundred and fifty Nok works have been recovered across a very large geographical area stretching from Southern Kaduna to Jos in *Plateau State*, Kegara in Niger State and Katsina Ala in Benue State. Many more are being discovered through archaeological excavation, illegal excavation and soil movement resulting from road construction. A common feature of the Nok valley, according to Bernard Fagg, "is a band of grey carbonaceous clay of up to six feet in thickness which provides a clue to the age of such artworks".

A unique feature of the Nok terracottas is that they represent the earliest coherent and articulate tradition of a naturalistic style in black Africa. They provide a tangible base on which to study subsequent artistic traditions, schools and movements in this region of Africa. It is worthy of note that the great schools of Ile-Ife, Benin, Owo, Igbo-Ukwu and other traditions in wood, stone, ivory, metal and clay of the indigenous cultures of Nigeria can trace their ancestry to the Nok terracottas, which have provided them with a legitimate and credible prototype. Some finely-made, intricate bronzes were discovered by chance at Igbo-Ukwu village near Awka in Anambra State in 1938. Consequently, the British archaeologist Thurstan Shaw carried out excavations on three sites in the area in 1954 and 1956 and found extraordinary works of Igbo-Ukwu culture from the 9ᵗʰ and 10ᵗʰ centuries. These may be the earliest "bronzes" made using the lost-wax process in sub-Saharan Africa. The three sites are Igbo Isaiah, Igbo Richard and Igbo Jonah, each of which is thought to have represented a different aspect of this ancient culture.

Igbo Isaiah is thought to be the burial site of an important ritual priest; Igbo Richard, where most of the bronze objects were recovered, has been interpreted as a shrine or a store of important regalia; and Igbo Jonah suggests a disposal pit where unwanted ritual items were deposited. All these interpretations are based on comparison of details of the archaeological context in which the objects were found with current ritual practices of today's inhabitants of the area. These objects are also thought to have been connected to the office of the *Eze Nri* among the Oreri Igbo. The *Eze Nri* is the most highly titled man in the community and he is responsible for the ritual cleansing that ensures the fertility of the land and people.

The distinctive features of the bronze sculptures found are the fine decorations on the surfaces, the use of natural forms and the common representation of insects able to threaten agricultural production. It is particularly the presence of insects on the sculpture that suggests the objects are related to the ritual functions of the *Eze Nri*.

The intricate and elaborate use of metal in a complex technical process points to the high level of economic and social advancement in the ancient culture that produced these works.

The Ife artworks, on the other hand, were not discovered by accident: on the contrary, the Ife people knew where these objects were kept and preserved. In 1910, Leo Frobenius, a German anthropologist on a scientific expedition, came to Ile-Ife to learn more about Olokun, the goddess of the sea and wealth, who is comparable to the Greek Poseidon and the Roman Neptune. Having learnt that the objects used in the worship of Olokun were either found in shrines or buried in the ground and dug up only when needed for rituals, with the consent of the Ife chiefs, Frobenius made arrangements for excavations to be carried out. The Olokun head and other works of art in brass, stone and terracotta were found. This discovery led to the collection of objects in other parts of the city. The amazement Frobenius felt at the quality of the Ife artworks led him to compare them to Classical Greek works and suggest that "a race, far superior in strain to the Negro had settled there". It has been proven that this statement is not true and the Ife still make use of these objects in their rituals. The tradition of bronze-casting in Ile-Ife can still be observed today. The objects have been dated to the period between the 12th and 15th centuries AD, which is referred to as the "classical" period in Ife's history.

Bernard Fagg, Frank Willet, Ekpo Eyo and Omotoso Eluyemi later worked in Ife in an area where a large number of naturalistic portrait-like sculptures were found. Further archaeological research in the "pre-classical" period has resulted

in many finds by both Paul Ozanne and Omotoso Eluyemi working at the Oba-femi Awolowo University of Ile-Ife, some earlier than the 12th century. It has been shown that the Ife sculptures are linked to the arts of Egbejoda, Owo and Benin. The research work carried out by Omotoso Eluyemi shows that artworks in Egbejoda (a region about 20 km east of Ife) were produced after the classical period, between the 15th and 19th centuries.

Ekpo Eyo, the former General Director of National Commission for Museums and Monuments in Nigeria, carried out excavation work in Owo, a town that lies mid-way between Ife and Benin. He found that the Owo arts bridge the gap between those of Ife and Benin. Owo arts have been dated to between the 13th and 16th centuries, and it is seen that the technology used to produce terracotta objects was based on the techniques and traditions of Ife.

In Benin excavations carried out by Graham Conam have indicated that in the 13th century brass bars were melted down and the metal used to form bracelets. According to oral tradition, the sculptures were not made until the 14th century when the lost-wax technique of casting was introduced to Benin from Ile-Ife. It is also recounted that sculptures, such as terracotta heads, and objects, like cere-monial stools and swords, originated from an early dynasty of kings called Ogiso that probably ruled before the 14th century until they were overthrown by a re-volt. A new dynasty was founded by the hero Oranmiyan from the neighbouring ancient town of Ile-Ife. Oranmiyan is described in oral tradition as having intro-duced the horse to Benin and he is represented in Benin artworks by the figure of the equestrian warrior.

There is no established date for the beginning of the second dynasty but it is clear that a flourishing kingdom was established before the arrival of the Portu-guese at the end of the 15th century. The Benin Kingdom was at its military peak, expanding and establishing tributary states in the surrounding region. Ac-cording to oral tradition, from about the mid-15th to late-16th centuries Benin ex-perienced a lot of cultural and artistic activities. Series of warrior kings enlarged the empire, rebuilt the royal palace on a grander scale, restructured the power or-ganisation of the chiefs and developed the religious system. All these innovations brought about the creation of new artistic forms in brass and ivory: in particular, low-relief brass plaques that portray court life and military victories, brass heads commemorating deceased kings and queen mothers, brass trophy heads celebra-ting military victories, brass figures of count functionaries to decorate the palace and its shrines, and elaborate ivory and brass regalia which adorned the nobles at State rituals.

Tsoede bronzes are thus named because oral tradition has it that Tsoede, the le-

gendary founder of the Nupe Kingdom in the 16th century and a ward of the court of the *Ata* (king) of Idah, escaped from Idah in a bronze canoe and distributed nine large bronzes on his way, some to Tada and others to Jebba, before founding the kingdom of Nupe.

The bronzes are divided into four groups. The first consists of Gara figures: two (a male and a female) on Jebba Island, and one in Tada. The second group consists of only the seated figure in Tada, which is the most important naturalistic sculpture in black Africa. Two other more recent-looking figures make up the third group, while the fourth group comprises figures of two ostriches and an elephant, making nine in all.

The male Jebba Gara figure — better known as the "Jebba Bowman" — and the Tada Gara male figure are thought to resemble Benin works because of the diadems on their foreheads. These depict faces with snakes issuing from their nostrils, a common feature in Benin works. The Tada seated figure seems in its naturalism and rigidity to belong to the Ife school. The two more recent-looking figures from Tada have a combination of Yoruba and Benin traits while the ostriches and the elephant belong to a yet unidentified school. Consequently, the nine Tsoede sculptures are seen to mirror at least four traditions of bronze sculptures, so their grouping may well have been accidental.

Other works like the Esie soapstone sculptures are still an enigma. Various stories from oral tradition are made up by the inhabitants of the area to explain their presence, but neither art historians nor archaeologists have done any better in explaining their origin. They are dated before 1850 on comparative basis or oral tradition.

From all that has been recounted about Nok, Igbo-Ukwu, Ife, Owo and Benin, one can conclude that Nigeria had a great history and a rich indigenous heritage in artworks before early contact with the Europeans. This is because the major art traditions flourished more than a century before the arrival of the white man. These works formed the classical period of Nigerian art. According to Frank Willet, "these artworks are realistic in form, classical in style, finished to perfection and advanced in technical skill". They are comparable with the finest examples of Italian sculpture or any other classical artworks from Renaissance Europe. It is well known that famous European artists like Pablo Picasso drew inspiration from Nigerian art forms and the arts of Africa as a whole in the early 20th century. They did this to create forms that departed dramatically from standard European art forms.

In 1979, the National Commission for Museums and Monuments put together one hundred pieces of its best ancient artworks for an exhibition called "Trea-

sures of Ancient Nigeria" that toured the USA, Canada and several West and East European countries.

The artworks on loan from Nigerian museums for the exhibition "Arts of Africa – 7000 years of African Art" are but a fraction of the cultural treasures of ancient Nigeria.

O.E

NOK

Nok culture, named after the village on the Jos plateau where it was first discovered in 1929, is the earliest known terracotta tradition in sub-Saharan Africa. By 1977 about 153 terracotta pieces had been found during mining operations, mostly in secondary deposits (washed away from their original locations and deposited further downstream) at old riverbeds in the savannah region of central and northern Nigeria, southwest of the Jos plateau. Since then, new sculptures are being found in a constantly expanding area (currently 480 by 320 kilometres), including the middle Niger and lower Benue valleys.

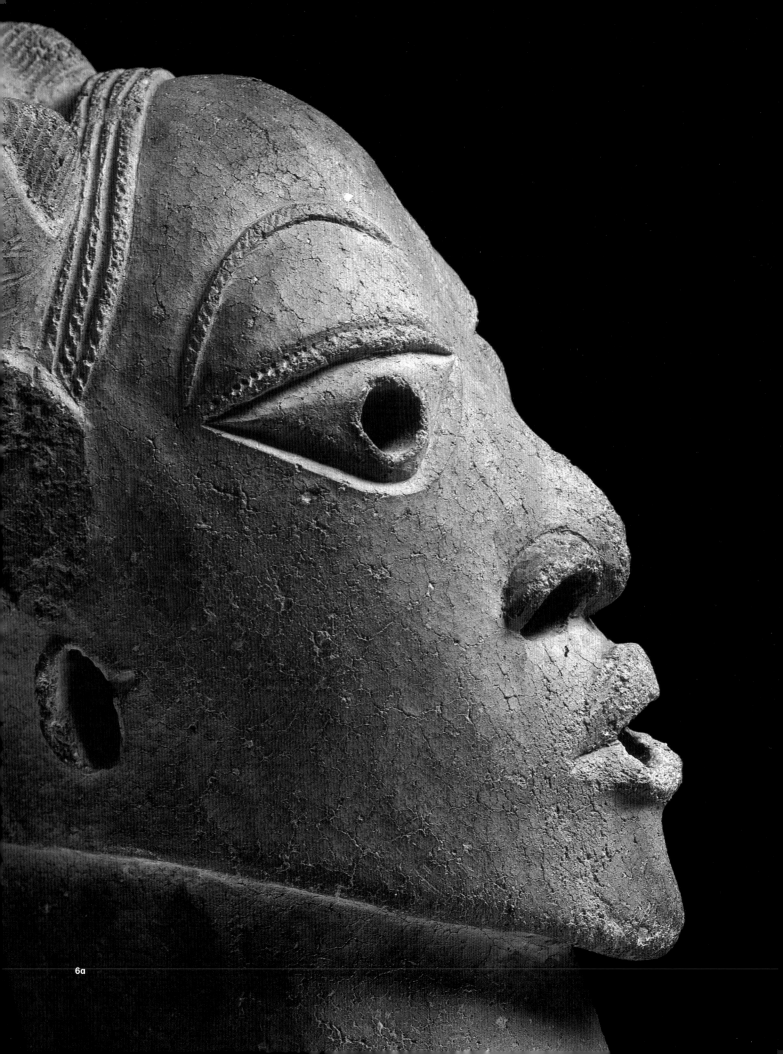

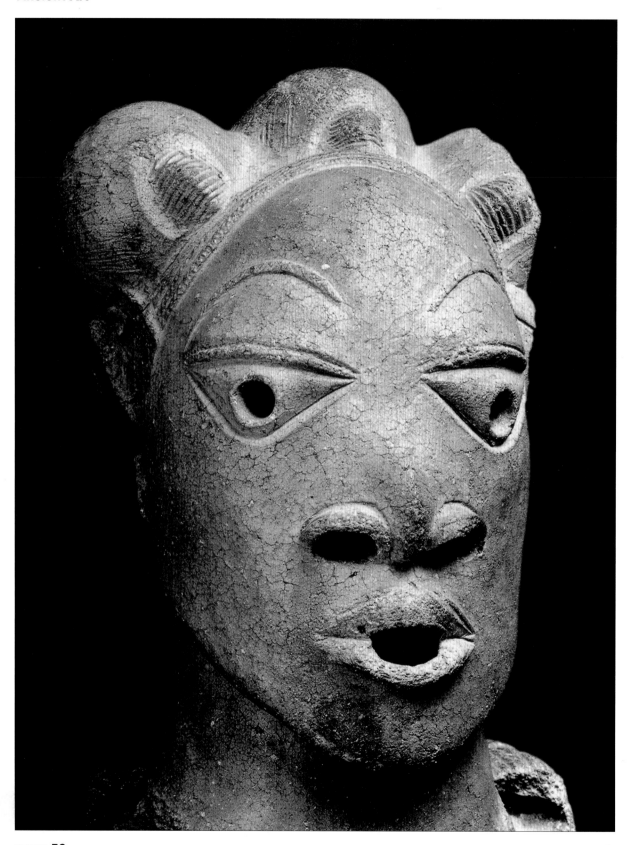

Archaeological excavations at sites such as Nok and Taruga have connected the terracotta sculptures to iron working. Research has shown some Nok culture sites were continuously occupied from 4580 to 4290 BC, about the time of the period of proto-Bantu dispersion in the area. Recent thermo-luminescent and radiocarbon dating, obtained from embedded elements in the charcoal of the sculptures, pushed the initial dating of the sculptures to between 900 BC and 1100 AD, though the central cluster of dates between 500 BC and 200 AD is often cited as the classical period of Nok art.

During the last decade, over a thousand of these sculptures have been illegally exhumed and exported to different parts of the world. While this has made them world famous, it has deprived scientists of vital contextual information needed to explain them. Consequently, Nok terracotta sculptures have been placed by the ICOM on its Red List of threatened world heritage items, protected by international conventions.

Several studies on the chronology, stylistic analyses and chronological sequence have made significant contributions to the understanding of the Nok culture. Nok sculptures represent a record of the world around them: human beings, animals, the dead, plants etc. Human figures are a central theme. They are represented in various standing, kneeling/genuflecting or seated positions, some with their chins resting on their knees, an arm lifted to the head, or both arms crossed in their laps. Over 60% of them have been identified as male by their attire, body decorations and hairdos, or by the small beard and, sometimes, moustache on their faces. The finds are interpreted as ritual and commemorative sculptures of local dignitaries: kings, queens and priests, portrayed as worshipers of religious cults.

Characteristic features of Nok art are the treatment of the eyes in triangular form or a segmented circle, the arched eyebrows balancing the sweep of the lower eyelid, sometimes to form a circle, and the pierced eyes, nose, mouth and ears. The location of the ears is misplaced and may be represented by simple perforations at the angle of the jaw or even at the back of the head. The torso is treated as a simple column, the accent being placed on the head (in proportion 1:3 or 1:4 to the body) and the limbs. Double (Janus) heads are also present. A profusion of beaded decorations and elaborate hairdos attract attention. These features suggest a well-developed and, probably, hierarchical society based on advanced agriculture, social order and developed art. Its craftsmen possessed the required technological knowledge to mould and fire the clay, an understanding of its properties and the mastery of skills needed to produce these elaborate and highly artistic sculptures.

Research conducted on more than one thousand Nok objects across the world has suggested that certain codes were followed in the positioning, gestures, ornamenta-

tion, accoutrement and coiffure of the figures, which makes possible attempts to differentiate styles and geographical variations, and work a tentative chronology of their evolution.

The geographical distribution of the Nok culture has been a subject of discussion and questions are being raised about the secondary context of the Nok finds in the north-east Katsina area and the different stylistic features of the Yelwa and Kagara finds in the north-west. They show that contemporaneous terracotta sculptural traditions existed in the lake Chad basin and along river Niger near Kainji, which were not directly related to the Nok tradition.

The Nok sculptural pieces have represented one of the best sub-Saharan African art traditions in exhibitions on more than four continents. Illegally exported Nok objects today adorn museums and art galleries all over the world.

V. I. E.

6a. **Nok artist,**
 Nigeria (Rafin Kura)
 Head
 5th century BC
 Terracotta, 33.8 cm
 Lagos, National Museum (inv. 79.R.1)

The object was found in 1954 in a tin mine near Nok, at a depth of around four metres. This human head is more or less life-size, and might have been part of a larger figure, over 1,2 metre high. It has an elongated form and protruding triangular eyes, wide dilated nostrils and an open mouth with plump lips. The hair is styled in the typical manner of Nok heads, collected in chignons, which are reminiscent of the hairstyles still in use in Nigeria today.
The holes which passed through the layer of clay, made in the pupils, and nostrils, below the ears, on the mouth and in the chignons on top of the head, were skilfully incorporated into the artistic style, but also had a functional purpose: to provide an outlet for hot air from inside the head during firing, and thus avoid cracking.

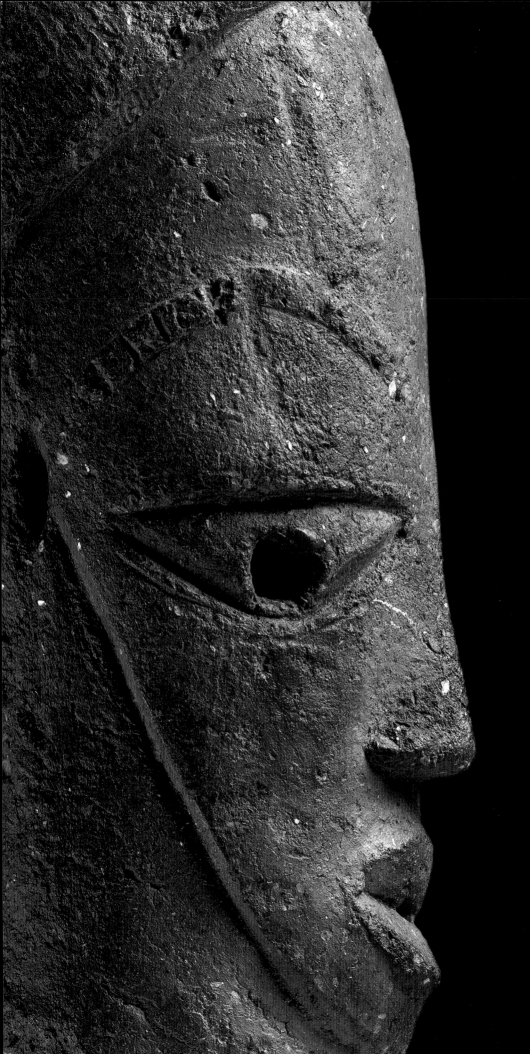

7a

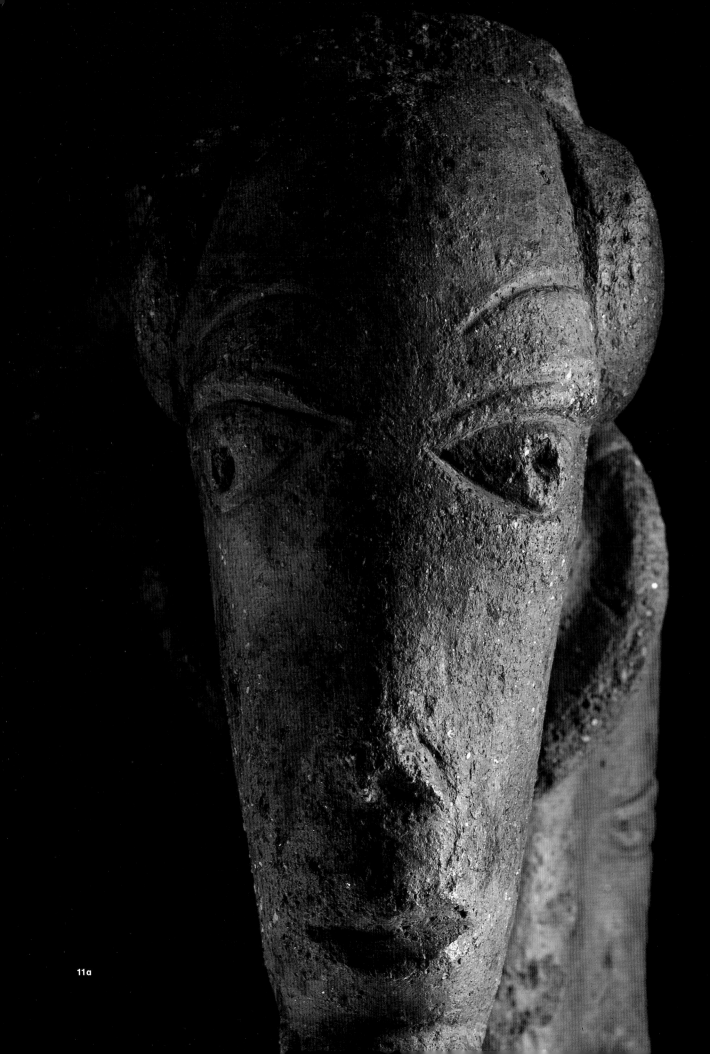

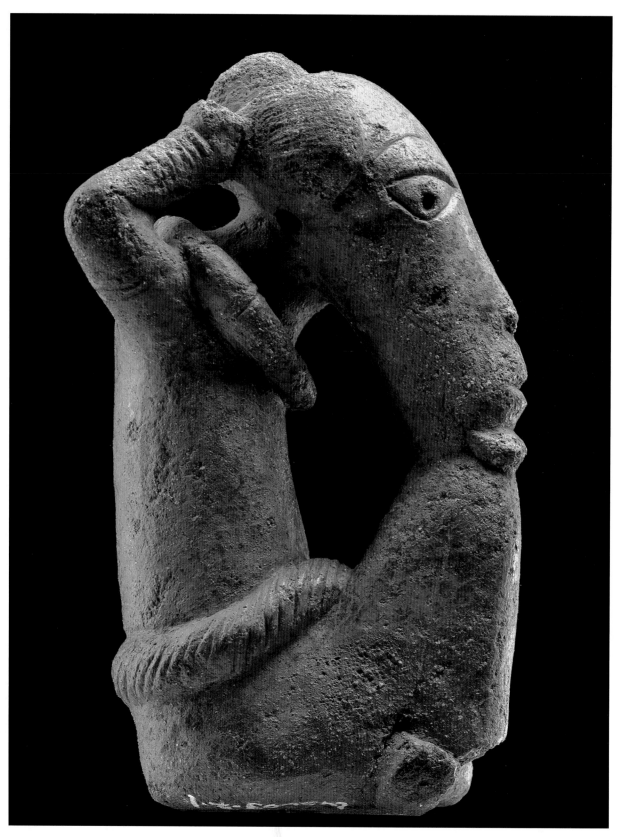

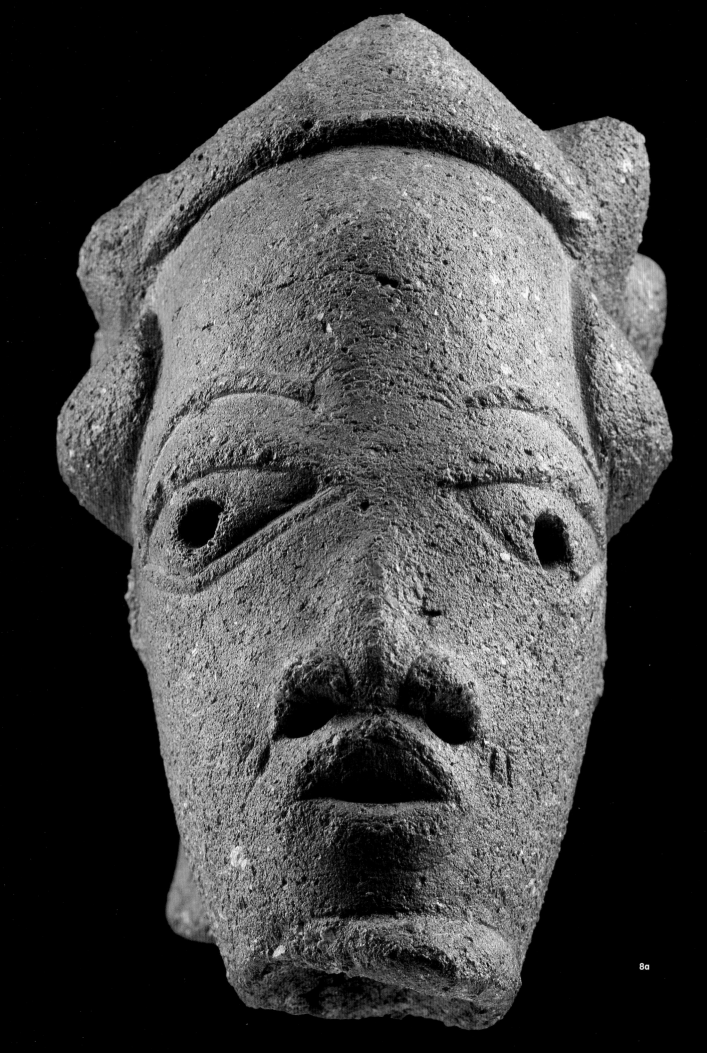

8a

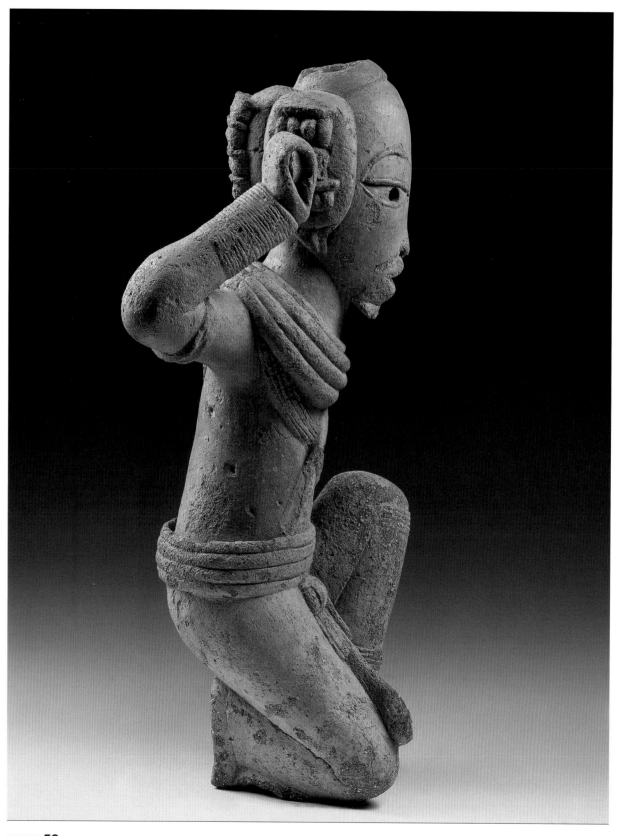

10a

7a. **Nok Artist,**
 Nigeria (Jemaa-Kafanchan road)
 Head
 Late 4th century BC
 Terracotta, 27.3 cm
 Jos, National Museum (inv. 63.J.2.36)

The elongated head, which extends from the neck to form a continuous cylinder, is characteristic of Nok iconography. This piece was found in 1963, together with fragments of another similar head, at a depth of around half a metre, in a gallery well near Jemaa.
The head was probably part of a larger figure (a two-headed figure), whose left hand supported an object held close to its head. This gesture, frequent in Nok terracottas, probably had a symbolic value.

8a. **Nok artist,**
 Nigeria (Jemaa)
 Head
 5th century BC - 2nd century AD
 Terracotta, 19.2 cm
 Lagos, National Museum (inv. LG.47.2)
 Donated by S.A. Gray

Human head with a conical and elongated form, which displays the usual characteristics of the Nok style as well as a short beard along the edge of the chin. The hair is styled in such a way as to form a ring of chignons around the head. Along the hairline can be seen a string of beads or the rim of a cap. It is thought that this elaborate hairstyle, found on many other Nok heads, had a ritual and religious meaning.

9a. **Nok artist,**
Nigeria (Odegi, mine of Agwazo)
Elephant head
5th BC - 2nd AD
Terracotta, 18.5 cm
Jos, National Museum (inv. J.29.1.1)
Donated by G. Diamanfidis

Elephant's head with a marked naturalistic style and anthropomorphic features.
Its proportions are well-balanced, with the typical large ears, a striped trunk and
long tusks, of which the tips are missing. The skull is represented realistically,
particularly in the bony prominence at the top. The eyes are styled as if they be-
longed to a human head. The line of the neck suggests that the complete statue
represented an anthropomorphic figure, either standing or seated.
In this object it can be seen that Nok art tends to represent figures of animals
(elephants, monkeys, snakes, etc.) more realistically than it does humans, while
however rendering some features (above all the eyes) in the same way as used for
human figures.

10a. **Nok artist, Nigeria**
Genuflecting figure with raised hand
9th BC - 2nd AD
Terracotta, 66.1 cm
Lagos, National Museum (inv. LMD 2000.3.1)

Nok figure in terracotta, which represents a genuflecting man with his right
knee resting on the ground. The face displays the typical geometric features of
the Nok style. The figure has a short beard and wears numerous bracelets and
strings of jewellery; its hair is divided into three locks. Around the waist the fi-
gure wears a high belt with pendants. The left hand has been lost whereas the
right hand is raised to his ear in a symbolic gesture.
This figure is a typical example of a highly developed style and shows that Nok
artists had achieved extreme technical skills in modelling and firing clay statues.

11a. **Nok artist, Nigeria**
Seated figure
5th century BC
Terracotta, 22.4 cm
Lagos, National Museum (inv. 2003.2.1)

Human figure seated on a flat round base. The elongated head rests on the
right knee, which is raised. The right hand is raised to touch the head in a ges-
ture which seems to be symbolic. The figure wears band armlets, an ornamental
collar and a high belt at the waist made of twisted strings of beads. The body
and limbs are rendered as simple cylindrical forms.

12a. **Nok artist,**
Nigeria (Bwari)
Crouching figure with raised hand
9th century BC - 2nd century AD
Terracotta, 10.8 cm
Lagos, National Museum (inv. 60.J.2)

Delicately modelled full-length figure of a crouched man, with his hand raised
to his ear in a symbolic gesture. The piece was found during mineral excavations
in Bwari, near Abuja.
The head is elongated and represents a third of the entire height of the figure,
according to the characteristic size ratios of African art (1:3 or 1:4). The figure's
male gender is indicated by the moustache and short beard. We can observe the
typical Nok hairstyle with hair gathered in six chignons and plaits falling down
onto the back, crowned with a helmet-like headdress.
The figure is overloaded with ornaments and provides a perfect illustration of
the importance of beads in ancient Nok culture: they were probably made using
bone, wood and clay, seeds and vegetable and animal fibres.
The discovery of quartz and cornelian beads in the sites in which Nok objects
were found indicates that they were locally produced.

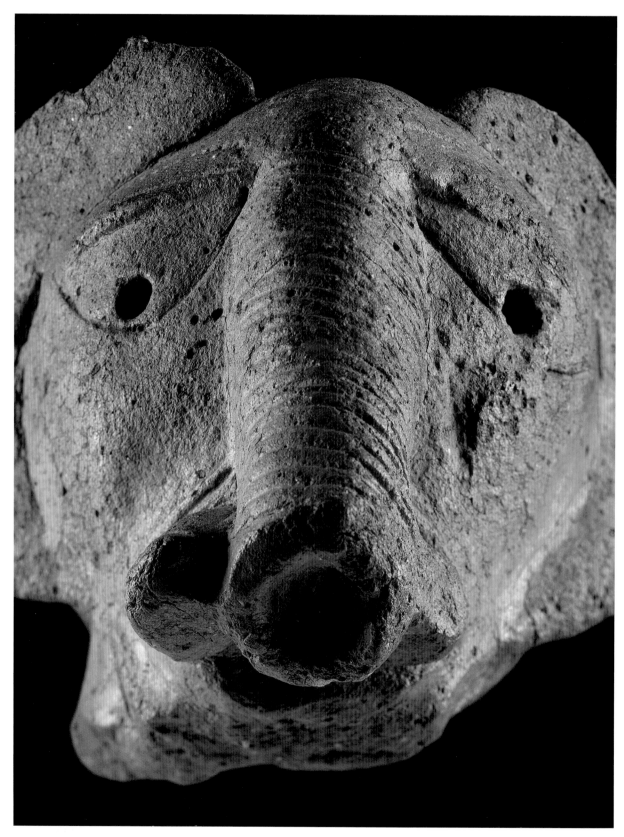

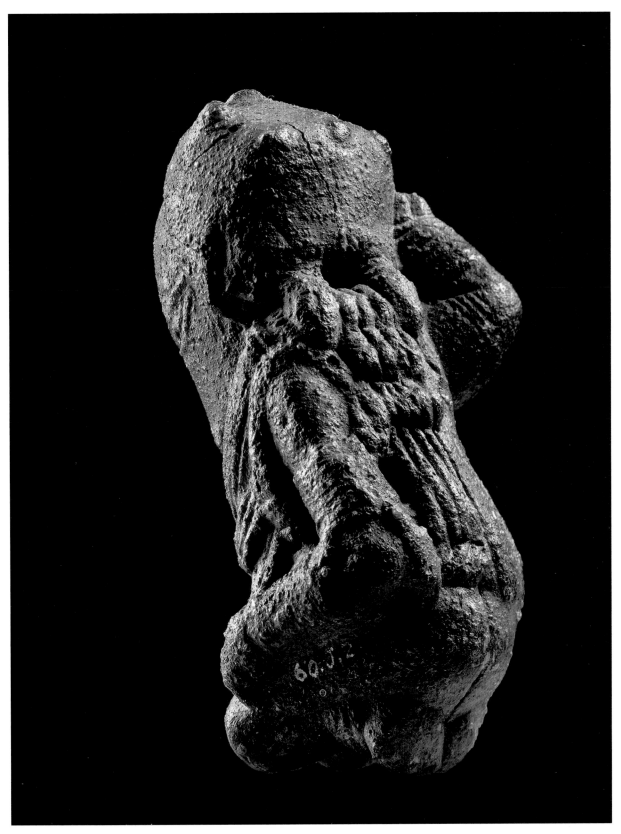

12a

IGBO UKWU

BRONZES

The Igbo Ukwu works represent the oldest known bronze-casting tradition in sub-Saharan Africa, dated to between the 9th and 10th centuries AD. They were discovered by chance in 1938 in Igbo Ukwu village in south-eastern Nigeria. Igbo Ukwu means "Great Igbo". The Igbo are one of the three major ethnic groups in Nigeria.

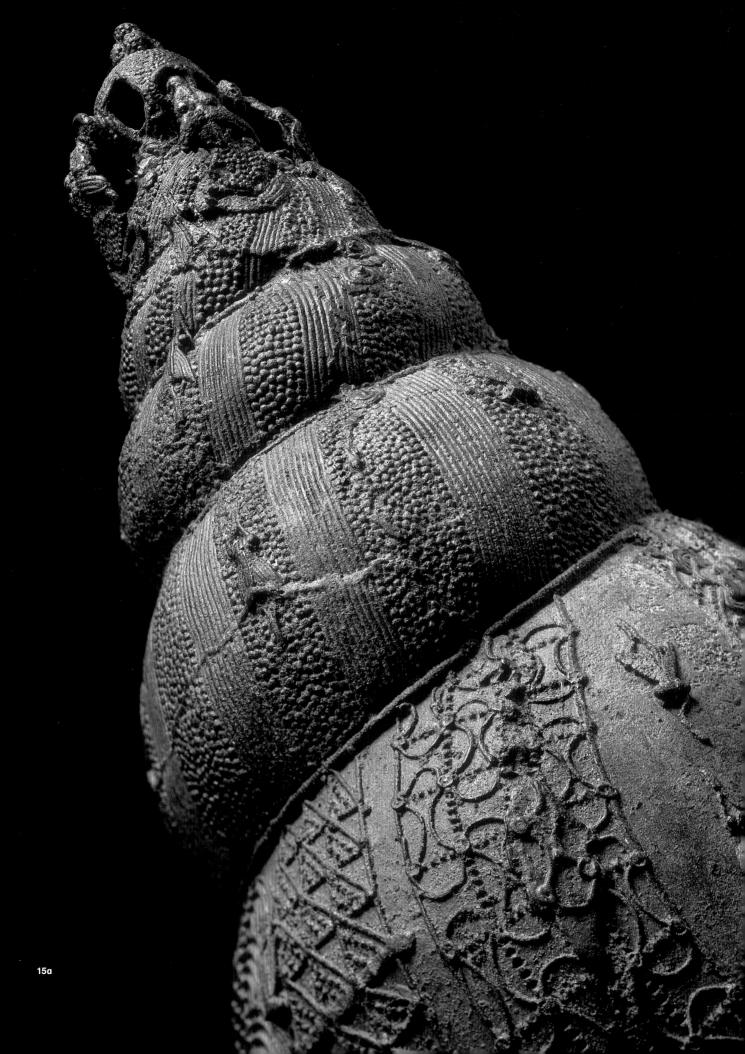

15a

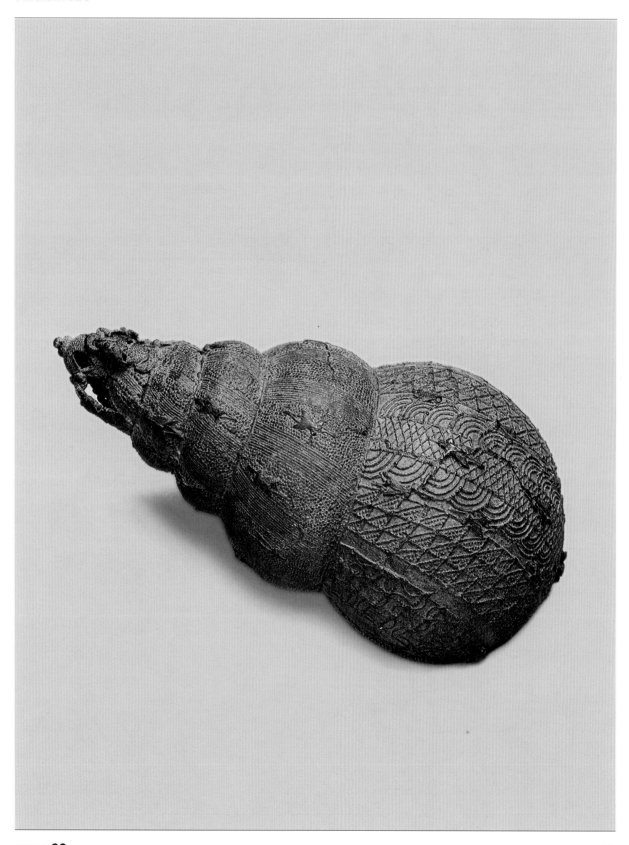

Between 1959 and 1964, profesor Thurstan Shaw excavated three major sites at Igbo Ukwu: a burial chamber complex at the Igbo Richard compound, a storehouse of ritual objects in the Igbo Isaiah compound and an ancient pit at Igbo Jonah. The sites yielded a radiocarbon dating of AD 850±120 years BC and AD 875±130 years BC.

The finds consisted of spectacular, exquisitely crafted objects in bronze, calabash, pottery and beads, representing weaponry, ornaments, ceremonial regalia, ritual receptacles, metal implements, etc. They presented a substantial material evidence of a well-organised, centralised society with flourishing commerce, agriculture, arts and craft production and elaborate religious traditions.

The Igbo Ukwu bronzes are the earliest evidence of artistic use of copper alloys in Black Africa. They were produced through the use of the "lost wax" or "hollow cast" method of casting, which involved the modelling of the object in wax and then replacing that with molten bronze. Scientific analysis shows that the Igbo Ukwu bronzes were heavily leaded and differed in their metal composition and technological process from the known Benin and Ife bronzes.

The bronze treasures from Igbo Ukwu are unique with their superb workmanship, lavish elaborateness of style and themes and their intricate details of decorative design. Their surfaces, decorated with geometric designs of parallel lines, triangles, circles and raised dots, then overlaid with fine threads, pellets and spirals, and, finally, superimposed with high-relief representations of animals and insects, are reminiscent of the famous Fabergé style. Beads of various shape, colour and size were also embedded into the bronze casting as decorative design. Complex objects were made in stages, the separate parts joined together with additional intricate castings, as if the casters revelled in the unlimited possibilities of their skill.

The Igbo Ukwu finds were related to the ritual paraphernalia of a divine king of the type of the nearby Nri tradition. Like ancient Ife, the Nri area was regarded by the Igbo people as the centre of creation of the world and a source of dispersion of political and religious authority among them; a place, where God revealed to men the knowledge of food plants. *Eze Nri*, the Nri priest-king, was a centralised institution of great antiquity and a custodian of the earth goddess (*Ala*) shrine, which was associated with crop protection, purification and fertility. The repeated motif by the Igbo Ukwu bronze-casters of numerous and various insects on their ritual vessels and ceremonial objects could well fit with the farm fertility and crop protection

functions of the earth deity cult, whose chief priest and custodian was the priest-king buried at Igbo Richard.

The Igbo Ukwu culture has raised a number of questions as to the origin, dispersal and production centres of the ancient bronze-casting and bead-working traditions in West Africa, which can be answered only though further research and excavations.

V. I. E.

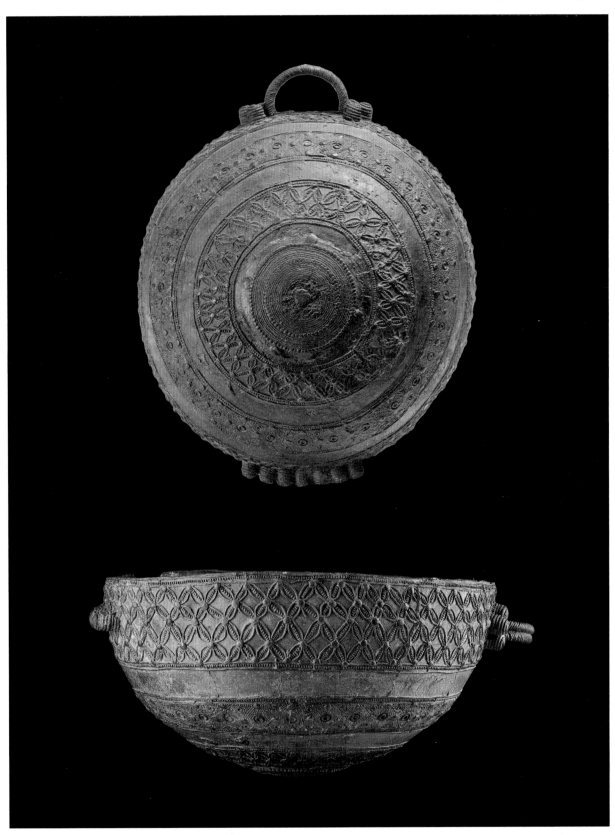

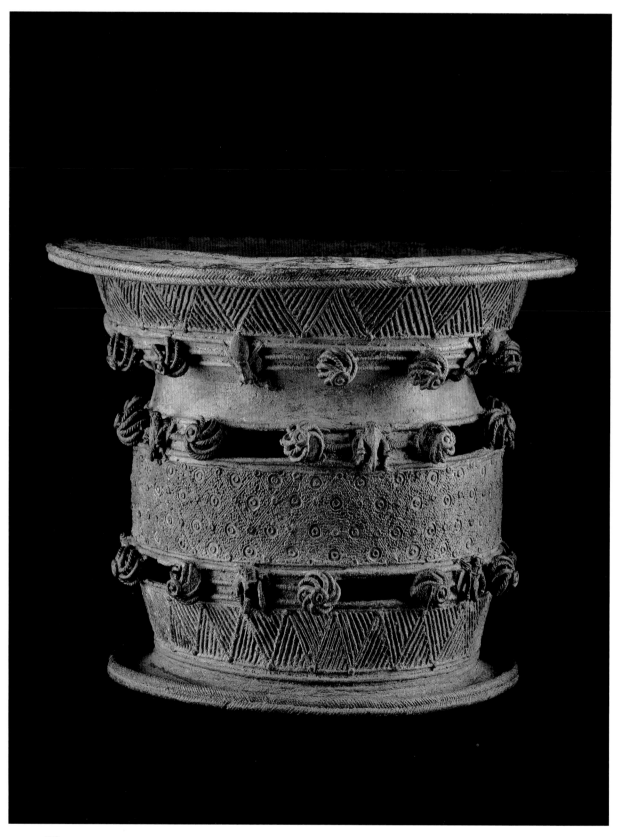

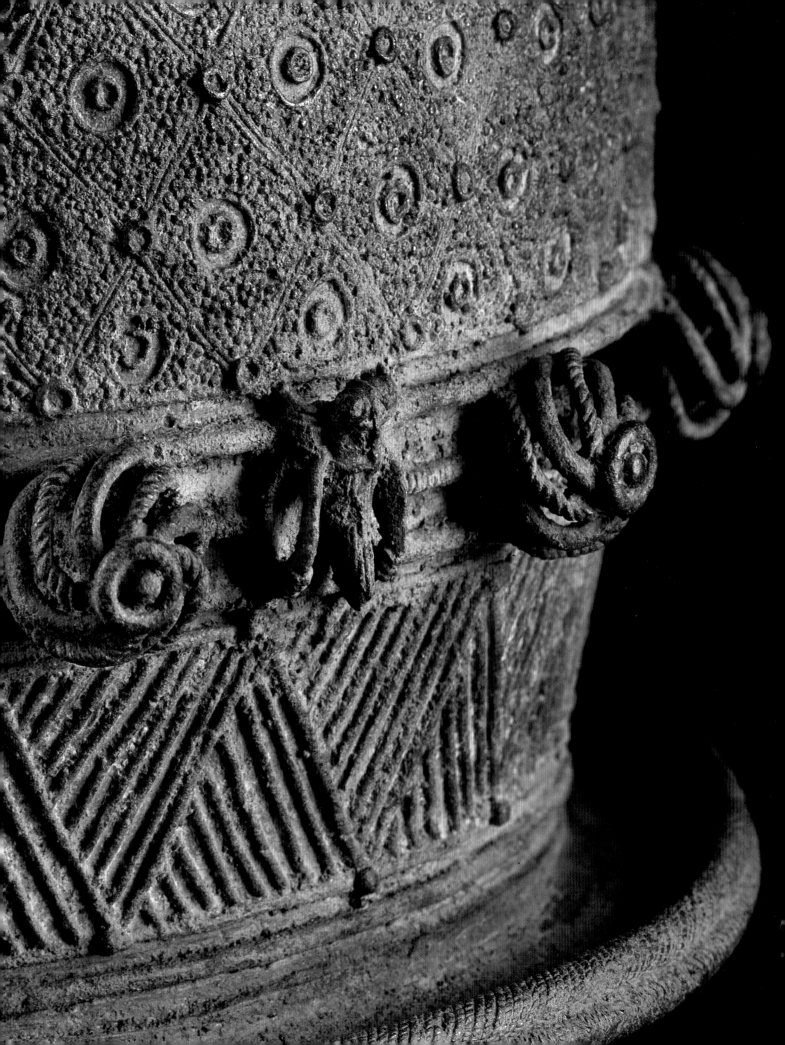

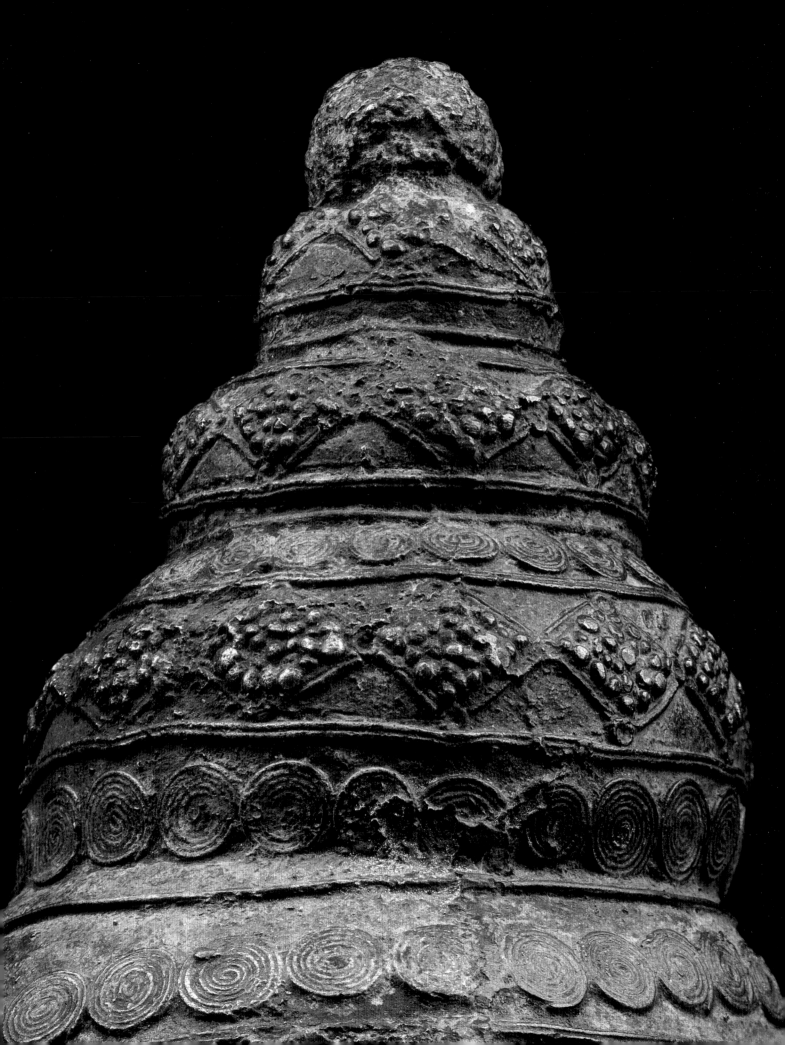

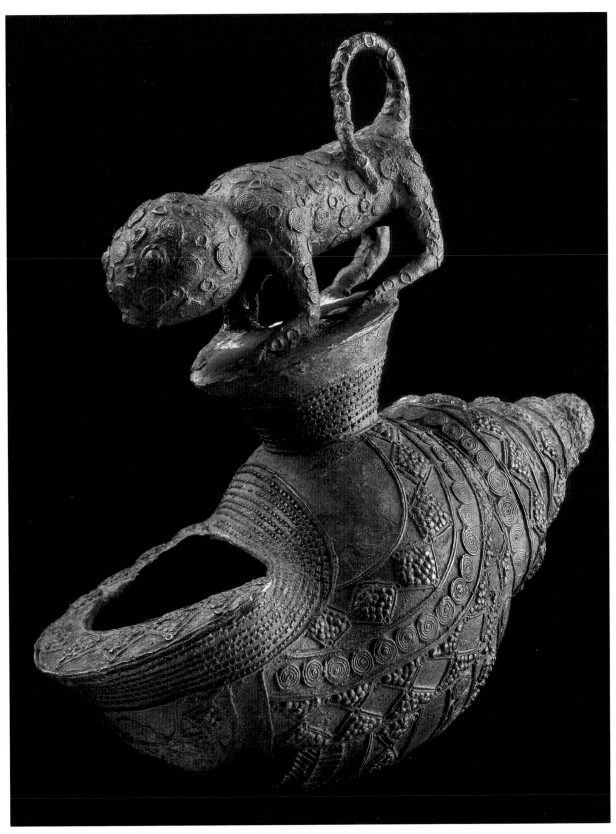

**13a. Igbo Ukwu artist,
Nigeria (Igbo Isaiah)
Cerimonial bowl**
9th-10th century AD
Bronze with high percentage of lead, diam. 35 cm
Lagos, National Museum (inv. 54.4.22)

Cast bowl in the shape of a half pumpkin. It was probably used in religious rites for holding water and sacrificial foods.
The external sides of the bowl display an elaborate striped geometric decoration of lines, concentric circles, small relief beehives and stylised *akoko* leaves.
The *akoko* tree is originally from the southern area of Nigeria, and various local ethnic groups use its leaves for ceremonial purposes and in religious rites.
This object may have been used by the Igbo people during ceremonies connected with the *Nri*'s priestly and royal function.

**14a. Igbo Ukwu artist,
Nigeria (Igbo Isaiah)
Cerimonial bowl**
9th-10th century AD
Bronze with high percentage of lead,
20.3 cm, diam. 27.3 cm
Lagos, National Museum (inv. 39.1.1)

Shallow bowl placed on a high cylindrical hollow base. The body of the object is decorated with geometric and three-dimensional decorations, including figures of insects (beetles and grasshoppers) realised by means of casting.
The object was cast in two phases, then the individual parts were assembled together and fixed with a middle section, also by means of casting and decorated with spirals and figures of insects.
This was a ritual object, probably used by the priest for ablutions or for holding the offerings aimed at placating the local gods.
The base of the vase is an important object in African culture, since a vase used to contain holy water must not touch the ground before being used in ritual ceremonies.
The motifs of insects depict the insects present in the habitat of the artists, and were perhaps linked with sacred rites, performed to avert the invasions of these animals in the crops.

15a. **Igbo Ukwu artist,**
Nigeria (Igbo Isaiah)
Ceremonial vase in the form
of a giant snail's shell
9th-10th century AD
Bronze with high percentage of lead, 29 cm
Lagos, National Museum (inv. 39.1.12)

Container used in the rites of the sanctuary. Its form imitates the shell of the
African giant land snail (achatina).
The sides of the container are decorated with dense geometric motifs upon
which are superimposed relief depictions of insects (grasshoppers and flies) and
animals. The pointed tip displays relief motifs of four snakes heads holding frogs
in their mouths.

16a. **Igbo Ukwu artist,**
Nigeria (Igbo Isaiah)
Vase in the form of a giant snail's shell
surmounted by a leopard
9th-10th century AD
Bronze with high percentage of lead, 24.3 cm
Lagos, National Museum (inv. RO MT/01.19)

Sacred vase used in the ritual ceremonies of the sanctuary. The shell is sur-
mounted by an animal, probably a leopard. For the Igbo, as for most African
cultures, the leopard symbolises authority, power and courage.
The sides of the object display dense decoration with relief geometric patterns,
composed of small circles, spirals, small beehives and triangles, typical of the
elaborate style of Igbo Ukwu.
In the Nsukka Igbo culture, this species of snail is a sacred animal, used in reli-
gious rites, and which it is taboo to eat.

IFE

ANCIENT ART

Ife is the sacred Yoruba city, regarded as the cradle of origin and seat of political and religious authority of the Yoruba people. It is the place where, according to Yoruba legends, man was created and from where various peoples dispersed to populate the world. Archaeological evidence dates the culture of the ancient Ife kingdom to the period between the 11th and 15th centuries AD.

The classical art of Ife was exposed to the world in 1910 by the German ethnographer Leo Frobenius. Having heard of its existence during his previous expeditions to West Africa, he visited the old town of Ile-Ife, where he discovered and excavated a number of terracotta and stone sculptures and a bronze head he identified as *Ori Olokun*, the deity of the sea.

Frank Willett, Bernard Fagg, Ekpo Eyo, Peter Garlake, Oliver Myers and other archaeologists and researchers later carried out extensive excavations in various sites in Ife. They found bronze, terracotta and stone sculptures, mostly shrine and tomb furniture items associated with pottery pavements. Twenty-one bronze sculptures and numerous terracottas in the same style were found during excavation of the royal shrine at Ita Yemoo and the royal tomb at Lafogido. The manufacture and use of glass beads in several beautiful colours was evidenced by both direct archaeological finds and by the elaborate representation of beaded ornaments on the sculptured figures.

In some places — Ita Yemoo, Obalara's Land and Lafogido — the pieces were found *in situ*, while elsewhere the finds were of artefacts reburied in relatively recent times.

Scientific dating of the materials through radiocarbon (for terracotta) and thermo-luminescence (for bronzes) yielded the following results: Ita Yemoo, AD 1365±70 years, AD 1395±65 years and AD 1446±50 years: Wunmonije, AD 1440±65, AD 1325±110 and AD 1270±100 years.

These dates placed the peak of "classical" Ife art between the 12th and 15th centuries AD. The dating also showed that the bronze tradition was developed later than the terracotta tradition and spanned three centuries from the 13th to 15th centuries AD.

The Ife bronze castings were made by the lost-wax or hollow-cast process. They can be more truly described as "brass" works due to their high zinc content. Some, like the mask of Obalufon, were made of pure copper, the production of which requires very high technological expertise. Production sites or evidence of local casting are yet to be found in Ife.

Ife bronze and terracotta sculptures show similarities to other African and present-day Yoruba sculptures.

Elements of abstraction and conventionalism, typical of most African art traditions, are present in the Ife art style. Metal and terracotta heads conform closely to a naturalistic canon and often show a sensitive distinction of bone, muscle

and flesh. Ife art was basically a court art; it represented royal figures and their attendants, produced with portrait-like naturalism for ritual purposes.

The discovery and study of these objects has helped in historical reconstruction and interpretation of the cultural affinity and level of technological advancement of the Yoruba people between the 11th and 15th centuries AD.

V.I.E.

19a. **Ife artist,**
Nigeria (Wunmonije District)
Head of *Oni*
12th-15th century AD
Brass and gold, 28 cm
Ife, National Museum (inv. 92.2.17)

It is generally assumed that this commemorative sculpture rendered with the naturalistic features typical of Ife portrays the head of an *Oni* (king) of Ife and represents an *Oni* of the dynasty of kings with unmarked faces.

Note the holes made along the hairline, which served to attach the crown decorated with beads, and the holes around the mouth and on the cheeks for attaching the veils of beads to hide the lower part of the king's face. The holes around the neck served for attaching the head to a wooden simulacrum: most African societies observed the tradition of using a simulacrum of the sovereign or of the deceased chief during the funeral rites, so that the population could pay their last respects to the dead king and witness the display of the royal insignia as a sign of the continuance and hereditary transmission of the monarch's function.

The figure has indigo stains, probably due to the addition of a small quantity of gold to the metal alloy during casting.

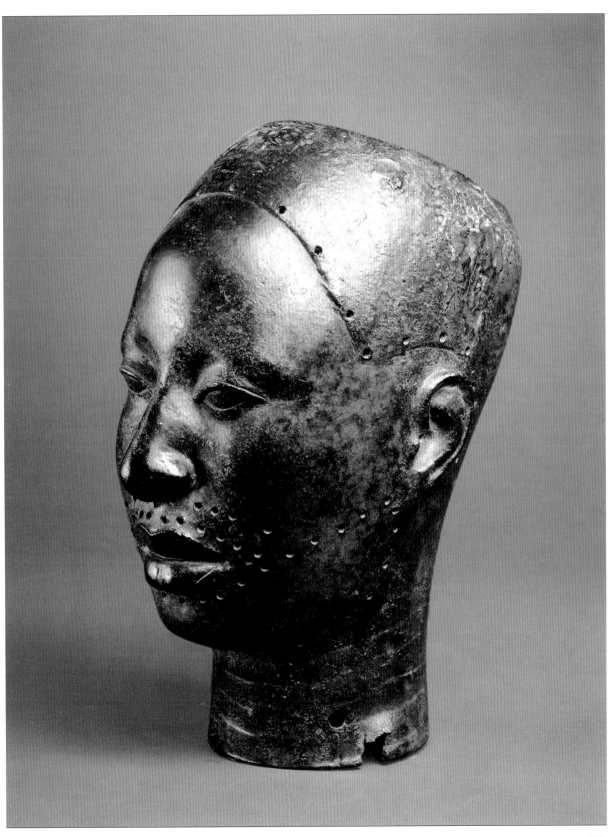

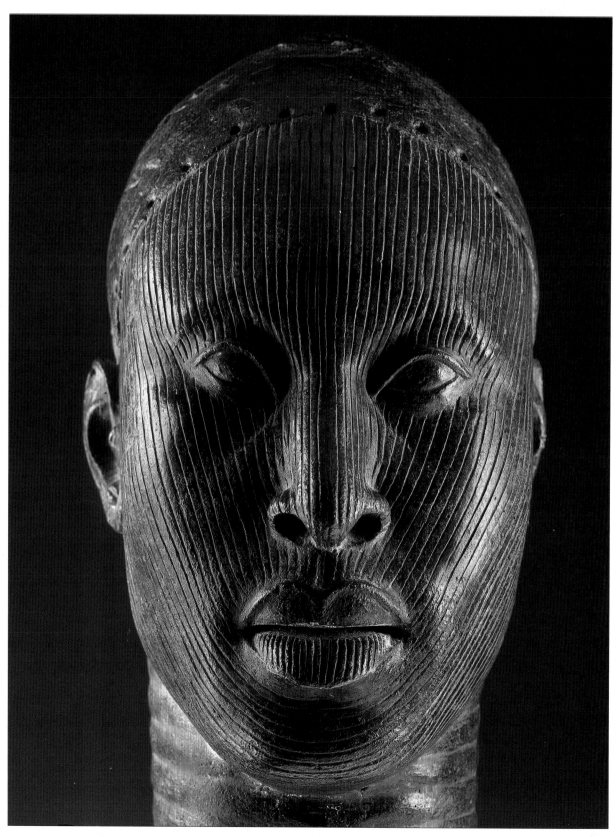

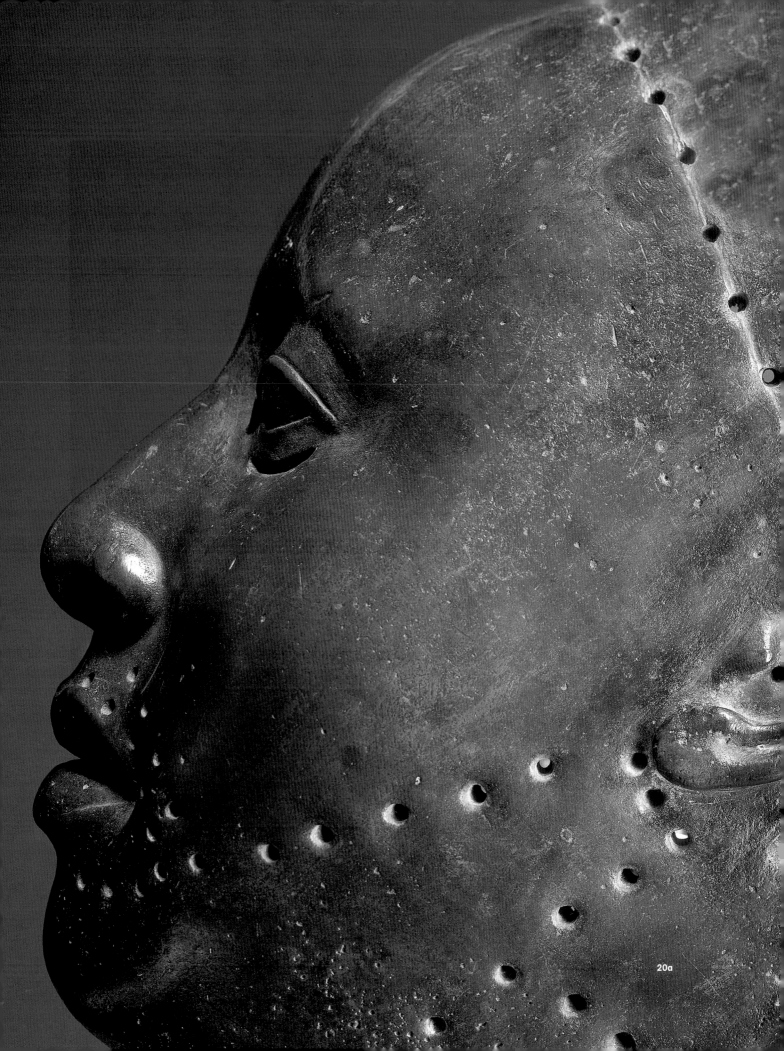
20a

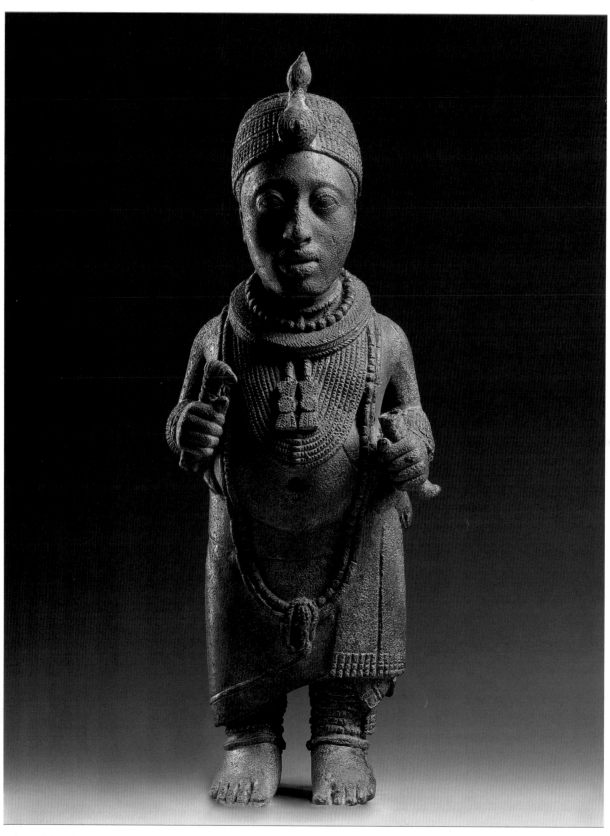

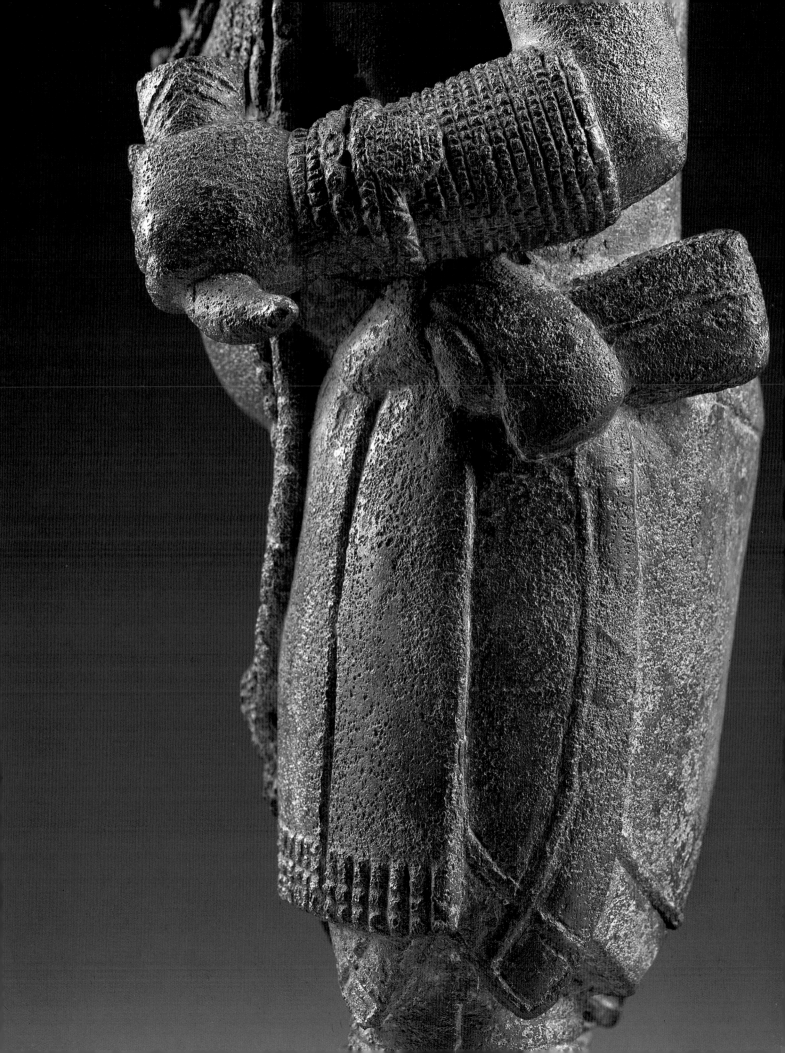

17a. **Ife artist**
Nigeria (Wunmonije District)
Head of *Oni* with crown
12th-15th century AD
Brass, 25 cm
Ife, National Museum (inv. 79.R.11)

This commemorative head has a crown of beads with a relief decoration at the front. The expression on the face is serene, and treated in a naturalistic style. According to oral tradition, ancient Ife was governed by two dynasties, one in which the *Oni* bore signs of ritual scarifications on their faces, and another in which the sovereigns did not follow this custom. The vertical streaks allude to the ritual scarifications, which identifies the *Oni* as belonging to the dynasty bearing these facial markings.
The furrows on the neck are signs of beauty in the African tradition. The holes around the neck served to attach the head to a wooden simulacrum.
It was believed that the king was a descendant of the god who founded the city, and possessed divine powers. The *Oni* lived shut away in his palace, in which there were many sanctuaries, and had to perform various religious rites in honour of the gods and ancestors. In public he always appeared with his face covered by veils of beads, since his person could not be desecrated by being displayed to the view of those outside the court.

18a. **Ife artist,**
Nigeria (Wunmonije District)
Head of *Oni*
12th-15th century AD
Copper alloy, 31 cm
Ife, National Museum (inv. Ife 6)

Head in metal, with a serene expression and the vertical streaks representing facial scarifications, characteristic of the "classical" art period in Ife. The holes around the head served to attach a crown, while those on the neck make it possible to fix the mask to a wooden simulacrum for display to the public during ceremonies.

20a. **Ife artist, Nigeria**
Mask of *Oni* Obufalon
12ᵗʰ-15ᵗʰ century AD
Copper, 32.6 cm
Ife, National Museum (inv. Ife 17)

Large copper mask with slits beneath the eyes. It is said that it represents the head of *Oni* Obalufon Alayemore, one of the first *Oni* of Ife. He is attributed with introducing the art of melting bronze in ancient Ife. The statue is however an idealised effigy and should not be considered a realistic portrait of that particular king.

The deceased *Oni* of Ife, Adesoji Aderemi, kept this mask in his palace, and it was worn on the occasion of the advent of a new *Oni* thus acquiring divine status. Its symbolic value comes from the myth according to which Obalufon, who reigned over Ife after the first sovereign, the god Oduduwa, personally transferred the right of reigning from Oduduwa to his successor *Oni*.

21a. **Ife artist, Nigeria (Ita Yemoo, Ife)**
Figure of *Oni*
Early 14ᵗʰ - early 15ᵗʰ century AD
Brass with lead, 47.1 cm
Ife, National Museum (inv. 79.R.12)

This is probably the only full figure bronze sculpture surviving from ancient Ife. It represents a standing *Oni*, with the traditional insignia of royalty and of his office: a medicinal ram's horn in his left hand and a ceremonial staff in his right. On his head he wears a crown with an elaborate decoration of beads with the royal trophy at the front. On his chest is a ceremonial collar. His arms and legs are covered with ornaments of beads, and there are rings on his toes. The thong tied around the waist is different from the style used today by the kings of Ife. The face is without streaks, and it is therefore likely that the *Oni* portrayed here belongs to a dynasty which did not practise facial scarifications.

The statue comes from the king's sanctuary, and probably represents the *Oni* performing a ceremonial ritual. According to traditional beliefs, the king-god was responsible for the well-being of the community and had to ensure the benevolence of the gods and ancestors, who had to be continuously venerated and placated with religious celebrations and sacrifices.

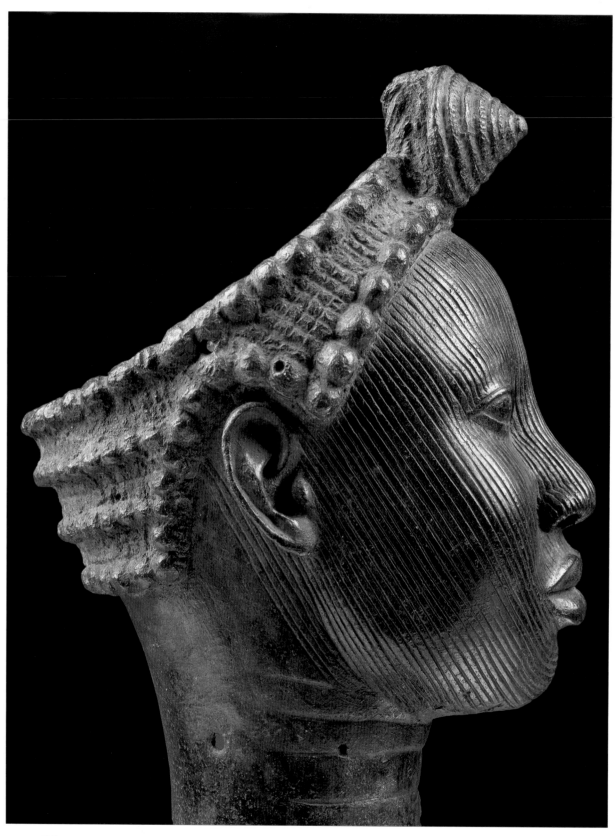

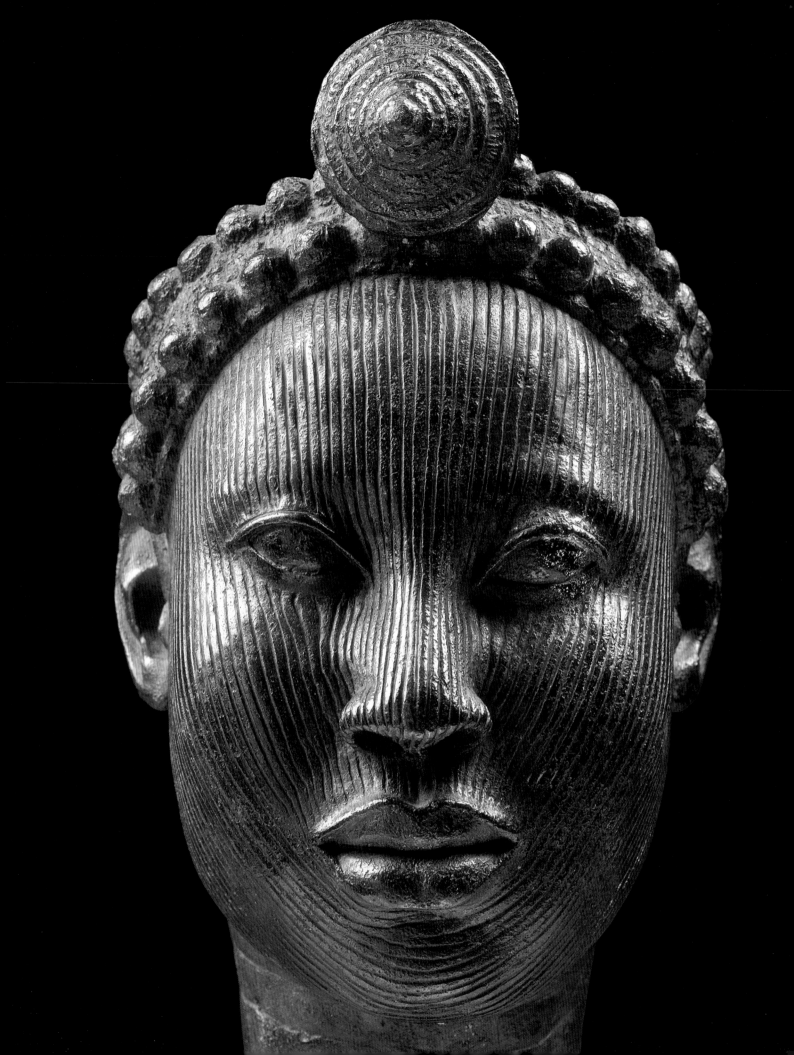

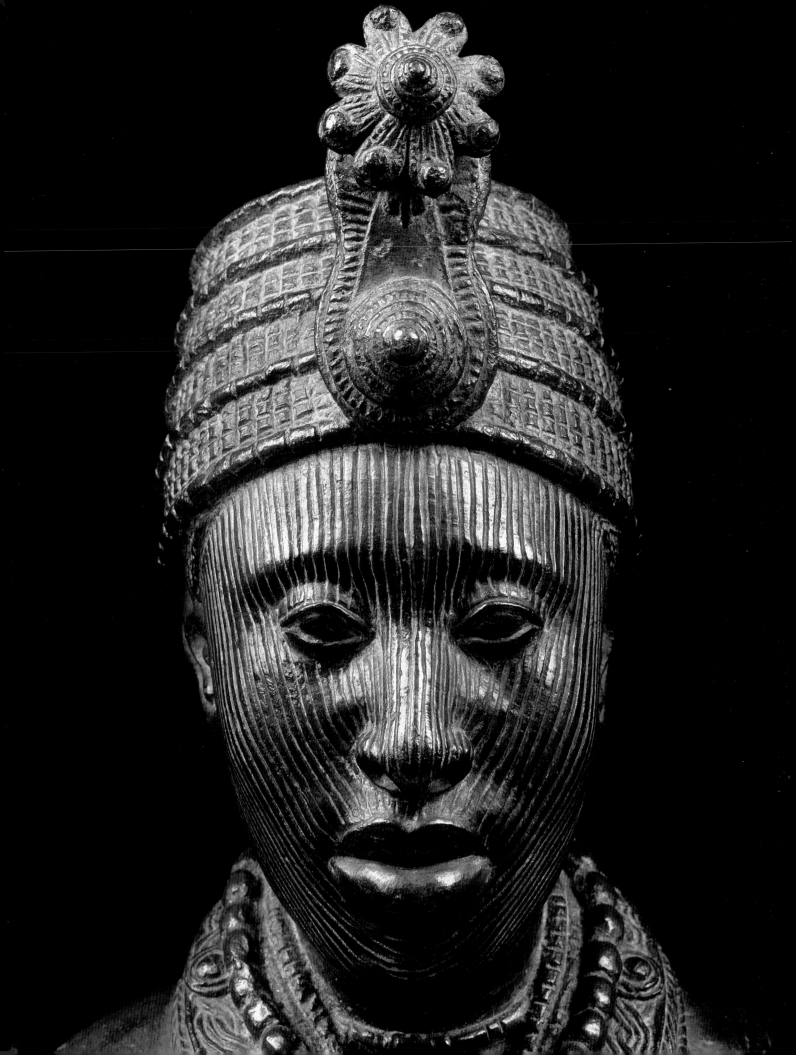

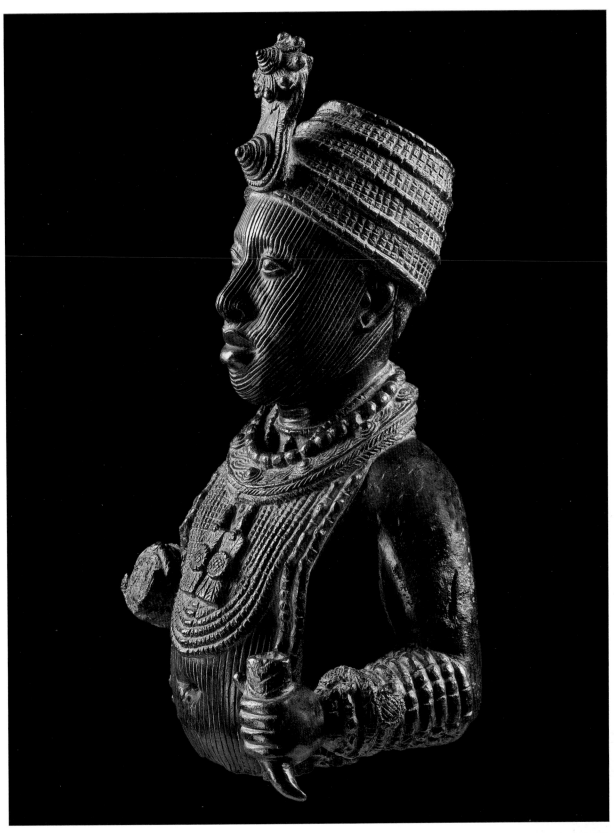

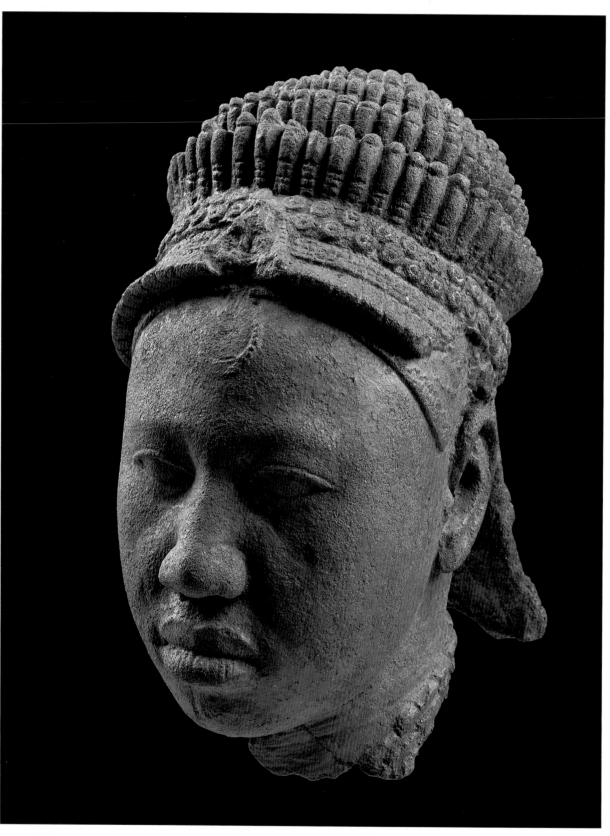

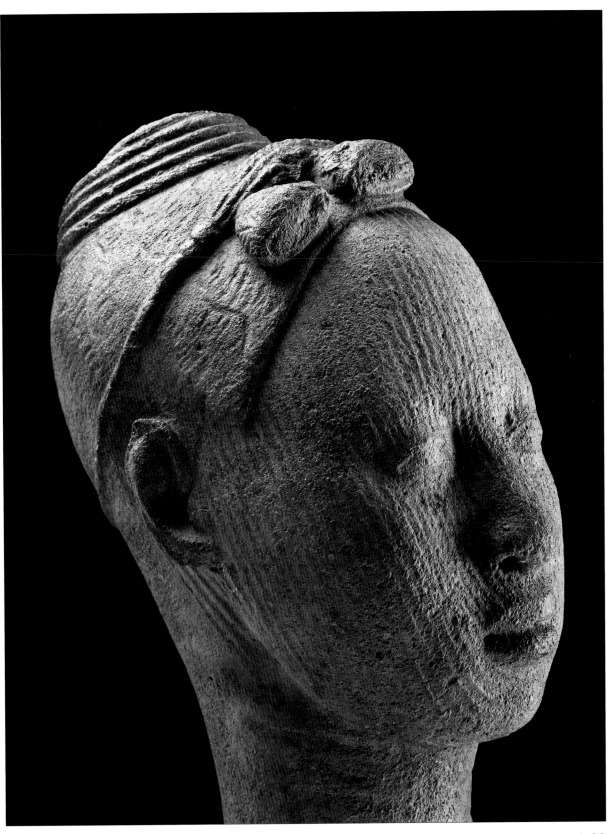

24a

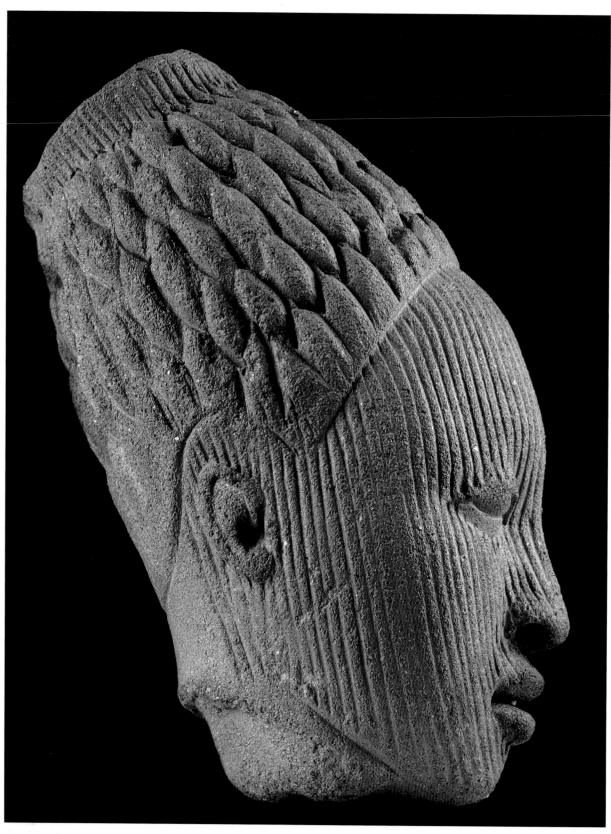

26a

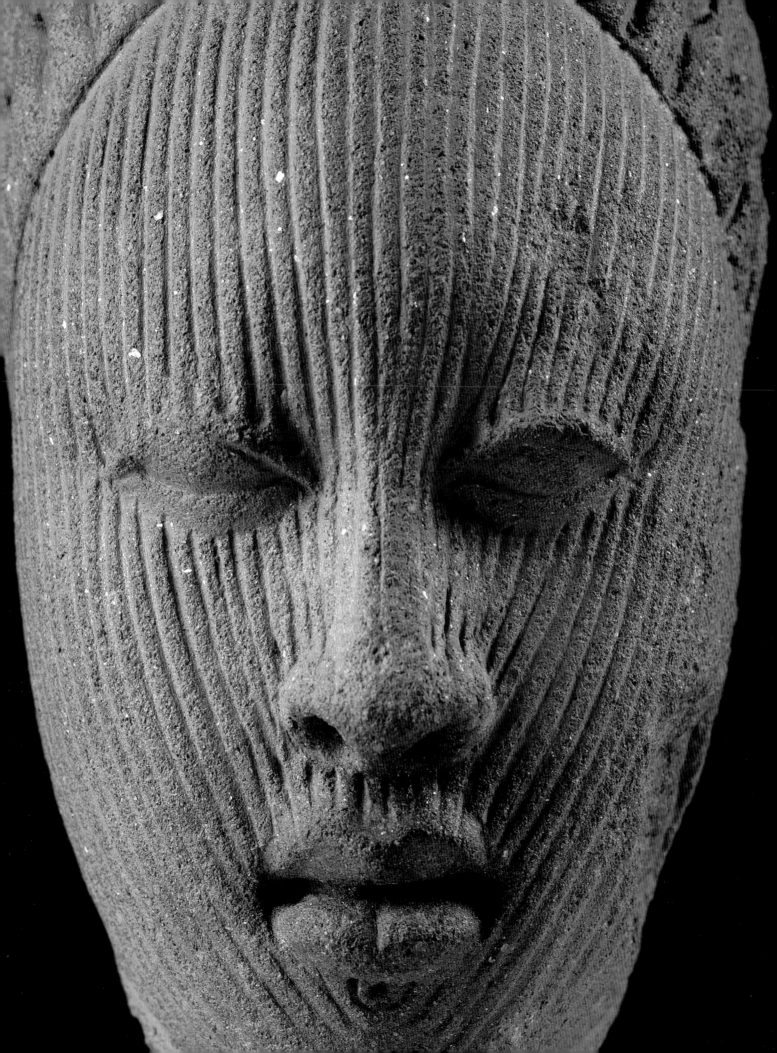

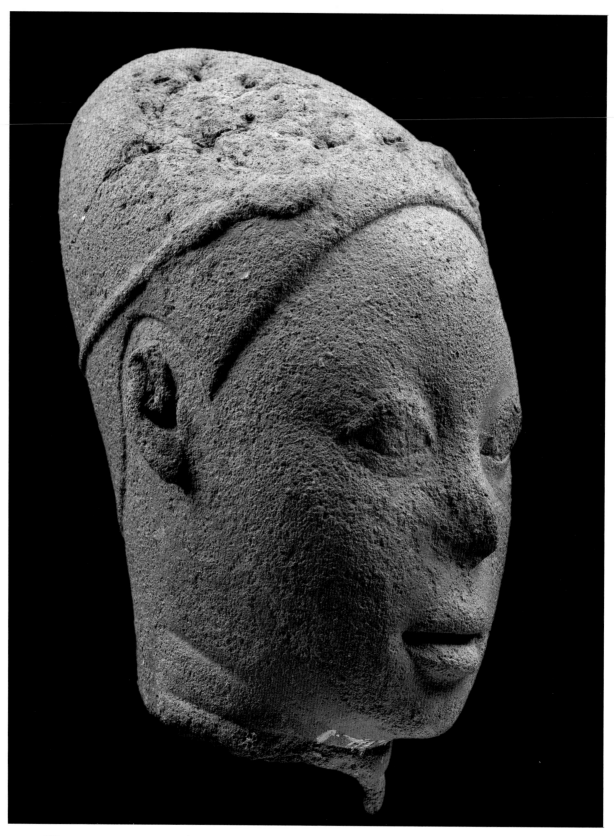

22a. **Ife artist,**
Nigeria (Wunmonije District, Ife)
Top half of a figure of an _Oni_
15th-16th century AD
Brass, with high percentage of lead, 37.3 cm
Ife, National Museum (inv. 79.R.9)

The sculpture, known as _Oni_ Lafogido, is one of the most beautiful bronze works of Nigerian art. The figure bears the royal insignia, the crown of beads with a double trophy in front, elaborate pectoral ornaments and necklaces and armlets full of beads. The round collar and the two small tassels on the chest have a ritual purpose. In his left hand, the figure holds a medicinal horn, while the right hand is truncated.
The streaks of scarifications are visible both on the face and on the chest; this identifies the dynasty to which the _Oni_ belongs. Traces of colour are visible on the face, eyes and beads.

23a. **Ife artist,**
Nigeria (Ita Yemoo, Ife)
Crowned head of a queen
12th-15th century AD
Terracotta, 23.2 cm
Ife, National Museum (inv. 79.R.7)

Terracotta head of an _Oluwo_, a female _Oni_, who, according to tradition, went out in the rain and whose regal garments were stained by splashes of mud. In her anger, she ordered that the most important public and religious places should be paved with fragments of terracotta. The ancient terracotta paving, realised using a complex technique, which required laying a large number of fragments of various sizes, covers an area of 3,2 square kilometres, and gave the city its name: Ile-Ife (the place of paving).
The head bears an elaborate crown of beads in five rows, with a royal trophy on the front, which has since fallen off. This head reflects the typical naturalistic style of classical Ife art and highlights the superb expertise of the ancient potters. The images of kings and queens from the royal sanctuary of Ita Yemoo, including this head, are considered commemorative objects with a symbolic value, and were used in the cult of the ancestors.

24a. Ife artist,
 Nigeria (Forrest of Iwinrin, Ife)
 Head
 12th-15th century AD
 Terracotta, 26 cm
 Lagos, National Museum (inv. 79.R.14)

Worthy of note is the serene naturalism of this woman's facial expression. Her hair is decorated by strings of beads ending in small tassels, indicating that she belonged to the royal family. The vertical streaks on the temples are part of the *gumbo* ritual signs of the Yoruba, characteristic of an Ibadan and Ogbomosho clan. There are also facial signs characteristic of the royal family of Awo, near Ede in the state of Osun. The same signs are used today by the people living in the zone of Oyo.

25a. Ife artist, Nigeria (Ife)
 Head
 12th-15th century AD
 Terracotta, 19.9 cm
 Lagos, National Museum (inv. 97.14.1)

Terracotta head with the naturalistic features and serene expression typical of Ife statuary.
It wears a small cap which was probably made using the traditional *aso oke* fabric, produced by the Yoruba. On the two sides of the cap there are two stylised snake motifs. The furrows on the neck, which are clearly distinguished, are a sign of beauty for the Yoruba culture.

26a. Ife artist, Nigeria
 (Ita Yemoo, Otutu District)
 Head
 12th-15th century AD
 Terracotta, 13.1 cm
 Lagos, National Museum (inv. 23/61)

Small woman's head in terracotta, part of an image of a full figure which has been lost. It displays the typical facial scarifications of ancient Ife and an elaborate basket shaped hairstyle which indicates that the subject belonged to the royal family.

27a. **Ife artist, Nigeria (Ife)**
Seated female figure
12th-15th century AD
Terracotta, 15.4 cm
Lagos, National Museum (inv. 2000.M.01)

The statuette represents a seated woman with a cloth wrapped around her body. Her hair is raised in a chignon and she probably had metal bracelets on her wrists. The lines of the body are defined with elegance and a detailed knowledge of human anatomy. Compared to the body, the head has the typical dimensions of African art: a quarter of the size of the full figure.
This is clearly a piece surviving from a composition, which would have included other statues and plastic works.

28a. **Ife artist (?), Nigeria (Tada)**
Seated figure
End of 13th - early of 14th century AD
Red copper, 53.2 cm
Lagos, National Museum (inv. 79.R.18)

This seated figure with truncated limbs is perhaps the most important naturalistic bronze sculpture in Black African art. It was found in the remote village of Tada and is thought to be a portrait of Tsoede, the founder ancestor of the kingdom of Nupe, who supposedly took it with him during his flight from Idah, around 200 kilometres away.
The seated figure appears relaxed, self-confident, and has an expression whose severity embodies serenity and inner strength. The head is covered by a thin cap headdress, and a locally made loin cloth is tied around the waist. The style is that of the Ife culture, and the date of its creation falls within the classical period of Ife art. Its realisation is an extraordinary technological feat for the age, since pure copper is extremely difficult to handle in the molten state.
The surface appears smoothed by the immersions in sand to which the work was subjected by the population of Tada, during the ceremony which was held every year (before their conversion to Islam) to ensure the good fortunes of the community.

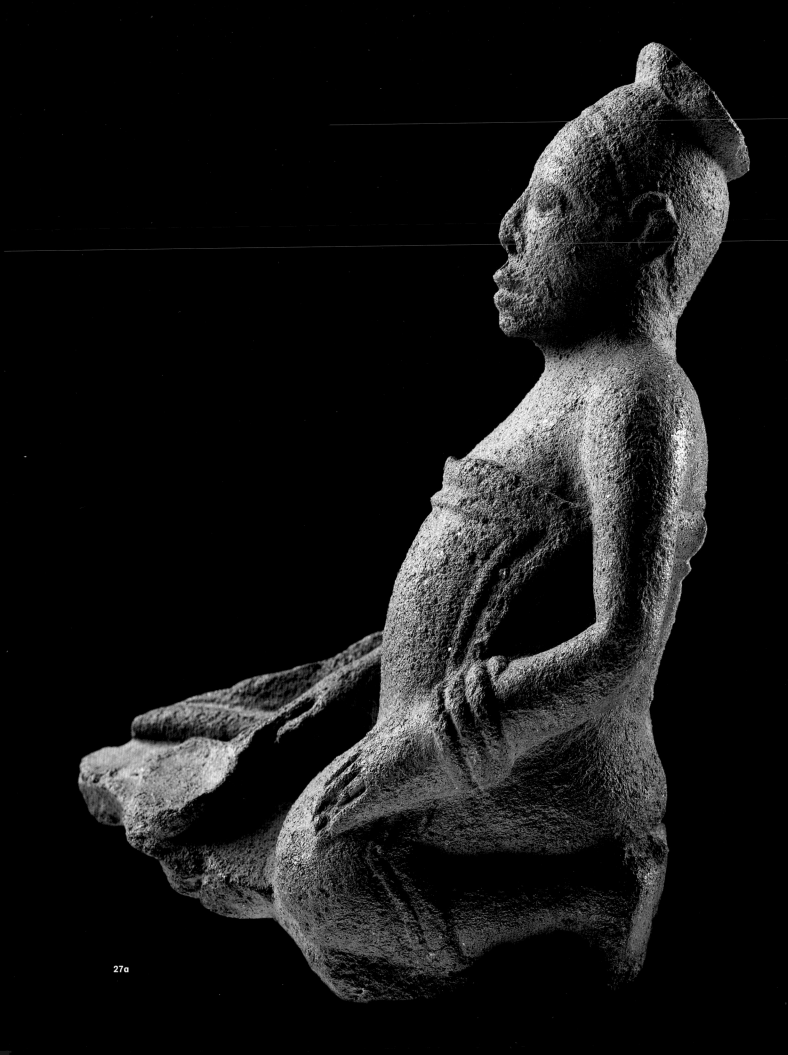

27a

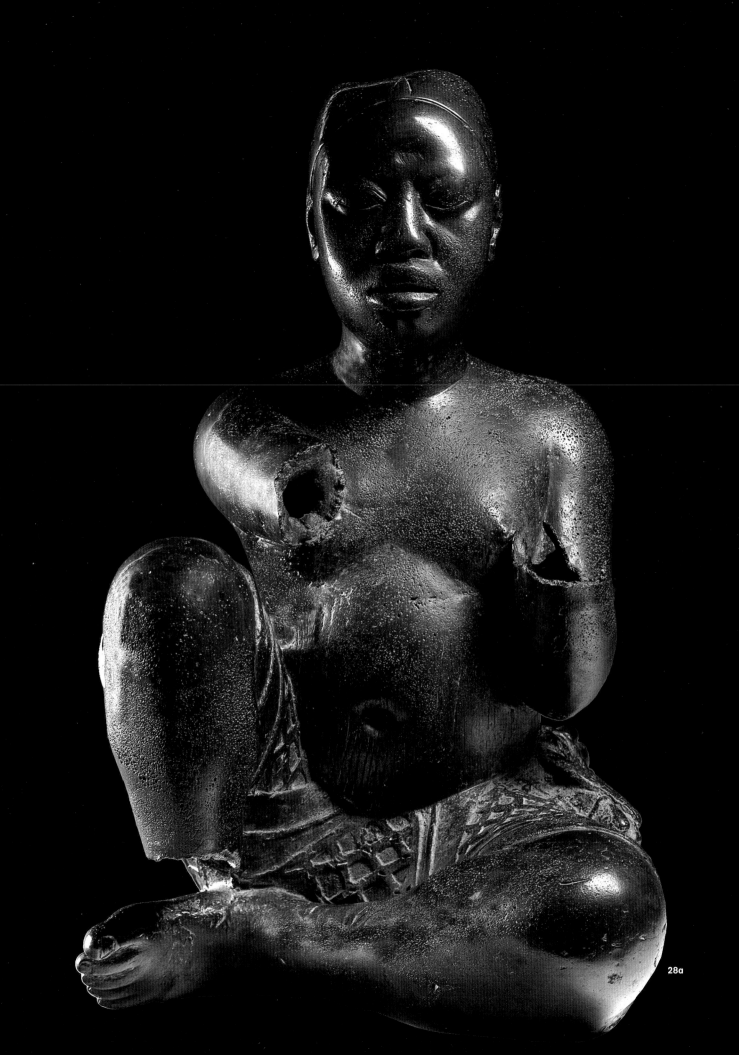
28a

TSOEDE

BRONZES

A group of bronze figures was discovered in two settlements, Jebba and Tada, along the river Niger to the north of Ife. They comprise the largest human and animal bronze works in sub-Saharan Africa. They are named after Tsoede, the legendary founder of Nupe kingdom, who is said to have escaped from Idah (the centre of Igala kingdom) in a bronze canoe and to have deposited the bronze figures as symbols of his authority at several places on his way upriver, before founding his kingdom at Nupe. The local people have incorporated them in their religious rituals in a secondary context.

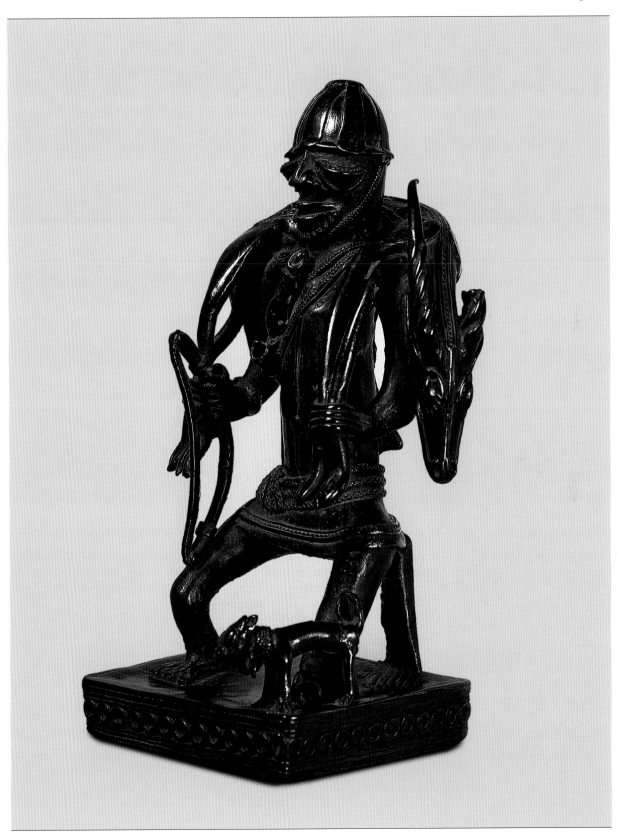

Though their art style has many similarities with those of ancient Ife, Benin and Owo, there are also important differences in the natural proportions of the head and limbs, the treatment of the face, the costume elements and the complex symbolism of the regalia. The bulging eyes, elaborate facial scarifications, kidney-shaped lips and tiny hands, as well as locally woven thick outer garments and protective vest are typical of these bronze sculptures.

The symbolic motifs depicted on head disks, chest pendants and the dresses can be related to similar motifs in Ife, Benin and Owo art iconography, though much more powerfully represented and accentuated. It has been suggested that they may have been produced at different art centres, since they can be categorized into four main stylistic groups.

The special significance of these works lies in their manifestation of the interrelationship between the prominent centres of political power and art traditions, namely Ife, Benin, Owo, Nupe and Igala.

V. I. E.

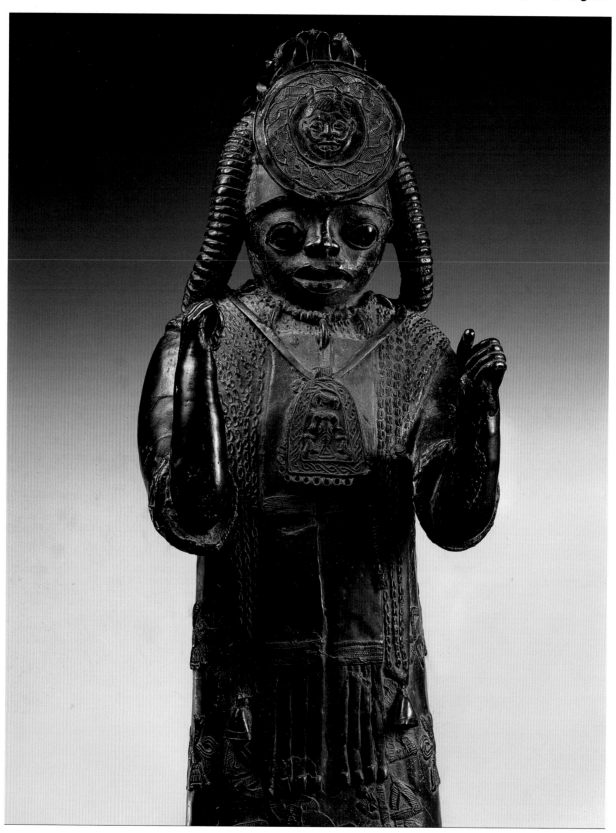

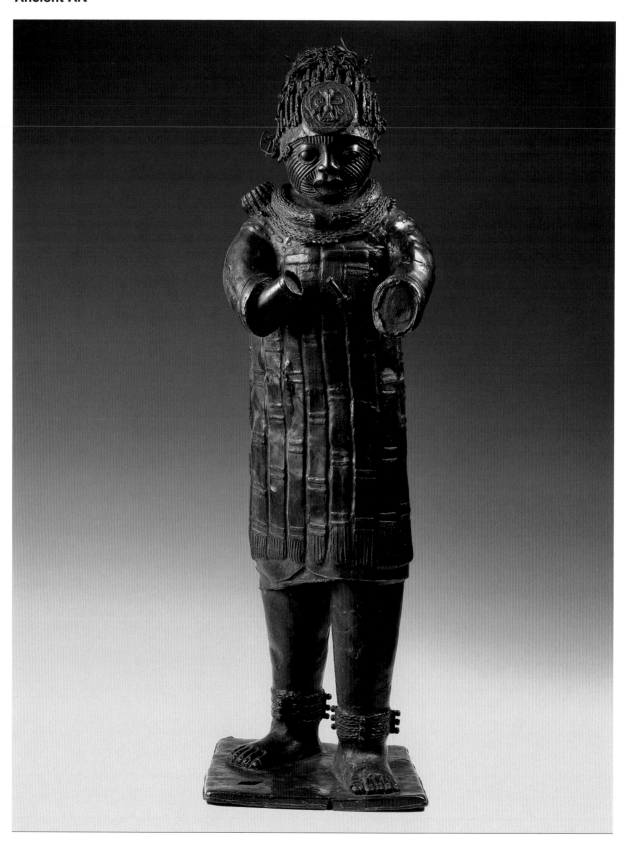

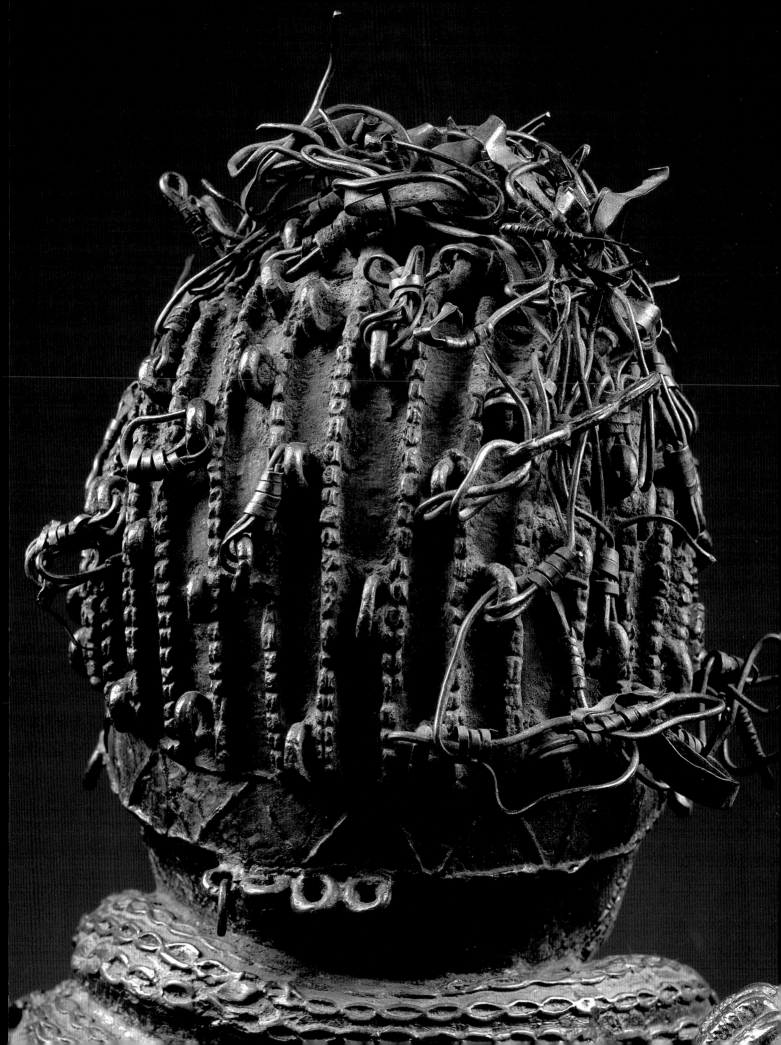

29a. **Artist from the Lower Niger culture, Nigeria**
 Warrior
 Early 14th - early 15th century AD
 Bronze with tin, 116.4 cm
 Lagos, National Museum (inv. 79.R.20)

The warrior wears layered garments: the outer layer is covered with shells, a strip of thick fabric, a necklace of beads and leopard's teeth as well as a chest medallion on which symbolic animals are depicted (among which different birds and a ram). The complex hairstyle is composed of a disc on which a face is engraved surmounted by horns with serpents coming out of the nostrils, surrounded by a geometric intertwined design typical of Yoruba art. This ornamental motif, which is also found in Ife, Owo and Benin, suggests that these works were originally realised further south than the place in which they were found.

30a. **Artist from the Lower Niger culture, Nigeria**
 Archer
 Late 14th - early 15th century AD
 Bronze with tin, 94.8 cm
 Lagos, National Museum (inv. 79.R.19)

Large sculpture depicting an archer with armour, carrying a quiver of arrows on his back and resting on a rectangular base. A small dagger is slipped into the front of the garment. It is one of the nine bronze statues found on the island of Jebba and in the village of Tada on the River Niger.
The statue displays the typical characteristics of the Tsoede bronzes: the kidney-shaped mouth, the bulging eyes with the profile in relief, the small head and minute arms, which in this case are truncated. The complex cap hairstyle includes a frontal disk, depicting a bird with unfolded wings holding a snake in its beak. The costume is composed of a number of layers; the exterior layer is formed of extremely thick cotton fabric, produced by sewing together strips of locally produced fabric, with a striped pattern and a fringe, as are still produced in the area of Nupe.

31a. **Artist from the Lower Niger culture, Nigeria**
Hunter with antelope
15th century AD (?)
Bronze, 35.6 cm
London, The Trustees of the British Museum,
(inv. 1952.Af.11.1)

The questions regarding the origin of this surprising image of a hunter, one of the masterpieces of Nigerian art, apparently found in Benin in 1897 (Fagg 1964, no. 58), so far remained unanswered. The work has thus been included, it is hoped only temporarily, among those provisionally grouped as sculptures from the Lower Niger Bronze Industry, together with no. 29a and no. 30a on show here, which are moreover stylistically completely different. It is perhaps worth mentioning that the base displays a decoration of circular elements, identical to those which can be seen on the Bini-Portuguese salt cellars and Owo containers (nos. 32b, 13b, 14b).

The high quality of the work, meanwhile, is beyond doubt. As William Fagg wrote, this sculpture is a "fundamental example of conceptual art". Here, the artist has expressed complete creative freedom, overturning the form of the human and animal body — the man's legs have different lengths, the lower part of the right leg is missing, and the antelope's front legs are both on the same side — whilst conserving, and even emphasising the rationality of the perfectly balanced composition.

OWO

Owo is an ancient town located on the eastern border of Yoruba, halfway between Ife and Benin. Some oral traditions trace its population migration from Ile-Ife.

The early art of Owo reflects the themes and naturalism of the 14th-century classical portrait style of Ife. Archaeological evidence suggests that by the mid-15th century, following the expansion of the Benin empire, Owo came under strong Benin influence. This was reflected in local architecture, political titles, ceremonial costume and regalia (coral beads, beaded crown, loop-handled sword) in art forms as well as religious rituals and ceremonials.

The Owo culture developed a distinctive style in terracotta and ivory sculpture. This style is represented by exquisitely executed sculptural figures and miniature portraits; profuse presentations of intricate beadwork on necks, wrists, arms and legs; this style it's also evident in the representation of human heads, of hands holding sacred leaves and of sacred animals, as in the powerful presentations of crouching leopards and human sacrifices.

Other objects characteristic of the Owo style were ceremonial pots decorated with symbolic reliefs of animals, the ritual objects, the armlets and the intricately carved ivory objects such as the salt-sellers widely known in a wide part of the region as "Portuguese ivories".

Archaeological excavations, conducted by professor Ekpo Eyo in 1971 at a grove named *Igbo 'Laja,* revealed altar concentrations of cultural artefacts, both human and animal terracotta sculptures, polished stone axes, cowries, palm nuts and fragments of metal gongs. The finds were linked to royalty and affluence and were interpreted in association with the *Oronse* cult and its festival, believed to have been started during the reign of *Olowo* (king) Reregen-jen, around 1340 AD.

This king married the beautiful Oronse, believed to have been partly spirit and partly human, who returned to the spirit world, but promised protection of the *Olowo* and his people in return for copious sacrifices of human and animal nature.

Some terracotta sculptures, though produced locally, displayed features characteristic of Ife art, while others resembled Benin art in form and concept, i.e. animal symbols such as leopards, mudfish, snakes, snails, tortoises, cocks, and the typical Benin vertical face marks over the brows, as well as the royal rosette design.

A third group, with stylistic features different from the other two, is known as the "Owo style". The finds from this group include human (a good number of them female) and animal figures, hands holding leaves or offering animals, terracotta representations of a basket filled with fruits and another with severed human heads.

Charcoal provided a radiocarbon dating of the early 15th century (515±90 years BP or AD 1435±90). Unfortunately, most of the sculptures were found in fragmented state, since they were periodically dug out for use in religious rituals and reburied in the early 18th century (195±90 years BC or AD 1755±90, calibrated to 1650 AD).

Owo art represents, historically and stylistically, the link between the art of ancient Ife and Benin and a channel for important cultural exchange between these two great art centres.

V. I. E.

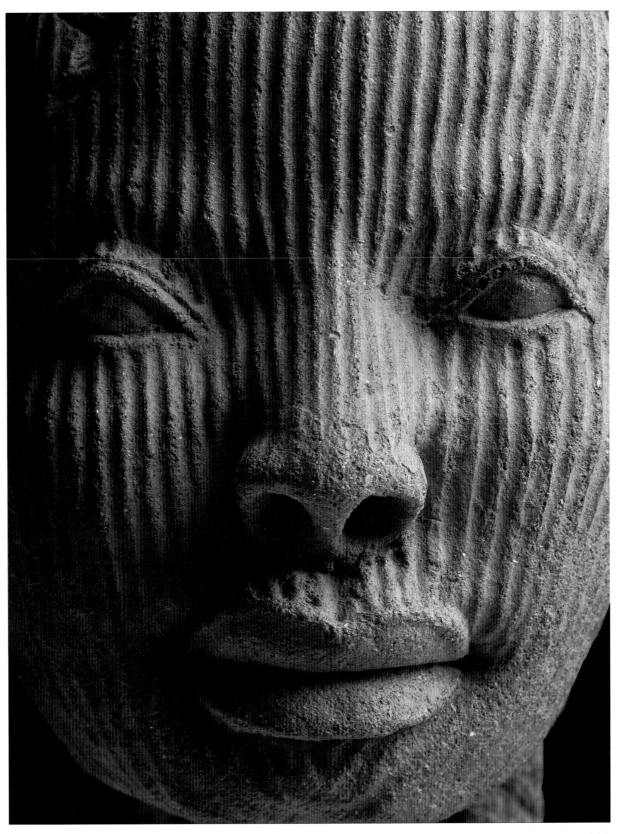

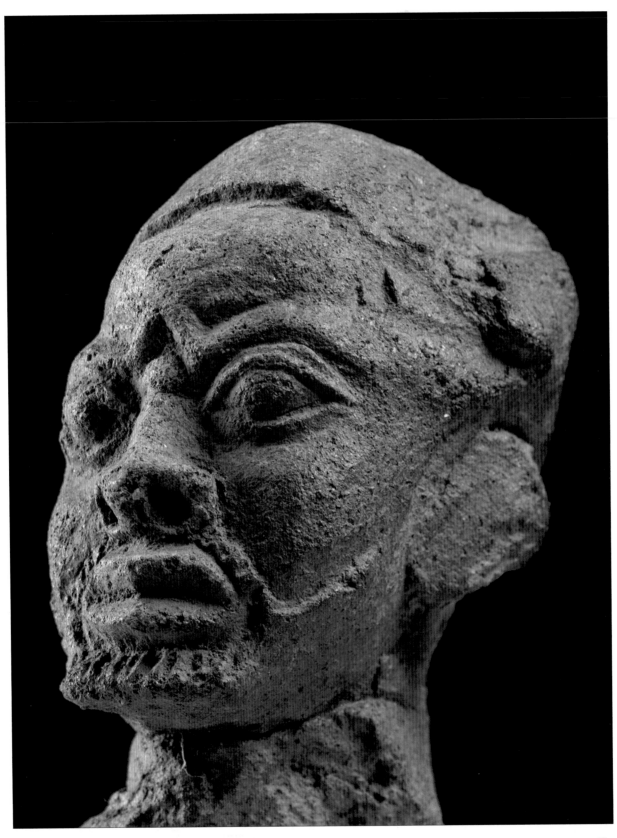

33a

32a. **Owo artist, Nigeria (Igbo 'Laja)**
Head
Circa 15th century AD
Terracotta, 18.4 cm
Lagos, National Museum (inv. 73.2.7)

Human head with cap headdress, typical of Owo portraiture. The vertical lines on the face, the slanted eyes and serene naturalism of the expression are characteristic features of Ife art. However, the scientific examination of the clay used makes it possible to conclude that the object was made locally.
On the basis of archaeological evidence we may suppose that by the beginning of the 17th century the tradition of naturalism in Owo statuary had been abandoned, but certain clues lead us to believe that during the 18th century the objects were discovered and reused as pendants. At the time of the archaeological excavations which took place in 1971, they were considered part of the insignia of the priestly class.

33a. **Owo artist, Nigeria (Igbo 'Laja)**
Man's head
15th century AD
Terracotta, 10.1 cm
Lagos, National Museum (inv. 73.2.3)

Fine portrait of a human face with a frowning expression, as if the subject were deep in thought.
The cap headdress, the sideburns, the moustache and the beard are rendered with skill, in the characteristic owo style. The right ear is sculpted with care, while the left appears somewhat rough, perhaps to indicate that the subject was ill.
The miniscule dimensions highlight the craftsmanship of the 15th-century artist, who displays a detailed knowledge of the anatomy of the human face.
The object was brought to light in 1971 by professor Ekpo Eyo, in Igbo 'Laja where there was a sacred wood in which ritual ceremonies took place.
Many miniature heads similar to this one have been found in Owo. They may have been part of larger compositions.

34a. **Owo artist, Nigeria**
Pendant
15th century AD
Bronze, 28.4 cm
Lagos, National Museum (inv. 74.G.1)
Donated in 1974 by the *Olowo* (king) of Owo

Bronze chest pendant in the form of a ram's head; the pupils are emphasised by iron inlays, according to the Benin style.
In Yoruba iconography the ram symbolises royal power and frequent examples are known of in wood, terracotta and bronze in the art of Ife, Owo and Benin, especially in connection with the cult of the ancestors of the king.
In ancient times, similar pendants or breastplates were part of the official costume of the king and members of the court in the kingdoms of Ife and Benin.
It was thought that the effigy of the ram ensured the wearer the protection of the divine ancestors.

BENIN

THE EMPIRE FROM THE 14ᵗʰ TO THE 19ᵗʰ CENTURY

The Ife prince Oranmiyan is said to have established a Yoruba dynasty among the scattered chieftaincies of the first Edo kingdom towards the end of the 13ᵗʰ century. He introduced a centralised political system under a divine kingship, which, together with subsequent administrative reforms during the 15ᵗʰ century, laid the foundations for the remarkable expansion and flourishing of the Benin kingdom. During the rule of *Oba* (king) Esigie in the 16ᵗʰ century, the Benin empire extended to Lagos and Dahomey to the west, to river Niger to the east, to Ekiti to the north and to the Atlantic Ocean to the south.

Viceroys, local governors and district officers were placed in charge of ward-organised military units and collected contributions from agricultural production and trade tariffs in their territories.

By 1483, commercial and diplomatic relations had been established between Benin and Portugal, which promoted international trade in spices, ivory and slaves and opened an avenue for Christian missionary activities and Western education for the princes of the royal court. The Portuguese brought gifts of copper, coral beads and gems for the court regalia and craftsmen's guilds, as well as ammunitions and soldiers for the royal military campaigns.

In 1485 Benin City was reported to have been an impressive place, "the largest and the best-ordered town" that the Portuguese had "encountered in the whole of Guinea". In 1667 Olfert Dapper described its plan and scenery, its fortifications and straight wide streets, comparable to those of Amsterdam, its royal court ceremonies, its art and military might. A huge retinue of couriers, officials, priests and servants, as well as thousands of slaves and organised guilds of court craftsmen were maintained at the king's palace, which occupied half of the city. The remainder of the capital was divided into wards, each of which performed special duties for the *Oba* (king).

The fortunes of the Benin empire declined after the 16th century due to internal rivalries, incessant wars on its boundaries, European trade penetration and constant incursions of Muslim groups from the north. The British punitive expedition of 1897 sacked the city and deposed the *Oba*. Over two thousand royal treasures were looted from the palace and shipped to Britain, from where they spread all over the world, creating a sensation for their extraordinary technical expertise and delicate modelling.

The corpus of Benin court art consists of a wide variety of objects in wood, ivory, iron, terracotta, leather and, especially (90%), in bronze. The *Oba* had the monopoly on the casting of bronze and the working of ivory and coral beads. By the 15th century, various objects, cast in copper alloys or carved in ivory, had replaced the earlier wood-carved sculptures and served as means of ancestral worship, court ceremonial and glorification of the divine royalty.

Portuguese travellers marvelled at the pillars of the palace courtyards, which were heavily adorned with bronze plaques documenting scenes of court life and depicting the *Oba*'s achievements in peace and war. Memorial heads and other altarpieces, ritual stools and vessels and animal figures symbolising royal power were placed on the numerous palace shrines.

Tradition relates the introduction of bronze-casting in Benin to a master craftsman, Iguegha, who came at the end of the 14th century from Ife on *Oba* Oguola's

request. The founding master was consequently deified and is still worshiped by the Royal Guild of bronze-casters, who practice the traditional lost-wax method of casting in the vicinity of the *Oba*'s palace.

Benin bronze art tradition has been divided by William Fagg into three main periods: early (from mid-15th to mid-16th century), middle (from mid-16th to mid-17th century) and late (from late-17th to late-19th century), during which Benin artwork gradually changed from naturalistic to more stylized and stereotyped, and, eventually, to heavily decorative "Rococo" style.

V. I. E.

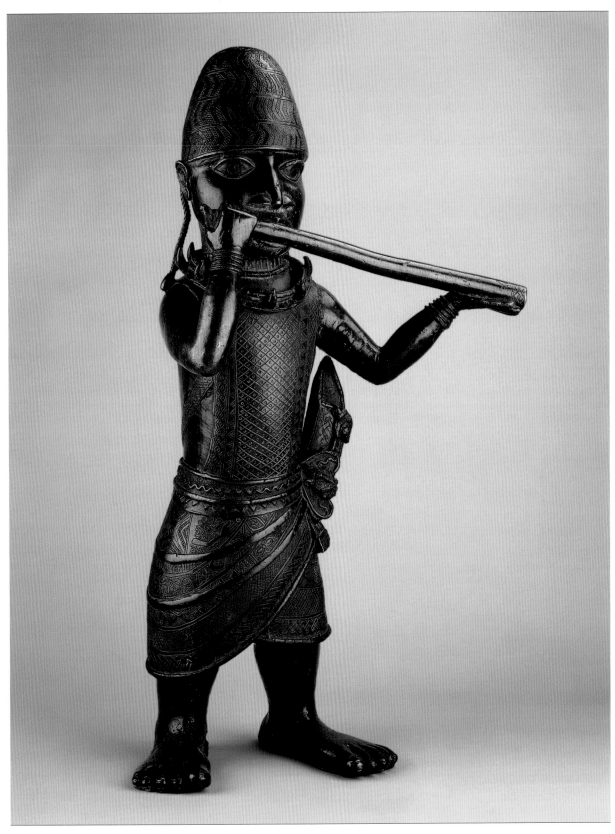

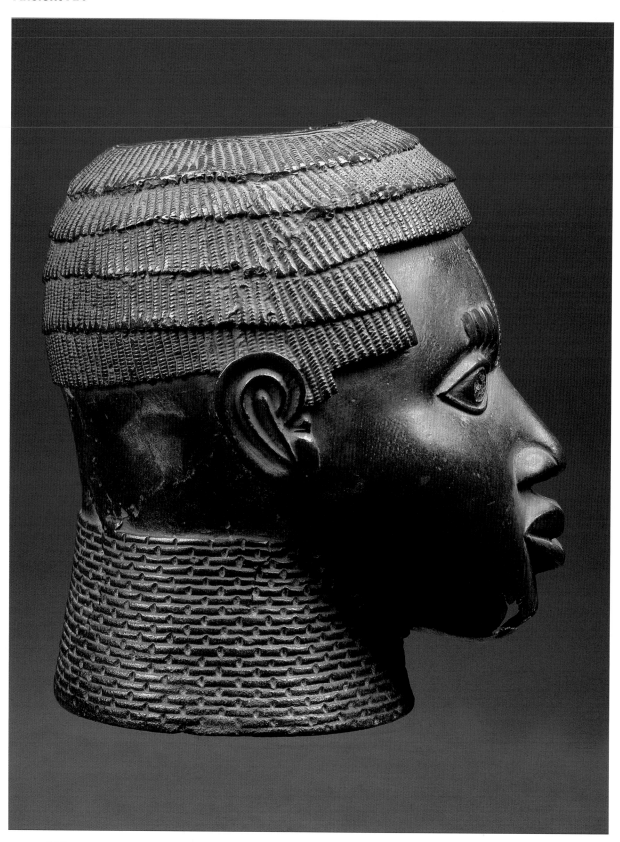

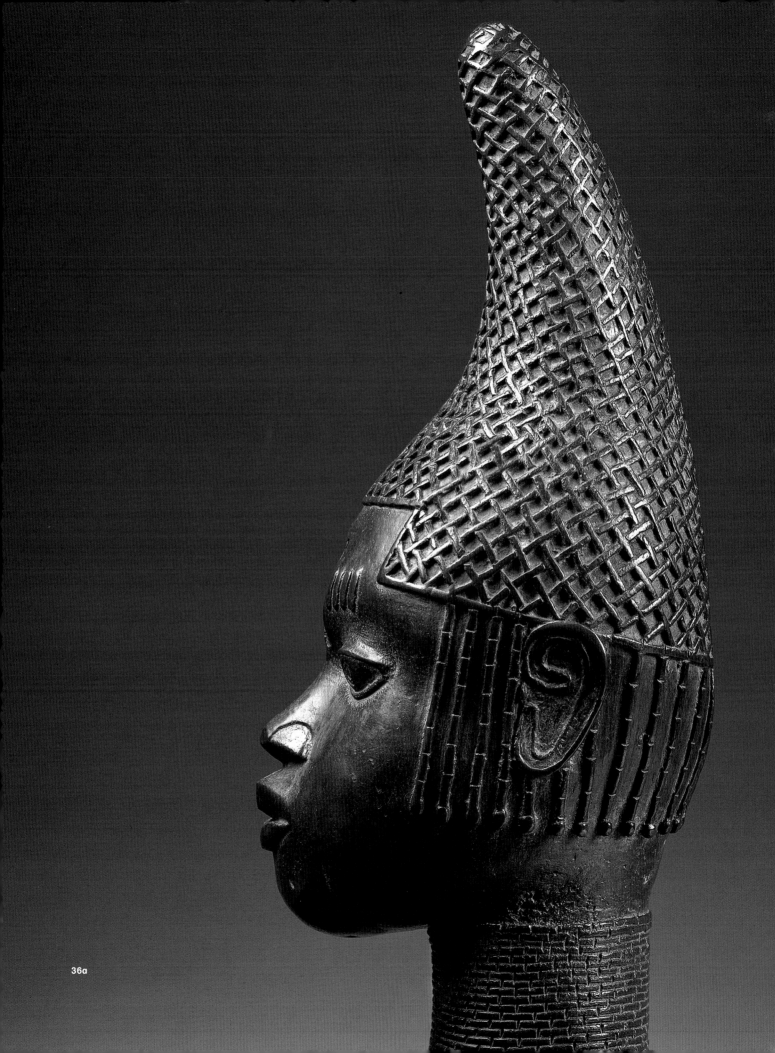

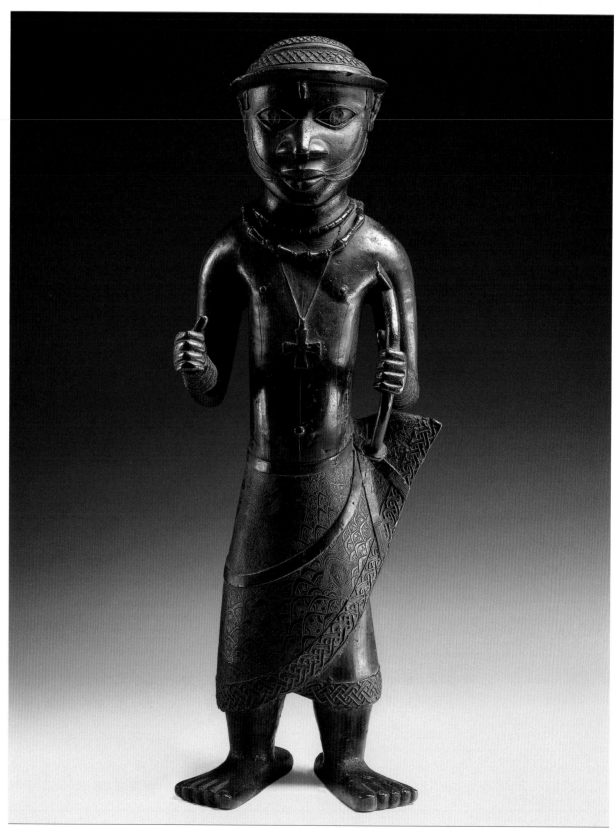

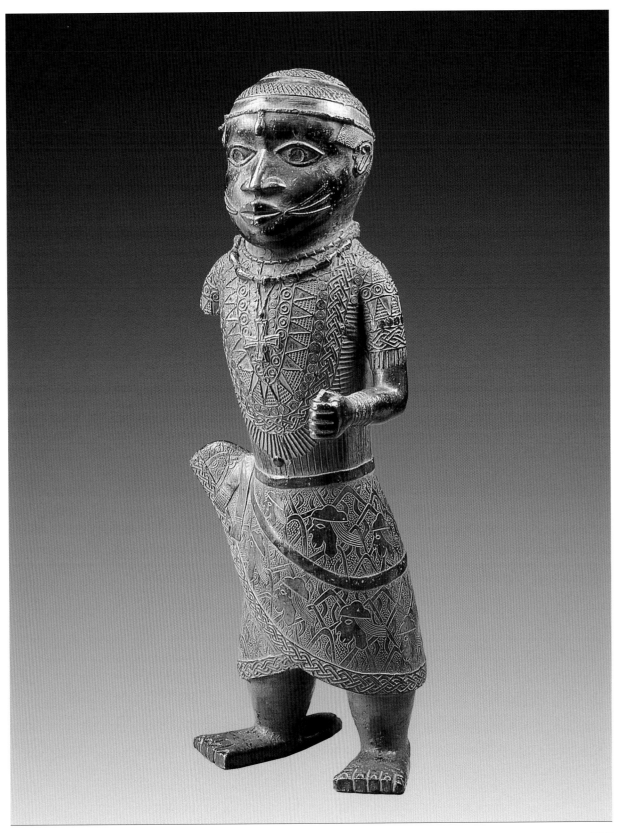

38a

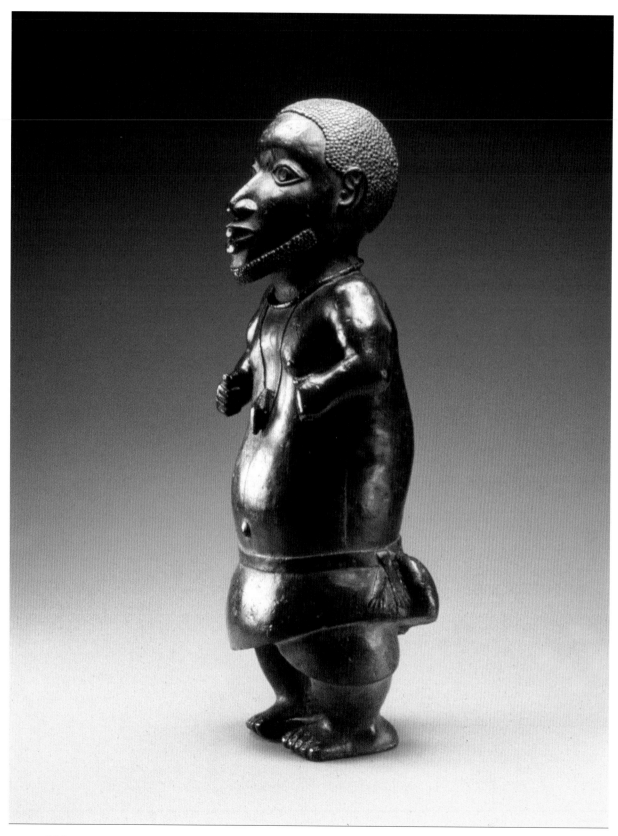

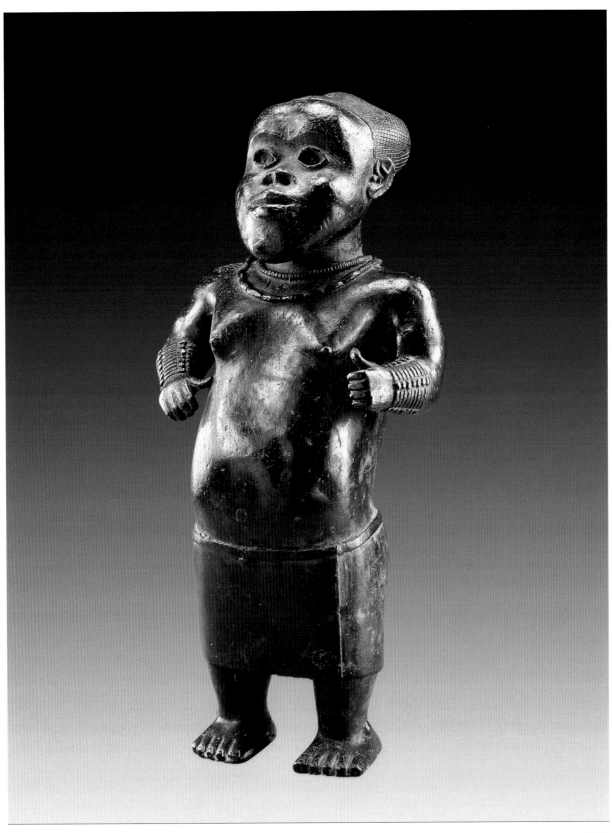

35a. **Edo artist, Nigeria (Benin)**
Head of *Oba*
Early period: late 15th
- early 16th century
Bronze, 20.8 cm
Lagos, National Museum (inv. 54.15.7)

Head of a dead *Oba*, whose face displays the typical scarifications of the Benin tradition.

Initially, on the death of the *Oba*, his head was transferred to Ife, the spiritual centre of the Yoruba, where it was buried. In exchange, a bronze head was sent to Benin, to be placed in the palace, in the sanctuary dedicated to the ancestors of the king. From the middle period (1550) onwards, the commemorative heads were made in Benin and used to support huge elephant tusks on which bas-relief carvings depicted the events which had taken place during the *Oba*'s reign.

The heads of the early period tend towards a more naturalistic representation, and the facial scarifications are depicted using iron inserts. They are also lighter and thinner, since before the great trade expansion in the 16th century metal was scarce.

36a. **Edo artist, Nigeria (Benin)**
Head of Queen Mother
Early period:
early 16th century
Bronze, 51.5 cm
Lagos, National Museum (inv. 79.R.17)

This is one of the most famous bronze heads from Benin. The high cone-shaped hairstyle, and the collar of beads are part of the insignia of the queen mother (*Iyoba*). Note the signs of scarifications on the face, typical of the people of Benin — above the arched eyebrows and the nose (the two vertical lines) — which are made during certain religious ceremonies.

It is said that the position of queen mother was introduced in the early 16th century by *Oba* Esigie, who conferred the title on his mother, Idia, and gave her a separate palace in Uselo, outside the city walls of Benin. From then on, the *Oba* continued with this custom, giving the title to their mothers three years after ascending to the throne.

37a. Edo artist, Nigeria (Benin)
Messenger
Middle period:
second half of 16th century
Bronze, 65 cm
Lagos, National Museum (inv. 54.15.8)

This standing figure represents a court herald, whose face bears the ritual "cat's whiskers" scarifications typical of the Idah people, from north of Benin. The herald's cap is decorated with beads, a necklace and a pendant in the form of the Maltese cross. The L-shaped metal object that the figure is holding in his left hand is a symbol of Ogun, the Yoruba god of iron and war. The thong is gathered and raised on the left side in accordance with the style used in the court of Benin, while the pattern on the fabric represents a Portuguese head. In the Benin bronzes, the presence of Portuguese elements is frequent, such as Maltese or Greek crosses, heads and soldiers carrying rifles. According to the oldest Portuguese chronicles, a brass cross (with a commander's staff and a brass cap helmet) was part of the royal insignia sent to each new Benin king by the "kingdom of Ogane". In describing the heralds from the Idah or Nupe territories (a powerful kingdom in the region of the Nupe-Igala people, at the confluence of the Niger and Benue rivers), Portuguese documents also talk of crosses hanging from a necklace and of "cat's whiskers" scars at the corners of the mouth.
This piece shows signs of a mixed origin, testifying the close relations which had existed between the kingdoms of Benin and Nupe since ancient times.

38a. Edo artist, Nigeria (Benin)
Messenger
15th -16th century
Bronze, 60 cm
Vienna, Museum für Völkerkunde (inv. 64.747)

The messenger of Vienna is distinguished from the Lagos figure (37a) by the sumptuous clothing which entirely covers his body, confirming the importance of his position. The stylised heads of Portuguese alternated with ornamental motifs, engraved on the lower part of the costume, are represented in profile instead of the frontal position as in the example from the Nigerian museum.

39a. **Edo artist, Nigeria (Benin)**
Hornblower
16th-17th century
Bronze, 59.7 cm
London, The Trustees of the British Museum
(inv. 1949Af.46.156)

The hornblower wears a rich costume, a sign of his important function at the court of the king of Benin. In the famous table in Olfert Dapper's book of 1668 which illustrates the annual procession of the sovereign outside the palace walls, a player is shown. The mouthpiece of the instrument is however at the top, rather than at the side, as it is in all the Bini instruments known, a sign that the illustrator did not see the ceremony, but was working from the text by the Dutch author, which does not specify the technical details of the horn. Hornblowers were often depicted on the plaques which were used to decorate the pilasters of the royal court (50a).

40a. **Edo artist, Nigeria (Benin)**
Court dwarf
14th-15th century
Bronze, 59.5 cm
Vienna, Museum für Völkerkunde (inv. 64.745)

41a. **Edo artist, Nigeria (Benin)**
Court dwarf
15th century (?)
Bronze, 59 cm
Vienna, Museum für Völkerkunde (inv. 64.743)

Dwarfs were traditional figures at the royal court of Benin, even if their function there is uncertain. An illustration in the volume by Olfert Dapper of 1668 shows them in the entourage of the sovereign in the procession that the latter, preceded by leopards on chains and musicians, made every year outside the palace walls.
The two sculptures, probably made for a royal votive altar, are different from a stylistic point of view, and we must therefore suppose that they are the work of two different artists. According to current opinion, the figure without a beard is thought to be the older of the two. This hypothesis is probably wrong, since the bearded dwarf, lighter and therefore with thinner sides, has actually been dated to the early 14th century (Duchateau 1994, 73).
Felix von Luschan (1919, 299) and William Fagg (1963, 24) considered the two figures the most beautiful works from Benin. Certainly, they are unique examples of their kind: their unusual naturalism makes them stand out from the stylised representations which usually characterise the art of the ancient kingdom, perhaps even suggesting that they originated from Ife.

42a. **Edo artist, Nigeria (Benin)**
43a. **Pair of leopards**
Middle period: mid-16th century
Bronze, 50.5 cm and 49.3 cm
Lagos, National Museum (inv.52.13.1 and 52.13.2)

The sculptures realistically represent the anatomy and appearance of leopards, whose ferocity is expressed above all in the teeth and eyes.
Leopards were the symbol of royal authority, and portrayals of these animals were found on the altars of the king's ancestors. Ewers, water containers used for ritual ablutions, were sometimes made in the form of a leopard.
In 1897, during the punitive expedition carried out by British forces, these two objects were looted from the royal court of Benin.

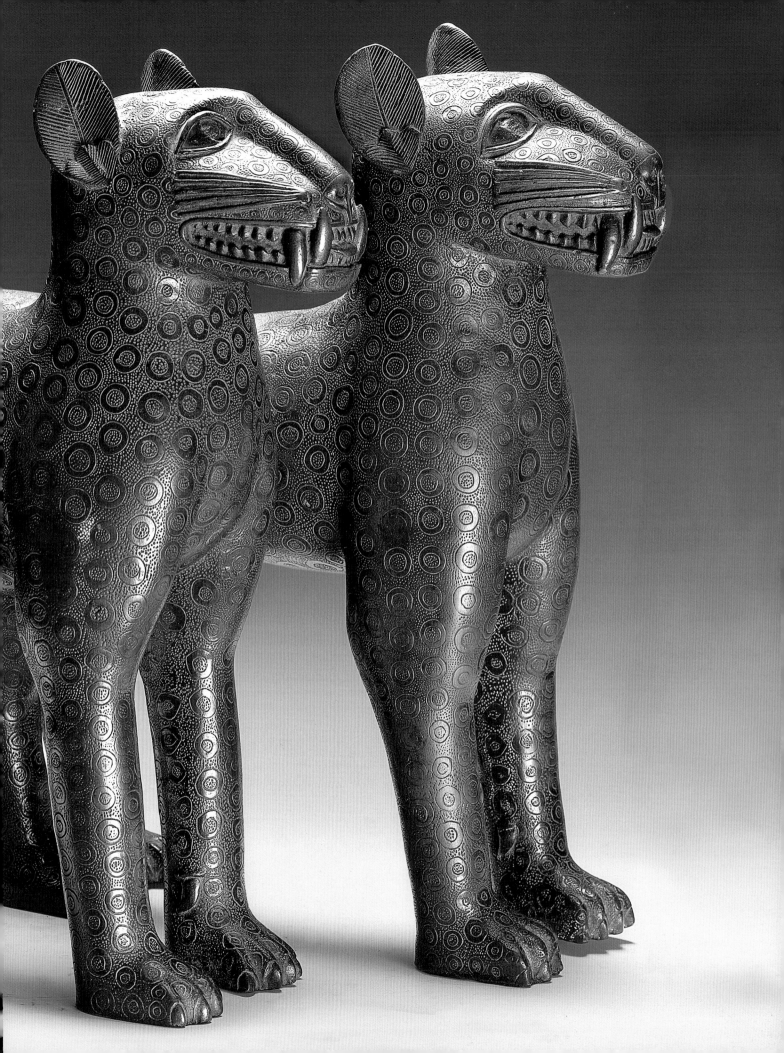

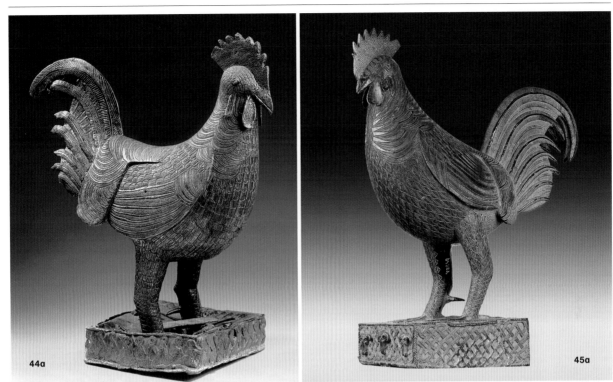

44a

45a

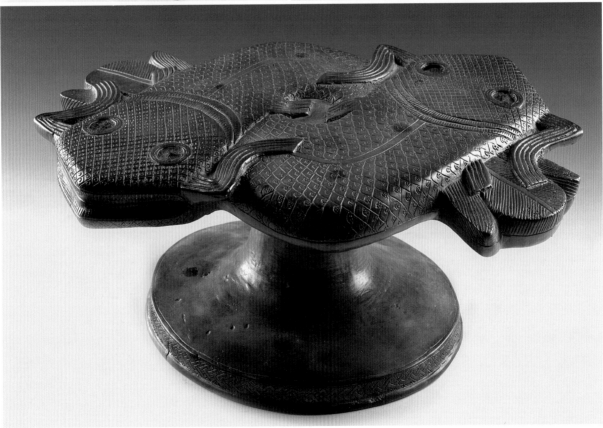

46a

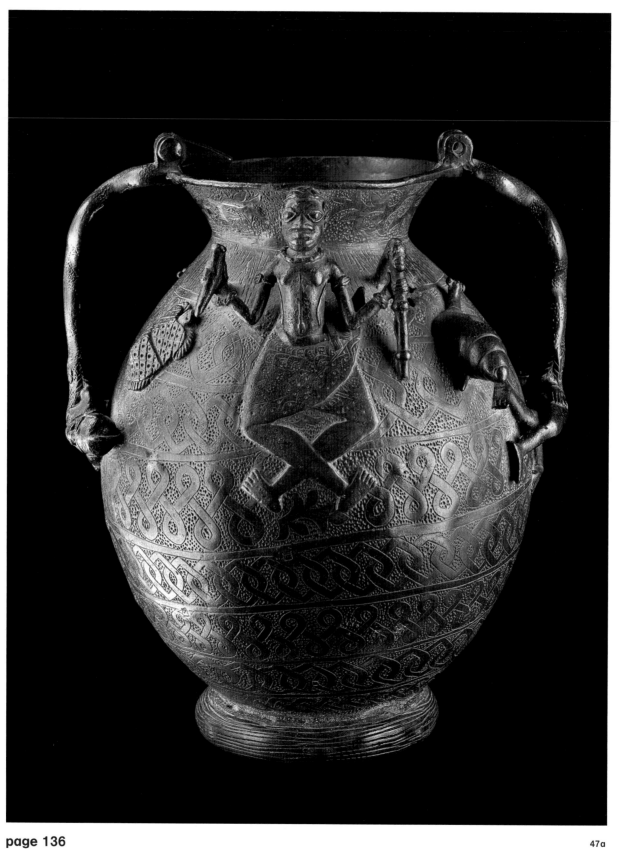

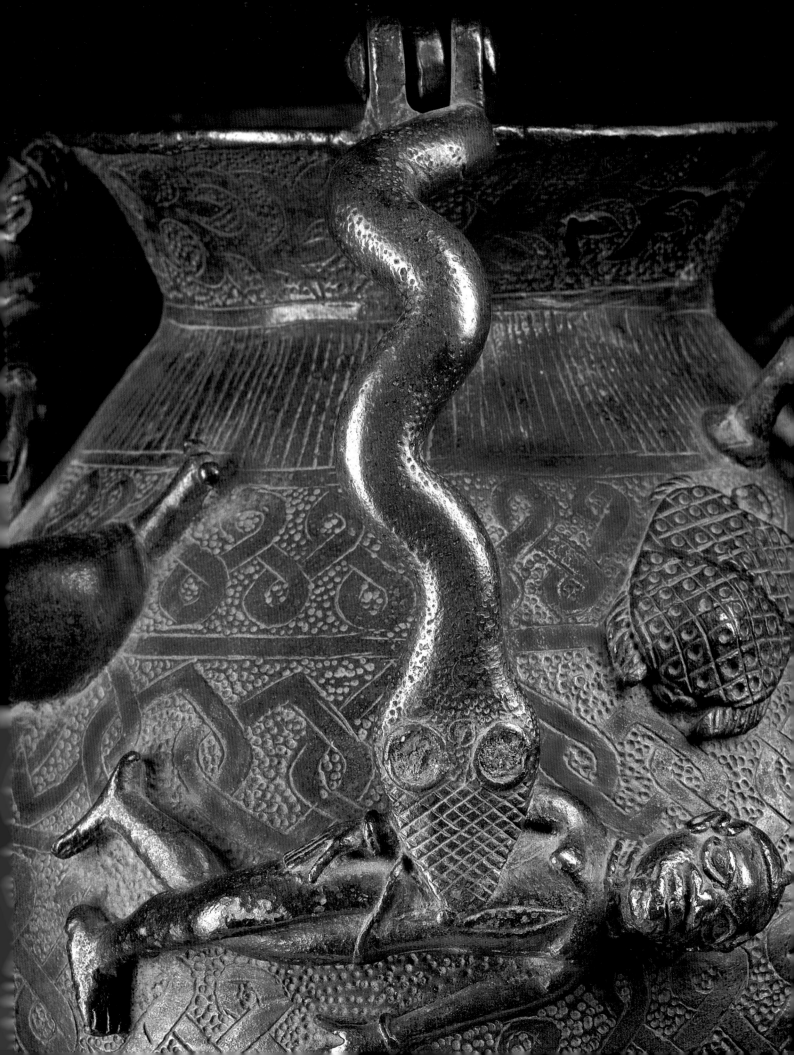

44a. **Edo artist, Nigeria (Benin)**
Cockerel
16th-18th century AD (?)
Bronze, 51.3 cm
Lagos, National Museum (inv. 53.22.16)

45a. **Edo artist, Nigeria (Benin)**
Cockerel
16th-18th century AD (?)
Bronze, 53 cm
Vienna, Museum für Völkerkunde (inv. 64.723)

These bronze cockerels come from a sanctuary for the cult of ancestors dedicated to the queen mother. They are placed on a rectangular decorative base, typical of Benin altar accessories.

The image of the cockerel became a symbol of the cult of the queen mother, which began in the early 16th century following the increased political weight of the king's mother. The queen mother was given the title on the third anniversary of the *Oba*'s coronation, and from that moment on remained segregated together with her own court in the palace set aside for her, outside the city walls of Benin. The head of the queen mother and the principal figure of her altar, the bronze cockerel, were popular subjects in Benin art in cast bronze.

On the back of the second piece, there are three visible heads of rams, a sacrificial animal in Nigerian culture.

46a. **Edo artist, Nigeria (Benin)**
Stool
Middle period: 16th century AD
Bronze, 36.6 cm
Lagos, National Museum (inv. 53.22.11)

Bronze stool with a circular base, supporting a column made of two catfish which form the seat in a complex interlaced motif.

Catfish and serpents were considered emblems of the water god Olokun and of divine royalty, and are often found in the iconography of Yoruba and Benin courtly art.

Ritual stools and depictions of animals, especially leopards and rams, were used in the sanctuaries of the king and during the various religious ceremonies which took place in the royal palace in Benin.

47a. **Edo artist, Nigeria (Benin)**
Ritual container
Middle period: 17th century AD
Bronze, 23.6 cm
Lagos, National Museum (inv. 54.15.5)

Sacred vase with ritual motifs in high relief on the surface. The lid, which would have been elaborately decorated, is missing. The upper sides of the vase displayed symmetrical patterns of tortoises and snails, and people sitting cross-legged holding ritual objects. The handles are formed by two pythons holding sacrificed human victims in their jaws. The lower sides of the vase are decorated by an intricate arrangement of geometric motifs, characteristic of the symbolism used in Yoruba and Benin art.
The python was considered the king of the snakes, and messenger of the water god Olokun, who was reincarnated in the person of the *Oba*.
Bronze vases similar to this, known as "ewers", some with theriomorphic features, were used at court for ritual ablutions.

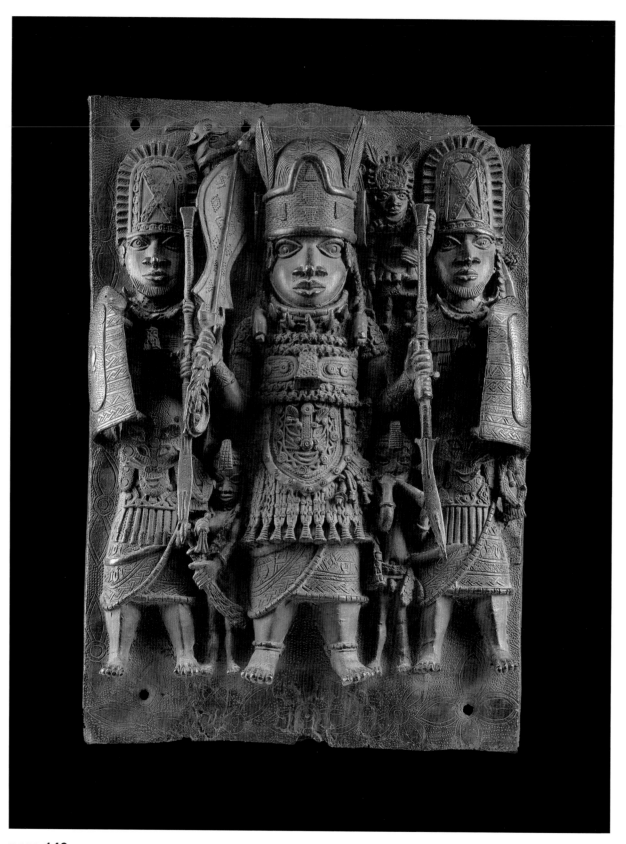

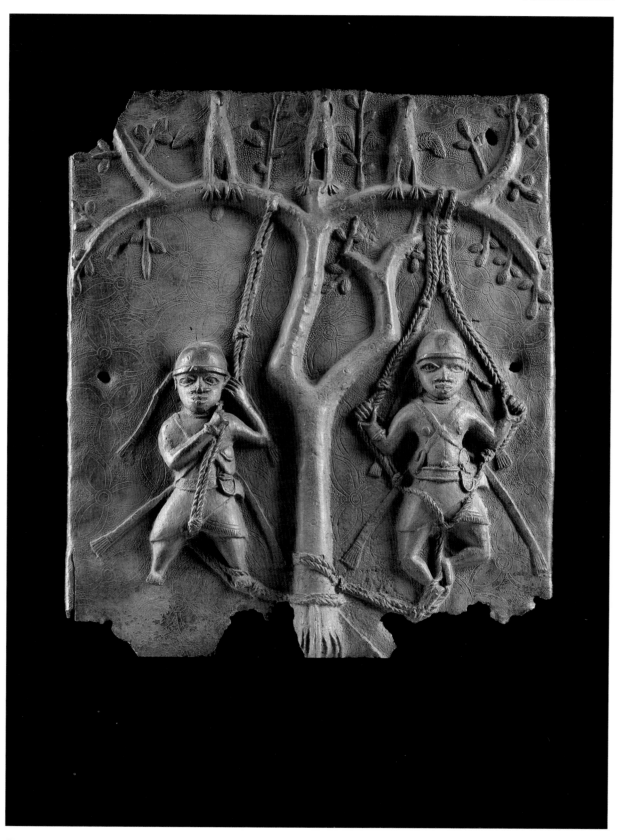

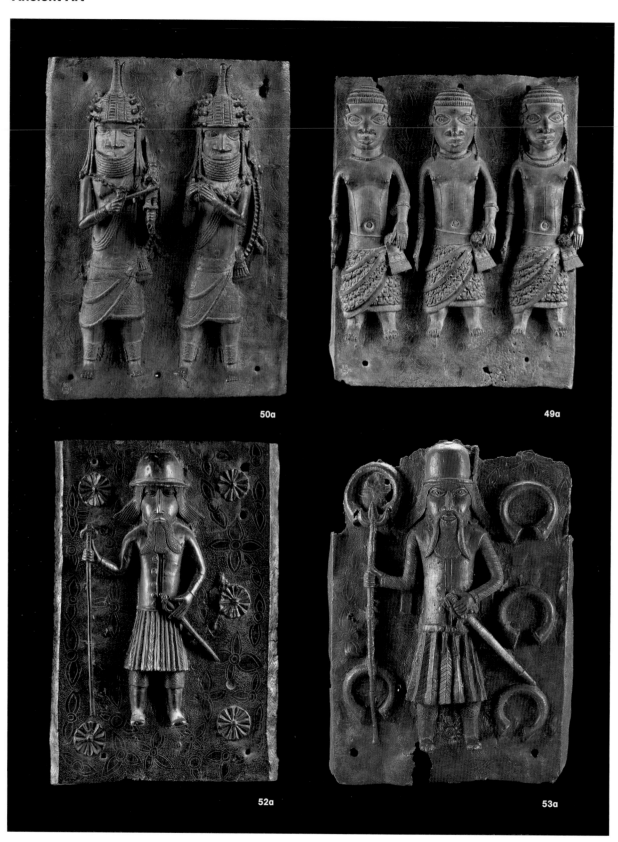

50a

49a

52a

53a

48a. **Edo artist, Nigeria (Benin)**
Plaque with king in military garb and entourage
Middle period: circa 17th century AD
Bronze, 51.6 cm
Lagos, National Museum (inv. 48.36.1)

The figure at the centre of this bas relief is the *Oba* of Benin in the role of commander in chief during the war, with all the insignia of his rank: cap helmet with feathers, necklace of leopards teeth and bell-shaped pendant on his chest. The king is holding the ceremonial sword (*eben*) and the staff of command, both royal insignia. He is accompanied by figures from the entourage, carrying the typical Benin shields. Below can be seen the king's servants: the sword bearer and the hornblower. The small size of the figures indicates that they belong to a lower social class.

At the top, the head of a two Portuguese soldiers are portrayed. Similar war scenes commemorate the march of Benin troops, accompanied by Portuguese soldiers, against Muslim invaders from the north.

The high relief of the engraving is extremely marked, which shows that the bronze founders of Benin possessed great technical expertise.

49a. **Edo artist, Nigeria (Benin)**
Plaque with three court servants
Middle period:
late 16th - early 17th century AD
Bronze, 48.3 cm
Lagos, National Museum (inv. 50.30.6)

One of the many metal plaques decorating the royal palace, showing scenes of court life. It portrays the servants (*Omeda*) of the *Oba* (king).

According to bishop Egharevba, an historian of the Benin, the custom of preparing cast bronze plaques to hand down the memory of certain events began during the reign of *Oba* Oguola, in the early 16th century.

50a. **Edo artist, Nigeria (Benin)**
Plaque with two court musicians
Middle period:
late 16th - early 17th century AD
Bronze, 48.3 cm
Lagos, National Museum (inv. 50.30.8)

These bronze rectangles, commemorative plaques engraved in bas-relief, faced the wooden pilasters in the courtyards of the palace of the *Oba*.
The scene shows the performance of a rite at court. One of the musicians strikes with a staff a ritual wooden gong, in the form of a human figure, while the second shakes a round rattle. The two figures wear conic caps decorated with coral beads, high collars, anklets and chest decorations with strings of beads characteristic of Benin courtiers. They wear thongs with a raised strap on the left side and tied to the chest pendants, a distinctive sign of the high class they held in the king's court.

51a. **Edo artist, Nigeria (Benin)**
Plaque with two men performing acrobatics
Middle period:
circa 16th century AD
Bronze, 43.6 cm
Lagos, National Museum (inv. 48.36.40)

The plaque, with subtle bas-relief, depicts an acrobatic dance performed during a feast of war in honour of Ogun, the Yoruba god of war and iron. The dance commemorates the legendary war against the heavens, following which the gods destroyed the ladder which connected heaven to earth. The dance was performed during the rites preparing for war.
Note the sacred birds (ibis), the harbingers of catastrophe perched on the tree, and the motifs of flower petals decorating the background.
This is one of the many bronze plaques used to face the wooden pilasters in the palace courtyards.

52a. **Edo artist, Nigeria (Benin)**
Plaque with Portuguese soldier
Middle period: 16th-17th century AD
Bronze, 49.2 cm
Lagos, National Museum (inv. 45.5.1)

Wall plaque depicting a Portuguese military commander, wearing all the insignia of his rank and holding a sword and command staff.
The Portuguese were the first Europeans to arrive in Benin, towards the end of the 15th century. They dealt in the large-scale trade of spices, ivory and slaves. In the 16th and 17th centuries Portuguese soldiers were involved in the Benin army and took part in some wars of expansion towards the north conducted by the empire.
In the background we can observe motifs of foliage and royal rosettes; similar rosettes appear in Ife and Owo artistic objects from previous periods.
The holes on the borders were for the metal nails which would have fixed the plaque to a wooden pilaster in the royal palace of Benin.

53a. **Edo artist, Nigeria (Benin)**
Plaque with Portuguese soldier
16th-17th century AD
Bronze, 46 x 34 cm
Vienna, Museum für Völkerkunde (inv. 64.799)

Images of the Portuguese are a frequent subject on plaques from Benin. The figure represented on this piece, which is now kept in Vienna, is similar to that of the plaque from the Museum of Lagos, even though the two works are by different artists: they have the same position, the same hairstyle, the same beard and moustache, the same sword and insignia, and the same background. The relief rosette however is here replaced by five copper "handles", a typical bartering currency between Africans and Europeans in the early centuries of their contact.

ESIE
SCULPTURES

The largest collection of stone sculptures in Black Africa was discovered in 1933 by a school inspector in the small town of Esie, west of the confluence of the Niger. In the surrounding woods over a thousand soapstone sculptures were found, representing human figures, probably images of ancestors.

The central site (where today the National Museum of Esie stands) contained sculptures in stone depicting men, women, children and animals, and were arranged on the ground in the form of a horseshoe and surrounded by sacred trees. It seemed to those who first discovered them that they had been broken into fragments as if destroyed violently, although no documentation exists to shed further light on such an event. The local population had found them when they had emigrated to the region in 1775, and incorporated them into their own religious practices as the nucleus of an annual festival. According to a local myth, the sculpted images were the foreigners that the divine powers had changed into stone to punish them for having threatened to harm the *Elosie* (king) of Esie. The figures, some bearded, whose height varies from 14 cm to over a metre, with rich decorations in beads and band armlets, may be standing or seated and display a wide range of complex hairstyles, giving the impression of great wealth and majesty. A certain number of figures, some also female, wear warriors' clothes and carry weapons, which indicates a warlike climate. Various kinds of occupations are represented, indicated by the tools used by the figures and the actions they perform, for example: farming, the grinding and cooking of foods, playing musical instruments, holding machetes.

The artistic style of the pieces varies, indicating different artists. Faces display well-defined individual characteristics; some are smiling, but in most cases the expression on the face is serious and severe. The distinctive features are the scarifications on the temples, elaborate hairstyles and small beards.

Research has revealed that the material used for the sculptures is soapstone, or steatite, taken from local deposits, and worked between the 11th and 14th centuries AD.

V. I. E.

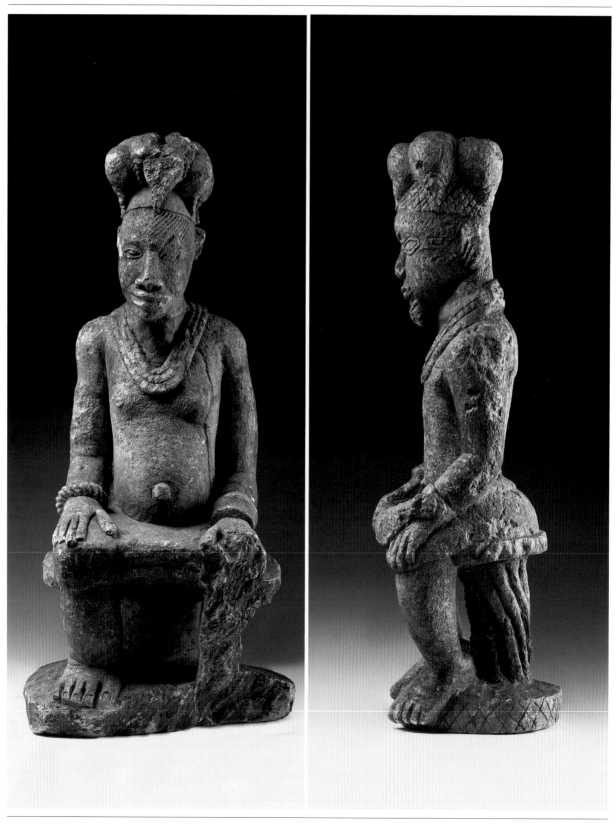

54a. **Artist from Esie, Nigeria**
Seated figure with a sword
Ante 1850
Steatite, 80 cm
Esie, National Museum (inv. HT 348)

Male figure sitting on a stool with a flat base. Both the hands are resting on his knees, covered with fabric; the right hand holds a ceremonial sword.

The stress falls on the treatment of the head, crowned with an elaborate hairstyle, formed by locks of hair gathered in chignons with twisted tips, held in place by a band around the forehead or by a beret. In terms of size, the head represents a quarter of the entire figure, a typical ratio in African art.

In Esie sculptures we also observe the attention to bodily decoration which characterises Nigerian artistic traditions.

The twisted bracelet on the right wrist seems to have a symbolic meaning, because it appears in other sculptures from the same complex. The three parallel cuts at the sides of the eyes, on both temples, are also a common element in Esie art.

55a. **Artist from Esie, Nigeria**
Seated figure
Ante 1850 AD
Steatite, 67 cm
Esie, National Museum (inv. HT 260)

Male figure seated on a stool, at rest, as if for a portrait. The hands decorated with banded bracelets, are resting on the knees, covered by a short loincloth. From the position, face and form of the body, the person depicted appears to be rather old.

The head is crowned with a complex hairstyle, formed by locks of hair gathered in chignons with twisted tips, which were held up by a type of high band around the forehead or by a beret. The signs on the face are due to scarifications practised in oblique lines on the forehead and in parallel cuts on the temples; both are indications of influences from other cultures. The mouth is wide, with protruding lips, under a nose of massive proportions.

From the neck hang three bead necklaces, a sign of the care for decoration which characterises wealthy societies.

The stone sculptures of Esie reveal technical expertise and attention to detail, especially in the treatment of the hair and facial scars.

CALABAR

THE RITUAL POTTERY

In Calabar (south-eastern tip of Nigeria) between 1976 and 1981 numerous ceramic and terracotta artefacts were found, during excavations carried out in construction sites. These included vases and bowls with rich decorations, human heads in terracotta and full-figure statues, clay headrests on cylinder or conic bases and ritual vases with relief depictions of animals, stone axes, armlets, shells and other symbolic objects.

The campaign of archaeological excavations, carried out in the late nineties by professor Ekpo Eyo and research students from Maryland University brought to light other terracotta headrests in a variety of forms and styles, together with statues and vases with complex decorations. Scientific dating methods placed the finds to a period between 500 and 1000 years before 1950.

The pottery of Calabar, still under study, in stylistic and chronological terms is connected to the migration of the Bantu people into the region of southern Nigeria and Cameroon. There are significant similarities between the complex ornamental motifs of these finds and the drawings made by the Kuba people in the river basin of the Congo, attributed to Bantu art.

In this exhibition these discoveries are represented by two stylised terracotta headrests from the collection of the National Museum of Calabar.

V. I. E.

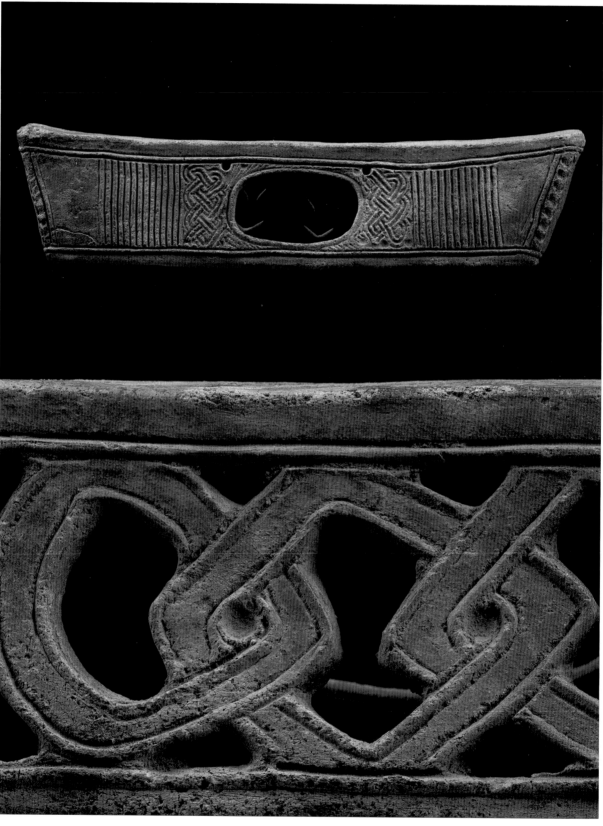

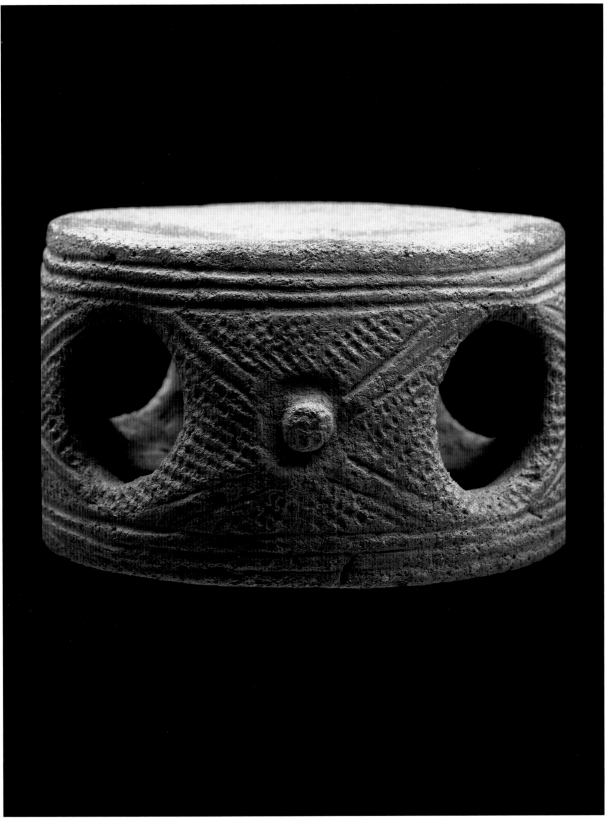

57a

56a. **Calabar artist, Nigeria**
(old road for Ediba, Calabar)
Headrest
Circa 445 AD
Terracotta, 44.5 cm
Calabar, National Museum (inv. A.1998.ORC.1.8)

This canoe was dug up in 1998 by professor Ekpo Eyo and his team from Maryland University; it has been dated using thermoluminescence.
The sides are made up of perforated intertwined forms, which testify to the mastery of extremely sophisticated techniques in working with terracotta.

57a. **Calabar artist, Nigeria**
(construction site for the new
library, Calabar)
Headrest
Circa 1100 AD
Terracotta, diam. 16 cm
Calabar, National Museum (inv. ORC.79.QA.15)

Cylindrical headrest with a hollow base decorated with geometric patterns. It was found in 1979, together with terracotta statues depicting human figures. The headrests and the statues were found amongst funeral objects.

BURA

NIGER

BURA

The necropolis of Bura-Asinda Sikka, north-east of Niamey, is one of the most recent and important acquisitions of African archaeology. Over four hundred burial jars in terracotta have been discovered, containing skeletons, and surmounted by human figures or riders also in terracotta, dated to the 3rd-11th century AD. These equestrian statues are still today the oldest testimony of the presence of horses found south of the Sahara.

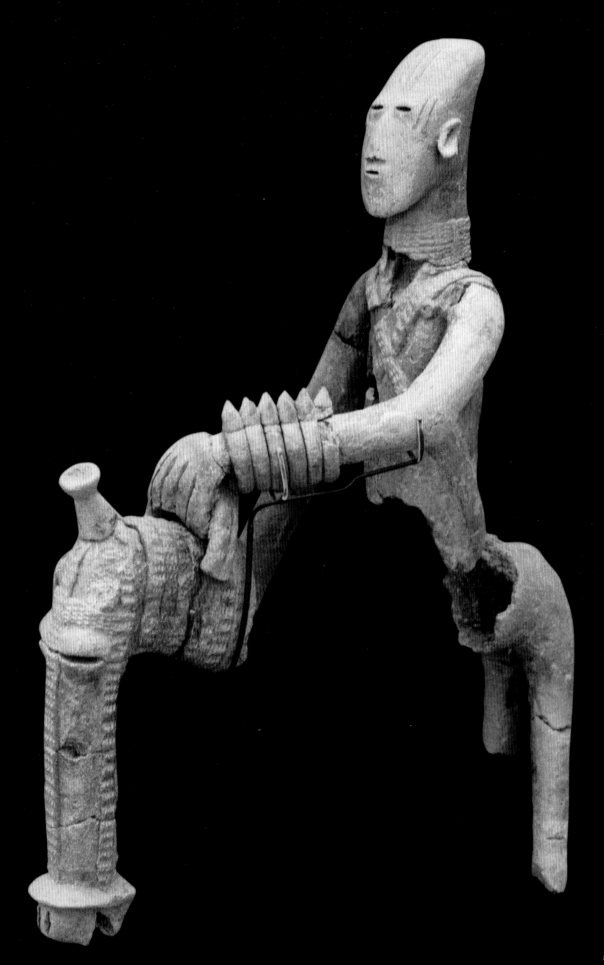

58a

58a.	**Artist from the Bura culture,**
	Bura-Asinda Sicca (Niger)
	Horseman
	3rd-11th century AD
	Terracotta, 62 cm
	Niamey, Institut de Recherches en Sciences
	Humaines, Niger (inv. BRK.85ACS.5e5)

59a.	**Artist from the Bura culture,**
	Bura-Asinda Sicca (Niger)
	Human figure
	3rd-11th century AD
	Terracotta, 28 cm
	Niamey, Institut de Recherches en Sciences
	Humaines, Niger (inv. BRK.703.781 .685)

This incredible figure of a rider, full of precious decorative elements, articulated and dynamic in the side view, displays a striking verticality when viewed from the front. This verticality is successfully suggested by the artist with the abnormal elongation of the animal's head, underlined by the elegant harnesses which seem to be echoed in the scarifications on the man's temples and forehead.

It is possible that the second figure is what remains of a rider. This seems to be suggested by the position of the arms, which despite being broken, are bent forwards as if holding reins. The body is covered with jewels, as in the previous image, to mark the authority of the person whose burial they marked.

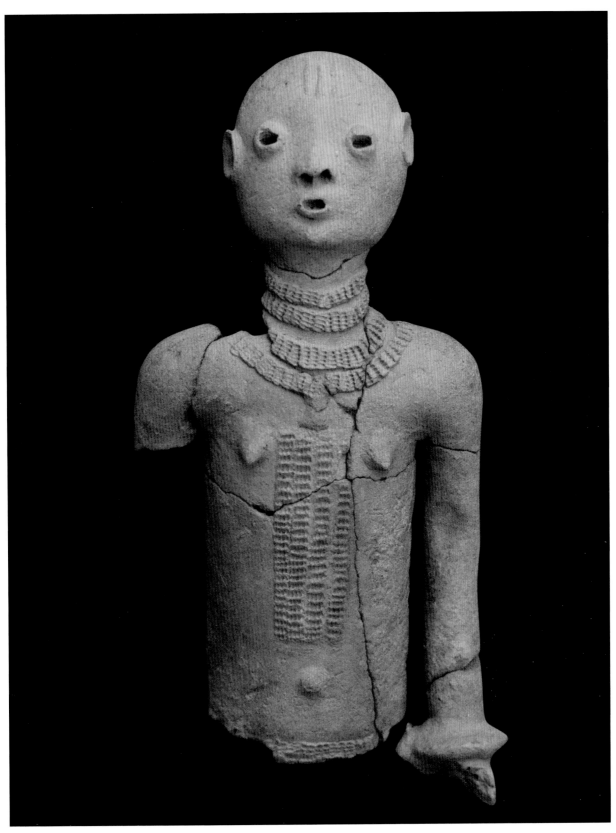

59a

SAPI

LIBERIA

SIERRA LEONE

SAPI

STONE
SCULPTURES

Sapi (or Sapes) is the name of an ancient people from Sierra Leone, with whom the Portuguese entered into contact in the second half of the 15th century. They are the ancestors of the Bulom, the Temne and the Kissi, in whose lands small sculptures in soft stone have been found from the 19th century onwards. These works are of human and animal figures, small in size but monumental in conception. The works, according to the scholars who studied them, are contemporary and perhaps even previous to the first contacts with Europeans (Tagliaferri 1989, *passim*).

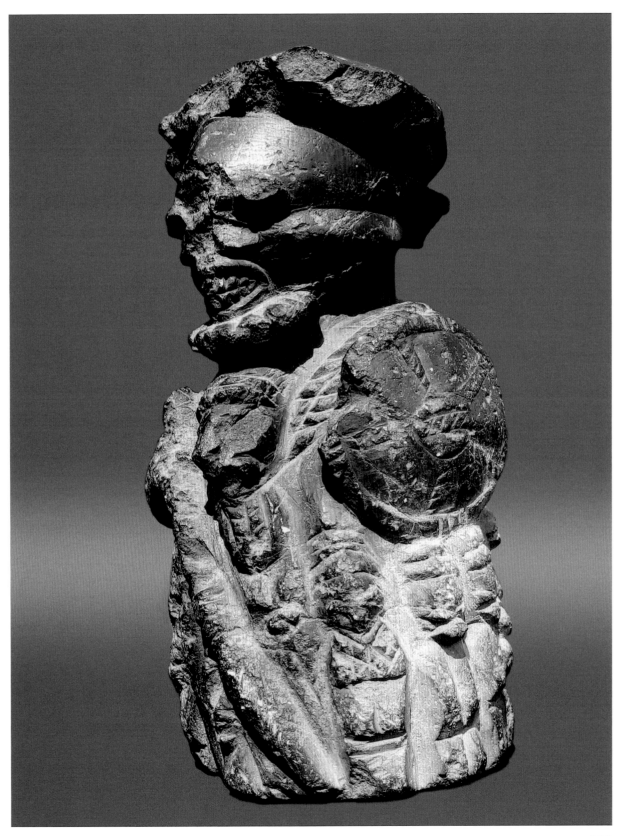

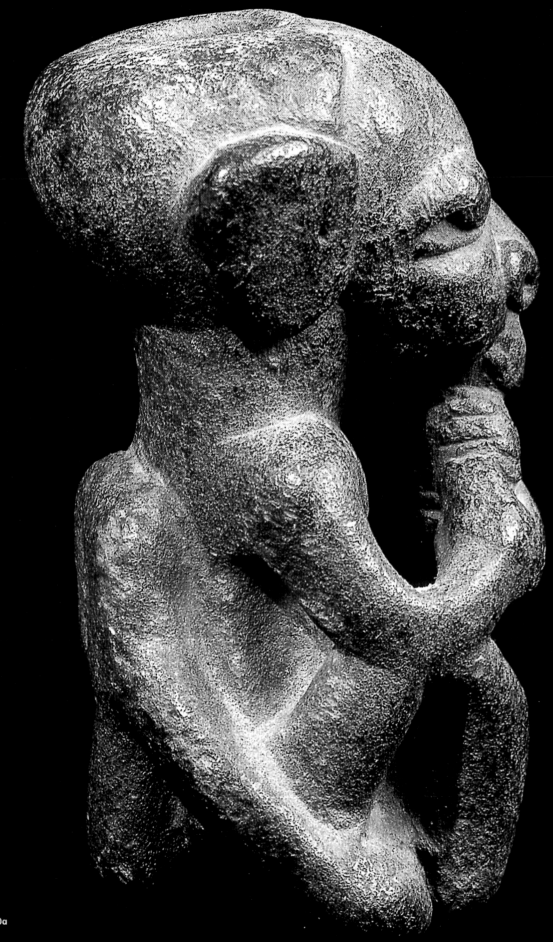

60a

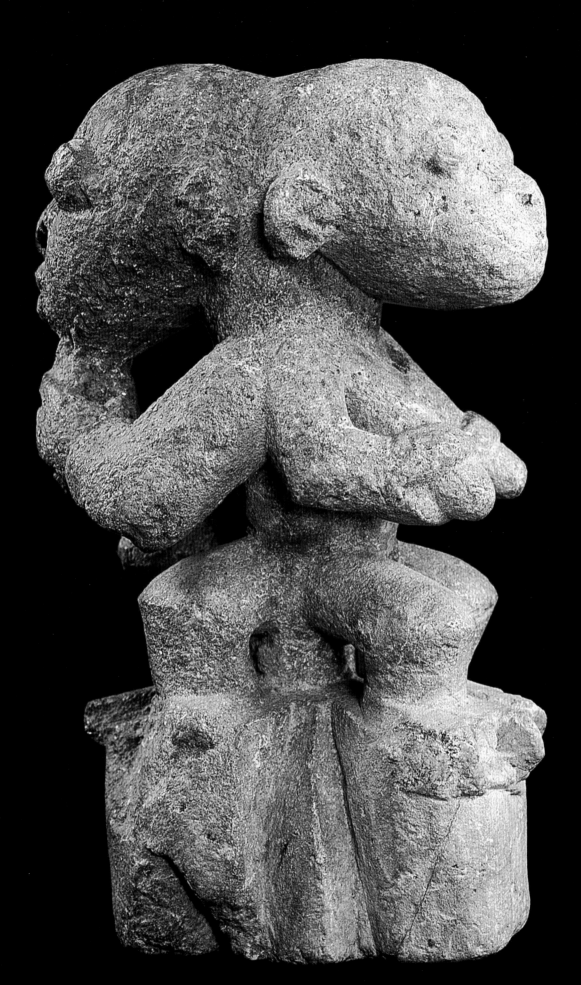

62a

60a. Sapi artist, Sierra Leone
Seated figure
15th-16th century AD (?)
Soap stone (steatite), 12.2 cm
Mario Meneghini Collection

The small figure seated on a three-legged stool is noteworthy for the airy com-
position, penetrated by wide open spaces which lighten it and give it a sense of
movement. The normal compactness of Sapi stone sculpture is concentrated in
the large head with its simple but expressive features. The image of the stool, ty-
pical of the region still today, is used with sumptuous ornamentation on the
Sapi-Portuguese salt cellar in the Museum of Modena (23b).

61a. Sapi artist, Sierra Leone
Chief figure
15th-16th century AD (?)
Soap stone (steatite), 27 cm
Mario Meneghini Collection

Its monumentality is a distinctive feature of this figure, the symbolic portrait of a
chief dressed with his weapons and attributes of power. The size, unusual in Sapi
stone creation, and the exceptional compactness of the form heighten the impres-
siveness of the work and underline the authority of the figure represented.

62a. Sapi artist, Sierra Leone
Two-faced figure
15th-16th century AD (?)
Soap stone (steatite), 23 cm
Mario Meneghini Collection

Two-faced figures are somewhat rare in Sapi art but not altogether absent, as
this piece shows. The skilful organisation of the volumes of the large heads and
bodies of the two figures joined at the back, gives deep value to this primordial
couple, whose expressive force and monumental quality remain unchanged.

DOGON

MALI

AT THE ORIGINS
OF DOGON SCULPTURE
DOGON

Africa was scarcely known to Westerners until the 20th century and its art is still unknown to most of them. For a long time, Mali remained unexplored — the Europeans had grouped for trade purposes along the coasts which had been discovered in the 15th century. Sudan, the future Mali, located in the interior, was known only through the accounts of rare travelers and it was only at the end of the 18th century that Mungo Park entered these regions, followed shortly afterwards by René Caillé.

The taking of Bandiagara and then Timbuktu by the French in 1893 led to the establishment of the Sudan colony, an occupation which ultimately was only a brief episode in history since it ended in 1958. From the beginning of their presence there, the French had wanted to reconnoiter this mysterious country. Lieutenant Louis Desplagnes was put in charge of exploring the Bandiagara plateau region, the only elevated place dominating the interior of the loop made by the Niger, this river originating in the Guinea mountains and going all the way up to Timbuktu before descending to the Atlantic. During a year of traveling, Desplagnes studied the Dogon country and its inhabitants and, very fortunately, collected oral histories about the arrival of these inhabitants which he recounted in his work *Le Plateau central nigérien* (The Central Nigerian Plateau), a book which is still today a reference. He brought back a few sculptures as well as excellent photographs destined for the Trocadero Ethnography Museum.

In 1931 the great Dakar-Djibouti expedition led by Marcel Griaule and with the participation of Michel Leiris discovered Dogon animists living traditionally in the Sanga region. This discovery incited Griaule and then Germaine Dieterlen, Solange de Ganay and Denise Paulme to return regularly to this group of villages to obtain a deeper knowledge of this civilization whose inhabitants claimed to come from "Mande" but which appeared to them as a closed society, maintained as such to preserve its coherence and unity. This spot became a sort of base for the researchers and then for tourists, for it is located on the edge of a cliff which rises spectacularly over the great Yatenga plain. Griaule published *Dieu d'eau* (God of Water) in 1948, an account of an initiation which enchanted innumerable readers. But he died too soon and the only research on the rest of the plateau was the description and ethno-linguistic analysis of these dialects by his daughter Geneviève Calame-Griaule.

After the war, confronted to the modern world, the Dogon who had become more and more islamized, lost interest in the ritual animist material, particularly as local antique dealers were in search of them. In fact, interest in "primitive" sculptures developed in the West. The first cultural objects arrived: initially masks for ritual celebrations about which Griaule had published a monograph in 1938; and then statuettes, which up until then had been carefully hidden, coming from family altars, others which were the protectors of the whole village and finally those belonging to the witch doctors facing competition from the medicine of the Whites, as well as sculpted wooden shutters etc... Everything or almost was sold, sometimes stolen, and was sent abroad, for a side effect of independence had been the disappearance of export controls. Unfortunately, no one worried about the origin and functions of the objects. In the West, among the artists, intellectuals or

collectors, no one was interested in the origin or the use of the sculptures but only in their aesthetic quality or perhaps how old they were. It was truly only in the second half of the 20th century that anthropologists began their research. For a long time one was limited to noting that the statues of the Dogon country had come from the plateau although to those who traveled all around this region, the people and their dialects provided obvious evidence to the existence of significant differences. In order to tell them apart and to discover their origin, it was necessary to know the many ethnic groups and to know how the plateau was peopled. We have undertaken this study, not without difficulty, for after the generation of those who sold these sculptures died, it became very hard to obtain information locally, even from the former blacksmith-sculptors who are very old today and all of whom have become Muslims.

HISTORICAL BACKGROUND

The African Middle Ages, like the European Middle Ages, was a period of great empires built up by kings backed by a military nobility and numerous vassals reigning over a third estate. In Western Africa, the Wagadu empire also called "Ghanaian" extended its power beginning in the 3rd century. Its capital was south of the present-day Mauritania, Kumbi-Saleh, the first vestiges of which were brought to light in 1914 by Bonnel de Mézières and which is known by the descriptions given about it by the Arab travelers Al-Bakrî, Ibn-Battuta and Al-Omari. These travelers estimated that the empire at its height had considerable power extending between Egypt, Libya, Morocco and the kingdoms of the forest of Africa.

Around the 8th century under the influence of Muslim Arab merchants, the emperor and the aristocracy converted to the new religion of Islam, thus disconcerting all the population which had been animist for millenniums. This is the account given by the legend handed down by oral tradition which says that the whole territory was placed under the protection of the great snake "Bida" in exchange for the regular sacrifice of the most beautiful young girl of the empire. But a year came when the young woman who was destined to be sacrificed had a lover who decided to save her by killing Bida. He did kill it, but the snake before dying swore to go away with the gold which was abundant around there and promised seven years of drought. And this disaster happened. The legend is perhaps the explanation of a popular reaction by the animists to one of the worst of those famines which regularly cause havoc to the Sahel and which therefore forced a large number of Ghanaians to migrate toward more fertile regions. The situation worsened with the war carried out by the Almoravides, a brotherhood of Muslim Ber-

ber nomads, fanatic warriors whose raids led them further and further from their Moroccan base and who conquered Kumbi-Saleh (1076). The Sosso from the south succeeded them for a few dozen years but left after their sorcerer king was defeated by the hero Sundiata at the battle of Krina (1235), victory which led to the founding of the Mali empire. All these wars and the growing desertification of the Sahara incited the inhabitants to continue their exodus toward the Niger river.

Three events will contribute to modify the native population of the plateau.

1° Migration from the Sahara

The disappearance of the Wagadu empire had led to the emergence of the Mali empire but also to those of small neighboring vassal kingdoms such as the kingdom of Mema led by the Nonos who had remained animists. This state will be quashed between the Mali empire and the wars with the Tuaregs, the Mossi and the Songhai. The Nono inhabitants will leave it, as can be seen by the disappearance of the *tumulus-togueres* (tombs of the chiefs). Some of them will go to settle in Dia, then in Jenne, others to found Nono in the Kunari. Were the Nono the aristocratic warrior class of Ghana or simply that of Mema? We don't know, but in 1903 in Jenne Charles Monteil writes, "The people of Nono were the first invaders of the region [...] they came from Bassikunu [...] some of them under the command of a woman, the others led by the brother settled in Nono [then] emigrated to Dia [...] but especially to Jenne". The Tarikh al-Sudan confirms that the Nono were under the command of the Queen Bikun Kabi who later would be defeated by the Songhai. Let us note that the women of the Sahara possessed a political power.

Those of Dia will go to Jenne-Jeno and will recreate a new Jenne on a better site closer to the rivers Bani and Niger and therefore sheltered from invaders on horseback, thus increasing the security indispensable to the development of trade. Jenne will become the most important city of the whole Niger loop, merely paying a tribute to the Mali empire. The animist villages from the surroundings carried out burials with funeral offerings of earthenware statuettes upon which were identified checkered scarifications on the temples of the statuette heads. Wooden statues in this realistic style of the ancient Jenne civilization, clothed in the same way, and having the same temporal scarifications, will be discovered on the Plateau among the families having the same traditions, the same names as those from Jenne. Can these wooden sculptures and those in earthenware be attributed to the Nono? Probably but there's no certainty. Consequently, following the

examples of Desplagnes and Tautain, we call them "Djennenke" since all of them came from Jenne's sphere of influence.

2° Migration from Mande

The Mali empire whose capital was at Niani will include all of Western Africa as far as Jenne and Timbuktu. It will reach its height with the famous Kankan Mussa pilgrimage to Mecca (1324) which had cost 14 tons of gold according to Ibn Battuta and will set Europe to dreaming about that continent of gold… This is probably the period when several families from Mande, resistant to Islam or no longer able to cultivate the exhausted soil, left in search of other lands. After an extensive journey along the Niger, with a stop in Jenne from where they may have fled from Sonni Ali, they arrived in Kani at the bottom of the Dogon cliff during the 14th or 15th century. Desplagnes explained that to settle in this place, they had to chase away the occupants of the site: people who were formerly called "tellem" and whose funeral offerings were discovered in caves which had been occupied since the 11th century, those crevices which were used at the same time as shelters, storerooms, sanctuaries and necropolis. Kept within them, the statues became covered with that thick patina made up of the concretions of sacrificial coatings. These very old busts with raised arms and flat backs will evolve over the centuries to a more realistic style: the face can be discerned, the legs begin to bend, and with the adoption of these statuettes by the Dogon-Mande invaders, they will become statuettes in the round.

The Mande migration, a gerontocractic society in which the farmers who were not much of warriors were under the authority of the lineage chiefs and the priests, led to intermarriage with native girls and the adoption of some of the local rites and customs. Their animist descendents "with filed teeth" are the ones who were studied by Griaule and his colleagues. Their sculptures, very different, are statues-emblems, symbols of lineage, commemorative portraits of important chiefs, feminine statues always linked to the fertility cult, and finally, statuettes destined for the rites of rain or magic: nude statues, powerfully modeled and inventive and whose aesthetic value depends upon the sensitivity of the sculptor, the artist.

3° The conquest of the Songhai

A determining factor was the great conqueror Sonni Ali, chief of the Songhai who, going beyond his borders, will take Timbuktu and then Jenne after a siege of "seven years, seven months, seven weeks and seven days" (1468).
Although some of the Jenne nobility had already embraced the religion of the

Prophet, he forced all the new subjects to convert to Islam, a policy which among other things led to the disappearance of animist funerary practices. Many fled the invaders, going toward Guimballa, others went to rejoin their families of the plateau, notably the Karembé and the Saman.

The ancient migration going back to the 10th and 11th centuries, reinforced by this arrival, will influence the Kolum, the northern region, the Duleru and will penetrate as far as the Tombo mountains, domain of the natives. The style of their sculptures will evolve over the centuries according to orientations unique to the different sculptors' studios. But always flexible, the statuary will retain its identity signs which are their checkered scarifications in the corner of the eyes. There were no significant conflicts between the southern and northern migrations until the arrival of the Toucouleur who forced all of the plateau with the exception of the southern cliff to convert.

In the north-east, a migration from Ghana of the Bondum language which came directly via the Lakes region will end up settling in the four (or five?) regions of Po-iyoo, where it will be rejoined by a part of the Dogon-Mande coming up from the southern cliff, and from Gondo. This region was strongly influenced by its Songhai neighbors for it is close to Hombori, their fourth capital which controlled the eastern plateau. It produces statues which are often very tall, with raised arms appealing to heaven, a syncretism of animism and Islamism, often having scarifications in wire mesh and small fan-like lines in the corners of the eyes coming from the Songhai influence, and in addition decorated with "korte" Muslim necklaces.

The Plateau and its inhabitants, its way of life, have been approached in particular from a sociological, religious and architectural point of view but rarely from the angle of the artistic creation. However this artistic creation reveals a corpus which although limited in number is one of the most astonishing ones, since it extends continuously from the 10th to the 20th century, a rather unique phenomena for Africa.

This brief historic review of the Plateau explains the diversity of styles which the statues presented here most convincingly illustrate.

H. L.

THE NIGER DELTA

TERRACOTTAS

In 1943 Théodore Monod brought to light the first terracottas in the region of the Niger delta, providing the first tangible proof of the existence of developed civilisations already in the early centuries of the last millennium.

These pre-existing civilisations then cohabited or integrated with those of Muslim invaders. The research, interrupted because of the war, was resumed a few decades later, with results which have thrown new light on the region's ancient art.
The function of the statues, prevalently single human figures — perhaps linked to a funerary cult —, and their meaning are at present uncertain.

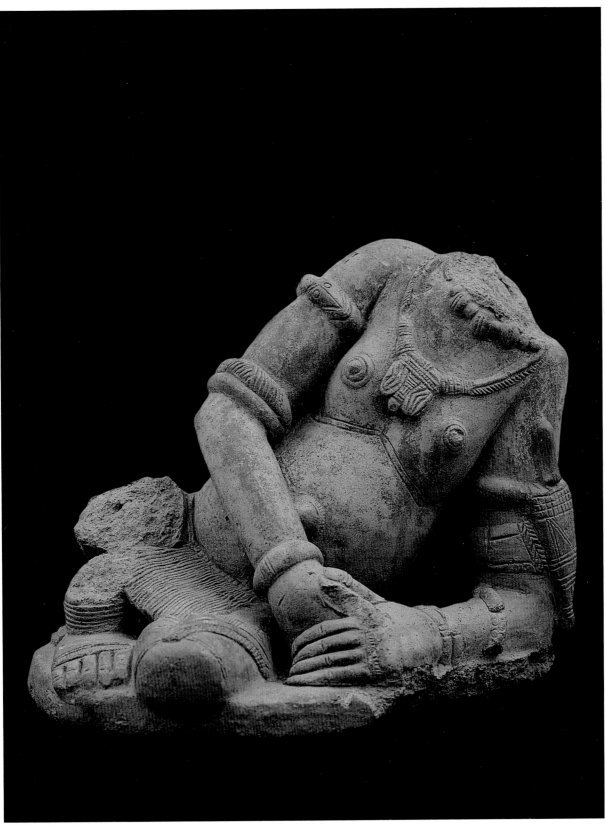

63a. Unidentified ethnic group,
Jenne-Jeno Thial (Mali)
Androgynous figure (without head)
13th century AD
Terracotta, 27 cm
Bamako, National Museum (inv. R 88-19-275)

64a. Unidentified ethnic group,
Jenne-Jeno, Mali (Mopti region)
Anthropozoomorphic figure
Not dated
Terracotta, 49.5 cm
Bamako, Musée National du Mali (inv. 90-25-10)

The figure brought to light by the Mac-Intosh in 1981, however mutilated it might be, reveals the hand of an extremely skilled artist. The full volumes of the body are arranged according to a soft diagonal, ending at the head, unfortunately missing, and the left knee.

The high rank of the person is indicated by the rich ornaments. The knife on his arm, the loincloth and the jewels are also carved on a number of figures attributed to the Dogon and dated to the 14th century, coincidences which indicate a link between the cultures behind the artist that created these terracottas and the wooden sculptures.

The second figure, fortunately complete, is different from the previous piece both in terms of the subject matter and the plastic technique. It is a "nice monster" with its expression of ironic cunning small head. The body, which widens subtly in the lower part, contributes to creating an image of attractive and ambiguous sweetness.

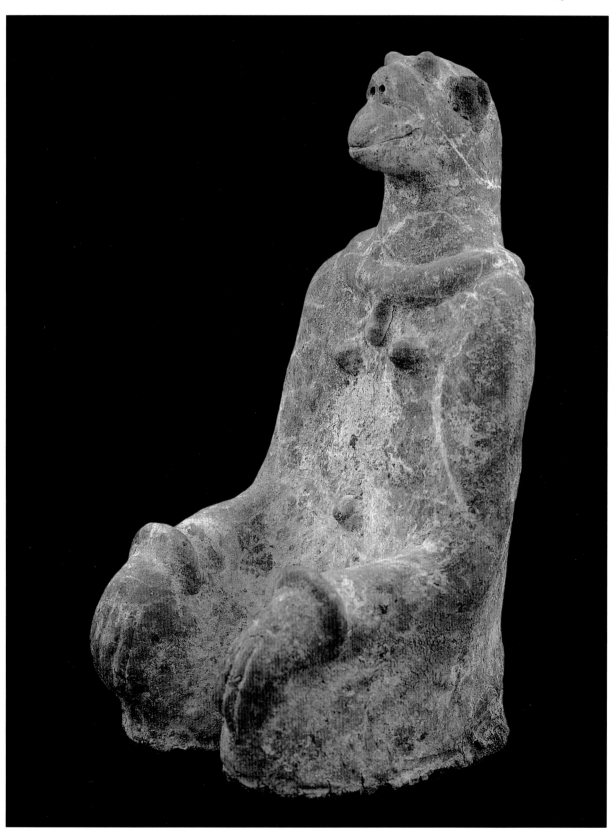

DOGON

The chronological sequence of the art produced by the inhabitants of the cliff of Bandiagara, the plain below and the plateau above is, at present, the most complete (since it is the most studied) of all African wooden sculpture. A few decades ago, first the ethnological studies of the Musée de l'Homme in Paris[1], and then tourism brought the artistic creations of these peoples public attention and fame. Until then, these works, all wrongly grouped under the generic name of "Dogon", had been enveloped in a fog of timelessness, making it impossible to trace their development over time, which moreover had until then been considered inexistent.

For a series of concomitant reasons, including the market, which attributes higher values to antique sculptures, a growing number of works were subjected to scientific analysis, such as carbon-14 dating[2]. There was no shortage of surprises, as dates were revealed of an antiquity that only the Parisian dealers of the early 20th century had dared to suggest, in a somewhat cavalier fashion and without any proof whatsoever.

These dates have contributed to the formulation of new hypotheses and helped confirm those advanced in the past, such as the presence in the region of pre-Dogon peoples or the existence of the Tellem, probably from the North, who may have settled in the 10th-11th century in the cliff (in whose caves, however, only two sculptures which may be attributed to them have been discovered). Another possibility is the arrival of the Dogon fleeing from Islam, who between the 13th and 15th century are thought to have mixed with local peoples. Other hypotheses regard the relations between the inhabitants of the cliff and the artists of the terracottas found in the region of the Niger delta, whose works show clear signs of contact.

While the new information and hypotheses raise new questions to which we are at present unable to provide definitive answers, they also offer new perspectives which were unimaginable until a few decades ago.

The variety of the formal solutions adopted by the artists of the region, also in the past, is extremely wide — albeit within a precise and dramatic vision — and is of no help, at least for now, in determining with precision the period in which the works were created. Alongside figures distinguished by a high degree of stylisation, and fascinating minimalist images of men, other figures of certain antiquity display more recognisable anatomy, facial scarifications, elaborate hairstyles, ornaments and costumes.

These forms and styles are however taken out and repeated in works from different periods, so that the hypothesis of a path from abstraction to a more realistic rendering of human anatomy is not supported by the lesser or greater degree of naturalism in the representation.

The attribution of a meaning, of a precise function for the sculptures reveals itself to be equally problematic. The meaning of the figures of hermaphrodites, fairly frequent in Dogon sculpture, for example, is ambiguous and a source of controversy among scholars of Malian art. Jean-Louis Paudrat (*Dogon* 1994, 64), mentioning the opinion of Jean Laude on human figures with raised arms, a gesture commonly interpreted as a prayer for rain, hypothesises a more complex function for the image, which he sees as evoking the sacrifice of one of the "Nommo" (the eight primordial genies of Dogon mythology), in a dialectic representation of death and its defeat in resurrection.

As an example of what has been briefly set forth above, the group of sculptures on display has been chosen for its high quality, and represents a time span of ten centuries. Some of the works have never been subjected to laboratory analysis, although stylistic similarities with scientifically dated works have led us to present them in the same section of the exhibition, albeit with the doubts mentioned previously, in order to offer the widest possible panorama of this form of art, which is beginning to emerge from the limbo of timelessness.

It should be remembered that even the scientifically tested dates are not as precise as those to which we are accustomed when dealing with European works of art; sometimes the test results indicate margins of error of up to a couple of centuries. Perhaps they are not definitive, but, taking into consideration that this exciting adventure is only at the beginning, we hope that in the near future it will be possible to have a clearer picture. And not only for the art of the Dogon people.

E. B.

1. Marcel Griaule (who availed himself of the information of the wise blind hunter Ogotemmeli, who revealed to him the complex mythology of his people), Michel Leiris, Germaine Dieterlein, Geneviève Calame Griaule and others have studied the various aspects of Dogon culture.
2. Leveau 1994, 243-247. The institutes which performed the dating tests shown on the information cards were: ASA= Alliance Science Art – Francine Maurer Gmbh. Paris; AZ= University of Arizona, Laboratory of Isotope Geochemistry; ETHZ= Institute for Particle Physics, Zurich.

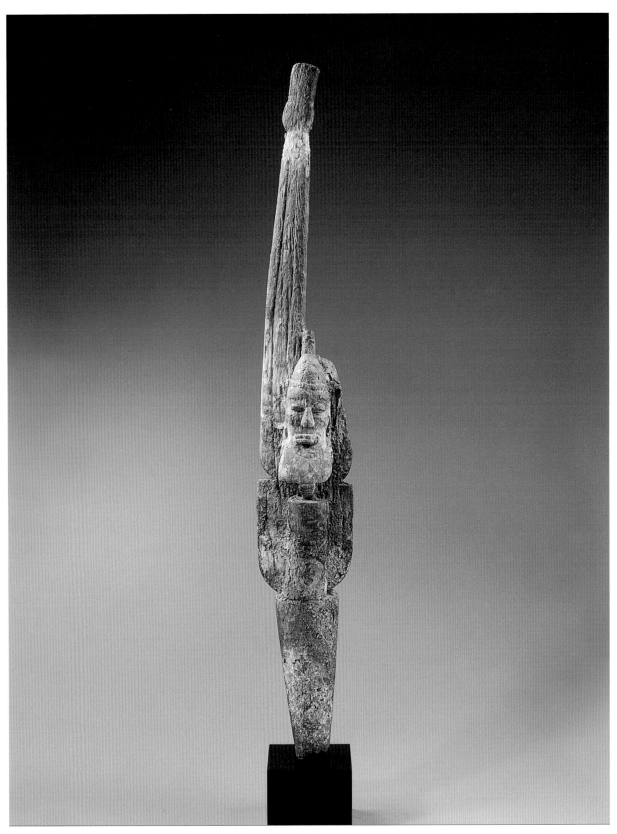

65a. **Pre-Dogon**
(Dogon/Soninke/Tellem) Mali
Human figure with raised arms
9th-11th century AD
Wood, pigments, 103 cm
Paris, Musée Dapper (inv. 0068)
Former Lester Wundermann Collection

This unfortunately mutilated monumental human figure from the Dapper Museum has been attributed to the 9th-10th century (ETHZ: 865-1046, 98%), an unexpected date for an African wooden sculpture.
The figure is summarised in the head and long arms which would have been raised (the left arm has unfortunately been lost) from a body suggested, rather than represented, by the assembly of three solids whose abstract volume throws into relief, by contrast, the realism of the splendid head, which has the nobility of a medieval king or saint.

66a. **Djennenke artist, Mali**
Kneeling figure
12th-13th century AD (?)
Wood, 31.5 cm
Private Collection (inv. Mains de Maître, n.7)

The representations of hermaphrodite figures are more frequent in Dogon and pre-Dogon art than in any other African culture, and are used to illustrate creation myths. According to Hélène Leloup (1994, no. 14), in this figure, "the head (beard and hairstyle) is male, while the attitude of respect and pregnant abdomen are female".
The figure, which is relatively small, is distinguished by its extremely precise composition, in the proportioned organisation of the elongated forms, arranged with discretion and elegance: the imposing head — almost a third of the entire figure —, the protruding abdomen and the block composing the hips and legs bent backwards. These artistic choices, which were certainly not accidental, make this sculpture a small masterpiece of clear formal discipline.

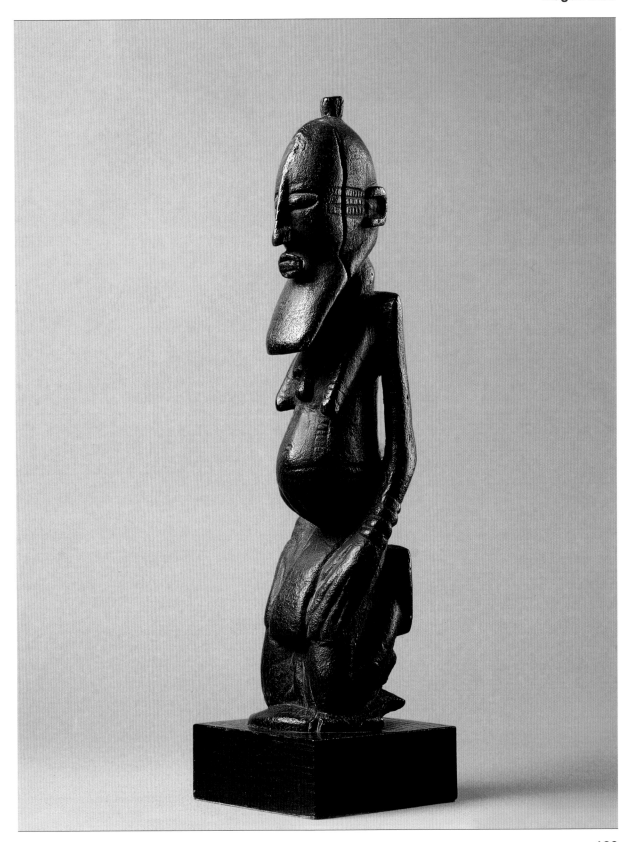

66a

Many wooden sculptures, collected in the region of Bandiagara are attributed to the ancient inhabitants, the legendary Tellem that the Dogon were said to have found when they looked onto the plain at the feet of the cliff of Bandiagara. They are human figures covered with a crusty patina of blood and millet mash, petrified over time, which makes them extremely evocative. Like the many sculptures attributed with certainty to the Dogon, also these have their arms raised in a gesture of supplication that ethnologists have commonly interpreted as a prayer for rain, but which could also be read as a dramatic need to communicate with the Supreme Being.

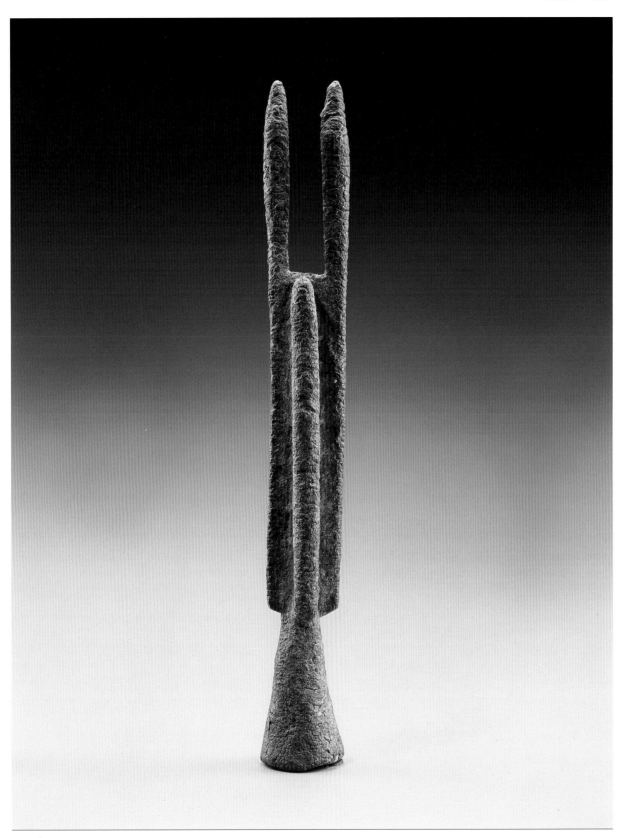

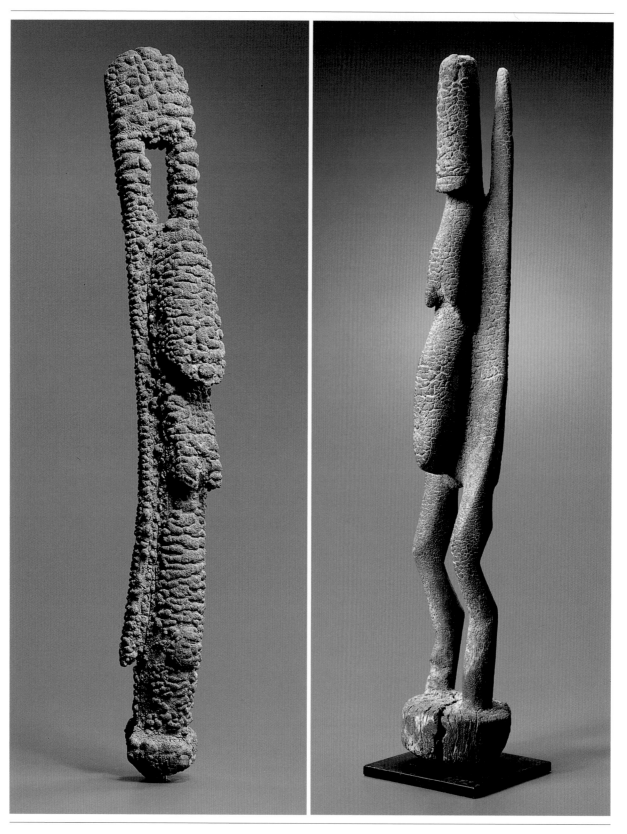

68a

69a

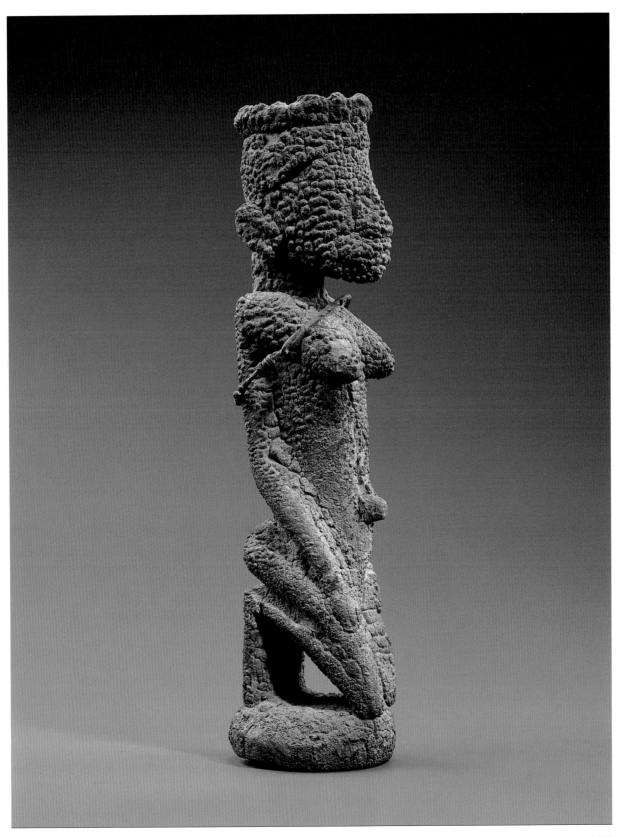

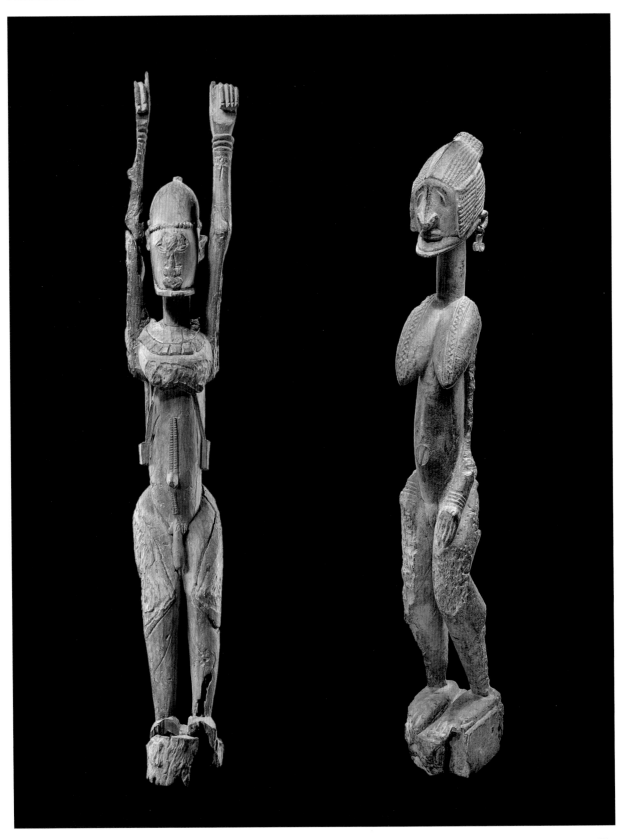

71a

72a

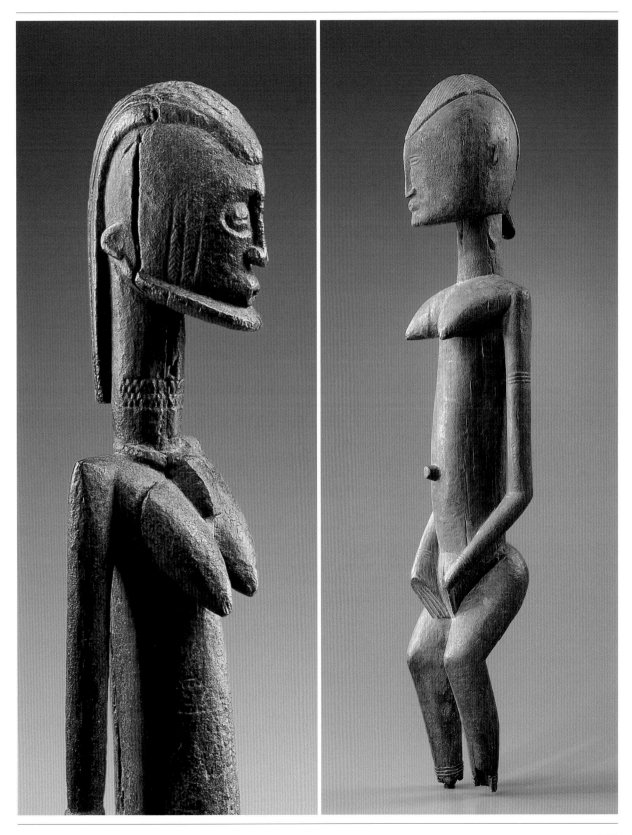

74a

73a

67a. **Tellem artist (?), Mali**
Human figure with arms raised
11th-16th century AD (?)
Wood, pigments, 43 cm
Paris, Musée Dapper, (inv. 0071)
Former Lester Wunderman Collection

The calibrated assembly of simplified, almost cylindrical volumes, of proportioned length, suggest a man of extreme minimalism, with an evocative and mysterious inner life.

68a. **Tellem artist (?), Mali**
Human figure with arms raised
11th-16th century AD (?)
Wood, sacrificial patina, 44 cm
Former Jef Vanderstraete Collection,
Private Collection (inv. 26.53)

The volumes of the large head, breast and abdomen of this sculpture emerge, like a sort of high-relief, from a board which continues upwards in the movement of the raised arms. A light backward flexion confers an extraordinary tension to the body, which seems to be released in the large hands. The thick patina of sacrificial material conceals the features of the face, but makes the surfaces of the entire figure vibrant, as if animated by a secret life.

69a. **Tellem artist (?), Mali**
Human figure with arms raised
11th-16th century AD
Wood, sacrificial patina, 68 cm
Private Collection

In this sculpture, the deconstruction of the elements making up the human body is even more marked, and involves the use of accentuated masses, with particular emphasis on the roundness of the abdomen, unusual in Tellem statuary. The continuity of the volume of the legs, trunk and short pointed arms compensates for the shortness of the latter by evoking, also formally, the upwards tension that distinguishes the figures of the ancient, mysterious inhabitants of the falaise of Bandiagara.

70a. **Dogon artist, Mali**
Kneeling figure
14th-15th century AD (?)
Wood, sacrificial patina, fabric, 36 cm
Former Jef Vanderstraete Collection,
Private Collection (inv. 17.05)

The sacrificial patina does not diminish the beauty of this kneeling figure, in a position which is recurrent in Dogon statuary. The thick covering does not affect the elegance of the forms and their balanced organisation, but gives the work an aura of mystery. The hidden features of the face, which can only be guessed at under the stony covering, reinforce the arcane expressiveness of this monumental head.

71a. **Dogon artist, Mali (Tintam style)**
Figure with raised arms
15th-17th century AD (?)
Wood, 125 cm
Private Collection

This monumental male figure, dated to the 15th-17th century, displays more than one similarity with the great works in the Metropolitan Museum of New York and in the University Museum in Bloomington, the former attributed to the 16th century and the latter as far back as the 14th-15th century (*Dogon* 1994, 26-27). This work has the same elongated volumes, seemingly stretched upwards by an unstoppable yearning, and restrained only by the large protruding hermaphrodite's breasts.

72a. **Dogon artist, Mali**
Female figure
17th-18th century AD (?)
Wood, 78 cm
Private Collection

This sculpture is almost certainly the work of an artist active in the region of N'duleri, who has been given the conventional name of "Maître des yeux obliques", due to the particular form of his figures' eyes. He is also attributed with four or five statues, one of which is on show in the Musée du Louvre, *Pavillon des Sessions* (*Sculptures* 2000, 94-96).
The erosion of the arms has accentuated the slender lines of the figure and revealed the rhythmic pattern of the volumes, among which the full breasts triumph, with their beautiful decoration. The facial features, typical of this artist's figures, emerge imperious from the slender parallel plaits which enclose them like a helmet.

73a. **Dogon artist,**
Mali (N'duleri region)
Figure
Wood, 69 cm
Private Collection

This figure, of sober and aristocratic elegance, is typical of the sculpture of the central-northern region of the plateau of Bandiagara, to which the woman husking millet also belongs.
The marked vertical movement distinguishes the slender forms of this naked body, decorated only by thin anklets, armlets and bracelets, whose relief work echoes the original stylisation of the hands. The head, which is large in proportion to the minute body, has the typical features of the region's statuary: close-set eyes, a small pouting mouth, and a hairstyle of thin plaits falling onto the nape of the neck.

74a. **Dogon artist, Mali**
Human figure
18th-19th century AD
Wood, pigments, 83 cm
Paris, Musée Dapper, (inv. 0084)

A solemn monumentality, not diminished by the absence of the lower part of the body, and austere reserve distinguish this elegant figure. The cylindrical form of the trunk, of the arms and neck, give a sense of noble verticality, ending in the beautiful head with severe features. The concise plastic language, free from superfluous virtuosity, recalls the laconic religiosity of certain figures from 12th century Europe. However, such links with a distant past is contradicted by laboratory tests, which attribute the sculpture to the 18th-19th century, that is to a relatively recent period and, in any case, closer to our time than its appearance would lead us to believe.

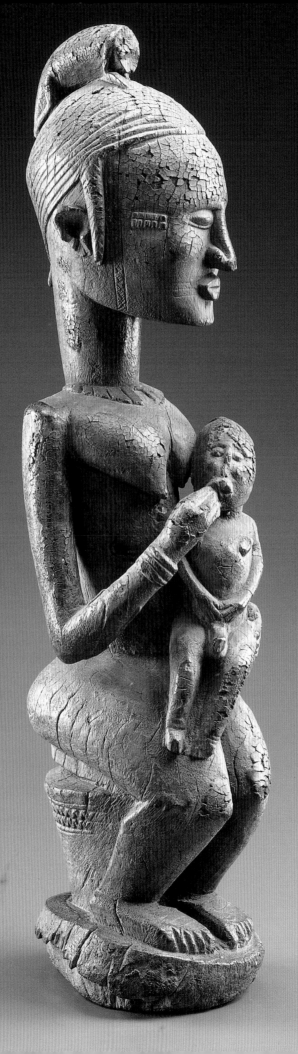

76a

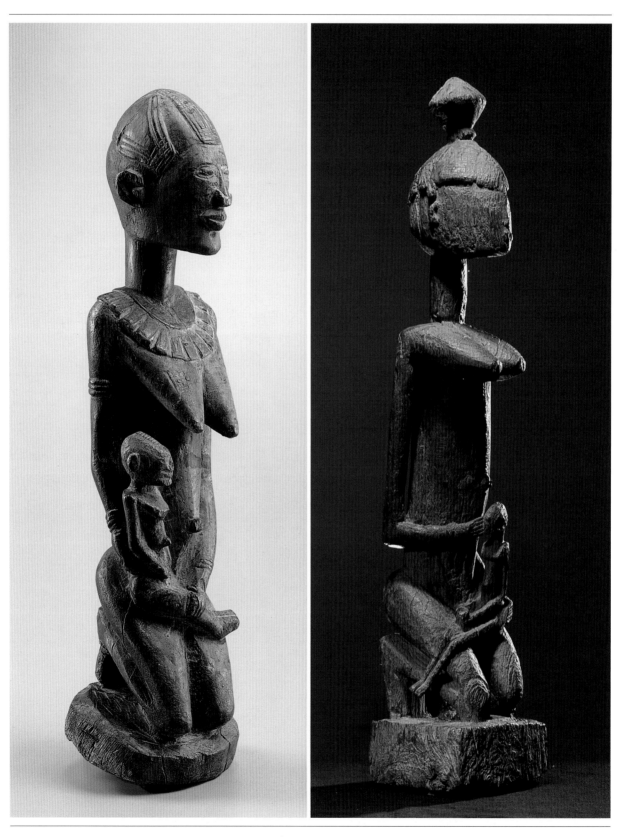

75a

77a

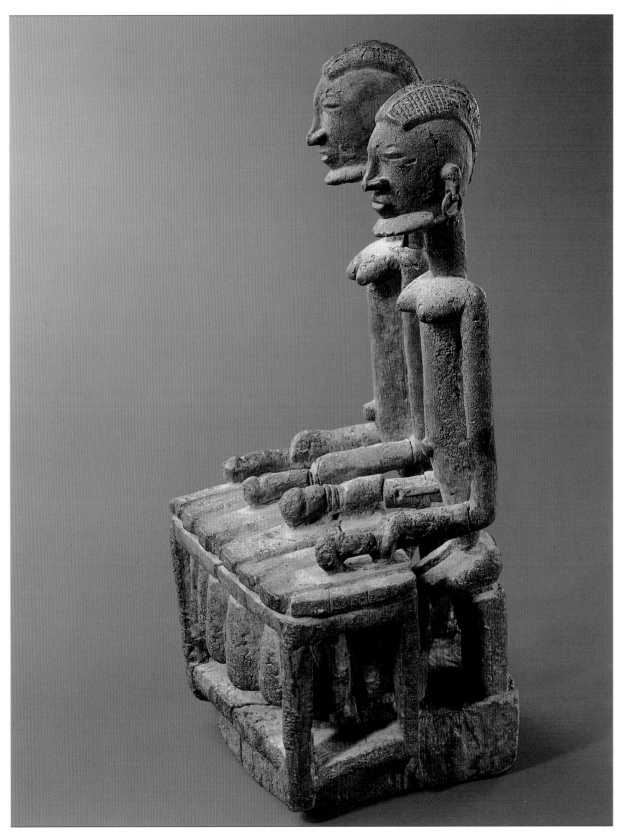

75a. **Dogon artist, Mali**
Maternity
15th century AD (?).
Wood, pigments, 49 cm
Paris, Musée Dapper, (inv. 0102)
Former Lester Wunderman Collection

In African art, as in European art, or art from anywhere else in the world, whether "civilised" or "primitive", similarity in subject matter is not necessarily reflected in the formal rendering of the work. The comparison between the three maternities on show demonstrates this.
Great composure and absolute absence of pathos distinguish this work of a monumental stature. The mother and child who is sitting rigidly in her lap are looking forwards, apparently strangers, were it not for the woman's hands delicately placed on her child's body, which establish a link, albeit tenuous, between the two figures.

76a. **Dogon artist, Malii**
Maternity
16th-17th century AD (?)
Wood, 68 cm
Private Collection

The frozen detachment seen in many Dogon maternities is dissolved in this sculpture, which Hélène Leloup attributes to the N'duleri style. The tender gesture of feeding the child, who proffers his eager lips, subtly suggests a close relationship and unusual emotional involvement.
The way in which the full volumes of the two bodies complement each other, and are developed within a spiral composition — notice the parallel and enveloping movement of the woman's forearm and the child's legs —, give a sense of warm reciprocal belonging which makes this work exceptional. It is dated to the 18th century (*Kunst* 1995, no. 7), but is probably older.
The chameleon (now broken) carved on the top of the woman's head is a symbol ambivalence, because of its possibility to change colour. According to Hélène Leloup (1994, no. 125), it may have served to encourage maternity in a sterile woman.

77a. **Dogon artist, Mali**
Maternity
Wood, 71,2 cm
Private Collection

Monastic austerity and sophisticated volumetric invention characterise this slender figure, probably of notable antiquity. The body of the woman, holding in her lap a "matchstick child" to whom she proffers food, shows a marked verticality.

The movement and different lengths of the arms are motivated by representational requirements, but at the same time, or above all, respond to formal needs: the correct pointed breasts, the slender trunk and the extremely long arms are perfect cones and cylinders; the slender neck supports the beautiful spherical head whose features are barely hinted at, yet are subtly expressive. This is crowned with the controlled movement of the hairstyle, gathered in an elegant chignon. Every element, in harmonious relation with the others, contributes to an overall sensation of ascetic purity, accentuated by the slight erosion of the surface.

80a. **Dogon artist, Mali (N'duleri region)**
Balafon players
15th-16th century AD
Wood, sacrificial patina, metal, 44 cm
Private Collection

This rare image of xylophone players — "balafon" in the local language — is the work of a great artist who has created a complex structure, perfect from every point of view, combining with great skill cylindrical, polyhedral, square and rounded volumes.

The heads of the two figures are almost identical, and seem to express concentration and awareness of the task they are performing. According to information collected in 1993, and reported by Jean-Louis Paudrat (*Dogon* 1995, 80 note no. 98), the work represents "a man and his sister playing an instrument [...] said to be uniquely used during funerary ceremonies".

79a

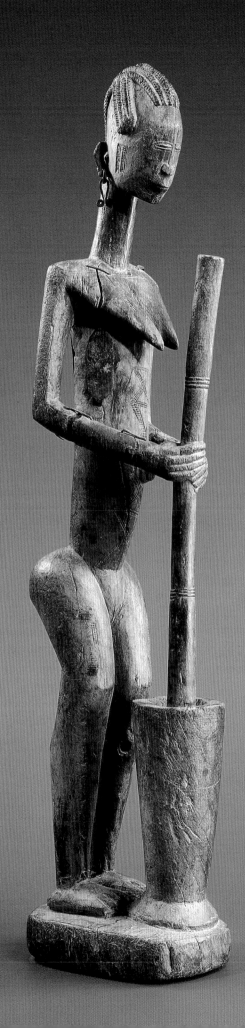

79a. **Dogon artist, Mali (Ireli village)**
Ancestral figure
16th-17th century AD
Wood, 50 cm
Su & Jan Calmeyn Collection

As in the famous sculpture which is now in the Louvre (*Sculpture* 2000, 77-79), the artist of this more essential work has also exploited the natural curve of the wood to create his disturbing figure (a snake-man?). He has in fact gone further in exploiting the form, by removing any distinction between the legs and the rest of the body, perhaps to represent one of the primordial genies (*Nommo*) "whose body and limbs were agile" and "who sometimes had only one leg" (Laude 1966, 181).
The artist has also rotated the head so that the relief of the arrow-like nose is aligned with that of the extremely long slender arm, which emphasises the unusual movement of this figure.

80a. **Dogon artist, Mali (N'duleri region)**
Woman husking millet
16th-17th century AD
Wood, pigments, 98 cm
Private Collection

The husking or cracking of millet in a mortar is not a frequent theme in Dogon art, and certainly not in recent times, even if this cereal is one of the basic foods for the peoples of the Sahel in addition to being, with blood, one of the components of the sacrificial patina which covers many ancient sculptures. The austere linearity of this elegant figure, probably the most poetic of those illustrating this theme, and its minimalist corporality, are expressed in the calculated verticality of the mortar and above all in the staff-pestle, extremely long and cylindrical like the woman's slender arms.
The meaning of the image has not been clearly identified. Kate Ezra (1988, 43) suggested, quoting Denise Paulme, that similar sculptures may have been the plastic equivalent of the funeral oration which celebrated the Dogon woman's work.

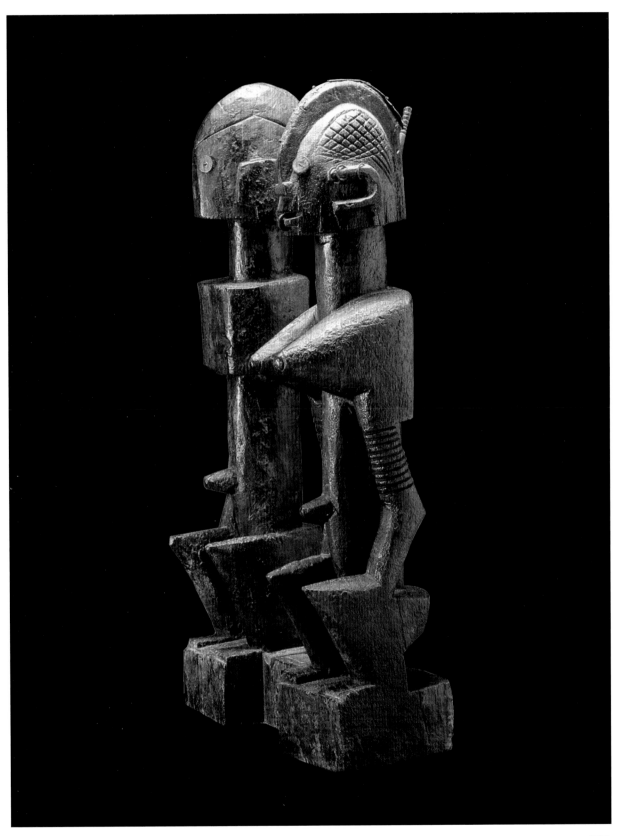

81a. **Dogon artist, Mali**
Ancestral couple
Wood, iron, 57.8 cm
Toronto, Collection Art Gallery of Ontario,
(inv. Acc No 99/472)
Gift from the Frum Collection, 1999

Over twenty years ago, William Fagg defined this extraordinary sculpture "a decidedly cubist work". Certainly, if it had been created by a European artist, the definition would have seemed more than justified, due to the highly successful assembly of almost pure volumes combined in a precise, fascinating man-woman couple.

However, the great African sculptor who produced the work didn't know Picasso or Lipchitz, and would surely have been surprised if someone had quoted the theories of the Paris School in reference to his works. Because, while the result seems to exemplify them perfectly, the motivation at the basis of African artistic creation is entirely different and responds to needs of a different nature: symbolic, religious or social. This does not mean that the artist was not interested in the formal result, which is of such a high quality that it could not possibly have been the product of chance. Note, for example, the rhythmic organisation of the various blocks, and the way they clearly complement each other. Hélène Leloup (1994, no. 135) suggested that this sculpture "came from the area of Dogo" and marked "the transition between the Dogon style and the Bamana style".

BAMANA

MALI

BAMANA

The determination of antiquity of a group of Bamana figures (the correct ethnic name has replaced the previous Bambara, with the pejorative meaning of heaten given by the converts to Islamism), is the second interesting challenge posed by Malian art, after that of the Dogon.

In the fifties, the conversion to Islam of the people in the region of Banan in Mali, between Doïla and Buguni, caused the abandonment of some sanctuaries of the ancient traditional religion and the destruction or sale of religious objects, including large wooden figures. When these appeared on the market, some were acquired by prestigious institutions such as the Museum of Primitive Art in New York (which subsequently became part of the Metropolitan Museum of Art), and by private collectors.

In 1960, in the catalogue for the exhibition "Bambara Sculpture from the Western Sudan", organised at what was then the Museum of Primitive Art, Robert Goldwater published two large figures (nos. 98 and 99) whose appearance places them in the group presented here. They were indicated as originating from the district of the Buguni in Mali, although their possible age was not mentioned.

A quarter of a century later (1986), Kate Ezra, in the catalogue for the exhibition "A Human Ideal in African Art — Bamana Figurative Sculpture" (under her curatorship), mentioned the results of C.14 analysis for four of the sculptures on show on that occasion — nos. 25, 27, 30, 34 — which had revealed surprising ages ranging from the 13th to the 17th century. The male figure no. 32 (no. 99 in Goldwater publication), curiously, does not appear among the dated

works, and nor does the female figure with the cup (no. 31), here exhibited as 83a, dated subsequently.

The same scholar, lastly, illustrated, in *Bamana — The Art of Existence in Mali* (2001, no. 125), a seated maternity with a tiny child in its mother's arms, belonging to a private American collection, to which is attributed a date between 1432 and 1644 AD, relatively in agreement with the dating of the pieces mentioned above.

In 2000 Hélène and Philippe Leloup published two upright figures (nos. 30-31) in the "Bambara" catalogue, respectively dated 1419-1526 AD (ETH Zurich, no. 21742) and 12th-16th century (ASA no. 11-24-36), plus a third (no. 32) and an unusual animal (no. 36, a ram, not on show here) from the same sanctuary, but not dated.

Lastly, an upright figure with similar features is part of an American collection. It should however be noted that sculptures nos. 25, 27 and 34 of the Ezra 1986 catalogue are of a different style and age to no. 30 and, above all, do not display the erosion which collectively distinguishes the works in the group from which the pieces on show come. We must therefore presume different provenances and dates of creation.

To make things more complicated, a test performed in 2003 attributes to figure 84a in this exhibition a probable age of 200+45 years (ETH-26877) which puts into doubt the possibility that this group of works were produced at the same time. This is a problem which is far from resolved, and requires both re-examination of the sculptures from the Metropolitan, and the analysis of the other works of the homogenous group, not dated scientifically but all coming from the same Malian sanctuary.

The human figures would have had a specific use and meaning in the Bamana culture, in particular in the southern regions of Mali, as part of the rituals of the male and female initiatory *Jo* society, and of the *Gwan* fertility cult. According to the informers of Kate Ezra (1986, 22), the sculptures were considered "extraordinary and marvellous things, [...] things that could be looked at without limits".

The cultural destination and original meaning of the ancient works of art, not limited to the Bamana, must however be verified, a task which is extremely difficult in the case of an oral culture, especially if the earlier dates are confirmed (13th-17th century). The persistence of use and meaning, with minimal variations, is habitual and proven for images from the religions and societies with writing, a tool which provides certain (or at least less uncertain) information on cultural phenomena of even the distant past, even if scholars do not always

agree on their interpretation. There is therefore no reason why the same should not also happen for the works of art of those African cultures which have different mechanisms of handing down knowledge.

E. B.

82a. **Bamana artist, Mali (Banan region)**
Female figure
12th-16th century AD
Wood, 116 cm
Private Collection

83a. **Bamana artist, Mali (Banan region)**
Female figure carrying an object
on her head
15th-16th century AD (1419-1526)
Wood, 130 cm
Private Collection

84a. **Bamana artist, Mali (Banan region)**
Human figure
17th-18th century AD
Wood, 75 cm
Su & Jan Calmeyn Collection

The ruthless passage of time has somewhat dried out these noble figures carved in a compact wood. By removing the perishable part it has revealed their intimate spiritual essence, and a tender and attenuated beauty, which the loss of parts of the limbs has done nothing to diminish. The bodies display a moving monastic austerity, and are composed using soft lines which flow from the legs to the shoulders in an elegant continuum, interrupted only by the Gothic slenderness of the neck, which throws into relief the noble heads.
In the first figure, "the missing left arm", according to the authors of the 2000 catalogue (Hélène and Philippe Leloup), "probably held a small pillow on which rested the mortar". The skilful composition compensates for the cancellation of the facial features, and gives the image a further touch of ascetic spirituality.
The slender forms of the second figure, which holds an urn or calabash (perhaps a fertility symbol) with both hands raised above its head, are arranged in a calibrated play on softly undulating volumes and spaces, which contributes to heightening the tender femininity of the woman, who is perhaps pregnant.
The third figure, male, slightly smaller than the other two, is no less noble in its austerity, tempered only by the hint of a knowing smile which illuminates and softens the features of his face.

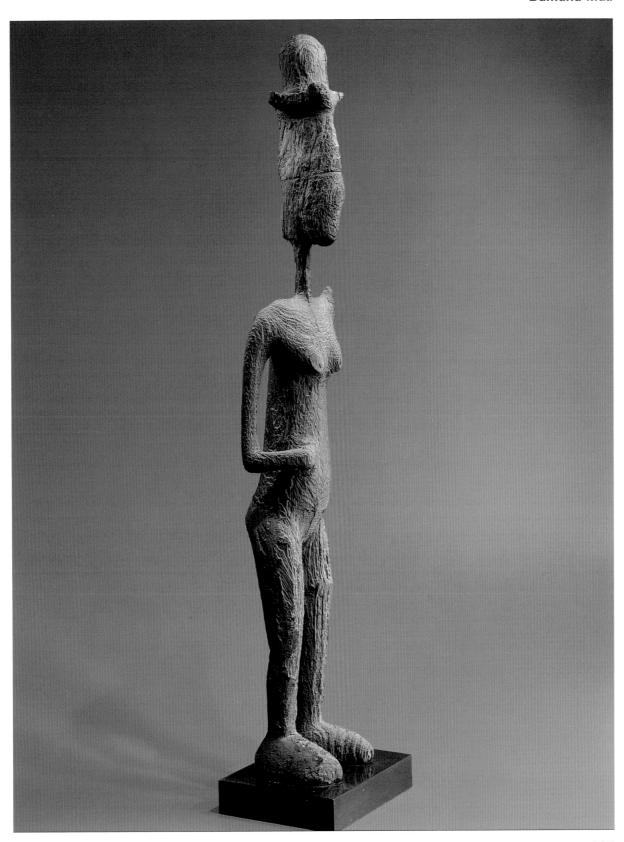

82a

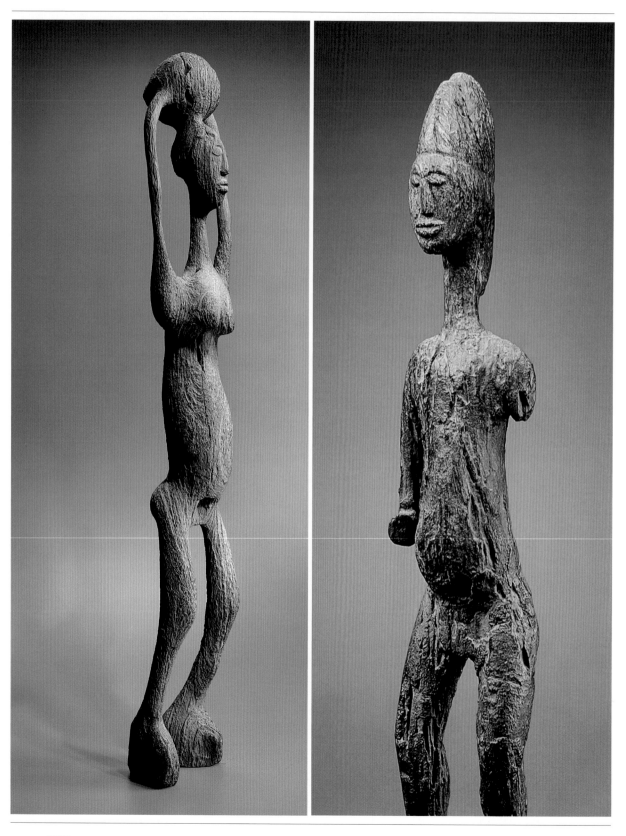

MBEMBE

NIGERIA

MBEMBE

An unusual and memorable exhibition with its relative catalogue (Kamer 1974) revealed thirty years ago the impressive ancient sculpture of a small Nigerian people, the Mbembe (a name given by foreigners), numbering around forty thousand individuals in 1965 according to Ekpo Eyo, in the region of Cross River on the borders with Cameroon.

Eleven monumental figures, plus the twelfth acquired some months before the show held at the Musée National des Arts d'Afrique et d'Océanie, and now at the Musée du Louvre,[1] and the thirteenth found recently, make up this group of works.

According to available information, the figures decorated monumental slit drums — a common type in the south-eastern regions of Nigeria and the south-western parts of Cameroon — whose sound could be heard up to ten kilometres away. In Mbembe society, the instruments were kept in a sanctuary, and considered sacred because they contained the spiritual force of the community or of the particular male association to which they belonged. They could be played only by a particular individual given this task by the chief of the community or of the association itself.

The Staatliche Museum für Völkerkunde in Berlin possesses the only complete example to my knowledge of such a drum, decorated by two figures at the ends (collected in 1908 by M. von Stefenelli), whose creation, according to Kurt Krieger (1969, II, no. 236) dates back four or five centuries, a date which is confirmed by radiocarbon analysis (Schreiben 1966)[2]. Unfortunately the fragility of the instrument, which measures an impressive 330 cm in length and weighs

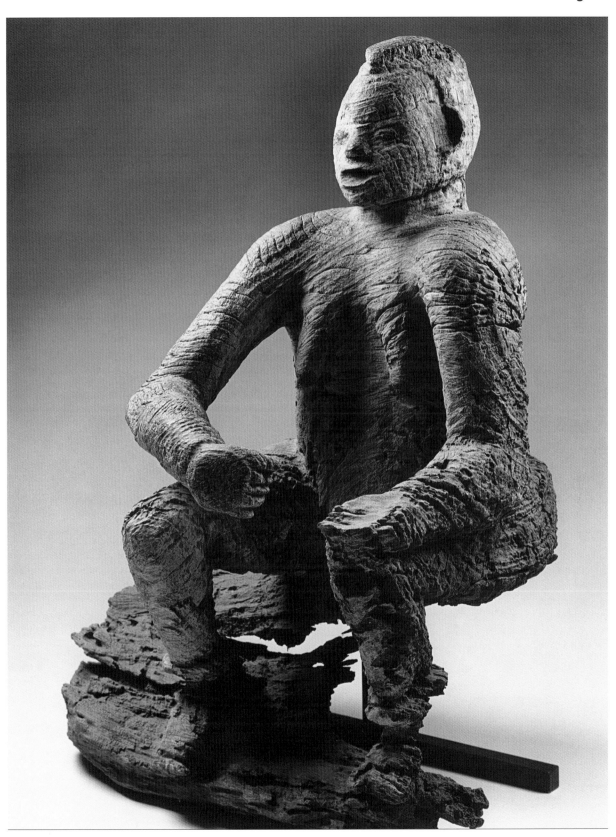

around a tonne, understandably made its transfer from the museum unadvisable. To go back to the figures, the function of decoration on giant drums is suggested for ten of them by being sculpted against the grain, an exceptional procedure in wooden statuary in general and especially in African works, and by the presence on the sides and back of fragments of the base and of the body of the original instrument. The possible date of the creation of these works has been scientifically ascertained so far for only one of them (1785 +35 years)[3], however the similarities, the common prominence and the same state of wear allow us to attribute a considerable antiquity to the entire group, composed as follows:

five seated female figures (including the one now at the Louvre),

one seated male figure,

one upright male figure,

one maternity with the child lying on the mother's knees,

one upright male figure, holding a head,

one seated male figure, holding a head.

The group of sculptures of common provenance is completed by three works which, while presenting a similar degree of erosion to the previous ones, do not have extraneous appendices. Moreover, they are carved according to the vertical direction of fibres of the trunk from which they are taken, and must therefore be intended as independent sculptures. They are:

one male figure, whose head has been lost,

one maternity with the child lying on the mother's knees,

one maternity with the child in an upright position clinging to the mother's body.

A fourteenth sculpture, a seated man, with a sort of crest on his head, much more eroded than the previous ones and of unknown origins[4], is part of the collection of the painter Arman.

The work of the artists and the action of time and nature are difficult to distinguish, but that does not make the final results any less fascinating. Erosion and the deep veining give the impression of stone, a sort of geological stratification in these perfectly simple and monumental sculptures, which go beyond the narrow field of culture to embody something universal.

E. B.

1. No. M.N.A.A.N. 74.1.1, *Sculptures* 2000, 136-138.
2. Quoted by Keith Nicklin in *Koloss* 1999, no. 63.
3. See *Power of Form* 2002, no. 36.
4. Nicolas 1996, no. 111; Vente Champin, Lombrail, Gautier (Enghien), June 23 1984, no. 92.

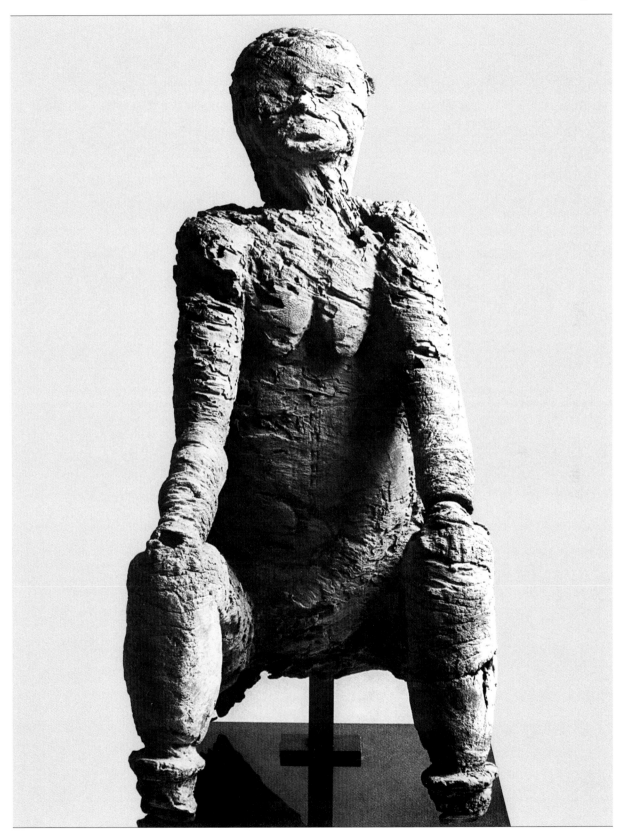

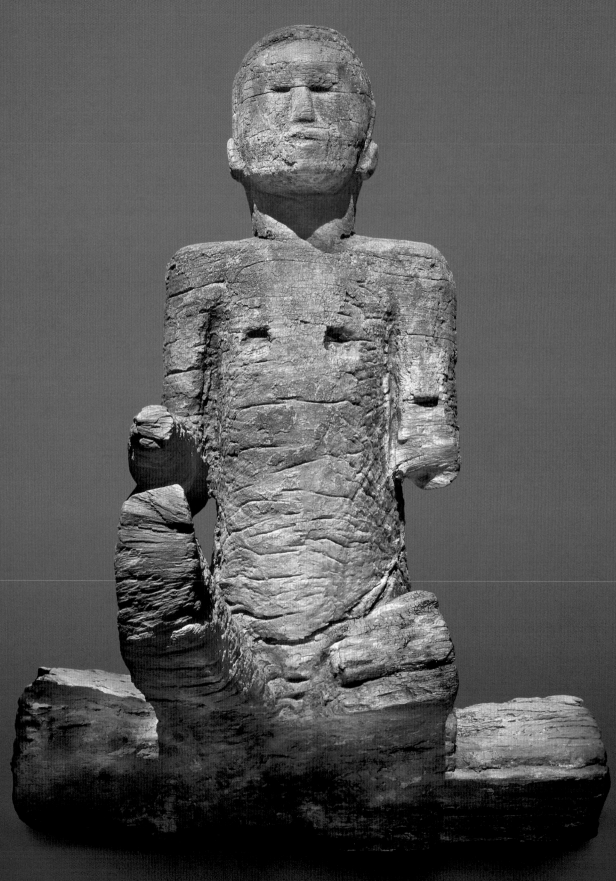

87a

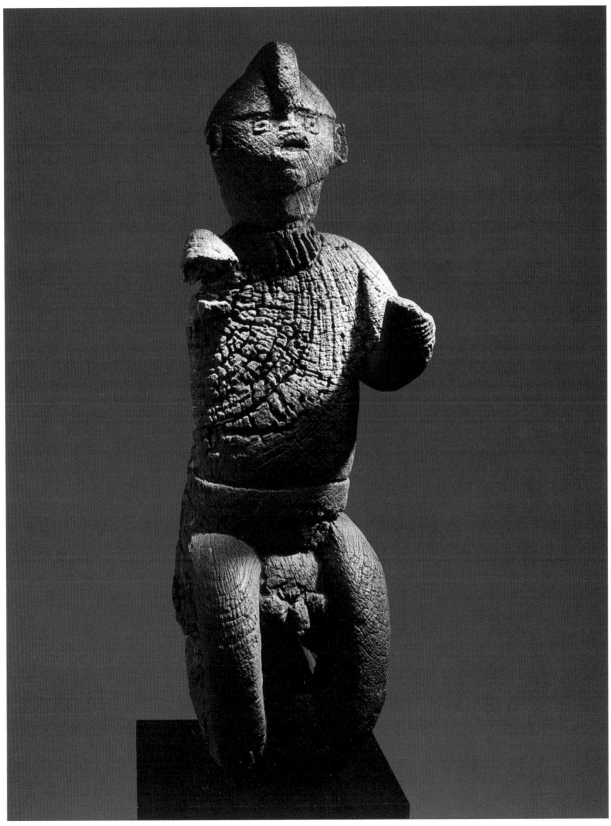

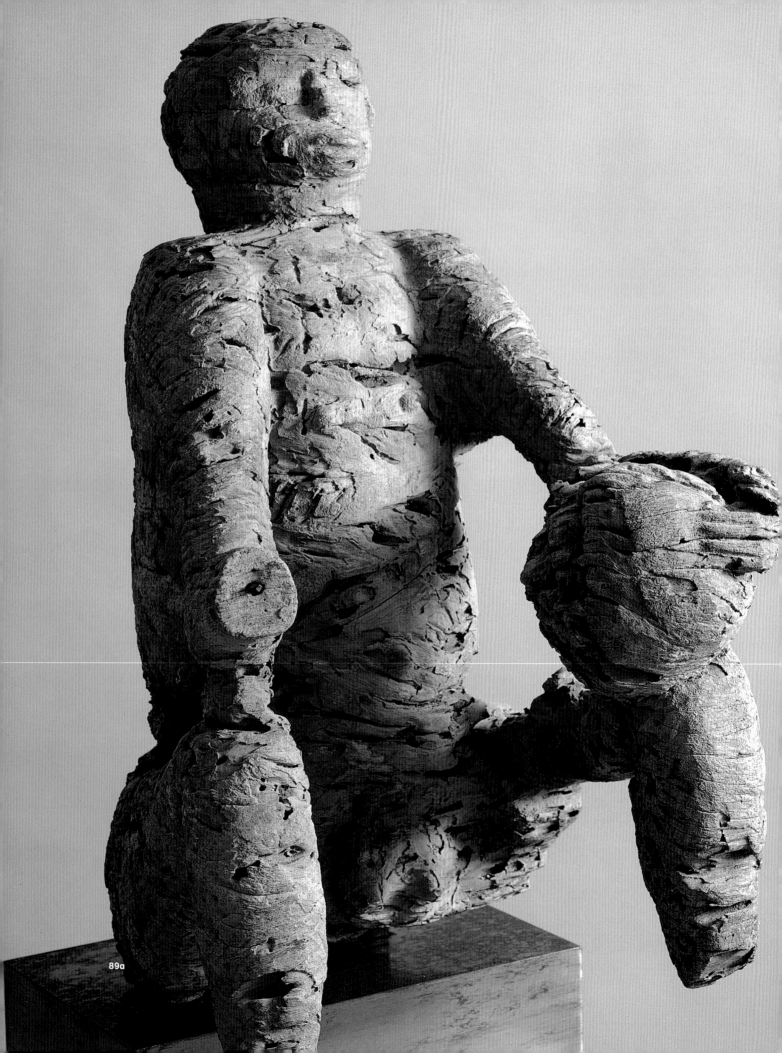

89a

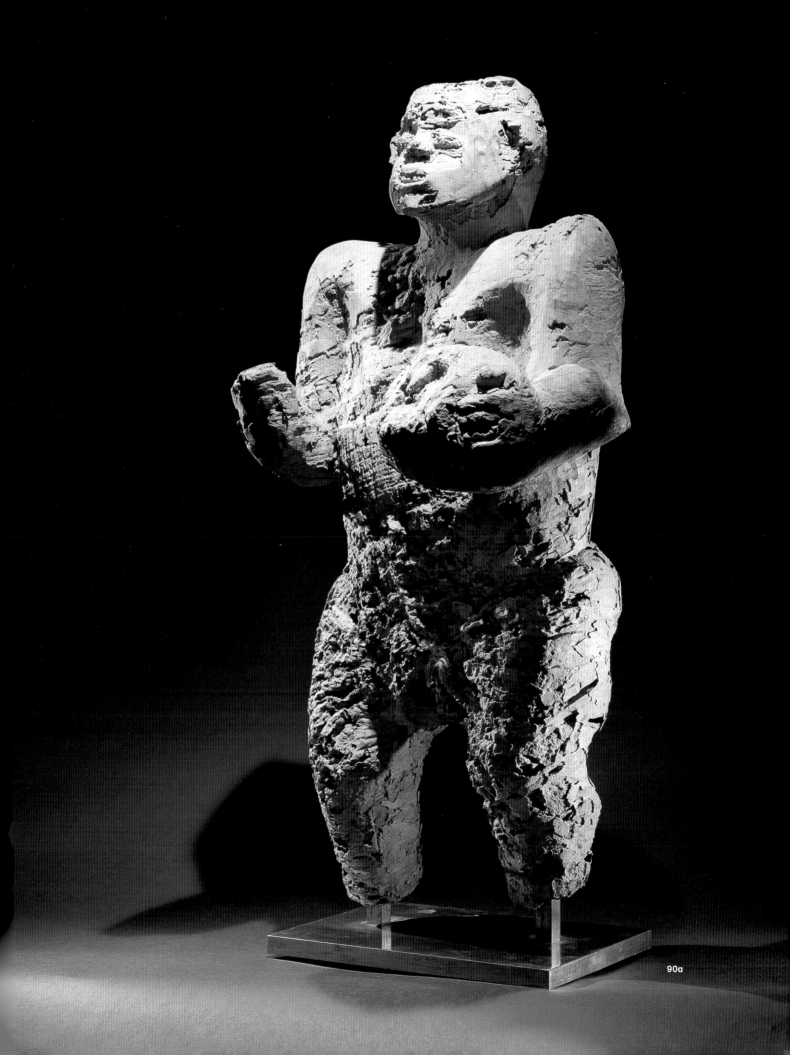

90a

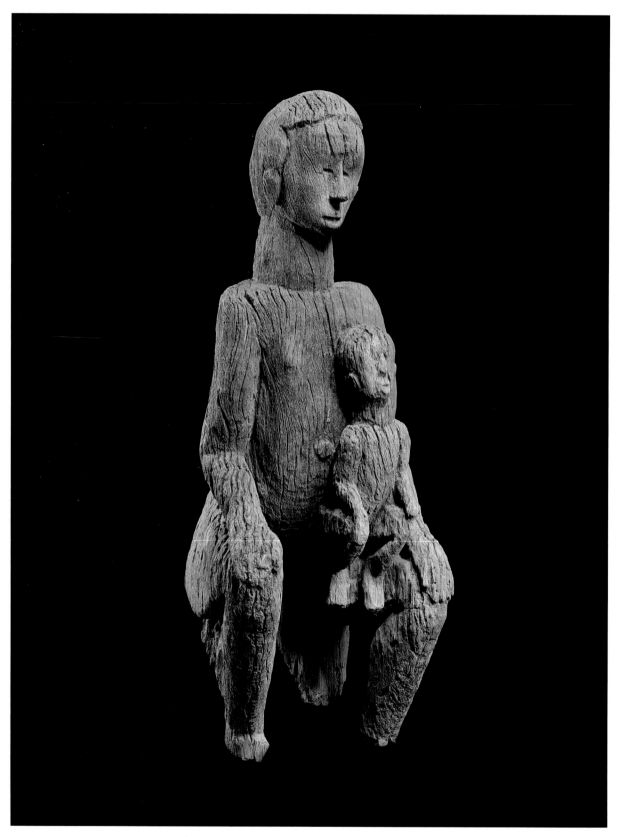

85a. **Mbembe artist, Nigeria**
(Cross River region)
Seated female figure
17th-18th century AD (?)
Wood, 71 cm
Private Collection, Paris

86a. **Mbembe artist, Nigeria**
(Cross River region)
Seated female figure
17th-18th century AD (?)
Wood, 75 cm
Private Collection

87a. **Mbembe artist, Nigeria**
(Cross River region)
Seated female figure
17th-18th century AD (?)
Wood, 76 cm
Liliane & Michel Durand-Dessert

88a. **Mbembe artist, Nigeria**
(Cross River region)
Kneeling figure
17th-18th century AD (?)
Wood, 101 cm
Private Collection

An aura of solemn detachment from worldly matters distinguishes the proudly raised heads of these figures; the intense stare of the small eyes, looking towards the horizon as if they were gazing into infinity, create, according to Ekpo Eyo, an "image of faith and eternity". The seated figures have the serious and solemn stateliness of certain Middle Eastern and ancient Egyptian statues. The living furrows of the cracks however attenuate their severity, and imbue them with a moving, human vitality.

89a. **Mbembe artist, Nigeria**
(Cross River region)
Seated man holding a cut-off head
17th-18th century AD (?)
Wood, 64 cm
W. & U. Horstmann Collection

90a. **Mbembe artist, Nigeria**
(Cross River region)
Chief holding a cut-off head
17th-18th century AD (?)
Wood, 89 cm
Private Collection

A radical change in expressive register is seen in two monumental sculptures, made necessary by the dramatic theme illustrated: two men, one upright, and one sitting down holding a cut-off head in his left hand.
The wrestler's body, the aggressive profile of the shoulders, the spherical head with its ferocious features (perhaps accentuated by the passage of time), the short neck, and the cut-off head, all contribute to the sense of drama expressed by these powerful and disturbing *memento mori*.
According to Hélène Kamer (1974), the first statue represents the chief Mabana, famed for his courage, who died in the 16th century.
The second is thought to be the portrait of the chief Appia, sculpted seventeen years before his death in 1613. The figure seems to be possessed by an uncontrollable violence released in a sort of explosion — completely natural and unforeseen by the artist — of the abdominal region, which reveals the centre of the trunk from which the drum was made: a gigantic tree of no less than two metres in diameter.

91a. **Mbembe artist, Nigeria**
(Cross River region)
Maternity
17th-18th century AD (?)
Wood, 94 cm
Private Collection

The situation is overturned in this sculpture, both because of the return to a domestic, tranquil theme, a maternity, and also because the image has been sculpted according to the usual vein of the wood, which raises questions as to its original function and collocation.

In accordance with a recurrent attitude in African sculpture, the mother seems to ignore the presence of a child and the sensation of separateness is underlined by the large hands of the woman which rest on her knees without touching the body of the child lying in her lap. The detachment is recomposed on a formal level by the harmony between the positions of the mother and child and by the aware adult expressions of both figures.

The tender volumes of the bodies with their rising movement, the fluid lines which define them, and the cracks which accentuate their verticality, provide a sensation of elevation which transcends their sheer materiality and endows them with a certain spirituality.

LOBI

BURKINA FASO

92a. **Lobi artist, Burkina Faso**
Female human figure
17th-19th century AD (?)
Wood, 73 cm
Private Collection, Paris

The art of the Lobi people was little known until the mid-20th century, when a series of exhibitions began to reveal its rich treasures, whose possible antiquity was still however unknown. The first to be dated was this female figure, created at least two centuries ago according to laboratory tests.

The passing of time and limited erosion have dried out this sculpture while respecting its monumental composition. The result is an impressive yet tender image, moving in its chaste solemnity.

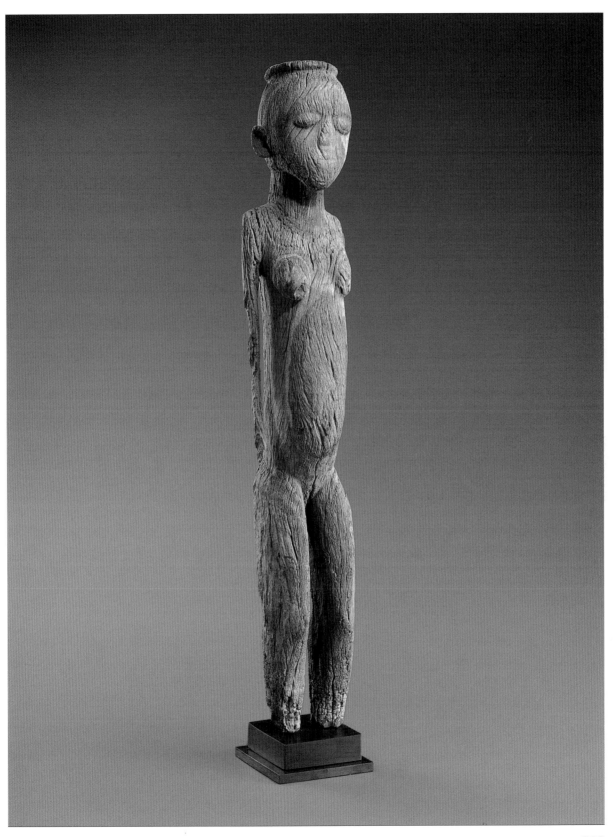

FANG

GABON

FANG

The antiquity of some Fang sculptures, which were normally placed on, or inserted inside, baskets containing the relics of ancestors (for this reason improperly called "guardians"), is a recent acquisition. Carbon-14 dating has revealed, along with other results obtained in recent decades, that the two works from the Horstmann collection (*Power of Form* 2002, nos. 41 and 42) were sculpted over a quarter of a millennium ago (ETH Zurich: 1745±40 years for the figure and 1700±35 years for the head).

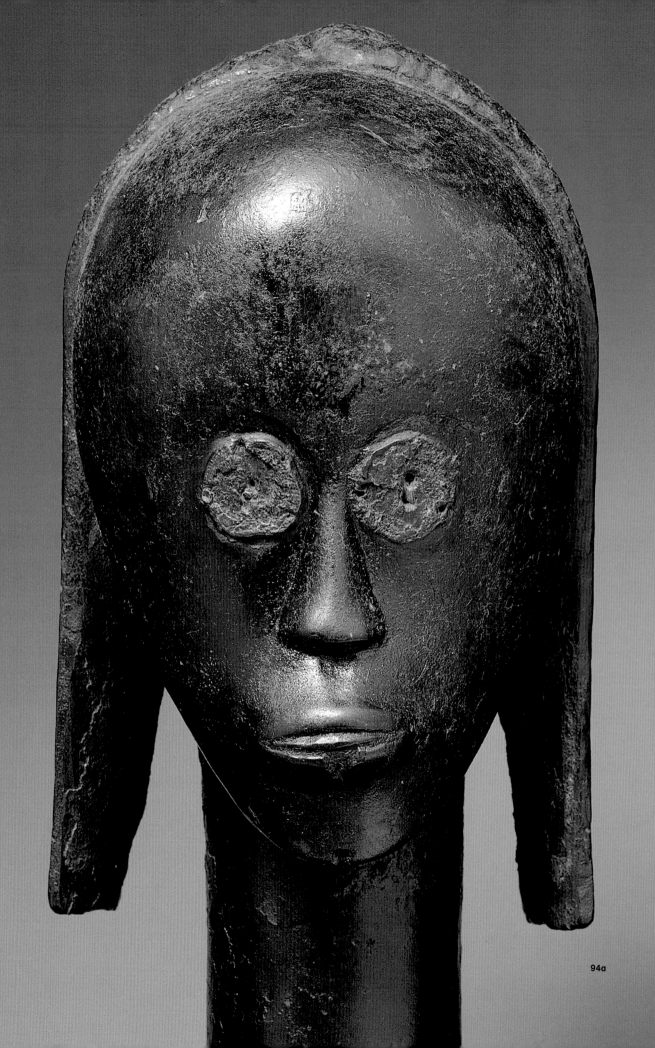

94a

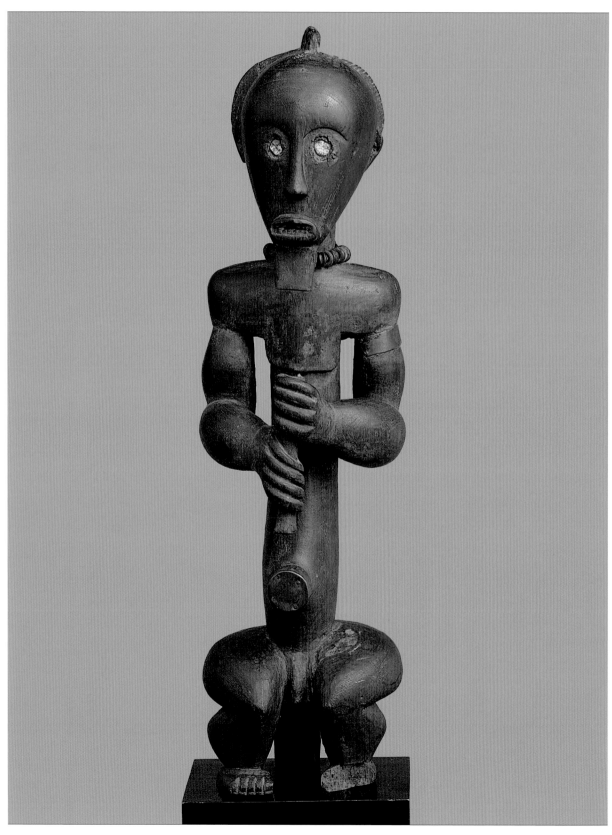

93a. **Fang artist, Gabon or northern Cameroon**
(Ngumba group)
Reliquary figure
18th century AD
Wood, metal, fibers, glass beads, 58 cm
W. & U. Horstmann Collection

94a. **Fang artist, Gabon (Betsi group)**
Reliquary head
18th century AD
Wood and metal, 51 cm
W. & U. Horstmann Collection

This famous male figure, already published by Carl Einstein in 1915 (no. 40), is distinguished by the original distribution of the volumes within a precise and articulated composition. The compact lower block echoes, in the upper part of the figure viewed frontally, the group of equal width of the muscular arms and flat shoulders, upon which sits the large trapezoidal head, further elongated by a square beard. The side view reveals unexpected movement, which focuses on the hands with spiral fingers, holding what is probably a musical instrument. The elegant slenderness of the long trunk is appreciated best in the rear view, where it is possible to appreciate the numerous and carefully designed asymmetries which animate the figure and bring it to life.

Heads are rarer than full-length figures. An austere purity, obtained with an extraordinary economy of means, is the quality which is most striking on the first impact with this monumental work.

AFRICAN
IVOIRES

ANCIENT IVORIES

FOR THE AFRICANS

ANCIENT IVORIES

CARVED BY AFRICANS

Ancient works of art in ivory represent a particular chapter in the history of traditional African art of the last centuries: a special section of this exhibition is devoted to these objects .

Ivories, in fact, have had a different history to wooden sculptures. The preciousness of the material and the fact that it was not perishable, added to the impossibility of retrieving material for alternative use by destroying the work (as happened with golden jewellery of pre-Columbian America, which was melted down to reuse the metal), have in some way contributed to their survival. For this reason, the number of ancient items conserved in museums and private collections in the West is relatively high, although it should be said that the majority of them, produced between the late 15th century and the mid-16th century, commissioned by Portuguese navigators, were made for export. These sophisticated works — known as "Afro-Portuguese" or, more precisely "Sapi-Portuguese" and "Bini-Portuguese" ivories, according to their provenance — are precious testimonies of the complexity and ambiguity of the relations between Europeans and the inhabitants of the African regions south of the Sahara in the early decades of contact. Two separate chapters are dedicated to these works.

The 16th-century chroniclers Ruy de Pina, Jeronimo Osorio and Garcia de Resende report that the ambassadors of the king of Congo, who came to Portugal in 1488 on the ships of Diego Cão, brought "carved elephant teeth and ivory objects and many well woven and beautifully coloured palm cloths", as a gift for the Portuguese King John II.

From then on, ivory sculptures and fabrics continued to arrive in Europe and became part of the collections of princes and rich merchants in the Renaissance, and subsequently entered in the collections of scholars in the baroque period.

The meticulous inventories of the Grand Dukes of Florence, the Medici family, document the possession of African ivory works already in the mid-16th century. Two oliphants, whose surface is decorated by an extremely fine decoration of meanders and fretworks in spiral patterns are mentioned in the de Medici records from 1553 onwards (they are on show, 1b and 2b). A further five similar instruments were subsequently recorded in various European collections.

In addition to the pieces from the Congo, there are seven horns (and two fragments) of extremely fine craftsmanship, with grooved sides and a crocodile's head at the tip. The earliest date of their certain presence in Europe is that of the piece now on show in the National Museum of Copenhagen, listed in the inventory of 1710 of the collection of the Dukes of Gottorp (4b). Table

XXX of the treatise on organology by Michael Preaetorius, *Theatrum instrumentorum*, published in 1619, however illustrates an extremely similar horn (the crocodile holds a human head between his jaws), wrongly attributed to Indian art. Also in this case, the entire group of ivories is so homogeneous that it strenghtens the hypothesis that all these instruments were produced in a short period of time in the same workshop, which William Fagg and myself hypothetically situate on the coast of West Africa.

Both these and the Florentine examples are side blown horns with the mouthpiece carved on the concave part of the tusk, an organological characteristic which shows they are African. At the same time, some of them have suspension eyes, a feature which is common in European instruments but not found in Africa. This leads us to assume that they were carved after the arrival of the Portuguese, or even for the Portuguese themselves.

The extremely rare horn conserved at the Musée Calvet in Avignon (10b), previously in the cabinet of curiosities of the scholar and collector Esprit Calvet in the late 18ᵗʰ century, was instead definitely created by a Sapi artist from Sierra Leone for local use.

In Benin, ivory was the prerogative of the sovereign and the carvers of the precious material belonged to a special corporation: the *Igbesamwan*, whose members lived in a special quarter. Three beautiful masks, armlets, percussion instruments and a certain number of horns figure among their creations. The latter were distinguished from other African instruments by the position of the mouthpiece, on the convex section of the tusk: see the beautiful bronze statue of a horn player (39a).

A further group of ancient horns — about twenty examples extremely similar to each other, distributed in various European museums, is also probably of Nigerian origin. This hypothesis is based on the similarities in the way of depicting animals (crocodiles and frogs) with ivories and relatively recent objects from the region of Calabar. They were probably produced between the late 16ᵗʰ and the first half of the 17ᵗʰ century. The first date is confirmed in the writing engraved on the surface of a horn belonging to this group conserved at the British Museum, transformed into a cup for libations after being redecorated in Europe and having an inscription added which invites its users to drink, along with the date of 1599.

Musical instruments are not the only testimony of the creativity of African ivory carvers. A dozen cylindrical vessels with lids and a group of double coaxial armlets are proof of the sophisticated craft of the ancient Owo carvers in Nigeria.

E. B.

KONGO

MEDICI'S
OLIPHANTS

1b. **Kongo artist, Democratic Republic
of Congo, Angola (?)
Oliphant with geometric decoration**
16th century AD
Ivory, 83 cm
Florence, Musem of Silver and Porcelain
(inv. Bargello-avori 1879 no. 2)
Former Medici collection

2b. **Kongo artist, Democratic Republic
of Congo, Angola (?)
Oliphant with geometric decoration**
16th century AD
Ivory, 57.5 cm
Florence, Musem of Silver and Porcelain
(inv. Bargello-avori 1879 no. 3)
Former Medici collection
Kind concession of the Ministero per i Beni e le Attività Culturali

The instruments conserved in the Museum of Silver and Porcelain may have been a gift from the King of Kongo to one of the popes of the powerful Medici family, probably Leo X (Giovanni de Medici), who, during his papacy (1515-1521) was in frequent contact with the African sovereign, who had converted to Christianity. It could, however, also be a gift from the King of Portugal, who hoped to secure the Vatican's support for his colonial policies.

The elegant engraved decoration is perfectly distributed over a spiral on the conic surface of the instruments. In its complex yet transparent geometry, it bears the mark of a virtuoso with total mastery of his craft.

The motifs — also visible on fabrics and sculptures, and tattooed on human bodies — have been part of the figurative heritage of the Kongo since immemorial time, and certainly before they came into contact with Europeans.

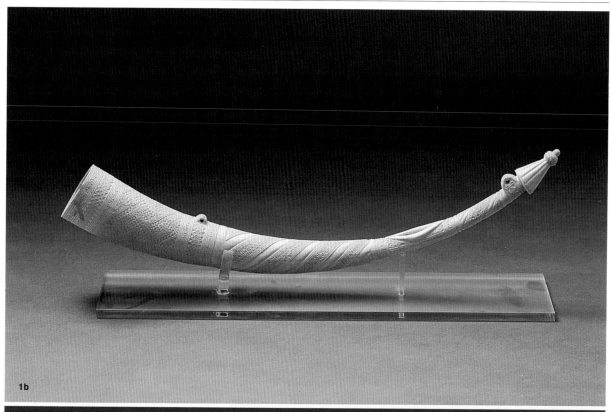

1b

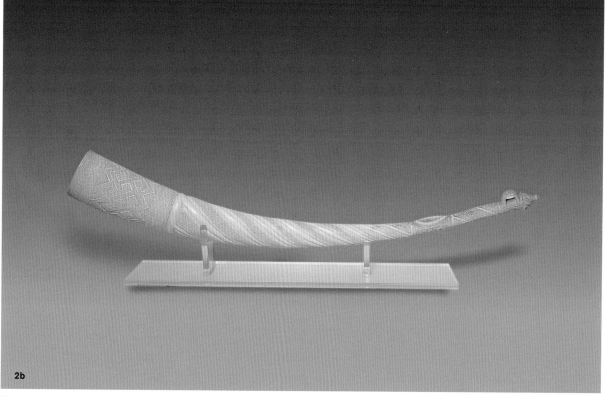

2b

OLIPHANTS

WITH CROCODILE HEADS

3b. **Artist from an unidentified ethnic group,**
Western Africa (?)
Oliphant
16th century AD (?)
Ivory, 66 cm
Copenhagen, National Museum of Danemark,
Ethnographic Collections (inv. Egc15)

4b. **Artist from an unidentified ethnic group,**
Western Africa (?)
Oliphant
16th century AD (?)
Ivory, 62 cm
Copenhagen, National Museum of Danemark,
Ethnographic Collections (inv. Egc17)

The mouthpiece on the concave section of the tusk proves that these two elegant oliphants are African. As far as regards their antiquity, the illustration of a similar instrument in a treatise of organology from 1619 establishes the date of their creation as at least late 16th century.

The craftsmanship is extremely refined, and there is a perfect balance of the relief bands decorating their surfaces, which widen along with the diameter of the tusks themselves. They end in a delicate scalloped design, a sort of corolla, which shows off, by contrast, the ferocious crocodile heads carved at the other end.

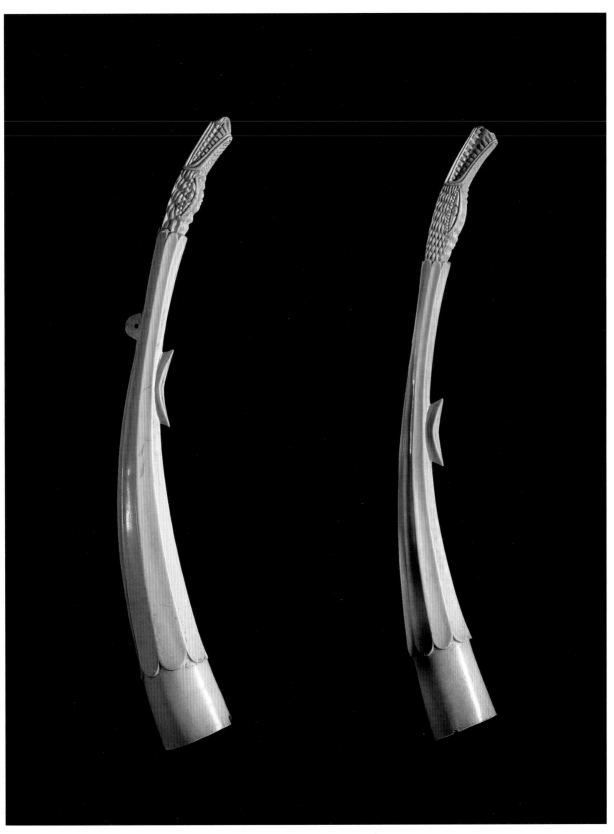

3b

4b

HORNS
CALABAR

5b. **Artist of the Calabar region, Nigeria (?)**
Horn
End of the 16th century AD (?)
Ivory, 71 cm
Copenhagen, National Museum of Danemark, Ethnographic Collections (inv. Gc13)

6b. **Artist of the Calabar region, Nigeria (?)**
Horn
End of the 16th century AD (?)
Ivory, 51 cm
Copenhagen, National Museum of Danemark, Ethnographic Collections (inv. Gc14)

7b. **Artist of the Calabar region, Nigeria (?)**
Horn
End of the 16th century AD (?)
Ivory, 70 cm
Ravenna, National Museum (inv. 12066)

8b. **Artist of the Calabar region, Nigeria (?)**
Horn
End of the 16th century AD (?)
Ivory, 46.5 cm
Ravenna, National Museum (inv. 12067)

9b. **Artist of the Calabar region, Nigeria (?)**
Horn
Ivory, 56 cm
Munich, Staatliches Museum für Völkerkunde (inv. 26.N.131)

The oliphant on show in Munich probably belonged to the royal bavarian collections already in 1598. The Fickler catalogue (1598) mentions "three indian ivory horns" among which one with a "carved crocodile". The description seems to match the horn on show despite its wrong indian attribution which was common at the time.
The two pieces now in Copenhagen were recorded in the inventories of the Dukes of Gottorp in 1710 and were acquired, together with oliphant 3b, by the Danish museum around 1751. It is uncertain how the two horns ended up in the National Museum of Ravenna; it is however highly likely that they come from the ancient collections of the Camaldolite monks in Classe of the 18th century. It is also probable that the instruments originally came from Calabar in what is now Nigeria, due to the similarities with the decorations on relatively recent objects from that region. As far as their age, the horns were probably made in a fairly circumscribed period, between the end of the 16th and the first half of the 17th century, as would be confirmed by the date "1599" engraved, presumably in Europe, on a piece kept at the British Museum (Bassani 2000b, 266).

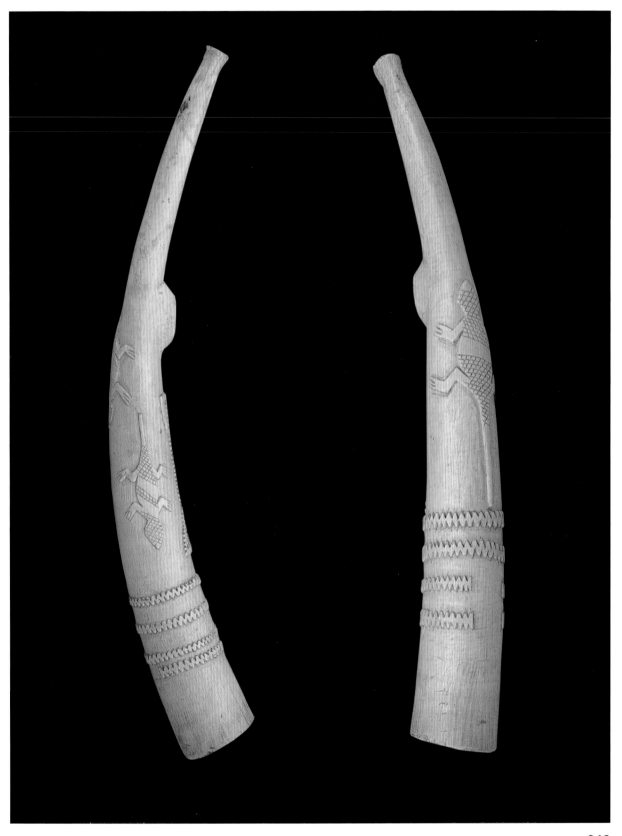

5b

6b

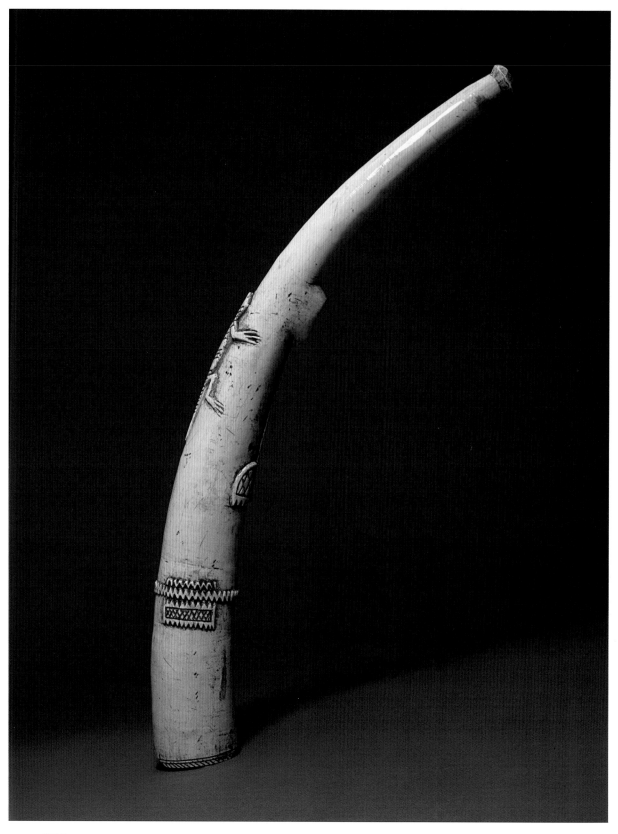

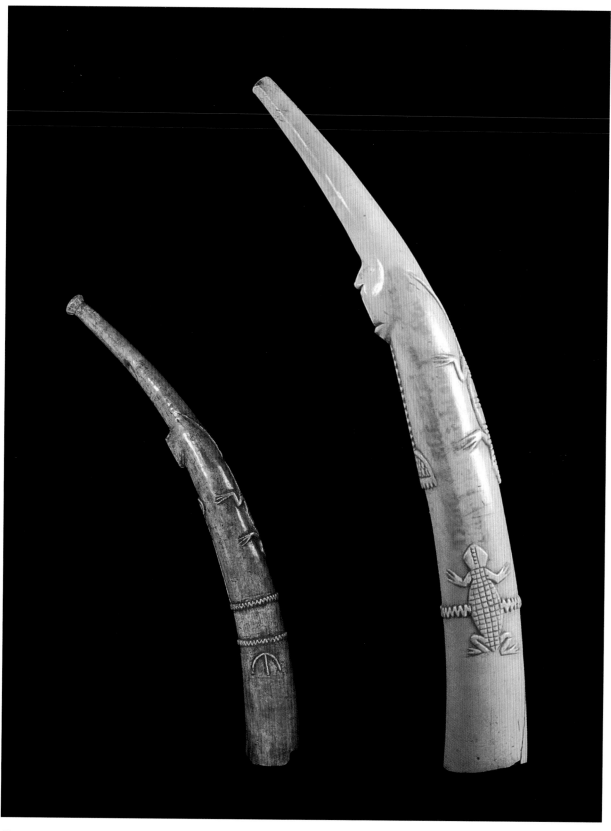

HORN

SAPI

10b. **Sapi artist, Sierra Leone**
Horn
16th century AD
Ivory, 74.6 cm
Avignon, Musée Calvet (inv. u.166)

This instrument, an extremely important example of ivory sculpture in Sierra Leone not made for export, was part of the collection of the scholar from Avignon, Esprit Calvet, in the second half of the 18th century.

The mouthpiece on the concave part of the tusk and the similarity of the figure on the back of an unidentified animal, to ancient stone figures (see pp. 161-168), allow us to attribute the instrument to the art of Sierra Leone, to consider it as created for local use and to date it back to the 15th-16th century.

The rider is excessively large for his mount, and this disproportion may be interpreted as a metaphor of power.

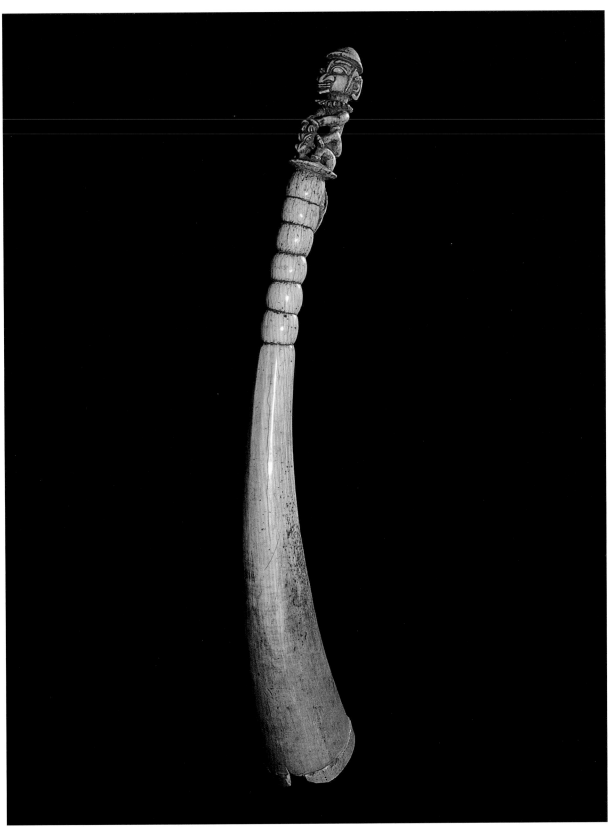

HORNS

BINI

11b. **Bini artist, Nigeria (Benin)**
Oliphant
16th-19th century AD (?)
Ivory, 54.5 cm
Vienna, Museum für Völkerkunde (inv. 91 916)

12b. **Bini artist, Nigeria (Benin)**
Oliphant
16th-19th century AD (?)
Ivory, 48 cm
Vienna, Museum für Völkerkunde (inv. 64 727)

The first and largest of these two splendid instruments was perhaps part of the ancient imperial Austrian collections, while the second arrived in Europe as part of the booty of the British punitive expedition of 1897.
The date of their creation can only be guessed at, but the extremely rich decoration displaying traditional motifs of ancient Bini iconography — people, animals and geometric motifs — lead us to suppose relative antiquity.

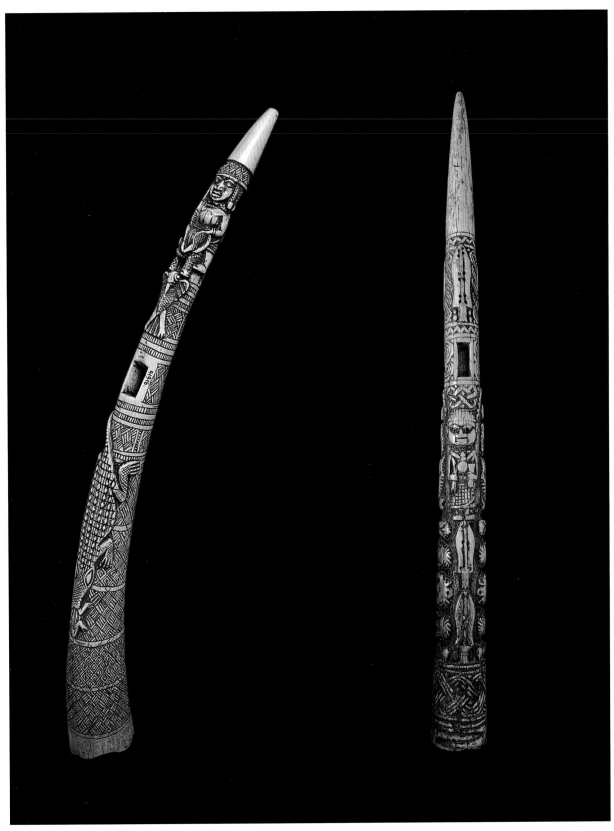

OWO

LIDDED VESSELS AND BRACELETS

A dozen vessels with lids, of monumental impact despite their modest size, and the same number of armlets and bracelets, probably dating back to the 17th century, testify the skill of ivory carvers from Owo, the Yoruba city-state, rival of Benin.

The base of the vessels displays a crown of small hollow cylinders also used in the decoration of terracotta works discovered during the excavations in the ancient Nigerian city, and of some Bini-Portuguese saltcellars. These similarities are in fact not coincidental and provide a clear indication of the centuries-old relationship between the figurative cultures of the two cities.

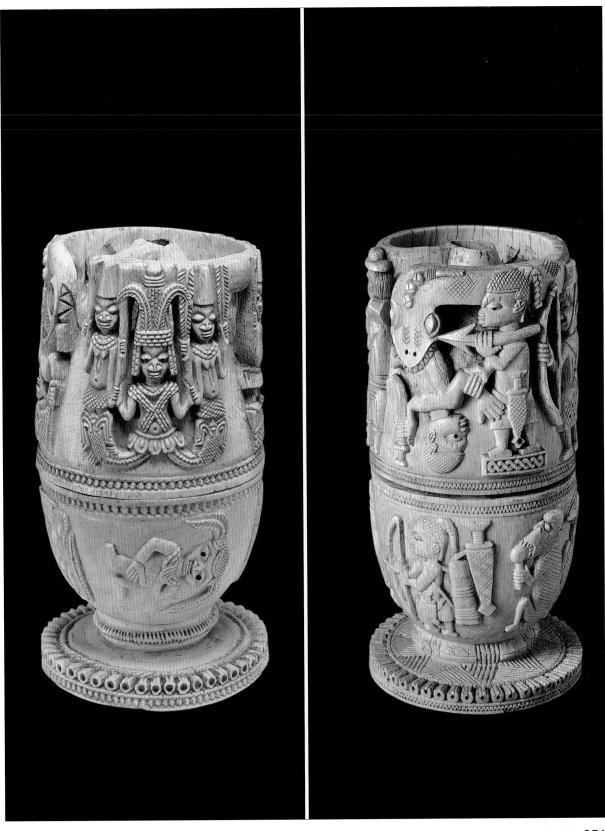

13b. **Owo artist, Nigeria**
Lidded vessel
17th-18th century AD (?)
Ivory, 12 cm
bpk, Berlin/Ethnologisches Museum,
Staatliche Museen zu Berlin (inv. IIIC 4883ab)

14b. **Owo artist, Nigeria**
Lidded vessel
17th-18th century AD (?)
Ivory, 25.5 cm
Lille, Musée d'histoire naturelle
et d'ethnographie (inv. 990.2.306)

The sumptuous full-relief and bas-relief decoration, also found on similar containers, symbolically illustrates the power of the sovereign, who is represented on the first ivory with two catfish for legs, according to the Yoruba tradition (of which the Owo are a part).

The second vessel also displays carvings of European figures, whose costumes and weapons date the piece to the 17th-18th century.

15b. **Owo artist, Nigeria**
Coaxial ceremonial bracelet
17th century AD
Ivory, 14 cm
bpk, Berlin/Ethnologisches Museum,
Staatliche Museen zu Berlin (inv. IIIC 4882)

17b. **Owo artist, Nigeria**
Coaxial ceremonial bracelet
17th century AD
Ivory, 11 cm, diam. 9 cm
Copenhagen, National Museum of Danemark,
Ethnographic Collections (inv. Dc27)

16b. **Owo artist, Nigeria**
Coaxial ceremonial bracelet
17th century AD
Ivory, 12 cm, diam. 9 cm
Copenhagen, National Museum of Danemark,
Ethnographic Collections (inv. Dc26)

18b. **Owo artist, Nigeria**
Bracelet
17th century AD (?)
Ivory, diam. 10 cm
Copenhagen, National Museum of Danemark,
Ethnographic Collections (inv. Dc25)

The coaxial armbands rotating inside each other, taken from a single block of ivory, confirm the extraordinary skill of the Owo artists, who were able to carve full-relief motifs despite the fact that the two cylinders, internal and external, are inseparable.

The decoration with human figures whose legs end in the form of a fish or frog, with two-headed birds and other monsters (*abraxas*), is also found in lidded vessels, and is part of the Owo figurative heritage.

The registration in 1689 of the two armlets and the bracelet in an inventory in the Danish museum, although wrongly attributed to the East Indies, is useful because it establishes the date of production as in the second half of the 17th century. This date is also confirmed by the presence of two similar bracelets in the Weickmann collection in Ulm prior to 1653.

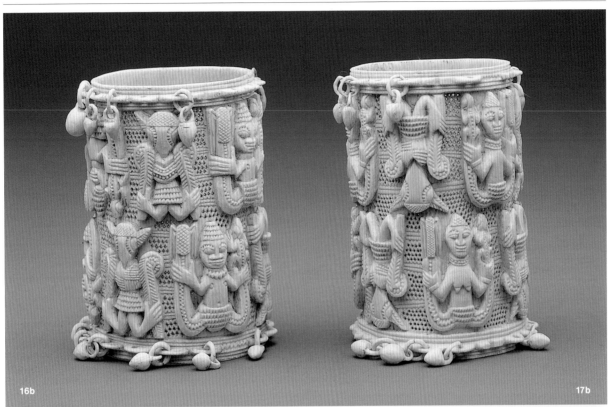

16b

17b

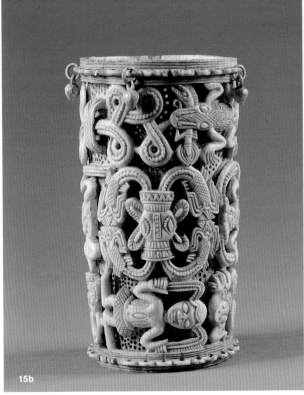

15b

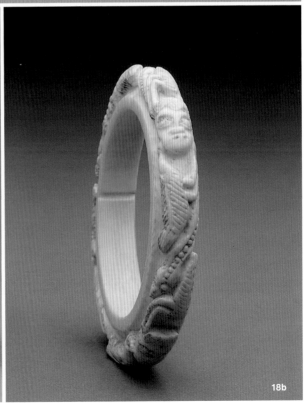

18b

WITNESSES

The interest in Africa and its inhabitants' material culture in past centuries is also witnessed in collections of European artists in which African weapons and objects appear.

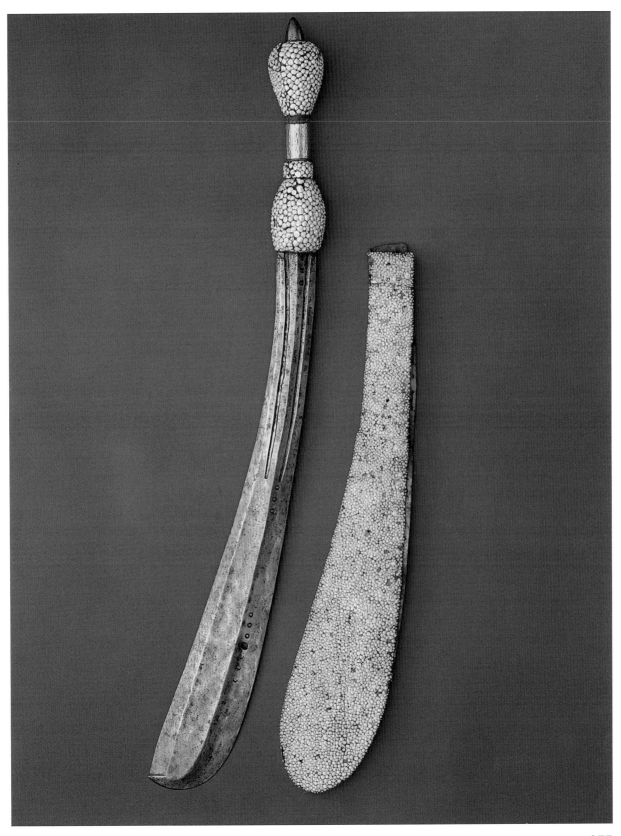

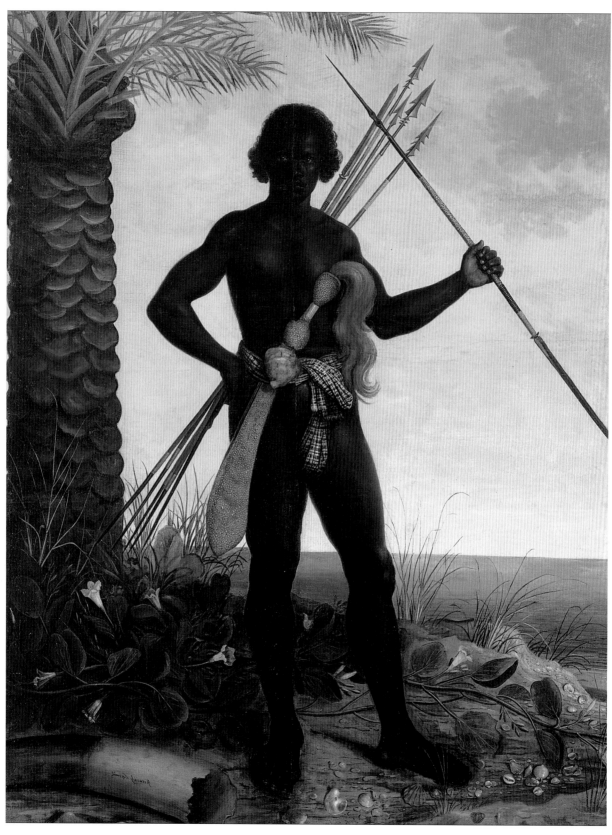

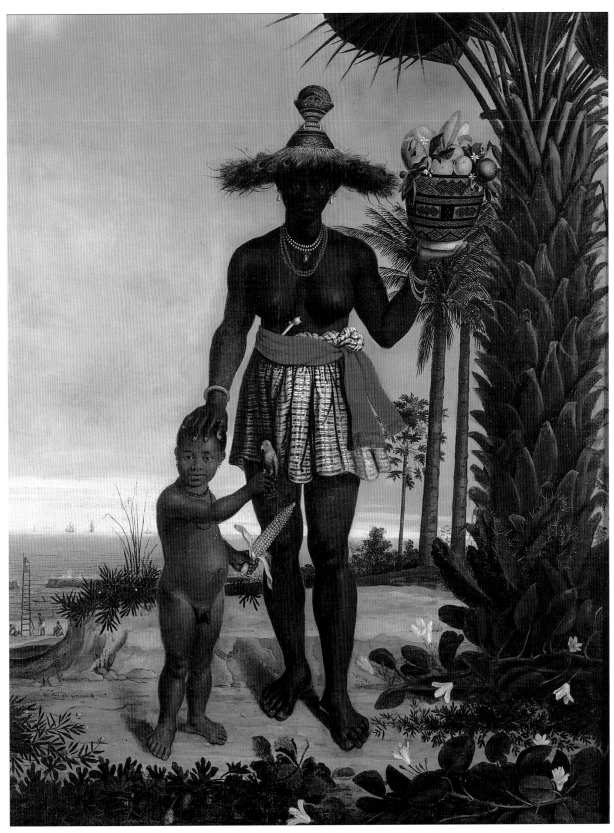

19b. **A. Eckhout, 1641, painted in Brazil**
African woman with basket
Oil on canvas, 289 cm
Copenhagen, National Museum of Denmark,
Ethnographic Collections (inv. N 38 A 8)

20b. **A. Eckhout, 1641, painted in Brazil**
African warrior with sword
Oil on canvas, 287 cm
Copenhagen, National Museum of Denmark,
Ethnographic Collections (inv. N 38 A 7)

21b. **Akan, Côte d'or (today Ghana)**
Sword
Wood, iron, ray skin, 80 cm
Copenhagen, National Museum of Denmark,
Ethnographic Collections (inv. Cb 8)

The two large canvases, painted by the Dutch artist Albert Eckhout in Brazil in
1641 for Prince Mauritz of Nassau (who gave them to the King of Denmark),
portray two African figures, certainly two slaves used as models: a woman with
a woven fibre Kongo basket full of fruit, and a warrior with a typical Akan
sword and its sheath in ray skin. The National Museum in Copenhagen
conserves the works of Eckhout along with two baskets and a sword, which
are similar if not the same as the ones in the paintings.
The baskets cannot be transported due to their fragility, but the works of Ec-
kout and the weapon are here on show to prove the faithfulness of the images.

IVORIES

SAPI-PORTUGUESE

IVORIES
SAPI-PORTUGUESE

Sixty-one saltcellars, including fragments (some of uncertain origin), three ciboria, two dagger handles, nine spoons, three forks, and forty elephant horns, distributed in museums and private collections all over the world, bear witness to the extraordinary ability of the Sapi carvers from Sierra Leone, acknowledged by the Europeans already in the first decade of the 16th century with words which leave no room for doubt. Valentim Fernandes, a Moravian scholar living in Portugal, in a report dating from sometime between 1506 and 1508, wrote as follows: "In Sierra Leone the men are very able and ingenious […] and produce works in ivory, marvellous to behold, of all the things that they are asked to do. That is, some make spoons, others salt cellars, others dagger handles and any other fine work".[1] It is probable that by "qualquer otra sotileza" the 16th-century writer intended the ciboria and, above all, the oliphants, not quoted in the list but which are a significant part of the group of ivory pieces carved in that region in that period, and which can be dated with the greatest confidence, due to the many precise iconographic correspondences with European works.

In the Renaissance, saltcellars were luxury furnishings which decorated the tables of the aristocracy. The Sapi-Portuguese examples are formed of a spherical container, divided horizontally into two more or less equal parts, and resting on bases in various shapes. As can be seen from the fully conserved pieces, the upper part, which acted as a lid, is surmounted by a figure or group of figures from both the African and European worlds.

The saltcellars can be subdivided more or less into two types: with a truncated cone base, and with a perforated cylindrical base. The analysis of the entire corpus has however revealed that the distinction is not that clear, and that elements of one type were sometimes mixed with those of the other.[2]

The geometric decorations repeat motifs from Manueline architecture (which

takes its name from King Emanuel I of the House of Aviz), which flourished in Portugal between the end of the 15th century and the early 16th century.[3] This helps us date the works, justifying their attribution to the group of Sapi-Portuguese ivories. The hypothesis that these decorative elements were taken from European drawings seems the most likely.

The spoons and forks repeated the European models with incredible virtuosity. The oliphants, the most spectacular pieces, have their mouthpiece at the apex rather than at the side, and are fitted with rings allowing a support strap or chain to be attached. The surfaces are entirely covered with scenes of deer and boar hunting. The most used model for the illustrations was probably a minute incunabulum: a devotional work — *Horae Beatae Mariae Virginis*, printed in Paris in 1498 by Philippe Pigouchet for Simon Vostre — probably found on the ships stopping off on the African coasts. The main images depict scenes of the life of the Virgin Mary and of the Passion of Christ, while scenes of deer hunting, according to the ritual of the "chasse à courre", were instead used to decorate the margins of the pages. They are reproduced on the surfaces of the oliphants with such precision that they leave no doubt as to their source (see Bassani and Fagg 1988, *passim*), but also display complete compositional freedom.

The evident similarity of the features of the figures sculpted on many ivory works and of those of ancient figures in soft stone (*nomoli*) excavated in Sierra Leone and Guinea — protruding globular eyes, arched nose, dilated nostrils - (see pp. 161-168), suggest that both the ivories and the stone works are the work of Sapi artists, who adapted their significant carving skills to the needs of European customers. Just as recounted by the admiring Valentim Fernandes.

E. B.

[1] Fernandes 1951, 96. Fernandes never set foot in Africa; to describe Sierra Leone, its inhabitants and their culture, he drew on the observations made by Alvaro Velho, who had spent many years there (Hart 1995, 38).
[2] The pieces on show illustrate the different types and originality of the solutions invented by the African artists.
[3] Spiral relief work and rows of grains, often juxtaposed to form bands, are visible above all on the capitals and columns of the great Portuguese works of architecture of the period, such as the convent of the Jeronimos in Lisbon or the cloisters of the monastery of Batalha.

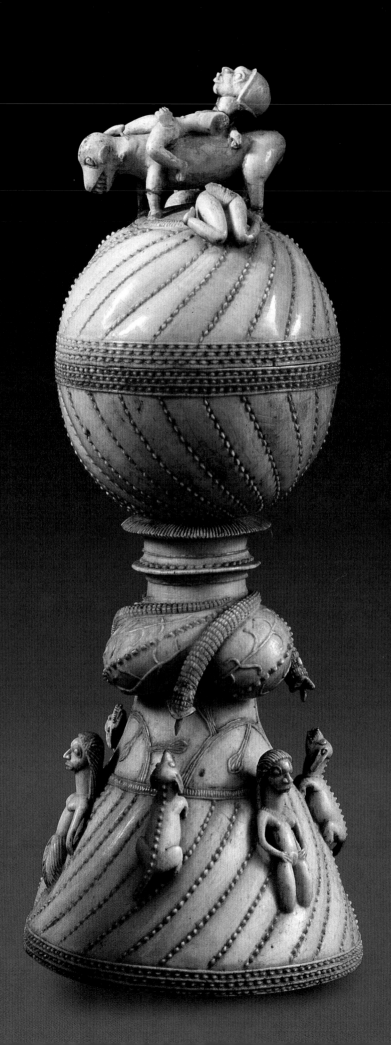

22b

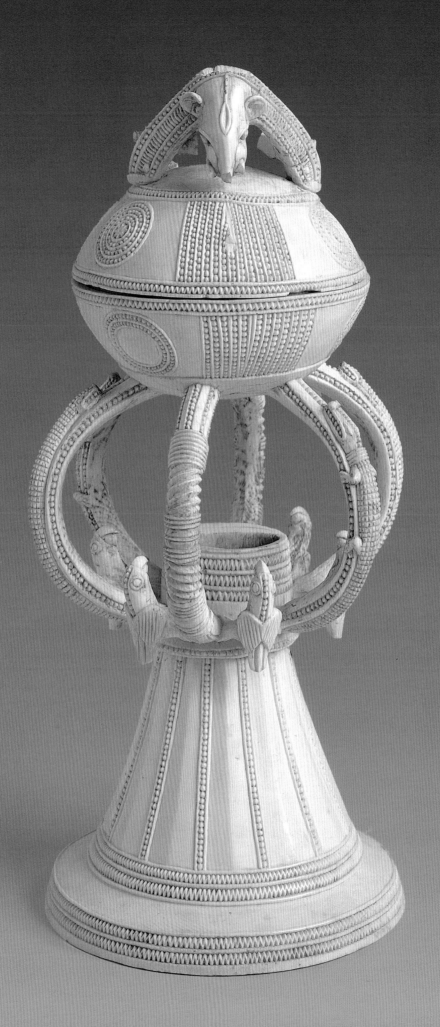

23b

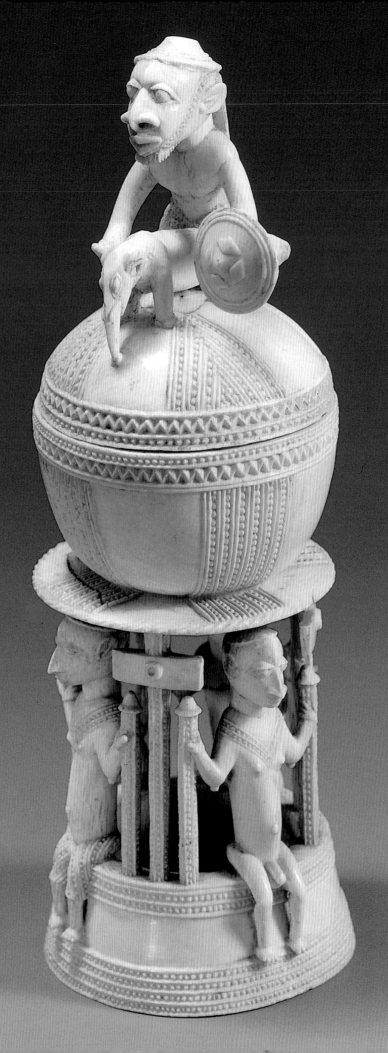

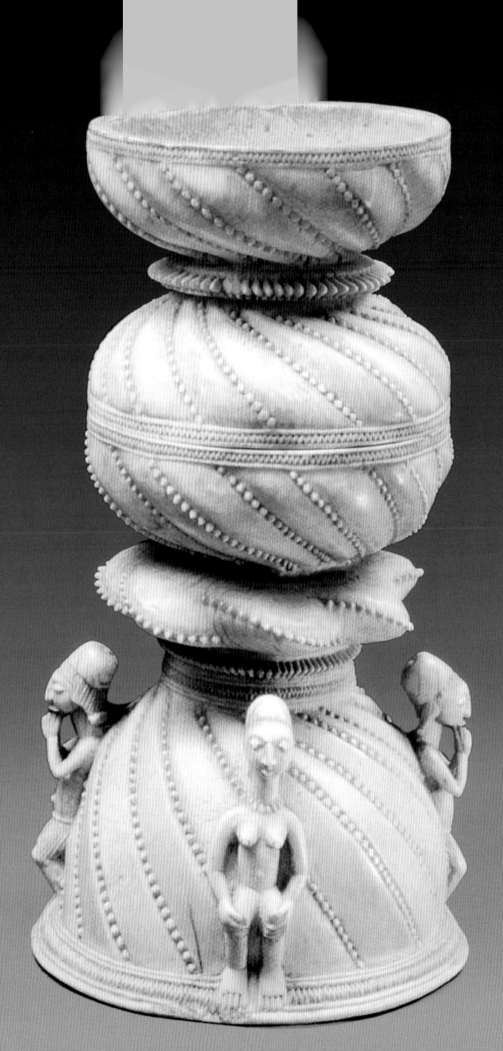

26b

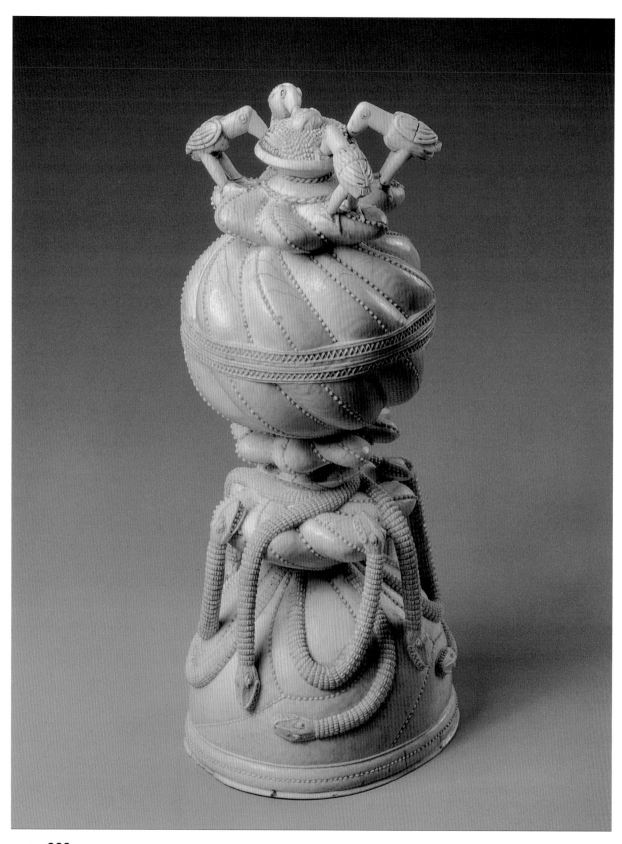

22b. Sapi artist, Sierra Leone
Saltcellar
15ᵗʰ-16ᵗʰ century AD
Ivory, 24 cm, diam. 9 cm
Bologna, Musei Civici d'Arte Antica (inv. 694)

This saltcellar is listed in the printed Bolognese inventory of Marchese Ferdinando Cospi of 1680 as an "ancient decorated ivory chalice with lid".
The snakes facing the presumed dogs are certainly a local motif. The group carved on the lid — a naked woman on the back of an animal, flanked by two other female figures — instead illustrates a theme completely foreign to the African world: a witch being taken to the sabbath by the devil in the form of a goat. The subject may have been suggested by the European client, who would also have provided the sculptor with a model to use as inspiration or even to be copied: a drawing, or more probably an engraving. Two sheets, respectively by Albrecht Dürer (dated 1505 and 1507) and Hans Baldung Grien (dated 1510) may have been the sources, freely interpreted by the maker of the saltcellar.

23b. Sapi artist, Sierra Leone
Saltcellar
15ᵗʰ-16ᵗʰ century AD
Ivory, 29 cm
Modene, Galleria Estense (inv. 2433)

The 1866 *Inventory* of the Modena museum (compiled after the union of Modena with the kingdom of Italy in 1859) describes this salt cellar (almost certainly already part of the ancient collections of the Dukes of Este, transferred from Ferrara to Modena in 1625), as a "ivory bowl formed from a single piece, with a foot and engraved lid".
A person of high rank, sitting on a ceremonial throne typical of Sierra Leone, was presumably sculpted on the lid of the container. The group, unfortunately, is seriously damaged and the human figure has been lost. The support of the container is an airy play of arches on which crocodiles and snakes are climbing; parrots are carved between the arches.

24b. **Sapi artist,**
Master of symbolism,
Sierra Leone
Saltcellar
15th-16th century AD
Ivory, 25 cm
Italy, Private Collection

The terrifying and elegant mass of entangled snakes, which, with the fluid climbing and falling movements of their parallel bodies and calculated curves is wrapped around the lower parts of this piece, is the original solution invented by the sculptor, which distinguishes his work and makes it unique in the panorama of Sapi-Portuguese ivories. Four birds carved around the top of the lid balance the snakes beneath.
The convincing similarities of some details of this saltcellar, which seem to be the subtle signature of the artist, suggest that also the pieces from the British Museum (inv. 67.3.25) and from the Museo Pigorini (inv. 104079), while displaying an extremely different iconography, are by the same sculptor, for whom William Fagg suggested the name, here maintained, of the "Master of symbolism" (Bassani and Fagg 1988, 134-135).

25b. **Sapi artist, Sierra Leone**
Saltcellar
15th-16th century AD
Ivory, 22.5 cm
Vienna, Museum für Völkerkunde (inv. 118.609)

Apart from the geometric motifs, the decoration of the first saltcellar from the Museum für Völkerkunde is entirely African. The preponderant mass of the figure on the back of an elephant (an extremely rare iconography), in comparison to the mount, suggests that this is a symbolic representation of a chief, whose status is also indicated by the elegantly decorated headdress and shield.

26b. **Sapi artist, Sierra Leone**
Saltcellar (the lid is missing)
15th-16th century AD
Ivory, 21 cm
Vienna, Museum für Völkerkunde (inv. 118 610)

This piece, with its containers placed one on top of the other, is unique amongst sapi-portuguese ivories. This type of composition is instead normal in Bini-Portuguese ivories (32b), and this raises questions on the origin of this particular form, also extremely rare in Europe, and on the period in which Portuguese clients ordered these works from African artists in the two regions, problems which so far remained unanswered.

28b 29b

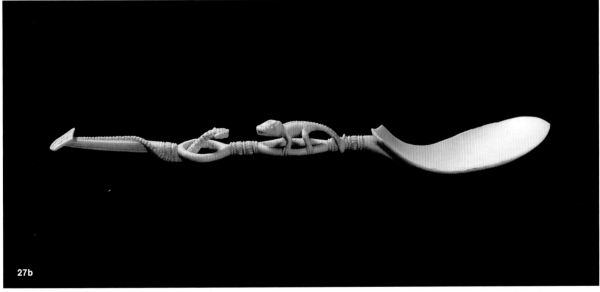

27b

27b. Sapi artist, Sierra Leone
Spoon
15th-16th century AD
Ivory, 22 cm
Copenhagen, National Museum of Denmark,
Ethnographic Collections, (inv. Ac136)

The Sapi-Portuguese spoons repeat fairly faithfully the form of European Renaissance pieces which probably served as models for the carvers. These, however, have introduced elements from the African world, such as the decoration of the handle of this most elegant piece (already recorded in the royal collections of Denmark in 1689, but wrongly described as an indo-oriental spoon), in which a snake and a smooth-bodied animal confront each other threateningly.

28b. Sapi artist, Sierra Leone
Spoon
15th-16th century AD
Ivory, 20.5 cm
Munich, Staatliches Museum für Völkerkunde
(inv. 26.N.129)

It is probable that the spoon from the museum of Munich was already part of the rich collections of the King of Bavaria in the 16th century.
The most original solution adopted by the artist, which allows a part of the handle to slide, is unique and reveals the hand of a real virtuoso. The two birds (parrots?) carved on the top of the handle are similar to those decorating some saltcellars.

29b. Sapi artist, Sierra Leone
Fork
15th-16th century AD
Ivory, 14.4 cm
Vienna, Museum für Völkerkunde (inv. 91 908)

This extremely rare fork was attributed by F. Heger to the collection of the Archduke of the Tyrol, Ferdinand I of Hapsburg, even though it does not appear in the 1596 inventory of the *Wunderkammer* of Ambras Castle in Tyrol, but only in the one drawn up by A. Primisser in 1821.
The miniscule object, evidently of a decorative nature, recalls in a miniaturised form the extreme elegance of the columns in the royal cloisters of Batalha in Portugal.

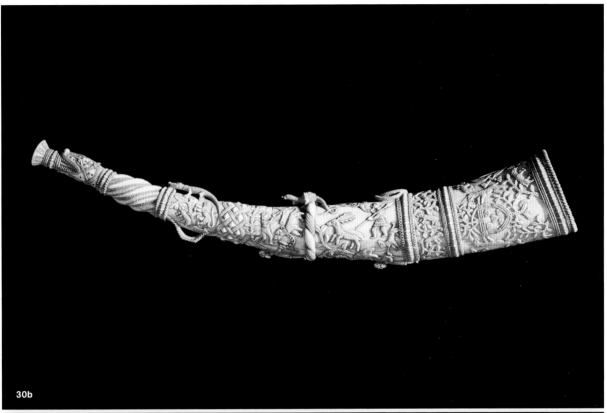

30b

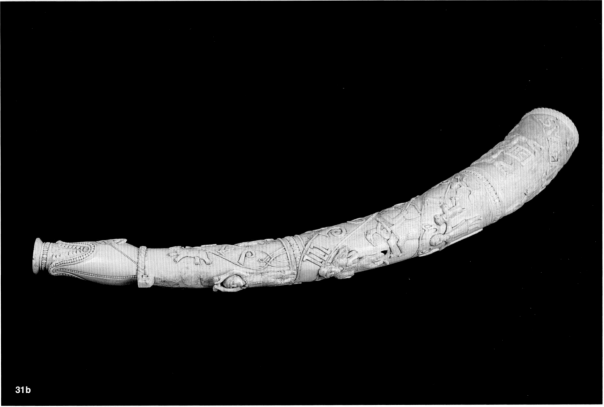

31b

30b. Sapi artist, Sierra Leone
Oliphant
15ᵗʰ-16ᵗʰ century AD
Ivory, 63 cm
Turin, Armeria Reale (inv. Q.10)

The oliphant from Turin is one of the most beautiful of the forty or so instruments found, both in terms of the elegance of its form and of the full-relief and bas-relief decoration, depicting fantastic monsters and deer-hunting scenes, copied from the margins of contemporary devotional books, probably the minuscule incunabulum *Horae Beatae Mariae Virginis* by Philippe Pigouchet of 1498.
Near the opening there are carved the blazons of the royal house of Portugal: the cross of the Order of Christ, the armillary sphere and the royal coat of arms. This, in the usual form of a shield, is hung from a tree trunk and flanked by two rampant unicorns. This image repeats with slight variations the stamp of the printer Thielman Kerver, who worked in Paris in the late 15ᵗʰ century: a coincidence which certifies the age of creation of the oliphants and, at the same time, confirms the European source of the decorative motifs embellishing its sides.
As far as regards the path which brought the precious instrument to Turin, it is very likely that it became part of the rich collections of the Duke already in the first decades of the 16ᵗʰ century, as part of the dowry of Duchess Beatrice of Aviz, daughter of the King of Portugal Emanuel I, who in 1521 married Charles III of Savoy.

31b. Sapi artist, Sierra Leone
Oliphant
15ᵗʰ-16ᵗʰ century AD
Ivory, 56 cm
Private Collection

Hunting scenes, mythological monsters — harpies and a centaur striking arrows — and an elephant with a small tower on its back, equally share the space in the bas-relief decoration of this instrument. The iconography of the elephant, clearly Indian with its large ears and because it is evidently tamed, is taken, like the other motifs, from a European source. A band wound in a spiral along the body of the horn bears the prayer in Gothic lettering: "DA PACEM DOMINE IN DYEB[US] N[OST]R[I]S."

IVORIES

BINI-PORTUGUESE

IVOIRES

BINI - PORTUGUESE

Sierra Leone was not the only region of Africa in which works destined for Europe were carved in the 16th century. Three oliphants, seventeen saltcellars and fifty-four spoons, collectively known as the "Bini-Portuguese" ivories, since they were produced in the ancient kingdom of Benin, are kept in European collections. The name is due to the combination of decorative elements typical of the Bini culture with Portuguese motifs, such as the costumes and weapons of the figures carved on the saltcellars (Bassani and Fagg 1988).

In European literature, works made for export in the ancient kingdom of Benin are mentioned for the first time in 1588, in the travel journal of James Welsh, "chief master" on the ship Richard Arundel (1904, 452), who wrote that in the Nigerian city it was possible to acquire "spoons of elephant teeth very curiously wrought with diverse proportions of fowls and beasts upon them". The claim seems late because the costumes and weapons of the Portuguese figures carved on the ivories probably predate the information provided by the British sailor by around half a century. Five spoons were already part of the Medici collections in 1560 (Bassani 2000b, nos. 486-490), nor can we rule out that some of the ivory works (*colhares* and *saleyros*) mentioned in the inventories of the Casa de Guiné of 1504-1505 among the goods imported into Portugal, may be of Nigerian origin (Bassani 2000, 180-181).

The Bini-Portuguese saltcellars differ from the Sapi-Portuguese versions both in their structure and decoration. They have two spherical containers, one placed on top of the other, a feature unknown in Nigeria and rare in Europe. The lower container, which is larger, and the lower part of the upper container, are enveloped by images of Europeans carved in the round and in full relief[1], and are covered by decorations which leave no part of the surface free: *horror vacui* is, in fact, a characteristic feature of Benin works. The movement animating many of the figures however marks the difference with saltcellars from Sierra Leone.

The presence of standing figures or riders makes it possible to subdivide Bini saltcellars into two groups: a first group, of six examples with standing figures, and a second, of eleven, with riders.[2]

Spoons is the largest group of Bini-Portuguese ivories in our possession (all the important ancient collections contain one or more examples) and are the only pieces mentioned in old European documents, even if incompletely and wrongly. On the handle various combinations of animals are carved in the round: birds, dogs, crocodiles, snakes, fish, shells, leopards, antelopes, monkeys and, in two unique cases, a European figure and a hand holding a 'handle' (Bassani 2000b, nos. 806 and 813).

The absolute perfection of the leaf-shaped bowl, and the absence of any decoration except the handle, have led some scholars to attribute spoon production to sculptors originating from Owo (and thus from the ethnic group of the Yoruba). They would have worked alongside Bini artists in the service of the *Oba* of Benin, and would have used their own motifs together with Bini and Owo iconography to decorate the ivories.

This theory is supported by the presence of small hollow cylinders carved into the

edges of the two halves of the upper container on the saltcellars of the group to which the piece on show belongs. This motif is almost inexistent in pieces of certain Bini manufacture. It is however relatively frequent in Owo ivory works; especially on the edge of the circular bases of some human figures and containers, whose date is uncertain but presumably prior to the 18th century, such as 13b and 14b on show here. The same motif is also found on terracotta sculptures, dated to the 15th century, which came to light during archaeological excavations in Owo (Eyo and Willett, 1980; Welsh, 1904).

As far as regards the location of the workshop in which the ivory works for export were carved, the most likely hypothesis is that it was near a port, probably the present-day Ughoton on the Rio Formoso, where Portuguese ships could drop anchor and trade with the emissaries of the Benin sovereign (see Bassani 2000, 297-304).

[1] Saltcellars with two containers placed one on top of the other do not correspond to the typology widespread in Europe in the 15th-16th centuries, nor are the vessels part of the *corpus* of traditional Bini products. In the case of the Bini-Portuguese saltcellars, the form may have been suggested by the customer, or adopted for compositional reasons, to allow the insertion of large figures which conceal the function of the containers.
[2] See Bassani and Fagg 1988, no. 115-118, 127 and 119-126,128. In the second group, riders and figures on foot in European costume are found alongside naked winged figures of an unidentified nature.

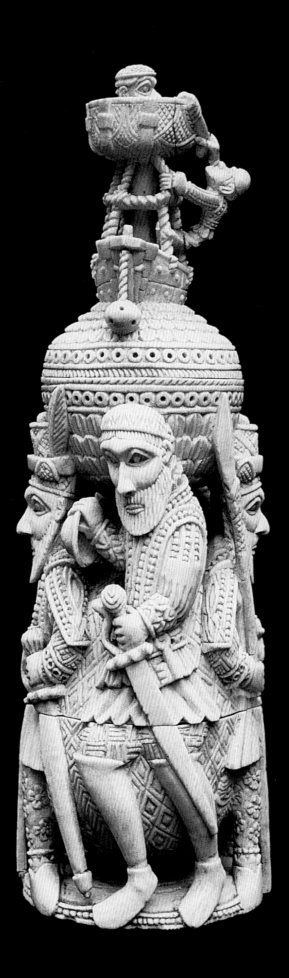

32b

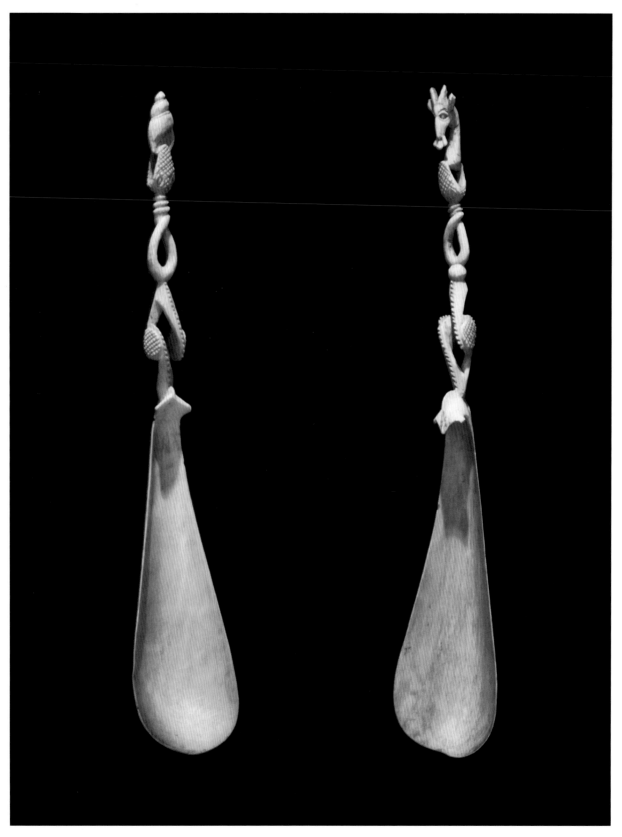

33b

34b

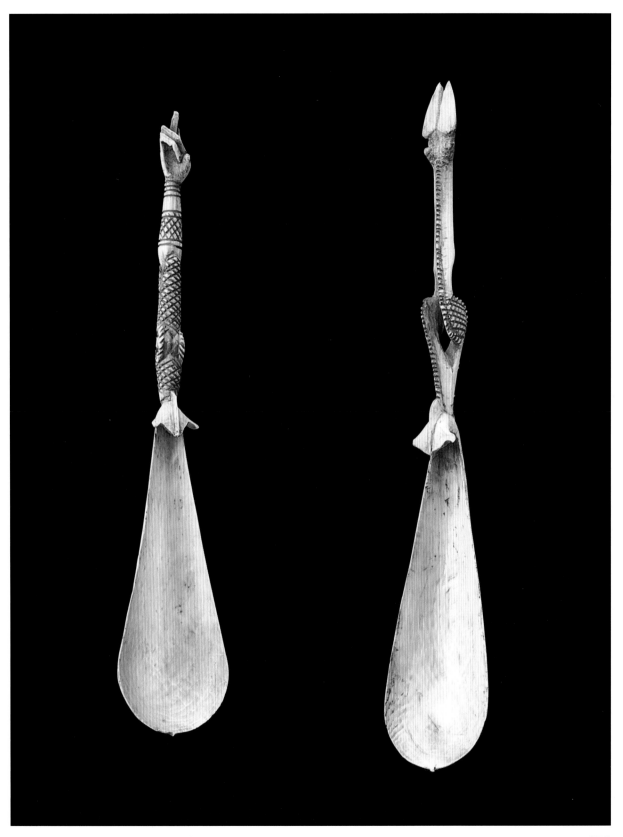

32b. **Bini or Owo artist, Nigeria**
Saltcellar
16th century AD
Ivory, 25.5 cm
Private Collection

This saltcellar is one of the two complete pieces decorated by two fully frontal figures interposed with two others in three-quarters profile, in a well balanced composition.

The figures resemble Portuguese important court personages, and their representation is common to illustrations contained in ancient travel books which may have been the models provided to the African sculptors; many details of the clothing employ elements derived from Manueline decoration, such as rows of grains.

The simplified form of the ship carved on the cover evokes that of mediaeval vessels, but not those used in long ocean voyages, which leads us to suppose that the African sculptors also used illustrations as their source for the ships. One detail however seems to require more careful consideration. The dynamic representations of the lookout on a sailor in the crow's nest and of another sailor climbing up the rigging decidedly contrast with the style of the ship and the imposing figures carved on the base. This suggests that the African artist saw the scene in real life, was struck by it and incorporated it into his work, adopting however a different expressive style, more in fitting with the impression it had made on him (Bassani 2000b, no. 793 and 285-304).

33b. **Bini or Owo artist, Nigeria**
Spoon
16th century AD
Ivory, 24.9 cm
Florence, National Museum of Anthropology and Ethnology,
Section of the Natural History Museum (inv. 216/1)
Former Medici collection

34b. **Bini or Owo artist, Nigeria**
Spoon
16th century AD
Ivory, 24.7 cm
Florence, National Museum of Anthropology and Ethnology,
Section of the Natural History Museum (inv. 216/2)
Former Medici collection

The two spoons (plus another three) were part of the property of the Grand
Dukes of Florence from 1560 onwards. They are thus the oldest documented
African objects belonging to a European collection, even if they were wrongly
described as "mother-of-pearl spoons". Subsequent records clarified the mistake
(Bassani 2000b, nos. 486-490), perhaps caused by the thinness and translucent
nature of the ivory which misled the writer of the first document.

35b. **Bini or Owo artist, Nigeria**
Spoon
16th century AD
Ivory, 22.5 cm
Paris, Musée du Quai Branly (inv. 70.2004.31.1)

36b. **Bini or Owo artist, Nigeria**
Spoon
16th century AD
Ivory, 25 cm
Paris, Musée du Quai Branly (inv. 70.2004.31.2)

The two pieces from the French museum display unusual iconography and add
new elements worthy of appreciation in the works of Bini-Portuguese spoon
carvers.

TRADITIONAL ART

Organising an exhibition of traditional African art is a disconcerting experience for a number of reasons, not least because of the sheer size of the undertaking. Offering a comprehensive vision was out of the question (how many works would we need? A hundred, two hundred, five hundred, a thousand?), so I decided to offer a sample of the various expressive forms invented by African artists, whilst aware that each choice is not only reductive but inevitably expresses the culture and taste of the person making the selection.

I should also warn the visitor that the groupings are somewhat arbitrary and ambiguous, and that the adjectives used to define the works belong to western terminology. African artists would definitely not have used terms so foreign to their culture.

Jean Laude (1966, 216-217) rightly warned that "the categories of the history of art cannot be transformed into universal aesthetic categories without introducing serious confusion into the analysis". Adjectives like "realistic", and even more so "expressionist", "cubist", "surrealist" or "abstract" have no equivalent in the critical vocabulary of Africans. For them, the figures or masks are the repositories of the spirits of ancestors or deities, i.e. of bodiless entities whose representation is aimed at allowing their communication with men, and cannot be conceived in terms of reality.

Nevertheless, as I've said on other occasions, we cannot in any way avoid "being trapped by the exportation of western aesthetic categories", as they were defined by Jean-Louis Paudrat (1978, 15); in other words, we cannot help but looking at African works of art with our own eyes, rather than as they were (or still are) perceived by Africans, especially those living in the country. The terms I have adopted for lack of more adequate ones are those which first come to the mind of a Western observer, who moreover soon realises that such categories express tendencies more than realities, and that since

they lack clear borders, expressive forms overlap each other.
On the other hand, the way we look at the works of art of our past also has little relation to the spirit with which our ancestors looked at them. A case in point is our attitude to works with religious themes or to those expressing the exaltation of power.
The two sculptures which open this part of the exhibition are in a sense emblematic.

E. B.

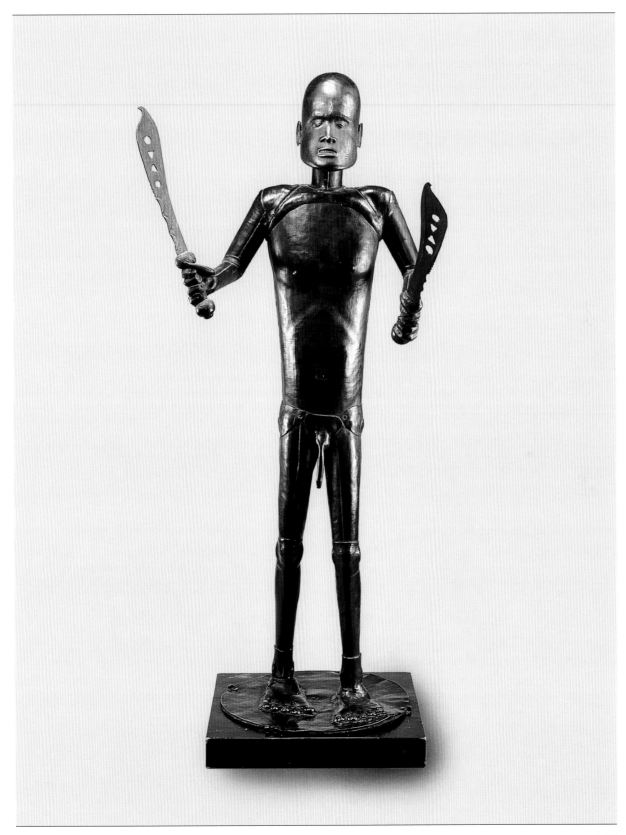

1c. **Huntondji Ganhu (?), Fen court artist,**
Benin Republic
Statue of King Glele
Before 1889
Wood, brass, 105 cm
Paris, Musée Dapper (inv. 2541)
Former collections "Treasures of the Behanzin King",
Achille Lemoine, bought by Charles Ratton in 1926

Due to its constructive technique, based on the assembly of separately profiled bronze sections, this famous work by an artist of the Fen people, representing King Glele (1859-1889) of the ancient kingdom of Dahomey and also the god of war, Gu, gives the impression of being an extraterrestrial creature or a ferocious yet regal robot, disconcerting in its powerful ambiguity.

2c. **Dogon artist, Mali**
Horseman
Wood and iron, 75 cm
Private Collection

The meaning of the figure of the Dogon horseman is not clear; some scholars believe that equestrian statues are images of *Hogon*, i.e. of religious chiefs, linked in some way to the myth of the creation of the world; others, more simply, consider them to be portraits of important figures in the society.
This example of undisputed monumental poise, is one of the finest examples of this kind of image, due to the harmony of its essential volumes, arranged in a composition of touching formal clarity, to the calculated proportion between rider and mount, and to the measured lines of the powerful volumes.
The sculpture, which has not been scientifically dated, displays some structural and formal similarities with a rider in a private collection (Leloup 1994, no. 112) dated to the 15th-16th century.

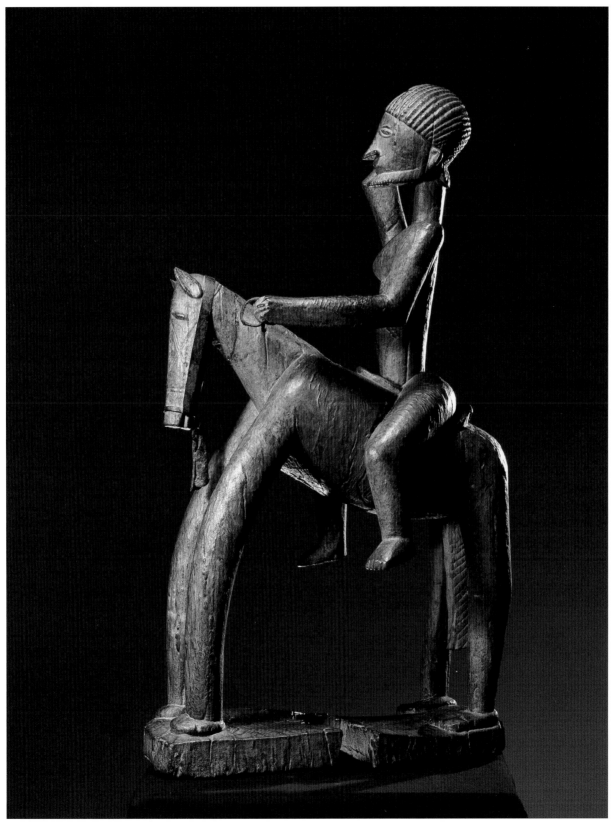

It may seem a little forced to apply the adjective "realist" to the sculpted works (figures and masks) grouped under this heading, especially if it is used to suggest the faithful reproduction of visible reality. Nevertheless, it is perhaps the best term to indicate the closeness of the works to their human models, while taking into consideration the iconographic conventions of each ethnic group and the creative choices made by the individual artists.

3c. **Luba Artist, Democratic Republic of Congo**
 Ancestral female figure
 Wood, 45.7 cm
 London, The Trustees of the British Museum
 (inv. AOA 1910.441)

Women are the most frequently represented subjects in Luba art, even though they rarely appear in the form of individual sculptures, but are usually incorporated in ceremonial instruments or symbols of power.
The sublime humanity of the figure on show — perhaps the most perfect sculpture of its type known — seems to express both the subject's importance and reserve. The subtle decoration, the large forehead and the simple yet elegant hairstyle, the firm cut of the lips and, above all, the large, perfectly-formed half-shut eyes, express an inner concentration and self-conscious dignity fitting to the prime position of women in the political and religious life of Luba society.

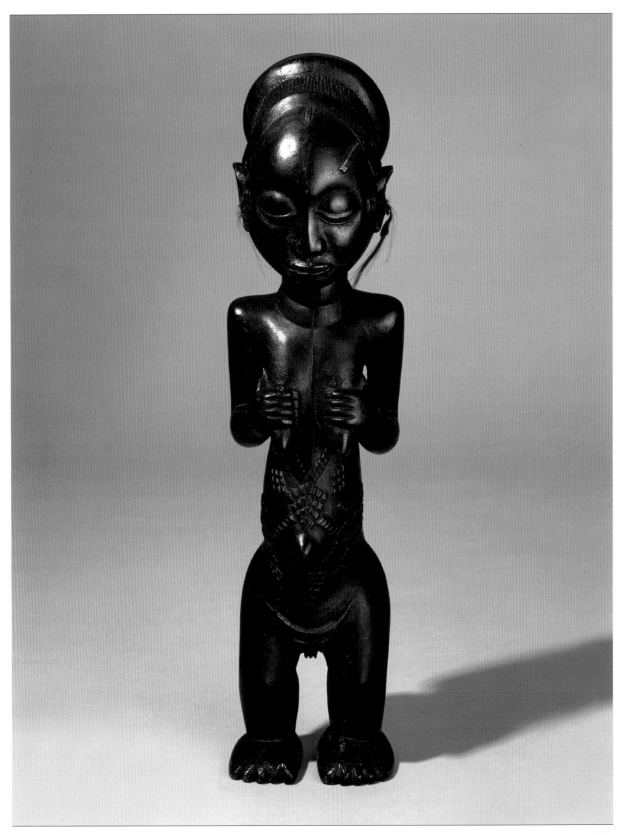

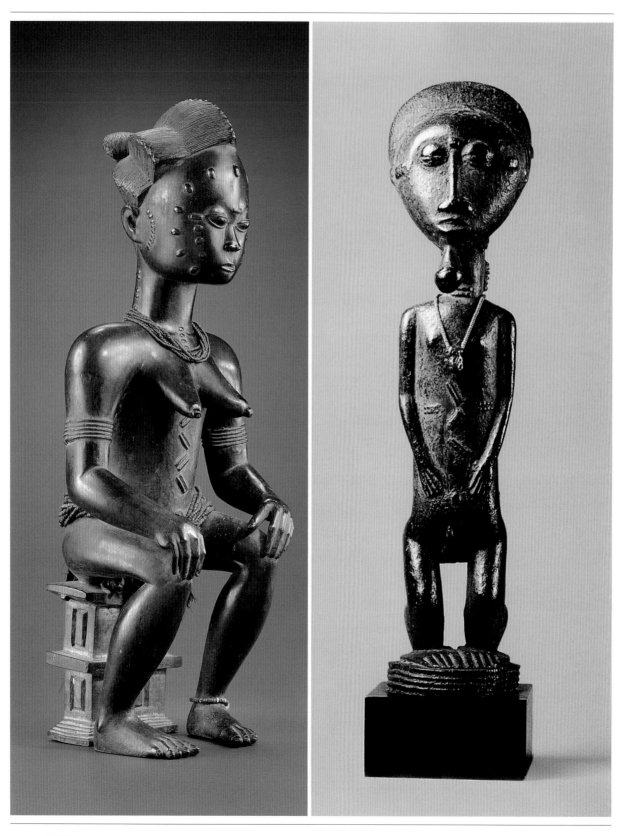

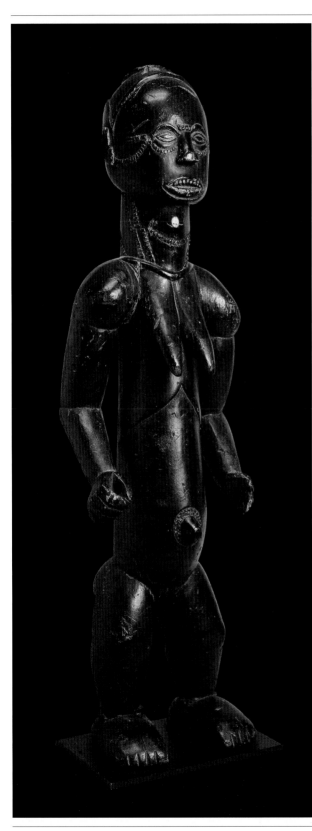

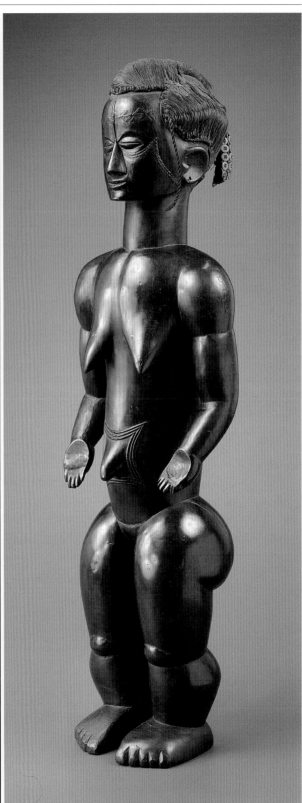

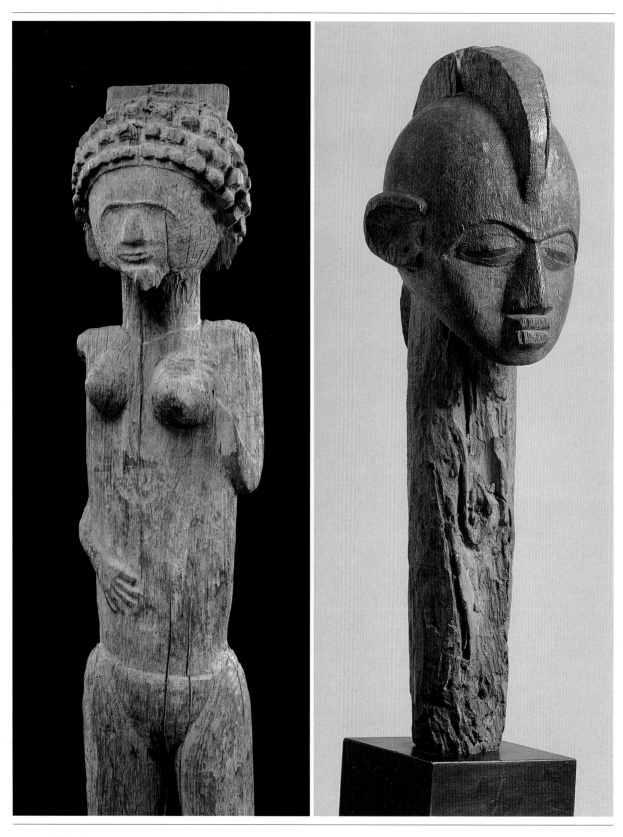

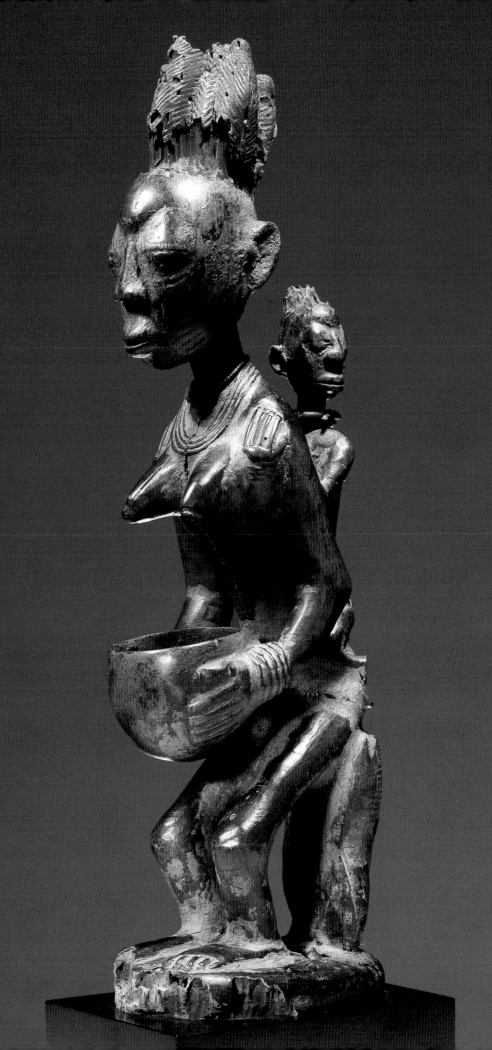

8c

4c. **Baule artist, Ivory Coast**
Human figure
Wood, pearls, fibers, 39 cm
Former R. Duperrier Collection
Private Collection

5c. **Baule artist, Ivory Coast**
Seated female figure
Wood, fibers, glass beads, 51.5 cm
Documentation Galerie Bernard Dulon

The human figures sculpted to "presentify" (make present) according to the apt term provided by Lucien Stephan (Kerchache, Paudrat, Stephan 1988, 239), the bride and groom which every Baule man or woman has in the other world — an entity to appease with particular attentions —, clearly express this people's ideal of beauty.

The images, stripped of excessive naturalistic detail, communicate a quiet solemnity, a reserved and shy dignity. The two figures are characterised by their tender studied forms and frontal arrangement. The terse forms, whose precious surfaces are adorned with subtly calculated patterns, have a secret life which is revealed in the subtle use of off-centre lines.

6c. **Bete artist, Ivory Coast**
Commemorating figure
Wood, fibers, nails, 64 cm
Collection Marceau Rivière

7c. **Bete artist, Ivory Coast**
Commemorating figure
Wood, dark patina, pigments, fibers, nails, 80 cm
Documentation Galerie Bernard Dulon

The Bete, a numerically large people who live on the banks of the river Sassandra, are known above all for their many terrifying masks. Their statues, meanwhile, used in ceremonies commemorating dead female ancestors, are quite rare, and are noteworthy for their sobriety.

The lines of the face are rendered with reliefs and subtle incisions tending more towards stylisation in the first figure. The sharp elegance of the beautiful pointed breasts matches the harmonious lines of the muscles, subtly hinted at and echoed by the movement of the bent and slightly open arms, in a pose of latent assertiveness.

8c. **Yoruba artist, Nigeria**
(Oshogbo region)
Maternity
Wood, 61 cm
Private Collection

The theme of mother with child is fairly common in Yoruba art. This beautiful group, probably made for a sanctuary dedicated to Shango, the god of thunder and lightning, depicts one of his worshippers.

Complexity of design and formal unity distinguish the sculpture. The bodies of the two figures are conceived as independent entities, and this detachment is emphasised by the son's turned head, which has the adult lines of the woman and the same thoughtful immobility. Nevertheless, at the same time, the two figures are indissolubly linked, as the boy's large hands clasp his mother's shoulders in an imperious, public declaration of ownership.

Evident analogies, or least correspondences in the details, with works whose geographical origins are known, (Fagg 1968, no. 118 and *Yoruba* 1991, no. 97), lead us to attribute this sculpture to a great master active in the area of Oshogbo (a central-northern region of Yoruba country). Faithfully interpreting his people's stylistic canons, he created a most personal work, moving in its human and spiritual expressiveness.

9c. **Lobi artist, Burkina Faso**
Head on a long neck
End of 19th - beginning of 20th century
Wood, 44 cm
W. & U. Horstmann Collection

Heads with long necks and full figures, that the Lobi keep in special sanctuaries, serve to combat misfortune, illness and the evil spells of sorcerers.

The great formal severity and the subtle rendering of the face, together with the atmospheric patina, give this head an aged appearance of touching nobility.

10c. **Sakalawa artist, Madagascar**
Funerary statue
Wood, 104 cm
Paris, Private Collection

According to a custom which dates back to the 17th-18th century (see *Sculptures* 2000, 210-212), the Sakalawa people from the south-western region of Madagascar marked the tombs of important figures with a funerary pole upon which stood one or more human figures.

Time has taken its toll on this fascinating female figure distinguished by its great sobriety, but also here has left its expressive qualities intact. The subtle arrangement of the volumes, the rich hairstyle and the rhythmic movements of the figure's arms have not been affected.

11c. **Chokwe artist, Democratic Republic**
of Congo (Southern Kasai)
Mask (*Phwo*)
Wood, fibers, metal, 21 cm
Tervuren, Musée Royal de l'Afrique Centrale (inv. R.G. 43143)

The term "realism" can also be applied to masks, beginning with this beautiful Chokwe example from the museum of Tervuren, an idealised symbol of woman, the ancestor and source of life.

The features drawn with surprising faithfulness and equal sobriety animate the luminous surface of the delicate oval face. The horizontal cut of the large, well-formed lips combines with the half open eyes to suggest a sort of interior concentration, also evoked in the luxuriant and equally "savage" hairstyle.

Marie-Louise Bastin attributed this mask to the style of the period of expansion, when the Chokwe in the second half of the 19th century, began to emigrate towards the Kasai from their "country of origin", the regions of Moxico and Muzamba.

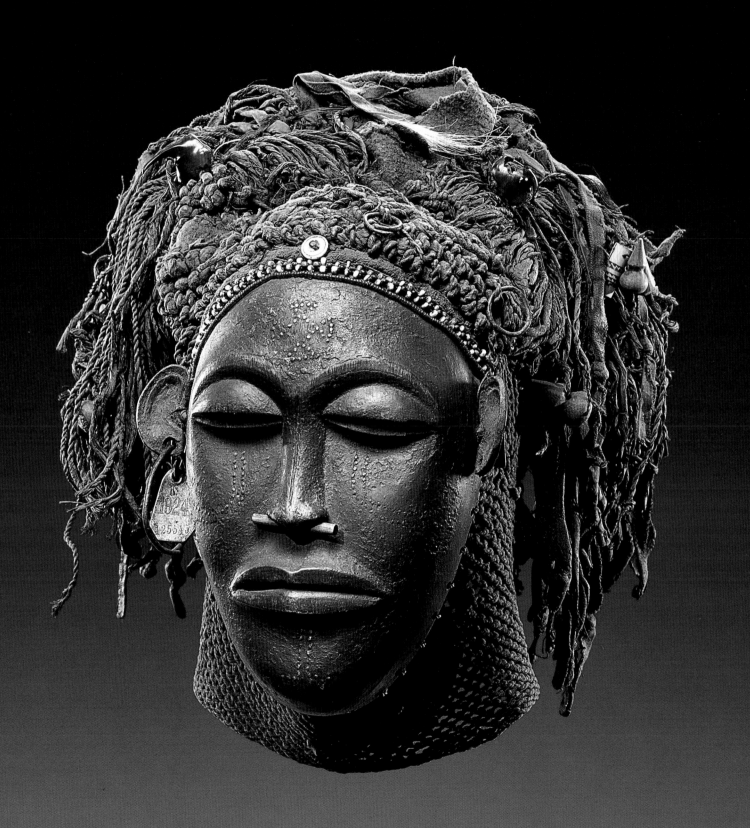

11c

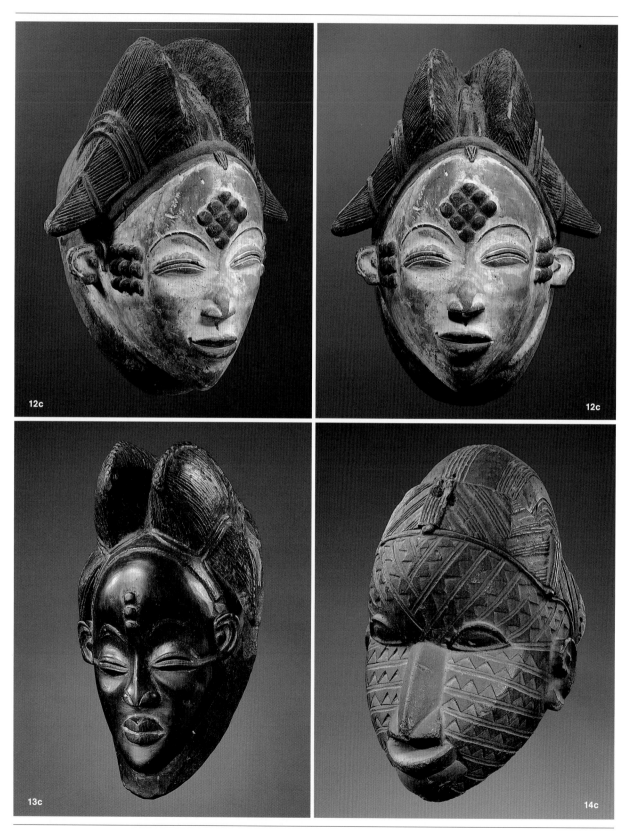

12c

12c

13c

14c

12c. **Punu artist, Gabon**
White mask
Wood, 28 cm
Documentation Bernard Dulon Gallery

13c. **Punu artist, Gabon**
Black mask
Wood, kaolin, 32 cm
Documentation Bernard Dulon Gallery

Naturalism and spirituality combine harmoniously in the masks sculpted by the Punu artists from the Gabon, who achieve results of sublime perfection in the most successful examples.

Masks like the first of the two on show were once used in funerary ceremonies, where it seems that they served to pacify the spirits of beautiful girls who had died prematurely.

The white mask, which conserves part of its white patina of kaolin, follows the classic model, and is notable for the sweetness of its soft and regular but not sentimental lines, harmoniously expressed in the oval face, whose slight asymmetry gives it life. A similar technique is used on the oriental-cut eyes, which are almost imperceptibly set at different levels, on the eyebrows, the ears and the scarifications, and on the slightly misaligned yet beautiful lips, with respect to the perfectly regular nose. These apparently minor touches show the artist's great sensitivity.

The function of the black Punu mask, similar to the previous one but rarer, has never been identified with precision. Some scholars have suggested that the black masks had a role in the administration of justice. The harsher colour and lines of the face, and above all the haughty expression on the lips, give the work an aura of authority and reserve.

A mask almost certainly made by the same artist, and now kept at the Musée du Quai Branly, was part of the Vlaminck collection.

14c. **Yoruba artist, Nigeria**
Mask
Wood, 23 cm
Private Collection

The helmet shaped masks of the Gelede cult of the Yoruba, practised mainly in the regions straddling the borders between Nigeria and the Republic of Benin, are used on the occasion of annual festivals aimed at promoting the community's well-being and social harmony.

The decoration with bands of affronted triangles, which covers the face and forehead of the example on show in a regular pattern (an extremely rare design) and continues in the simple and elegant lines of the hairstyle, goes beyond mere "realism" to enter the realm of "decorativism".

Bass relief decoration and the use of colour are not frequent practices in African art. However, when they are used, artists show surprising imagination, while respecting the symbolic motivations behind their creativity

15c. **Bamileke artist, Cameroon**
(Baham kingdom)
Seated figure
Wood, glass beads, fabric, 84 cm
Private Collection

The covering of many statues, seats and attributes of royalty with a colourfully festive "skin" of pearls threaded on fabric is a particular invention of artists from Cameroon. Without affecting the structural plastic values of the works, this technique makes it possible, at the same time, to transmit precise messages through colours and their arrangement and combination.

This figure, with its large flat head and slender cylindrical limbs, has all the attributes of a sovereign, such as the pipe with an extremely long barrel, a horn for libations of palm wine and a pumpkin flask for containing it. The royal symbolism is strengthened by the heads of two lively leopards on which the sovereign's feet rest. This is a powerful and precious image which testifies the African artists' wide-ranging ability to respond to their societies' religious and civil needs, each time with new and appropriate solutions.

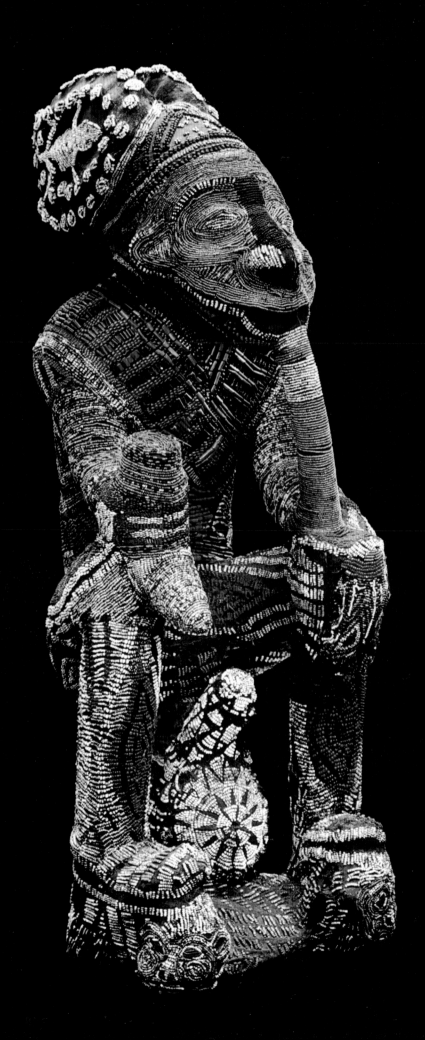

15c

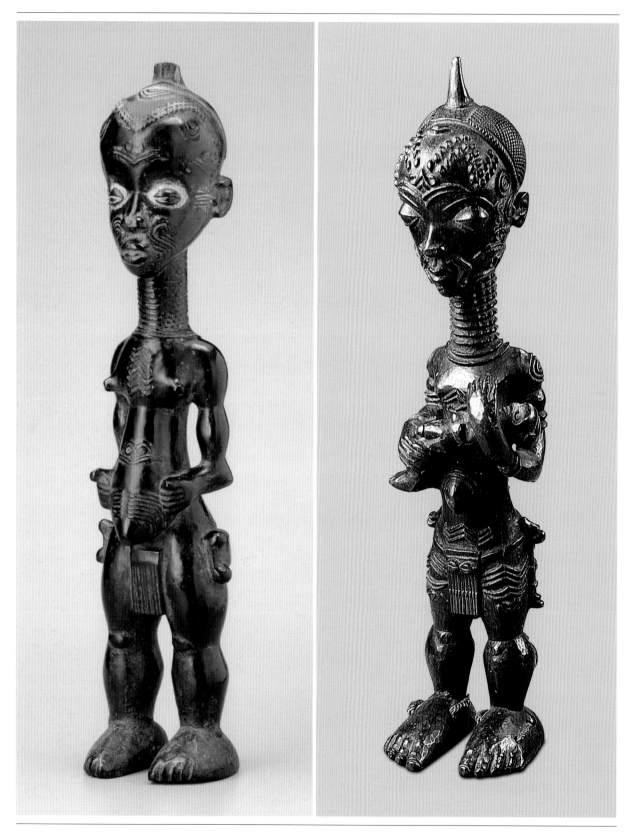

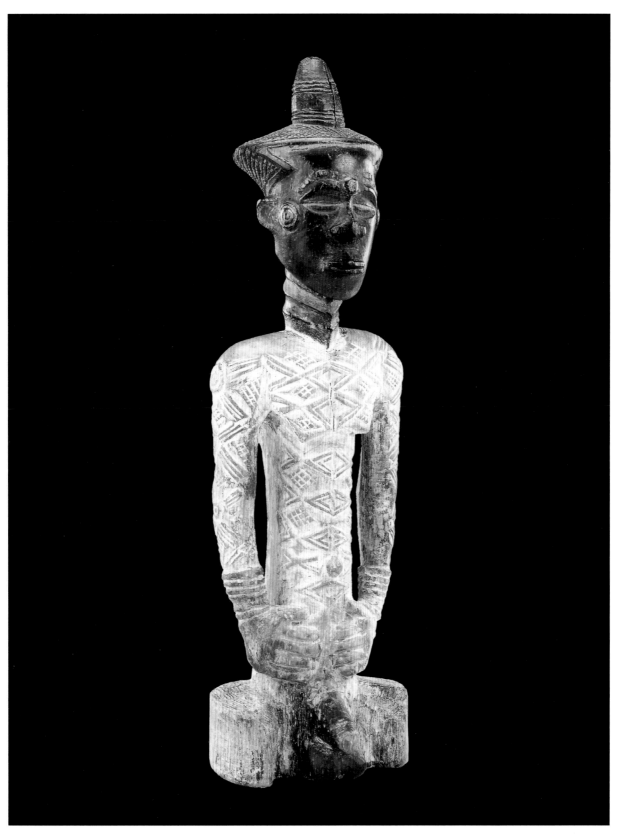

16c. **Luluwa artist, Democratic Republic of Congo**
 Maternity
 Wood, 41 cm
 Tervuren, Musée Royal de l'Afrique Centrale (inv. R.G. 18805)

17c. **Luluwa artist, Democratic Republic of Congo**
 Female figure
 Wood, 47 cm
 Tervuren, Musée Royal de l'Afrique Centrale (inv. RG.43850)

Body decoration is a peculiar trait of Luluwa sculpture, and echoes a cosmetic practice widespread among the women of the upper classes.

Figures of mothers with children or of pregnant women are associated with the fertility cult, and were sculpted for mothers who had aborted or had continually lost children on the suggestion of the priest-healer, in order to encourage normal pregnancies. The tattoos, considered signs of beauty, indicated the high position of women in society, and disappeared over a century ago; the motifs, however, were represented on the sculptures in an exaggerated form.

The first of the works on show is a fine example of these propitiatory images. An elegant decoration of cleverly arranged cheloids covers the disproportionate spherical forehead and cheeks, and is echoed in the slender ringed neck and in the motifs which subtly decorate the bright slender body. The diagonal position of the tender baby, trustingly lying in its mother's arms, provides the composition with dynamic movement.

An extraordinary reserve seems to compensate the joyous nudity of the young body of the second figure, covered by a simple loincloth, and articulated in elegant globular volumes, exalted by the shiny patina, achieved by daily rubbing the statue with a mix of oil and red earth.

18c. **Ndengese artist, Democratic Republic**
 of Congo (Western Kasai)
 Human figure
 Wood, pigments, 53 cm
 Tervuren, Musée Royal de l'Afrique Centrale (inv. RG.3699)

Sculptors of the Dengese, a small people of the Kasai region related to the Kuba, are above all famous for what are probably figures of royal ancestors or chiefs, collected in the past. The austerity of the form is tempered by the bright and sumptuous bas-relief decoration, which envelops the bust and the arms in an arcane sheath. The complex ordered geometric motifs which compose it are a sort of sign language (*Tresors* 1995, no. 143). The fluid structure, the upwards movement, the contrast of the white column of the body with the black of the head, and the dignified control of the features, contribute to forming a bright yet mysterious image, with an aloof dignity.

If we take "expressionism" to mean the deformation or exaggeration of reality for expressive purposes, many Chokwe sculptures could be termed "expressionist", due to their arbitrary amplification, not only in terms of size, of certain parts of the body such as the hands and feet.

19c. **Chokwe artist, Angola (Moxico school)**
 Figure of Mwanangana chief
 19th century or before
 Wood, leather, 35.5 cm
 Lisbon, National Ethnology Museum (inv. AA.964)

20c. **Chokwe artist, Angola (Moxico school)**
 Seated chief
 19th century or before
 Wood, copper, brass, fibers, glass beads, 43 cm
 Lisbon, Ethnographic Museum of the
 Sociedade de Geografia (inv. SGL-AB-924)

The perfect marriage of power and finesse distinguishes both this highly beautiful standing figure from the National Ethnology Museum and the seated figure from the Sociedade de Geografia, which, along with only a few other sculptures, Marie-Louise Bastin attributed to the 19th century and to the style of the "country of origin". These two absolute masterpieces display a finely-measured blend of Apollonian grace and expressive strain, of realistic features and hyperbolic exaggeration, revealing the skill, and creativity, of two great artists.
The small head with its authoritative features is magnified and placed in proportion to the figure's overall size by the immense construction of the fantastic, albeit realistic headdress, in which rounded forms and Baroque Bernini swirls harmoniously unite, as if to suggest the perfect marriage of power and finesse mentioned above.
The first sculpture represents the legendary foreign hunter Chibinda Ilunga, who, according to oral tradition, started a new Chokwe dynasty by marrying Lueji, the daughter of the dead chief.

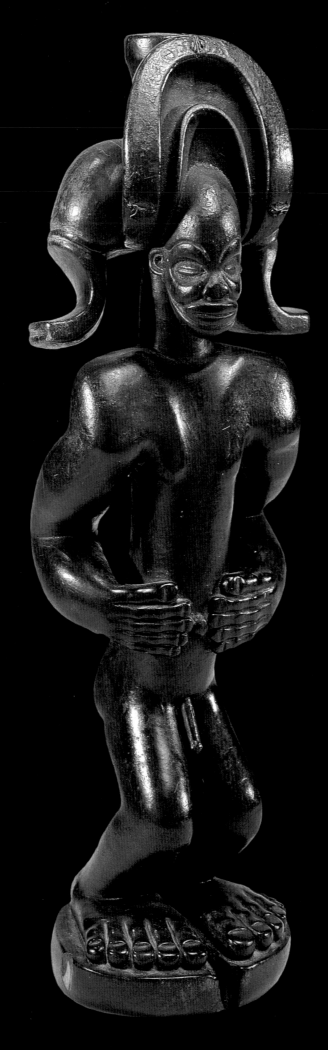

19c

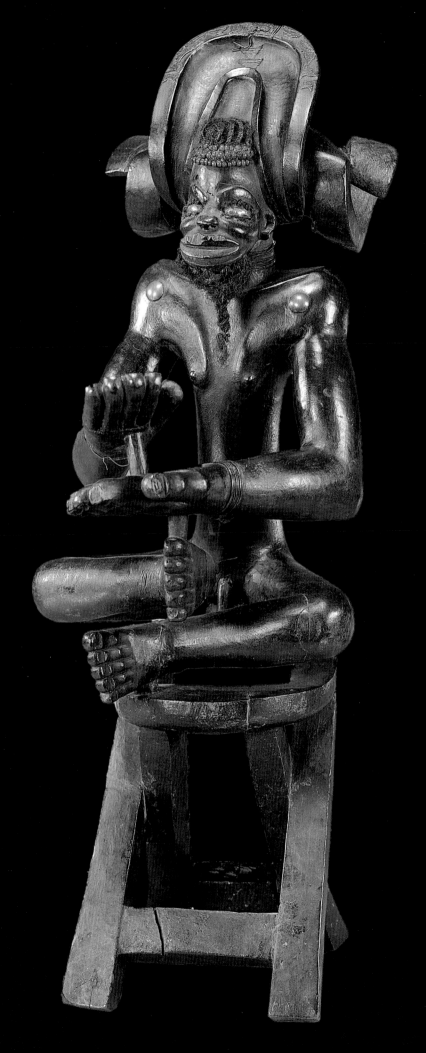

20c

The label of "cubist", applied to the representation of men and objects with geometrically recognisable forms, has frequently been used to describe works of African art, due to the treatment of the various parts of the human body as independent and volumetrically defined elements and due to their apparently arbitrary assembly. In reality, as I have already said, the artists not only were unaware of this definition, but would have rejected it, since they considered their distortions of visible reality as metaphysical rather than formal in nature.

21c. **Bangwa artist,**
Cameroon (kingdom of Batufam)
Portrait of the Queen Nana with child
Circa 1912-1914
Wood, 103 cm
Toronto, Collection Art Gallery of Ontario (inv. Acc.2004/68)
Gift of Dr. Murray Frum, 2004

The sculpture on show is the image of Queen Nana, wife of King (*fon*) Metang who acceded to the throne of Batufam in 1912. On the occasion of the enthronement of each sovereign, an effigy was made of the king and of the first queen whose pregnancy would prove his virility.
The work is distinguished by the bold articulation of the peremptorily defined masses: the spherical head animated by the strong and expressive lines of the face, the perfect cylinders of the strong neck and limbs, the pregnant abdomen, the large conic breasts. In the side and rear views, the decomposition and reduction of the parts of the body to pure volumes is even more evident. The volumes are however organised according to strict compositional rules which, while not ruling out movement (which is only hinted at), ensure the image's formal coherence and monumental poise, without compromising its explosive vitality.

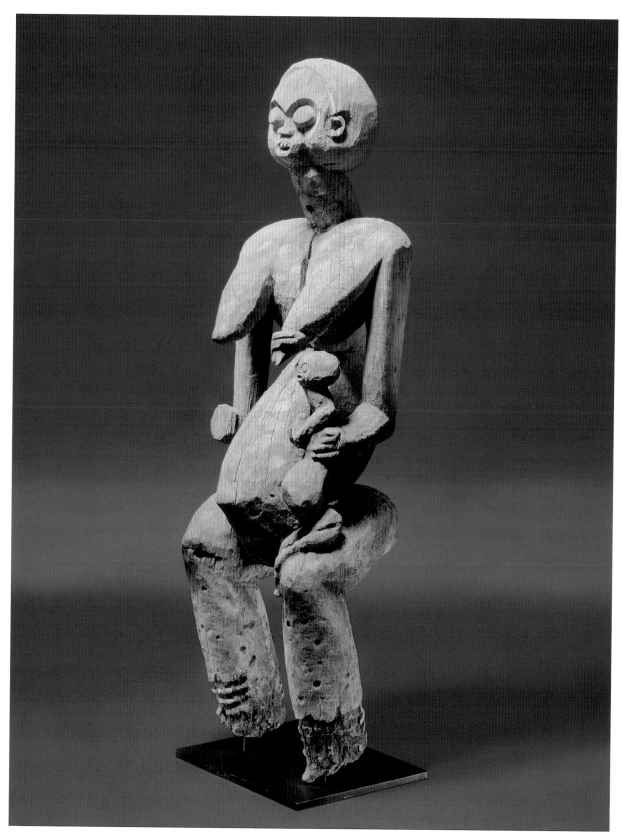

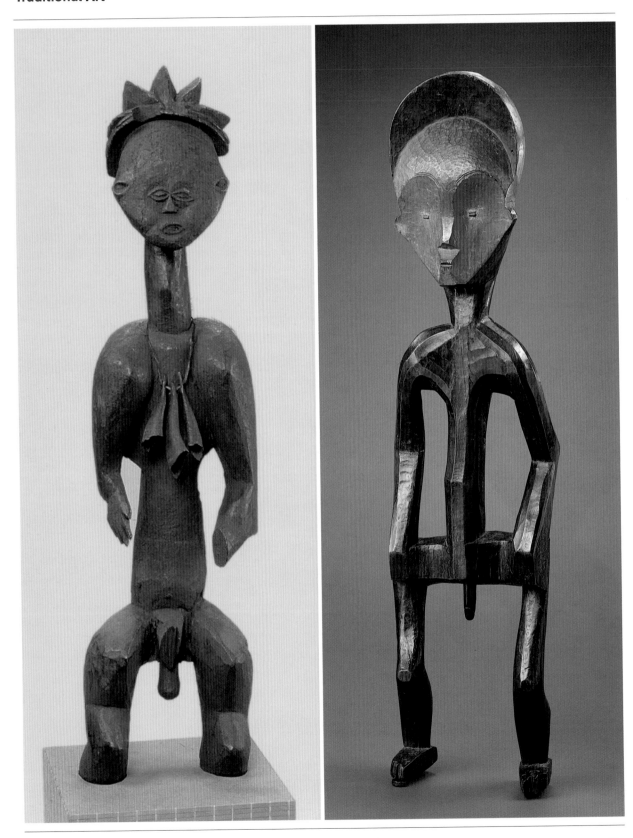

22c

23c

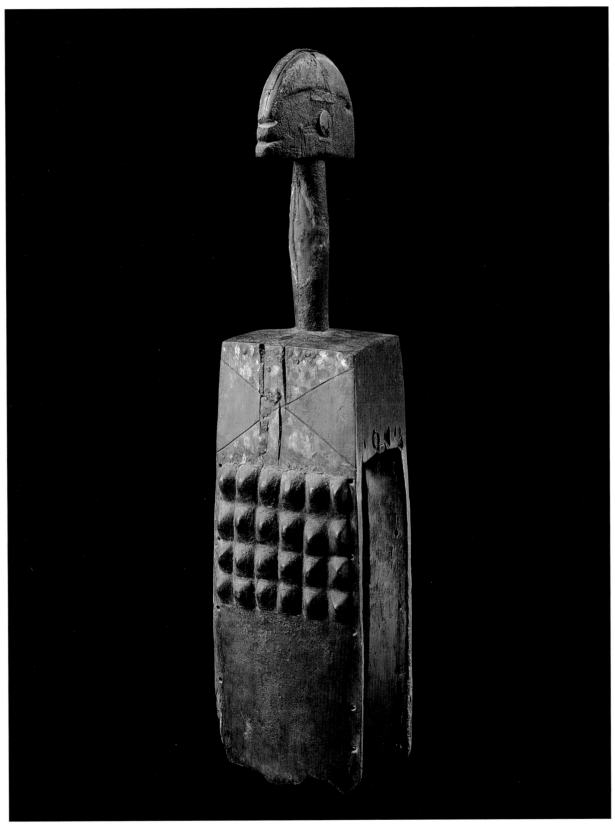

22c. Suku artist, Democratic Republic of Congo
Male figure
Wood, horn, leather, 89.7 cm
Tervuren, Musée Royal de l'Afrique Centrale (inv. R.G. 65.38.1)

The decomposition into independent volumes also distinguishes this rare figure probably for magic/religious use (judging by the horns hanging from its neck), which is an exceptional example of Suku art.
Large rounded yet pointed blocks compose an animated structure, which changes according to the angle from which it is viewed, and yet remains unitary and harmonious. A curious asymmetric hairstyle sits atop the beautiful oval head, where the miniscule features of the face are outlined under a disproportionately large forehead.

23c. Mbole artist, Democratic Republic of Congo
Human figure
Wood, 94 cm
Switzerland, Private Collection (courtesy of Entwistle, Londres)

The reduction of the human body to a set of geometric forms and a tendency towards abstraction are recurrent characteristics in Mbole statues. The piece on show is distinguished by the essential lines of its volumes and the orthogonal arrangement of full and hollow spaces according to a strict design.
According to scholars of Mbole culture, statues like this represent a man hanged for having violated the secrets of the *Lilwa* society, and acted as a warning to the initiates of the society.

24c. Mumuye artist (?), Nigeria (Benue region)
Shoulder mask (?)
Polychrome wood, 128 cm
Brussels, Private Collection

The use, meaning and very ethnic origin of this monumental work are uncertain; the indication "shoulder mask" given by W. Gillon (1979, fig. no. 82), which tentatively attributed the work to the Waja, leaves some perplexities regarding the absence of holes for the eyes in the two pieces of wood which form the "yoke". There is however no doubt that the artist is a real master in the concise rendering of the human form, which displays much more severe stylisation than in other similar works known. Strict proportional relationships govern the construction of the presumed bust: a parallelepiped with rectilinear outlines, with bas-relief decorations whose geometric austerity is softened by the round elements composing them. The flattened crescent-shaped head, a real masterpiece of understatement, fits with the underlying structure and perfectly combines with its linear economy.

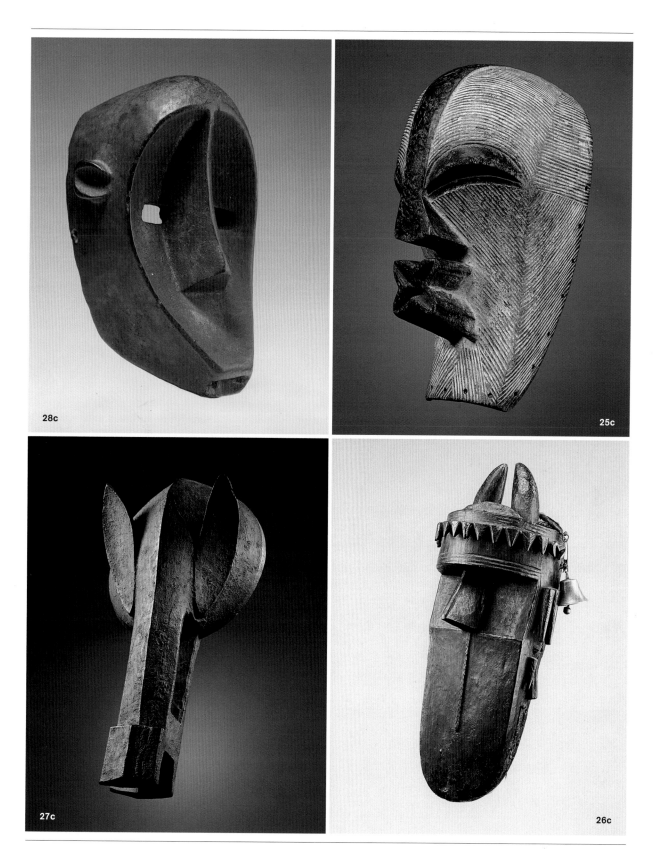

28c

25c

27c

26c

25c. **Songye artist, Democratic Republic
of Congo**
Mask
Polychrome wood, 43 cm
Private Collection

The masks of the Songye were worn by members of male secret societies both
for exercising social and political control over the territory and for the forced
levy of tributes for the heads of the societies themselves. The masked dancers
were perceived as supernatural creatures, alien and ferocious beings whom it
was impossible to oppose.
The example on show is of striking severity due to the clearness of its decisive
and harsh volumes, and their precise grouping. The volumes seem taken from a
manual of geometry: a pyramid and a starred parallelepiped which emerge, po-
werful and perfectly aligned, beneath a hemispherical forehead. A dense and
skilfully executed network of white kaolin incisions entirely covers the mask,
exalting the dark lines of the face. The head is of a monster, a gigantic man-in-
sect of extreme expressive violence, which the rigid geometry of the features
does nothing to make less disturbing.

26c. **Toma artist, Guinea (Kuglema village)**
Mask of the *Poro* society
Wood, metal, 54 cm
Brussels, Private Collection

The horns are the only elements in which the artist breaks the geometric for-
mality characterising this mask, a successful blending of a human head and that
of an animal. The arbitrary lengthening of the face, giving an impression of
movement by a slight change of inclination, is marked by a sort of horizontal
divide and by the delicate central relief which follows the movement of the
nose and vertically divides the smooth surface. The clear cut of the protruding
forehead and the crown of small stylised horns, turned downwards, provide the
composition with a dramatic element which is offset by the soft curve of the
chin, as regular as if drawn by compasses.

27c. Bamana artist, Mali
Mask-headdress of the *Kono* society
Wood, sacrificial materials, 50 cm
Private Collection

The mask-headdresses of the *Kono* society, worn horizontally on the head by a dancer hidden under a costume covered with feathers, had a function, in the Bamana world of the past, to promote the fertility of women and of the fields and, above all, to intimidate soul-eating creatures (Colleyn in *Bamana* 2001, 188). The nature of the represented animal is disputed: according to some scholars it is an elephant, albeit highly stylised.
A skilled fusion of apparently irreconcilable straight and curved lines distinguishes the piece on show. The presumed trunk, a parallelepiped which is compact and at the same time light thanks to the two cavities, flows with extreme naturalness into the hemispheric skull. The transition is underlined by the thin and forceful ridge, which runs along the entire length of the sculpture.
The extremely elegant leaf-shaped ears and the fine relief work at the tip of the trunk, perhaps evoking the nostrils of the elephant (the ears and relief are unusual in this type of mask), conform to the extreme plastic economy of this piece which, in its geometric purity, displays a certain realism.

28c. Bamana artist, Mali
Mask of the *Kore* society
Wood, 25 cm
Milan, Extraeuropean Collections - Municipal Collections
of Applied Arts and Engravings, Castello Sforzesco
(inv. n.3.2000.n.7)

The *Kore* is the last of the Bamana initiatory societies. It has eight degrees and shows man the path from bestiality to wisdom. Each degree, which is reached after a period of apprenticeship, has its own zoomorphic mask or particular emblem. The monkey mask distinguishes the eighth grade, and the dancers who wear it mimic the movements of the animal. The dances take place at the end of the dry season to pray for abundant rains.
This example, one of the most abstract and perfect of those known, reveals the hand of a great sculptor. An uninterrupted ridge limits the perfect concave form of the animal's snout. From this emerges the imperious and perfectly triangular nose whose root is naturally joined to the top of the ridge itself, giving unity to the structure. The rectangular eye openings illuminate the base of the depression without interrupting its continuity. The sculpture, realised with an extraordinary economy of means, is impressive for the precision of its absolute volumes, of its essential and unchangeable curves.

The ambiguity of western terms, and their inadequacy in defining the creations of African artists, is emblematically seen in this work by a sculptor from Cameroon, which has been tentatively defined as "cubist" due to its strict decomposition into independent volumes, but also "surrealist" due to its ability to evoke mysterious worlds.

29c. Bamileke artist, Cameroon
Monumental mask said "Batcham"
Wood, 96 cm
Brussels, Private Collection

The function of masks such as this (we know of a dozen) is uncertain, but seems in some way connected to the royalty of the small Bamileke *chefferies*. Tamara Northern (1984, no. 99) suggested that they were used in the ceremonies for the coronation of a sovereign and for his funeral; according to Pierre Harter (1986, 39) they may also have had a role in the nomination of his successor. The various elements of the monumental head, stripped bare of their natural referentiality, act independently within an ordered system in which the decomposed, superimposed and counterpoised volumes are arranged in a coherent expressive whole. The extremely high forehead, stretched like a sail with a thin crest running down the centre, dominates the powerfully protruding block of the cheeks, of the nose and, above all, of the disproportionate mouth. Erosion has almost entirely cancelled the subtle geometric decoration which covered the surface, bringing to light the living fabric of the wood fibres beneath and making the sculpture seem to throb with inner life.

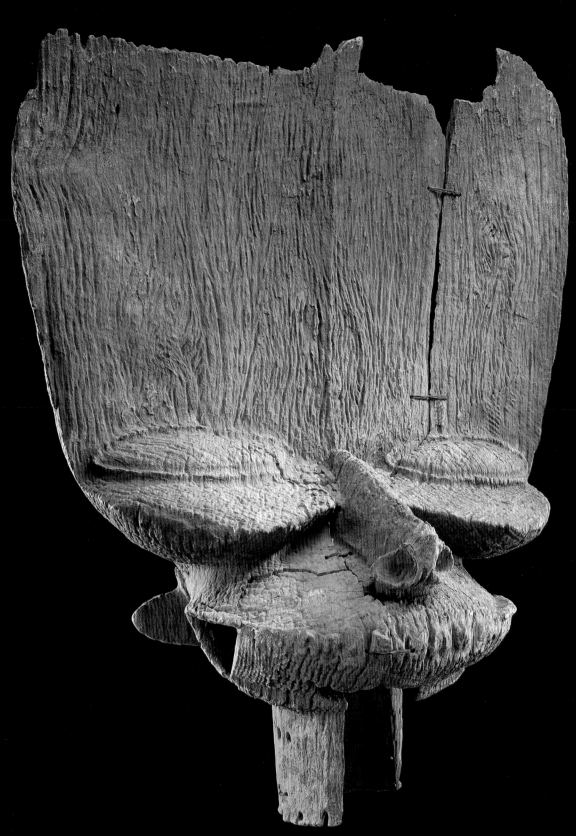

29c

The overturning of perception and the introduction of an imaginary reality distinguish the artistic movement known as "Surrealism", which was popular, particularly in France, in the twenties.
African art offers more than one example of creations which we would define "surreal" (whose formal motivations are however unknown), although the African artists would never have used the term, since it defines a concept foreign to their culture.

30c. **Chamba artist, Nigeria**
Ancestral couple
Wood, 58 cm
End of 19th - beginning of 20th century
W. & U. Horstmann Collection

The meaning and purpose of sculptures such as this one, extremely rare in Chamba art and in African art as a whole, still remain obscure, although the artist's creative skill is evident.
Two figures, apparently a woman and a man indissolubly linked by a common pelvis and a single pair of legs, seem condemned to live together for eternity, yet at the same time are isolated in a metaphysical solitude, underlined by the strongly expressive but blind faces, turned forwards.
The head with simplified lines, the arms unnaturally joined to the body and the large disarticulated hands intensify the emotional impact of this fascinating lunar couple.

31c. **Zande artist, Democratic Republic of Congo**
Anthropomorphic *Sanza*
Wood, fibers, 61 cm
Tervuren, Musée Royal de l'Afrique Centrale (inv. R.G.7602)

The *sanza* is an extremely common musical instrument in Africa. The sound issued from the plucked reeds is amplified by the sound box to which they are attached. The example on show is highly exceptional, and not only because of its size. The human appearance given to the instrument does not have functional motivations, and the form perhaps responds to an unidentified religious-cultural symbolism. However, in the light of the result, it is also clearly dictated by aesthetic considerations on the part of the artist, who was obviously a genius.

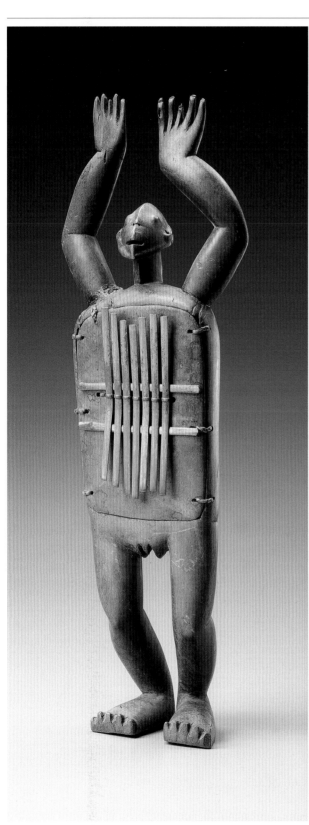

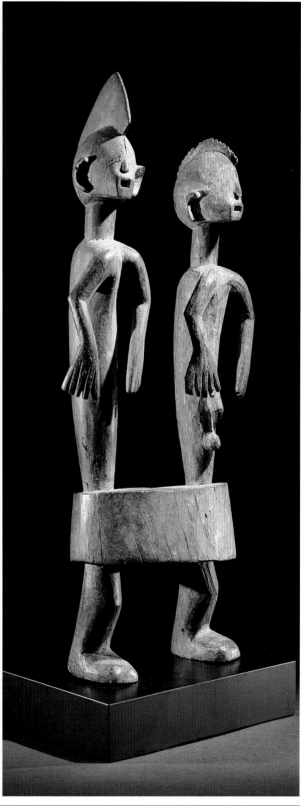

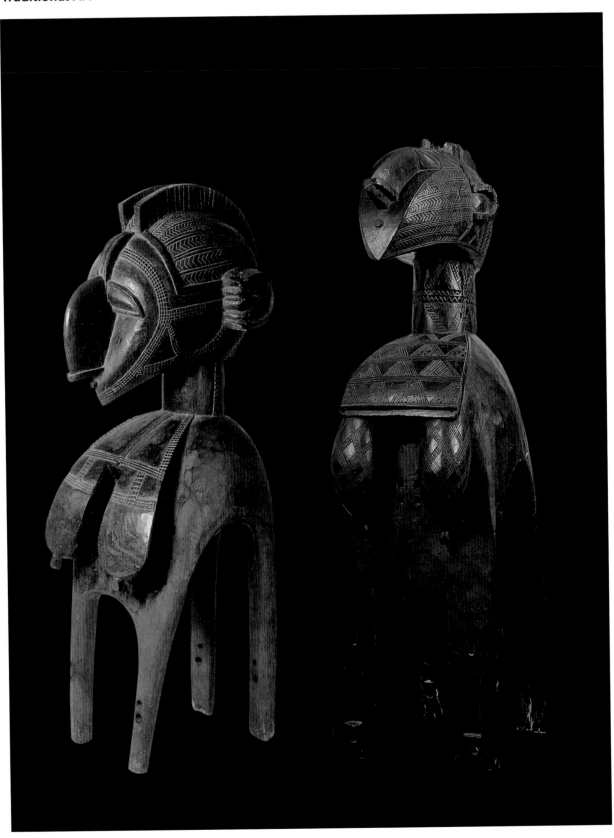

32c

33c

The work convincingly unites sound and its effect, in other words dance. Note how movement is rendered by the slight bending of the legs and, above all, by the fluid movement of the raised arms, amplified by the open hands, which are enormous compared to the intentionally small head, seemingly of some mysterious insect. This disproportion underlines the power and position of the limbs and exalts their expressiveness.

32c. **Baga Artist, Guinea**
Shoulder mask
Wood, 136 cm
Marceau Rivière Collection

33c. **Baga/ Landuma/ Nalu artist, Guinea**
Shoulder mask
Wood, 120 cm
Paris, Larock Collection

The *D'mba* (*Nimba* in current language) dance headdresses, large female busts resting on four "legs" which served to support them on the shoulders of the dancers hidden by a large cloak of fibres, are the best known artistic creations of the Baga people from Guinea, for the first time brought to light in 1886 (*Le Tour du Monde* 1886, I, 273-374).
D'mba, according to modern Baga informers (Lamp 1996, 158) is not a spiritual entity, nor even a deity, but certainly possessed enormous spiritual power. Promising children and abundant crops it came out, in the past, above all during the ceremonies linked to the sowing and harvest of rice.
The first sculpture, with its heavy forms, perfectly exemplifies the classical African notion of unlimited expansion and growth. The imperiously protruding volumes, the firm cuts and the imperious curves harmoniously interact to form a majestic and coherent composition of clear structural compactness and great visual impact.
The second mask illustrates a less frequent type and differs substantially from the first in the distribution of volumes and the angular outlines. The small aggressively pointed head, seemingly of some disquieting fantastic insect, stands over an imposing bust in which the breasts are the only elements, and whose full roundness suggests a still active source of nourishment.
The engraved decoration adorning the parts of the mask not usually covered by the fibre costume, together with the splendid patina, add value to the works and heighten their sculptural quality.

The word "mask" has a multiple meaning. In today western cultu-re it commonly indicates a covering of the face to hide the features of the person wearing it for games or theatrical purposes. In traditional African cultures it has, or had, a much wider cultual and religious function, as a powerful and mysterious instrument with which the masked individual cancelled his human nature to acquire a supernatu-ral one, to give life to immaterial forces which could exercise social control at the service of the community. Over the years, the rites in-creasingly became a profane spectacle, and the formal quality of the works diminished.

Even when they represent a human face, African masks are extremely varied in their shape and size, in accordance with the expressive styles of the various peoples but also of the creative skills of the various arti-sts. The four masks on show, without the costumes which normally would have completed them, are an example of the variety of formal approaches adopted by African sculptors.

36c. **Kwele artist, Gabon**
Mask
Wood, kaolin, 55 cm
Paris, Musée Dapper (inv. 4536)
Former Charles Ratton Collection

A pointed oval turned downwards, set in a larger oval frame, is the defining form of this famous Kwele mask. The oblique eyes and the simplified yet per-fect nose heighten the soft concave lines of the heart-shaped face below large arching eyebrows. Their elegant curve is anticipated by the division at the top of the presumed horns: a clear and only apparently simple structure, in which every element contributes to its perfection.
Masks like this were used, according to Leo Siroto, in complicated initiation rites in which the succession to power was decided.

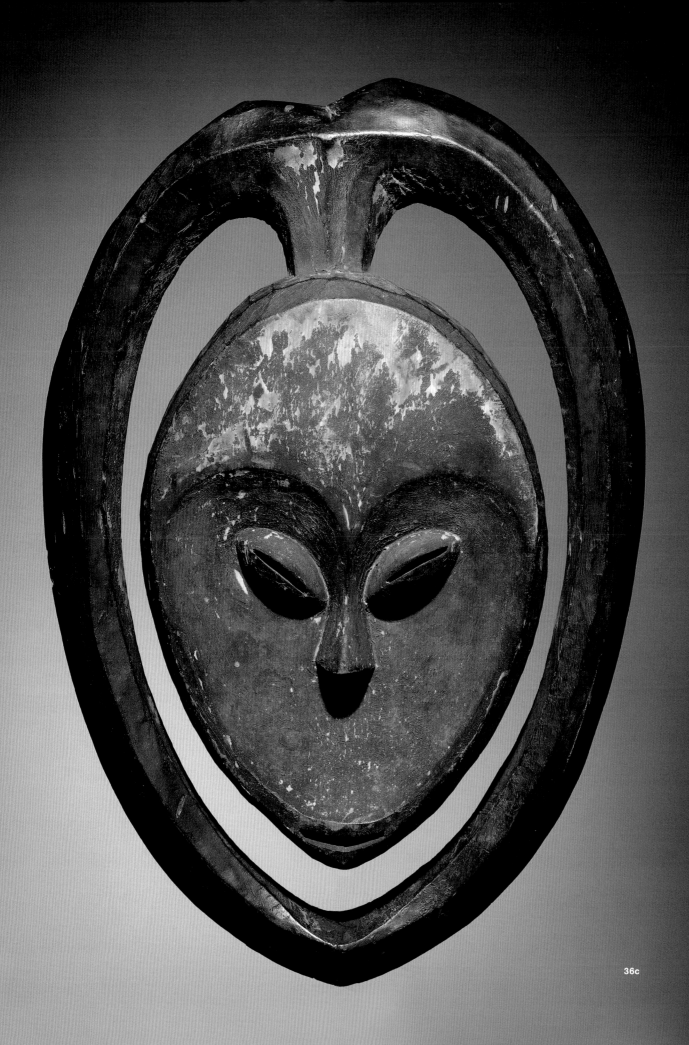

36c

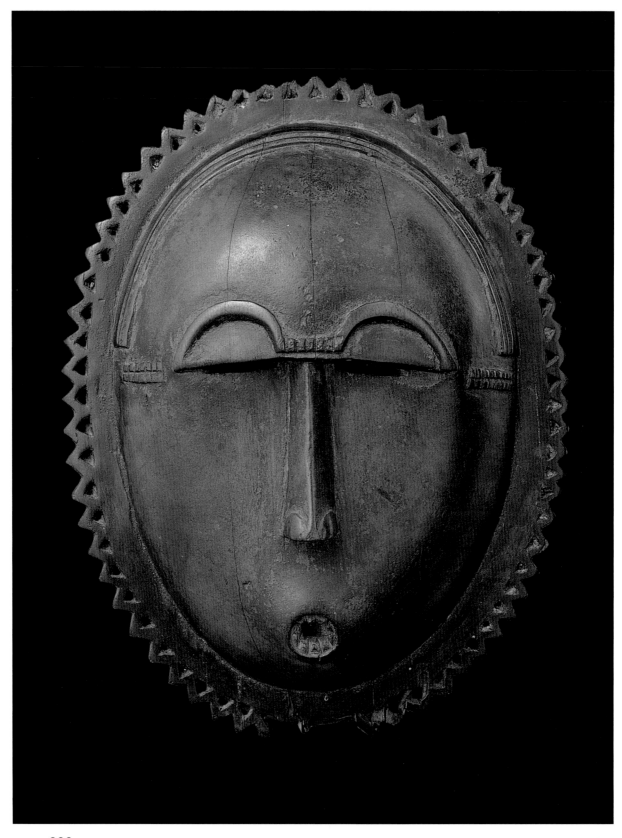

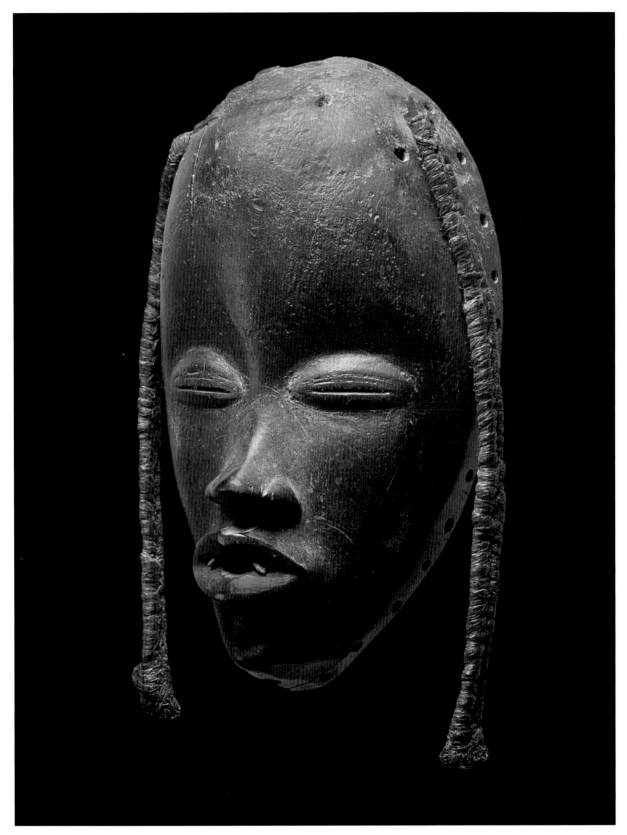

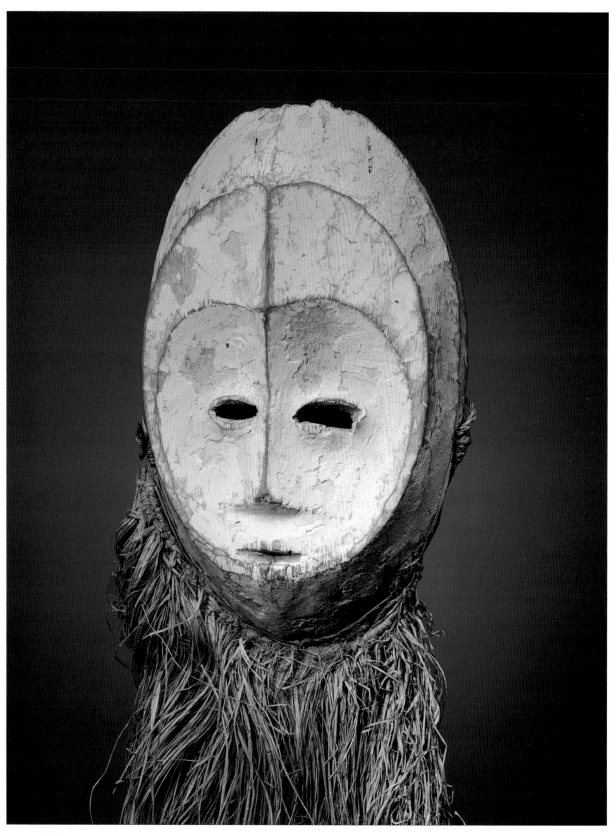

34c. **Dan artist, Ivory Coast**
Mask
Wood, hair, 22 cm
Marceau Rivière Collection

This mask perfectly exemplifies the naturalistic tendency of Dan art. The expressive simplification-accentuation of the facial features (the slit eyes, the regular nose, the slightly prominent lips, the high smooth forehead, the shiny patina and the lack of hair, with two flimsy yet elegant plaits) suggest a spirituality which it does not seem out of place to describe as "monastic".

35c. **Yaure artist, Ivory Coast**
Mask
Wood, 22 cm
W. & U. Horstmann Collection

The economy of the geometric elements used to make a human face and the great subtlety employed in doing so are the expressive marks of the author of this work. Here, the circle is the predominant form: in the overall shape decorated with the elegant trimming of perforated wolves' teeth, in the small mouth, and in the semicircular reliefs of the hairstyle and eyebrows. The straight line of the thin nose and the cuts of the eyes, extended by subtle scarifications, are the only straight markings on the softly rounded surface of this beautiful mask, which displays exemplary minimalism.

37c. **Lega artist, Democratic Republic of Congo**
Mask
Wood, kaolin, fibers, 24 cm
(without the beard)
Tervuren, Musée Royal de l'Afrique Centrale (inv. R.G.52.29.1)

The wooden masks of the Lega are the emblem of the members of the *Bwami* society which brings together all the initiated men of the community. They express the transcendent relationships between the living and the dead and symbolise the particular bond which unites the initiates.
This face of extreme purity is distinguished by its perfect oval shape, containing a heart-shaped concavity, divided by subtle relief work, flanked by eye markings and completed with the slender line of a small mouth without lips. These are minimal elements, whose expressiveness and figurative effectiveness lie in their perfection and in the equilibrium of their positioning. The brightness of the white patina, which has partly disappeared as a consequence of handling, enhances its simple perfection.

Formal diversification distinguishes not only the works of different ethnic groups, but is also found within groups with common origins and destinations. The three groups of Dan masks, Kongo maternities and Bamana antelopes are a convincing proof of this.

The styles of the Dan masks range from naturalistic but subtly simplified representation of the human face to geometrical stylisation, with results of elegant serenity on one hand and expressive force on the other. Attributing a style to a certain region is difficult because of the loans and differentiations which have taken place over time, not to mention the formal choices made by the various artists. The four sculptures on show give an idea of the variety existing in a common and recognisable universe.

38c. **Dan artist, Ivory Coast/Liberia (?)**
Mask
Wood, pigments, 24 cm
Paris, Musée Dapper (inv. 4538)
Former René Mendès-France Collection (painter)

The refined decoration of this mask from the Musée Dapper subtly punctuates the surface of the perfectly oval face, accentuating the beautiful half-open eyes and soft lips. The slight erosion of the surface and the deep patina with reddish reflections enhance the tenderly traced lines, contributing to the sensation of suspended elegance which the work emanates.

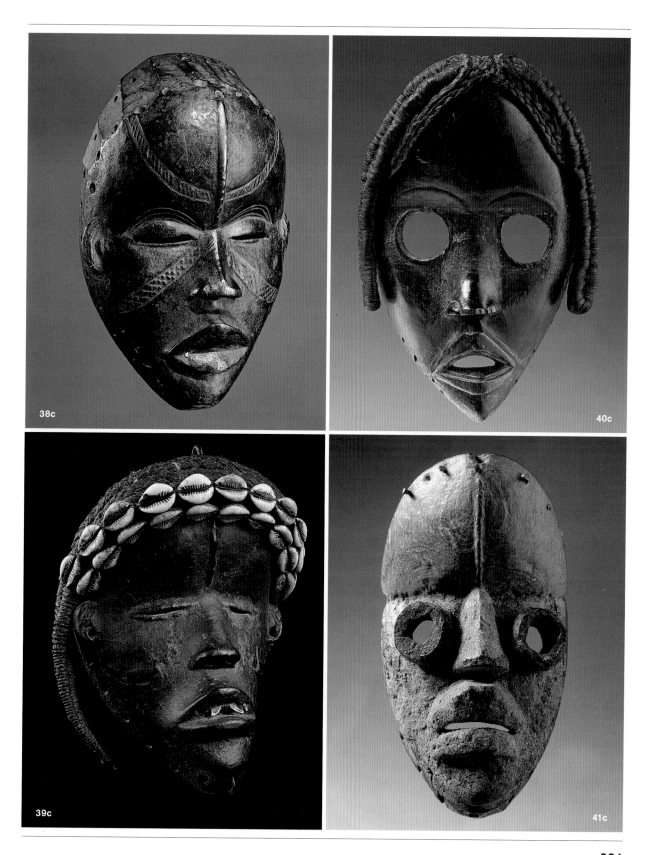

38c

40c

39c

41c

39c. **Dan artiste, Ivory Coast/ Liberia (?)**
Dance mask
19th century
Wood, hair, cowry shells, metal, 23.5 cm
Private Collection

The absence of any decorative elements increases the underlying dramatic force of this mask. The contrast between the half-shut eyes, barely hinted at in a thin horizontal incision, and the large mouth with its small ferocious teeth is intensified by the accentuated inclination of the forehead with respect to the lower half of the face, which is particularly appreciable when seen in profile.

40c. **Dan artist, Ivory Coast/Liberia (?)**
Mask
Wood, hair, 21.5 cm
Milan, Extraeuropean Collections - Municipal Collections
of Applied Arts and Engravings, Castello Sforzesco
(inv. n.28.2000.32)

This piece, as thin as a shell, is distinguished by its elegance and the sobriety of the sculptural approach adopted by the artist. The large cavities of the round eyes, on the exact centreline of the face, are the dominating elements, since they confer an aura of solemn and mysterious spirituality on the mask, whose surface is embellished by the black shiny patina.

41c. **Dan artist, Ivory Coast (?)**
Mask
Wood, iron, sacrificial patina, 24 cm
Milan, Extraeuropean Collections - Municipal Collections
of Applied Arts and Engravings, Castello Sforzesco
(inv. Africa.n.30)

The distinctive trait of this mask, with its appearance, is the volumetric rendering of the facial features. The dihedron of the nose, the tubular eyes and the half-open lips, strikingly protruding from the face, are naturally inserted into the perfect oval, whose symmetries attenuate its expressive force. The almost total loss of the sacrificial patina reveals the fibre of the light and compact wood and contributes to the sensation of tempered austerity expressed in the mask.

42c. **Kongo (Yombe) artist, Democratic Republic
of Congo**
Maternity
Wood, 29 cm
Tervuren, Musée Royal de l'Afrique Centrale
(inv. R.G. 24662)

The meaning and function of the images of mother and child, frequent in the
statues of the Kongo people is, according to Albert Maesen, probably related
to fertility rites.
In this example, the work of a great master active between the 19th and 20th
century in the village of Kasadi (after which he was named, Bassani 2001, 162-
165), the woman is represented in all her cultural and social prestige. Every ele-
ment of the image contributes to providing this impression: the strictly frontal
position, the dignified pose, the bracelets and necklaces, the headdress normally
reserved for chiefs, and the fine tattoos which repeat traditional motifs (the
same ones sculpted on 16th century Medici oliphants; see 1b and 2b).
No other Yombe sculptures have the same aristocratic austerity in their vo-
lumes, or the controlled and extreme formal clarity found in the works of this
great sculptor, qualities which, together with the intense and remote expression
of the figures portrayed, make them unmistakable.

43c. **Kongo (Yombe) artist, Democratic Republic
of Congo**
Maternity
Wood, 32 cm
W. & U. Horstmann Collection

The maternity of the Horstmann collection is distinguished from the previous
work by a series of elements, starting with the unusual iconography.
The sensation of quiet and domestic humanity suggested by the group is accentua-
ted by the soft rendering of the volumes, in particular the head, and by the absen-
ce of geometric decoration which instead characterises the works of the "Master of
Kasadi". These are elements which make this image more earthly, more human,
without altering its formal clarity or diminishing its expressiveness.

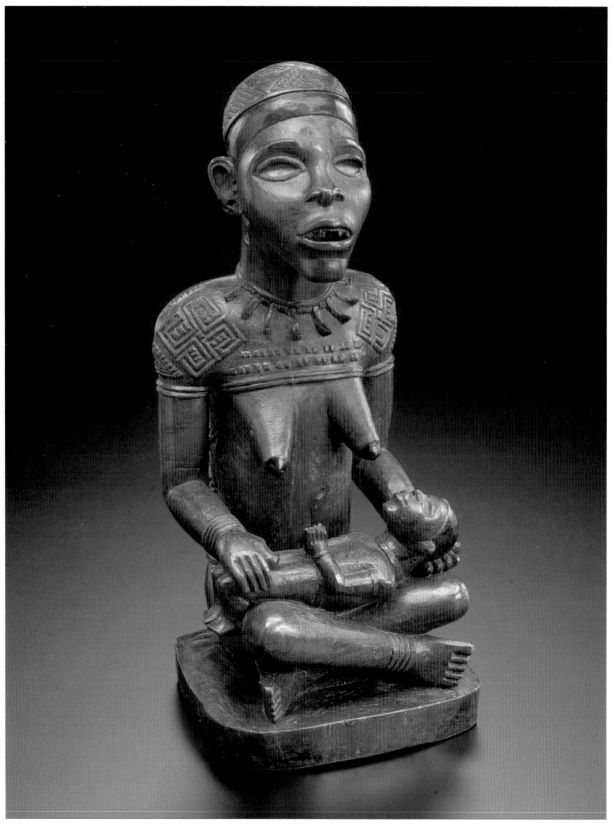

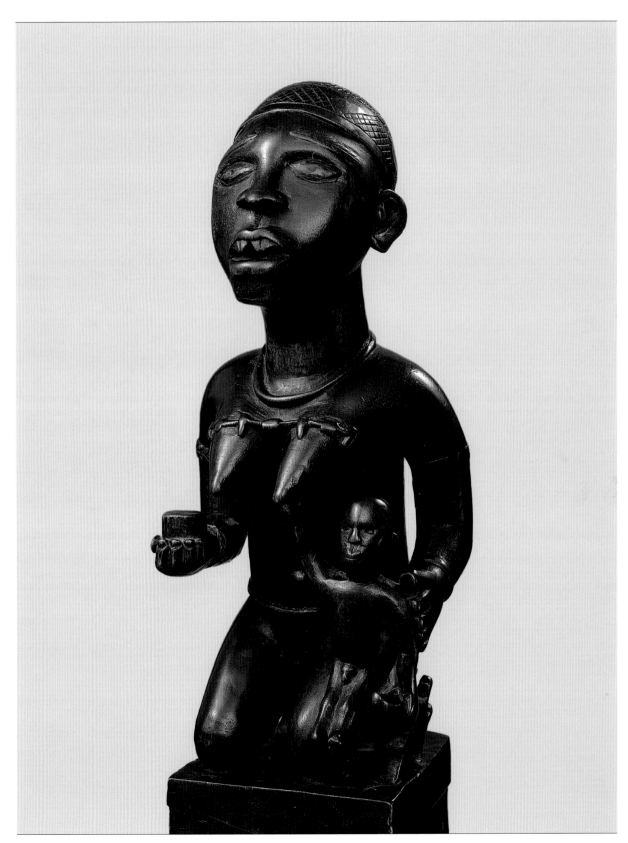

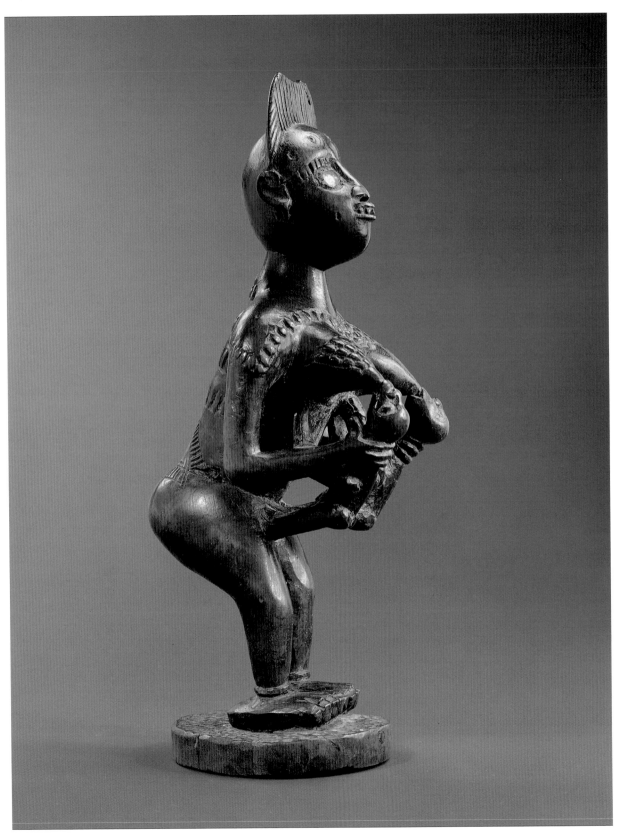

44c. **Kongo artiste, Democratic Republic of Congo**
Mother nursing twins
Wood, 25.5 cm.
Private Collection

So far this piece is the only Kongo sculpture known to illustrate the theme of maternity this way. Two children — instead of the usual one — greedily sucking the large divaricated and protruding breasts of their mother, who is portrayed upright in an unusual position, form an airy, yet powerful and unusual group. They seem animated by a sort of animal vitality, heightened by the wild features of the woman's head. This is the opposite of the calm dignity seen in the two previous images.

The headdresses of the *Chiwara* society are without doubt the best known works of Bamana art. Sculpted in the form of an antelope, they are a metaphor of the untiring worker and were worn during propitiatory ceremonies for the fertility of the soil; now they are mainly used for entertainment. Despite having identical meanings and functions, the headdresses are sculpted according to regional styles which vary greatly from each other

45c. Bamana artist, Mali
Antilope
Wood, 84 cm
Milan, Extraeuropeen Collections - Municipal Collections
of Applied Arts and Engravings (inv. Africa n.5)

Vertical movement is the distinctive trait of antelopes in the Segu style. The animal represented here is the hippotragus or horse antelope. On a body of essential forms there sits a large head and neck, decorated with an impressive perforated mane (the serrated edge symbolises the animal's zigzag run but also the movement of the sun in the tropics) and with horns pointing upwards.
This headdress embodies elegance and lightness. Viewed sideways, the body has the form of a trapezium wider at the top, as if the animal was about to jump; this sensation is supported by the curve of the short pointed tail, also directed upwards. The verticality and the impression of weightlessness give the sculpture of a sort of "gothic quality", according to a perceptive definition by William Fagg.

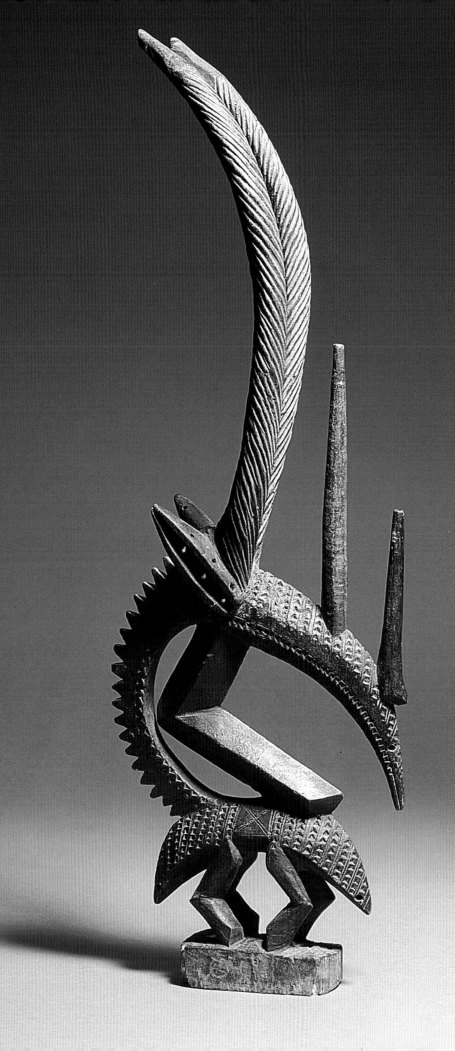

47c

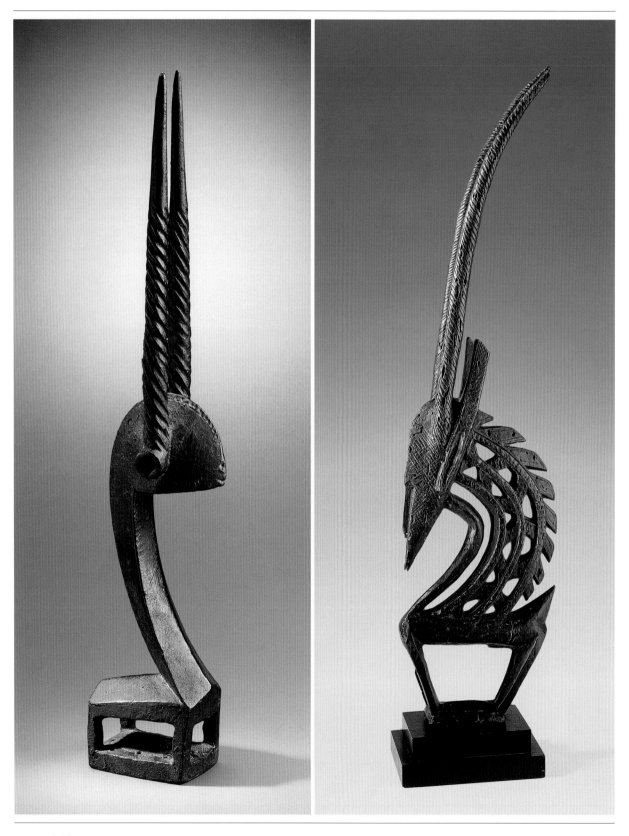

46c. **Bamana artist, Mali**
Antilope, headdress
of the *Chi Wara* Society
Wood, 56 cm
Brussels, Private Collection

Simplification bordering on abstraction is the element which distinguishes this figure. Nevertheless, the idea of the throbbing antelope ready to spring emerges powerfully from the volumes which compose the animal: the bold curve of the neck leads our gaze towards the simplified but dynamic head. The deep spiral incisions of the twisting horns heighten the work's verticality, which the small plinth symbolising the body does nothing to restrain.

47c. **Bamana artist, Mali (Bougouni or Dioïla region)**
Antelope, *Tjiwara* headdress
Wood, 51 cm
Munich, Staatliches Museum für Völkerkunde (inv. 14.7.6)

In this headdress from the museum of Munich, only the long arched horns and the toothed arch of the mane express the idea of the antelope, since the rest is a fantastic combination of different forms among which the pangolin dominates. The dynamic nature of the composition, based on milled curves, is heightened by smoother volumes: the presumed neck and legs, unnaturally yet skilfully bent at right angles, with counterposed angles.

The fact that works of art have the same purpose does not necessarily mean that they display a similar formal approach. The figures that the Fang and Kota from Gabon put on the baskets or bark containers containing the bones of their ancestors are, perhaps, the most convincing example of this. The simulacra could not in fact be more different in terms of form and the materials with which they are made.

48c. **Fang artist, Gabon**
Reliquary figure
Wood, 37 cm
Private Collection

The figures and the heads are not portraits of a particular deceased person, but the symbol of a collective ancestor who watched over the destiny of the community.
Economy and symmetry are the distinctive traits of this male figure with a collected pose and globular volumes. The precise horizontal division, with the forearms exactly dividing the figure in two, is combined with the perfect yet not rigid frontal position, attenuated by the slight offsets between the elements along the vertical axis.

49c. **Fang artist, Gabon**
Reliquary head *nio byèri*
Wood, pigments, 29 cm
Paris, Musée Dapper (inv. 2659)

The heads, rarer, and according to Tessmann (1913, vol. 2, 117) introduced in a previous age, have the same function as full figures.
A mellow serenity and delicate form are the qualities which are most attractive in this work, coming from the famous collection of the English sculptor Jacob Epstein. The features of the face, rendered with masterful subtlety, and the elaborate hairstyle do not conflict with the intentionally spherical form of the head, and actually intensify its sophisticated purity.

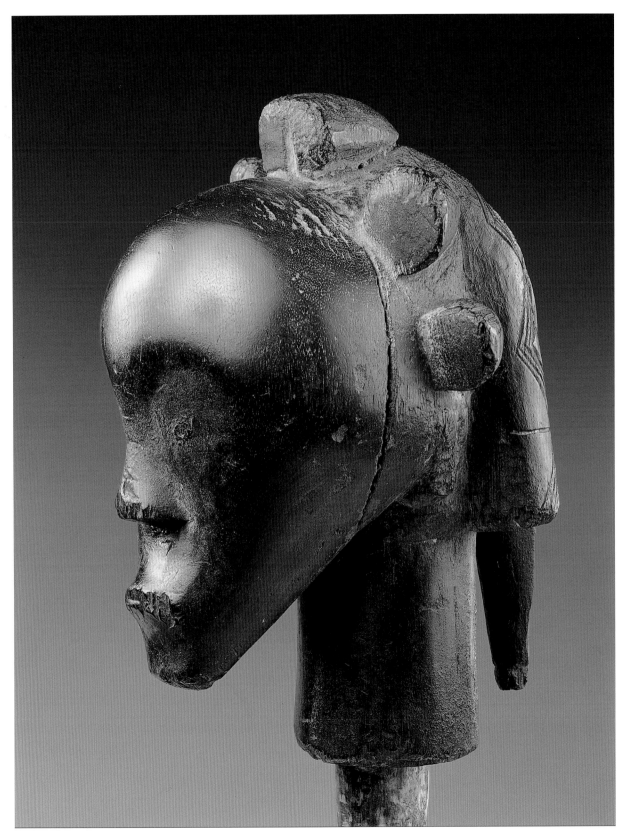

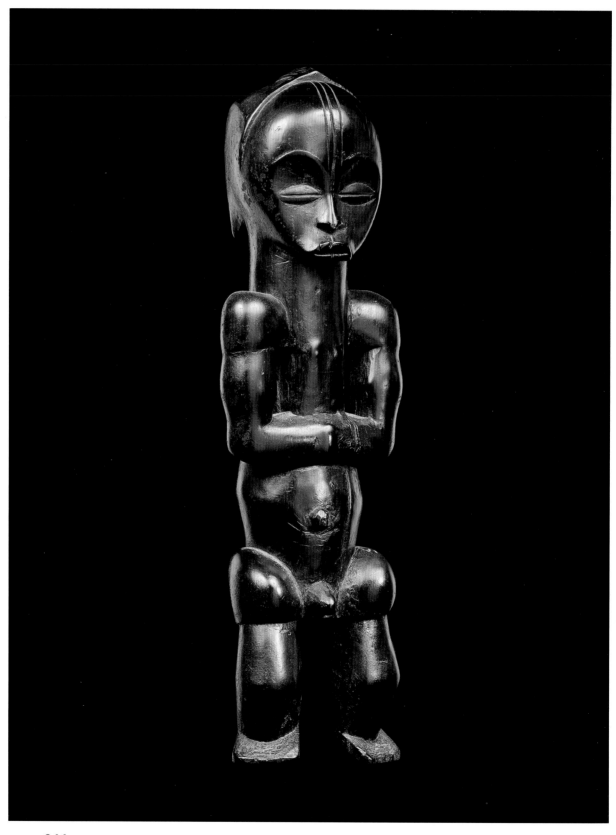

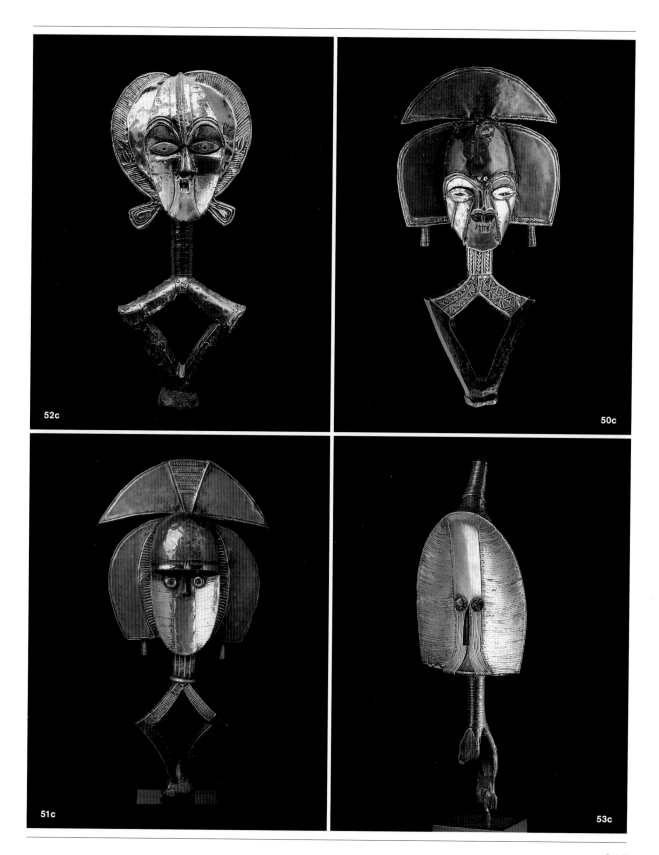

52c

50c

51c

53c

50c. **Kota/Ndassa artist, Gabon**
(Congo, Zanaga region)
Reliquary figure
Wood, copper, brass, pigments, 60 cm
Paris, Musée Dapper (inv. 0605)
Former Paul Guillaume Collection

51c. **Kota artist, Gabon (Obamba)**
Reliquary figure
End of the 19th century
Wood, copper, brass, 57 cm
Former H. Couillard Collection, Private Collection

52c. **Kota artist, Gabon**
Reliquary figure
Wood, copper, brass, 51 cm
Private Collection

Figures which are totally different from those of the Fang in terms of structure and general conception perform a similar function for the nearby Kota and Mahongwe. In their abstract formal dryness, these arbitrary images, in wood covered with thin plates or copper and brass scales, have no link with the physical reality we presume they symbolise, i.e. the body of a mythical ancestor.
The large wings at the sides of the head and the crescent which usually stands above it could be a fantastic rendering of the hair, but also, in the opinion of some scholars, the projection of the volumes of the head itself, according to a formal approach which would anticipate, in this case, the revolutionary intuition of the European Cubists.

53c. **Mahongwe artist, Gabon**
Reliquary figure
Wood, copper, brass, 47.5 cm
W. & U. Horstmann Collection

The Mahongwe sculptors progressed even further in rendering the figures of their ancestors, with an ovoid ring supporting a delicately concave ellipse truncated at the bottom, lined with thin horizontal reeds framing the facial features which border on the abstract. This is an almost codified reference to the human form.

The appearance of many sculptures may sometimes lead us to misinterpret the function they performed in the African context in which they were created. This is certainly the case of the "power figures" of the Kongo and Songye peoples — the so-called "fetishes", as they have often, and dismissively been defined — whose aggressive appearance seems to contradict their protective nature as beneficial intermediaries with otherworldly forces.

54c. **Kongo (Yombe) artist, Democratic Republic of Congo**
Power figure
Wood, glass, fabric, skin, feathers, leather, 34 cm
Munich, Staatliches Museum für Völkerkunde
(inv. 93.630)

The enchanting and disturbing figure from the museum of Munich is an emblematic example, also in visual terms, of the ambiguity of meaning and function seen in these works, due to the dramatic contrast between the noble head, sculpted with extreme tenderness, and the savage masses of animal skins and coloured feathers from which it emerges, clear and shining like ivory.

55c. **Kongo (Yombe) artist, Democratic Republic of Congo**
Power figure *(Nkisi Nkondi)*
19th century
Wood, nails, glass, various material, 87 cm
Lisbon, Ethnographic Museum of the Sociedade de Geografia,
(inv. SGL-AC-311)

The powerful monumentality and the expressiveness of the oval head, with its large gaping eyes and a wide-open mouth, are the qualities which characterise the imposing figure from Lisbon. The magic attributes — mirrors, nails and blades — make this large sculpture threatening and disquieting. Its function was to find and neutralise the forces harmful to individuals and society.

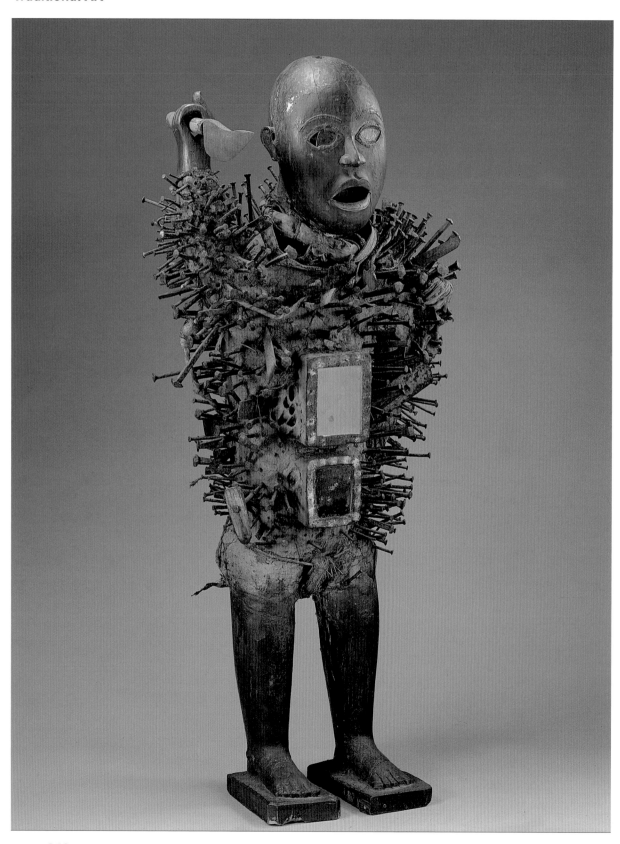

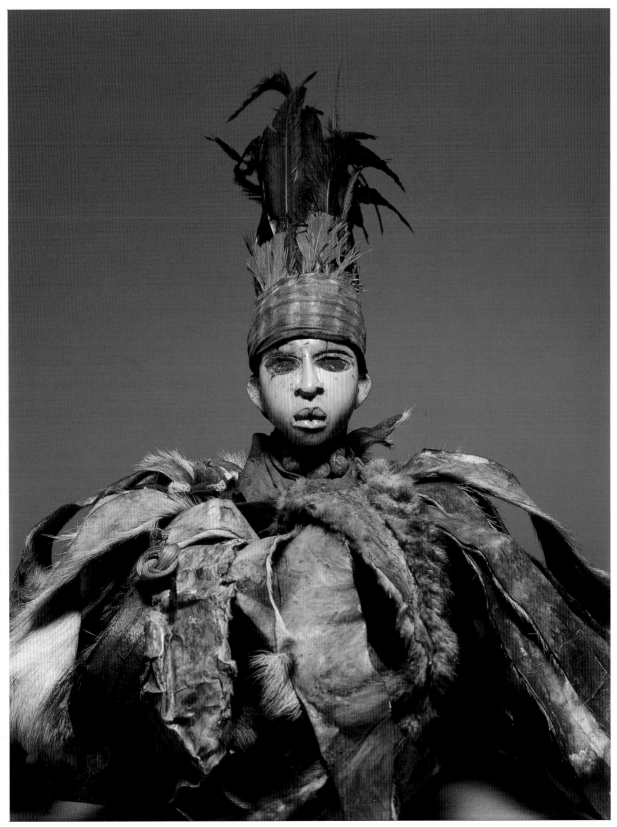

Despite their terrifying appearance, also the figures of the Songye have a protective or therapeutic function; that is, they serve, according to Els de Palmenaer (2001, no. 38) "as protection against negative forces that beset people in the form of infertility, disease, death and bad harvests". The medical substances, placed in cavities made in the sculpture or in a horn fixed to the head or hanging from the statue itself, were effective only if mixed according to the prescriptions of the magic specialist considered the real creator of the work.

56c. **Songye artist, Democratic Republic of Congo**
Magic figure
Wood, horn, metal, glass beads, skin, 98 cm
Former Jef Vanderstraete Collection, Private Collection

This sculpture is one of the most imposing of its kind and, to our eyes, surely the one with the most aggressive appearance, with its accompaniment of feathers and wild animal skins, which cover it like a barbarian cloak. The dominant element is however the well-proportioned head supported by a cylindrical neck, whose elegant length is underlined by the many necklaces. A copper mask intensifies the aggressive violence of the face: the monstrous conic eyes in the deep orbital cavities, the large mouth, the attentive decoration with sharpened nail heads and the crown of scales which sits on the forehead contribute to creating that fierce aura which pervades this impressive work of art, a ferocity moreover contradicted by the beneficial function attributed to it by scholars.

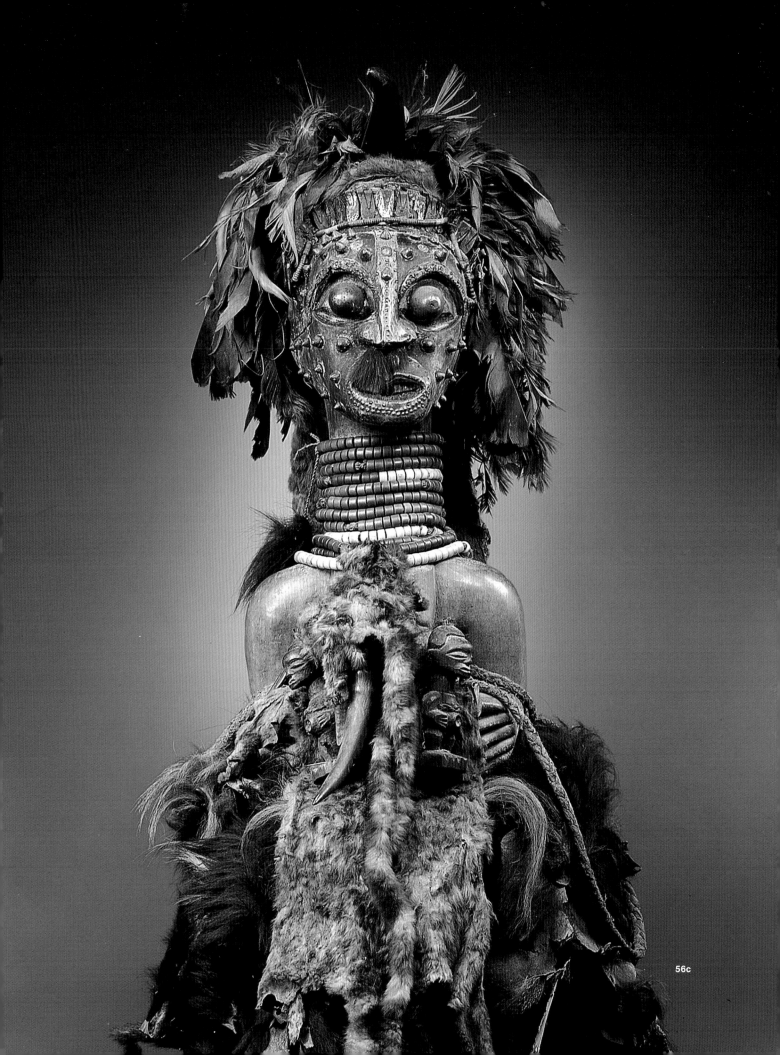

56c

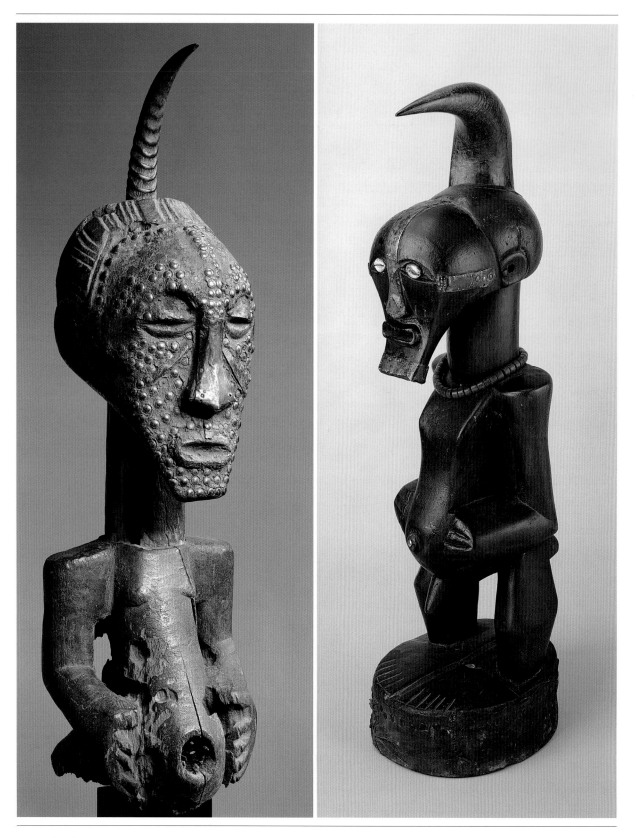

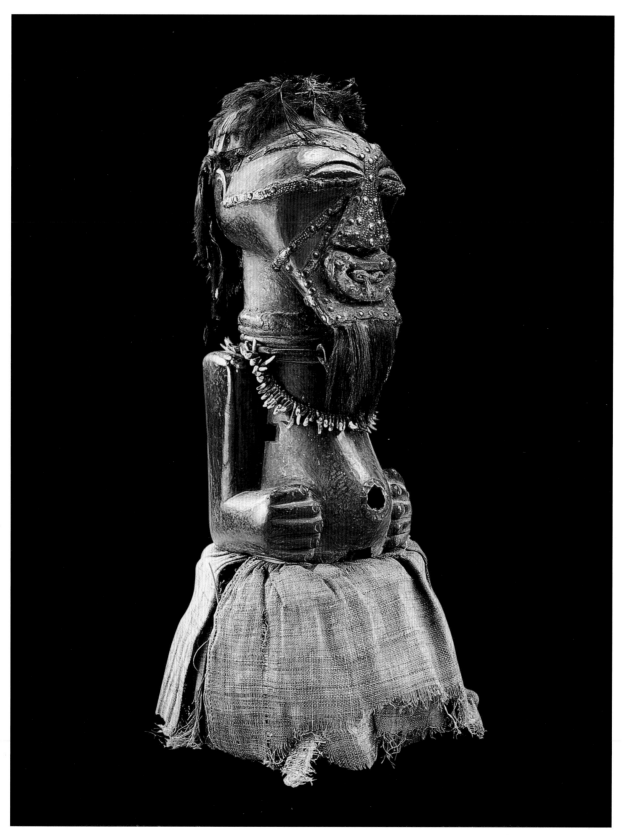

57c. **Songye artist, Democratic Republic
of Congo**
Magic figure
Wood, horn, metal, glass beads, cowry shells,
78 cm.
W. & U. Horstmann Collection

The disarming nudity of this figure makes it possible to appreciate its monumen-
tal articulation and the sophisticated overall formal design. Carefully calculated
correspondences — the protruding large head and the prominent stomach — and
evident disproportions combine and integrate to create a powerful image whose
aggressiveness, concentrated in the sharpened horn, is tempered by the perfection
of the volumes and the beauty of the shining surface

58c. **Songye artist, Democratic Republic
of Congo**
Magic figure
Wood, horn, copper, 84 cm.
Private Collection

This large sculpture, despite being reduced in the lower part, conserves its
power, which the passing of time has only purified but not cancelled. The strips
of copper and the brass nails which cover the large elongated head underline its
precise design, of touching asceticism.

59c. **Songye artist, Democratic Republic
of Congo (Cabinda region)**
Magic figure (Mukisi)
Wood, metal, fabric, hair, feathers, teeth, skin,
78 cm
Brussels, Private Collection

The large head is the dominating element of this gigantic figure. Its imposing
volume is the same of the massive and simplified bust, whose round abundance
is heightened by the volumes of the square arms bent at right angles, as if to
underline the imperious frontal pose.
The small half-open eyes, of an unusual and beautiful lenticular form, acquire a
sort of poetic interiority from the contrast with the exaggerated volumes of the
nose and mouth which emerge from the long concave square face, contributing
to the powerful, mysterious expressiveness of the monumental head.

While the statuary of the Luba people is the triumph of the female body, that of the nearby Hemba above all celebrates the male ancestor of great lineage, a figure which in that society witnessed and legitimated power and possession of the land. The role of the woman, mother of sovereign, origin and support of power itself, is illustrated above all in ceremonial thrones. The style of the sculptures, while conserving a common approach, changes according to the region of origin: François Neyt (1977) identified as many as twelve different variants.

60c. **Hemba artist, Democratic Republic of Congo**
Ancestor figure
Wood, black crusty patina, 75.5 cm
Belgium, Private Collection

This large figure in the Niembo style (created, according to Neyt, in the first half of the 19th century) is noteworthy for its imperious monumentality. Harmonious and expressively accentuated forms compose a lean and powerful bust, set off by its naked smoothness. The impressive hairstyle in the form of a cross balances the volume of the large hemispherical head. The regular face, enclosed between the relief of the beard and the plait framing the high bright forehead, is the essence of reserve and solemn authority.

61c. **Hemba artist, Democratic Republic of Congo**
Ancestor figure *Singiti*
Wood, 60 cm
Milan, Extraeuropeen Collections - Municipal Collections of Applied Arts and Engravings, Castello Sforzesco
(inv. Bassani no. 73)

A bold volumetric approach, fully appreciable in the profile view, combined with an elegant plastic form, distinguish this figure, attributed by Neyt to the style of the northern Hemba. The imperious head is in perfect harmony with the structure of the work; the features of the face, rendered with incisions and precise volumes, act as a prelude to the movement of the broad shaved forehead and the extraordinary hairstyle. The interwoven plaits, carved in full relief, enclose on the rear a large cavity which almost seems to make the entire figure levitate.

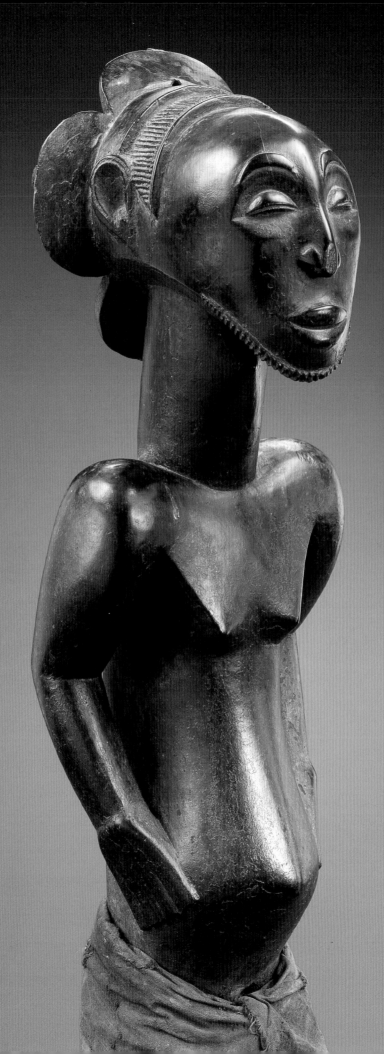

64c

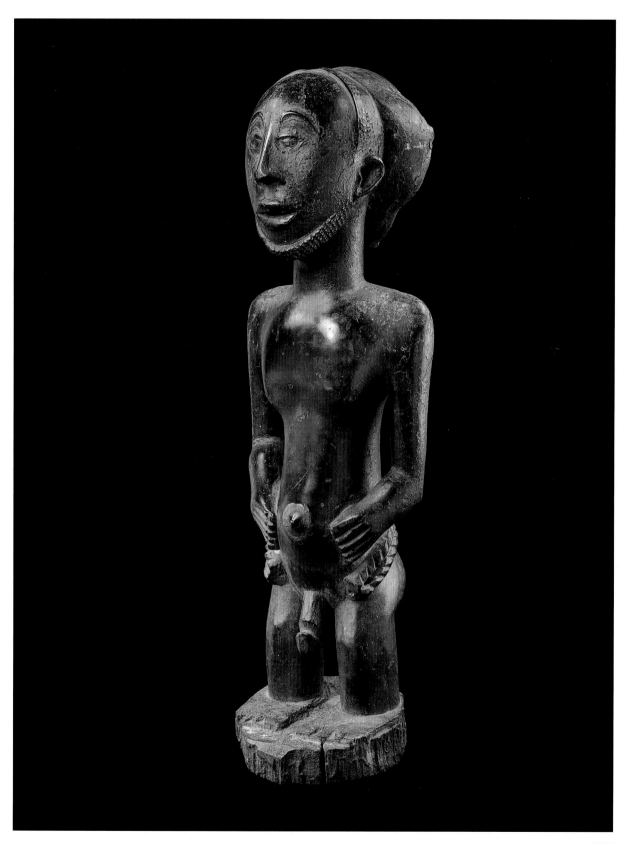

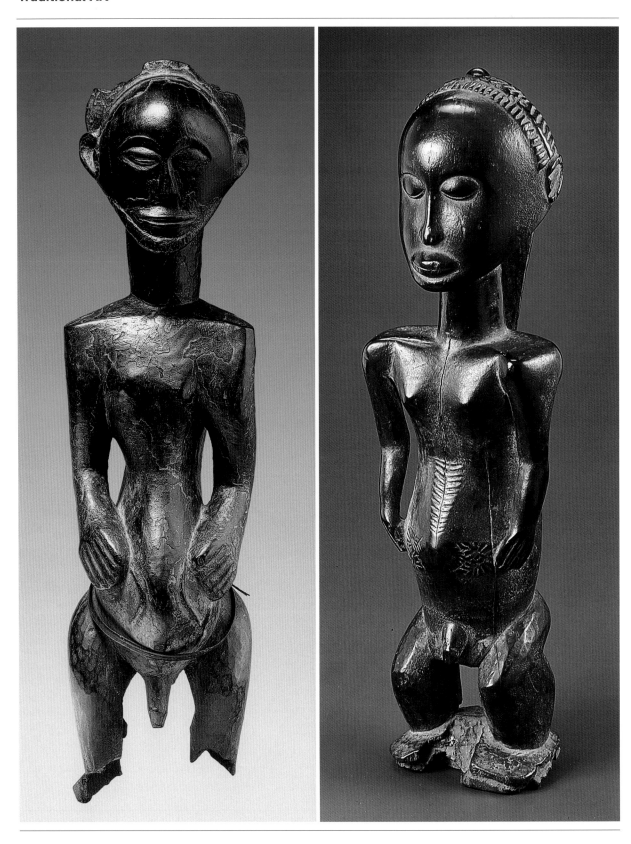

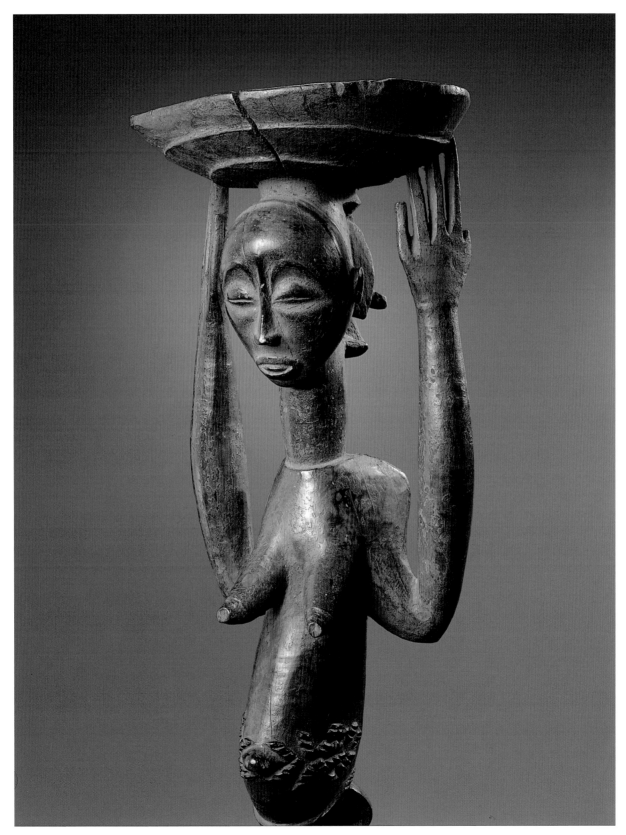

62c. **Hemba artist, Democratic Republic
of Congo
Ancestor figure**
Wood, 75 cm
Brussels, Private Collection

The exceptional hairstyle is the distinctive feature of this fine figure: four plaits
cleverly wound to form a sort of headdress which, in the frontal view seem an
elegant crown. The thin relief of the diadema and the straight beard enclose an
Apollinian refined face. The roundish and reather heavy body is dominated by
the enormous prominence of the abdomen which is particularly appreciable in
the side view which reveals also the interplay of the volumes in a well balanced
composition of regal authoritativeness.

63c. **Hemba artist, Democratic Republic
of Congo
Ancestor figure**
Wood, 47 cm
Belgium, Felix Collection

This sculpture, in the Mambwe style, is clearly differentiated from the others by
its anatomic proportions. The body seems to have withstood great pressure, be-
coming more robust in its efforts to resist it. Sophisticated analogies and subtle
antinomies reveal the hand of a skilled artist: the unusual plaited hairstyle which
descends in points between the shoulder blades, for example, has the same form
as the elegant motif decorating the generous convex volume of the stomach. The
pouting lips and delicately swollen cheeks of the tender childish face form a
subtly disquieting contrast with the robust body of a baby Hercules.

64c. **Hemba artist, Democratic Republic
of Congo**
Ancestor figure
Wood, fabric, 69 cm
Private Collection

This figure belongs to the style of the Hemba from the Luika river, and the differences with the previous works are evident, not so much in the position of the body as in the way in which the various details are rendered and, above all, in the large head with its regular but resolute features. A powerful neck, with a pointed Adam's apple, supports the elongated mass of the head, aggressively projected forward. This is offset volumetrically and visually by the extremely elaborate and striking hairstyle, also here quatrefoiled, which opens at the rear like a majestic flower. The features of the face, less generically conventional, seem to be personalised, and a profiled view reveals them in all their aloof imperiousness.

65c. **Hemba artist, Democratic Republic
of Congo**
Caryatid stool *(Kihona)*
Wood, 47 cm
Brussels, Private Collection

According to François Neyt (1993, 97), the Niembo workshops of the Luika produced "the most refined and somptous seats". The example on show, despite the loss of the lower part of the caryatid, is a perfect example. The female body, slender and elegant — tensed in the effort of supporting —, the beautiful tapered breasts, the long and aristocratic hands and, above all, the beautiful expressive head and monumental hairstyle, testifies to the important role of women in Hemba society.

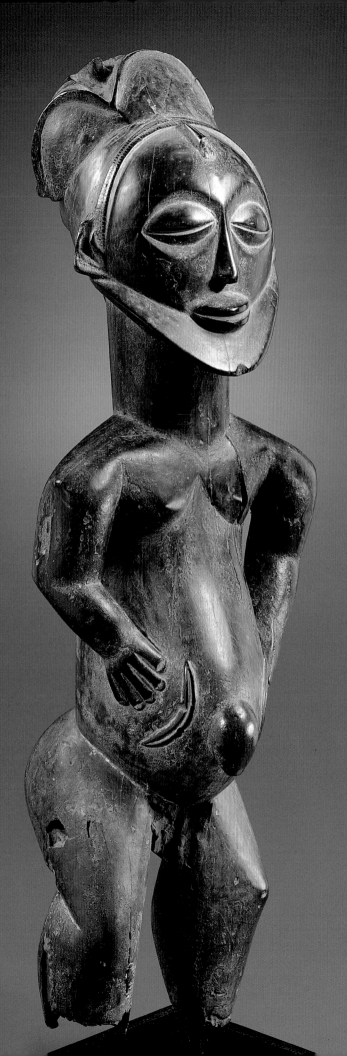

62c

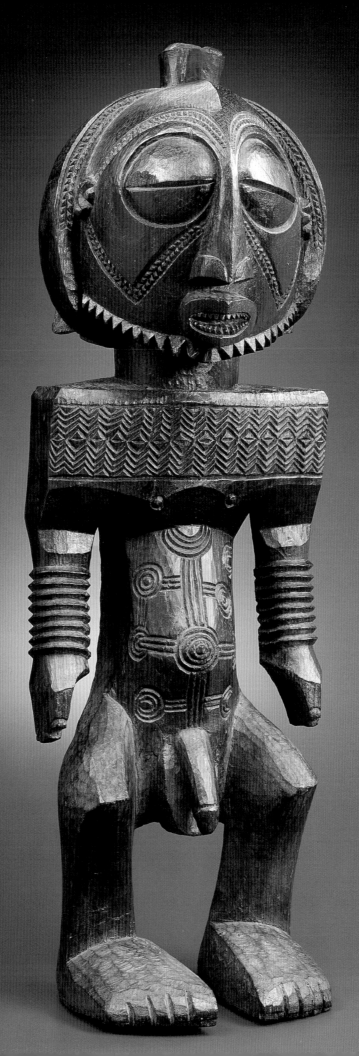

66c

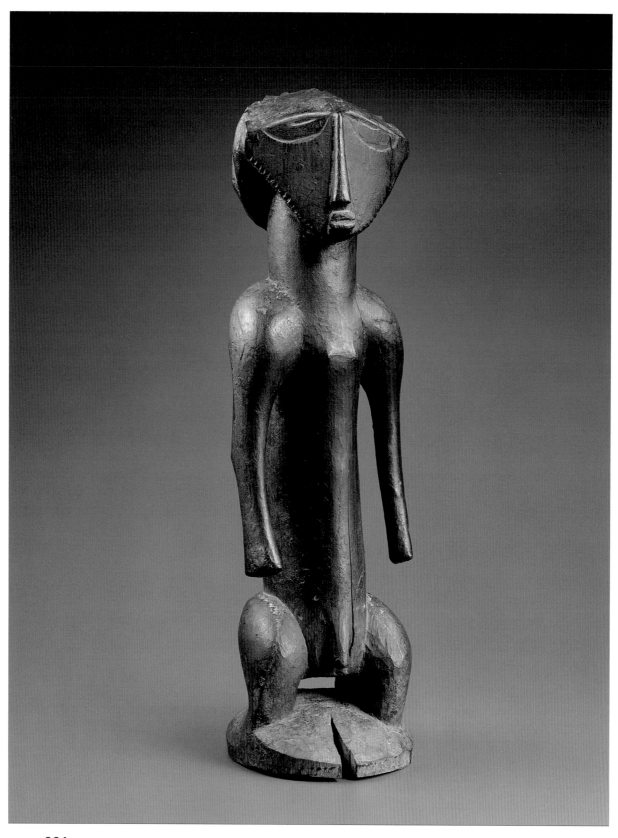

66c. Boyo artist, Democratic Republic of Congo
Ancestor statue
Wood, 99.5 cm
Private Collection

The balanced game of strictly arranged volumes and the decoration perfectly integrated with the volumes themselves, are the particular qualities of this monumental image of a royal ancestor of the *Baka kunga*, one of the four Sumba royal families of the Boyo people. The body with its geometric forms acts as a support for the monumental head; the rectangular block of the chest, covered by an ordered zigzag engraved pattern, and the short vertical arms with superimposed bracelets, contrast and enhance the spherical mass above. The enormous hemispherical eyes, in perfect circular orbital cavities, are the most striking feature of the large sunny face of this figure of supernatural majesty.

67c. Sikasingo/Boyo artist, Democratic Republic of Congo (Kimano region)
Royal ancestor statue
Circa 1820-1880
Wood, 59 cm
Brussels, Private Collection

Elementary volumes, fluid profiles and the absence of all superfluity distinguish this effigy of a royal ancestor from another Boyo group, completely different from the previous work.
The cylindrical body is a smooth column, enclosed between the plinth of the pelvis and the short powerful legs and the monumental head with its harsh volumes. The large half-open eyes act as a hinge between the triangular face and the wide smooth forehead, thrust backwards, which is united with the hairstyle and its vertical plaits, hidden in the frontal view. Sophisticated simplicity and monumental poise contribute to forming a regal figure of composed authority.

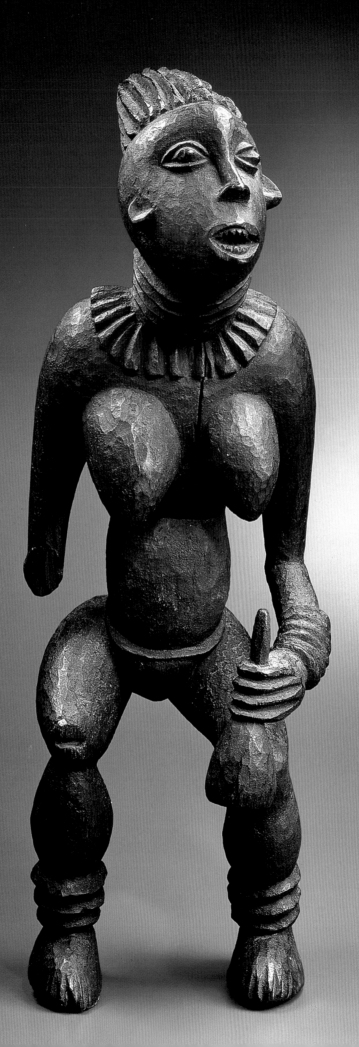

70c

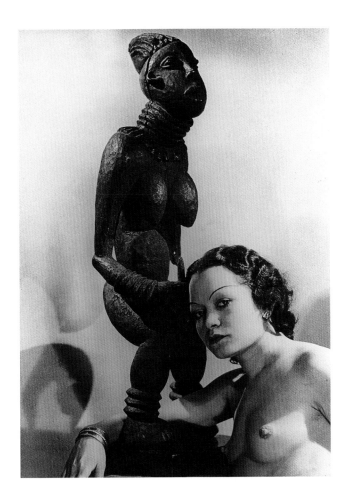

70c. **Bangwa artist, Cameroon**
Commemorative statue of a princess
Wood, pigments, 85.1 cm
Paris, Musée Dapper (inv. 3343)
Collected in 1897-1898 by Gustav Conrau, brought to Europe in 1899;
former Arthur Speyer, Charles Ratton, Helena Rubenstein and Harry
A. Franklin Collections

This sculpture, collected by Gustav Conrau at the end of the 19th century, is one
of the greatest monuments of Bangwa people art. It is a work of intense vitality in
which the movement which animates its forms is however extremely disciplined:
the head, proudly raised and slightly turned on the opposite direction to the bust,
skilfully breaks the frontal pose.
The work has been part of famous collections, such as that of Elena Rubinstein,
and was photographed by Man Ray, alongside a model with white skin, in images
which became famous.

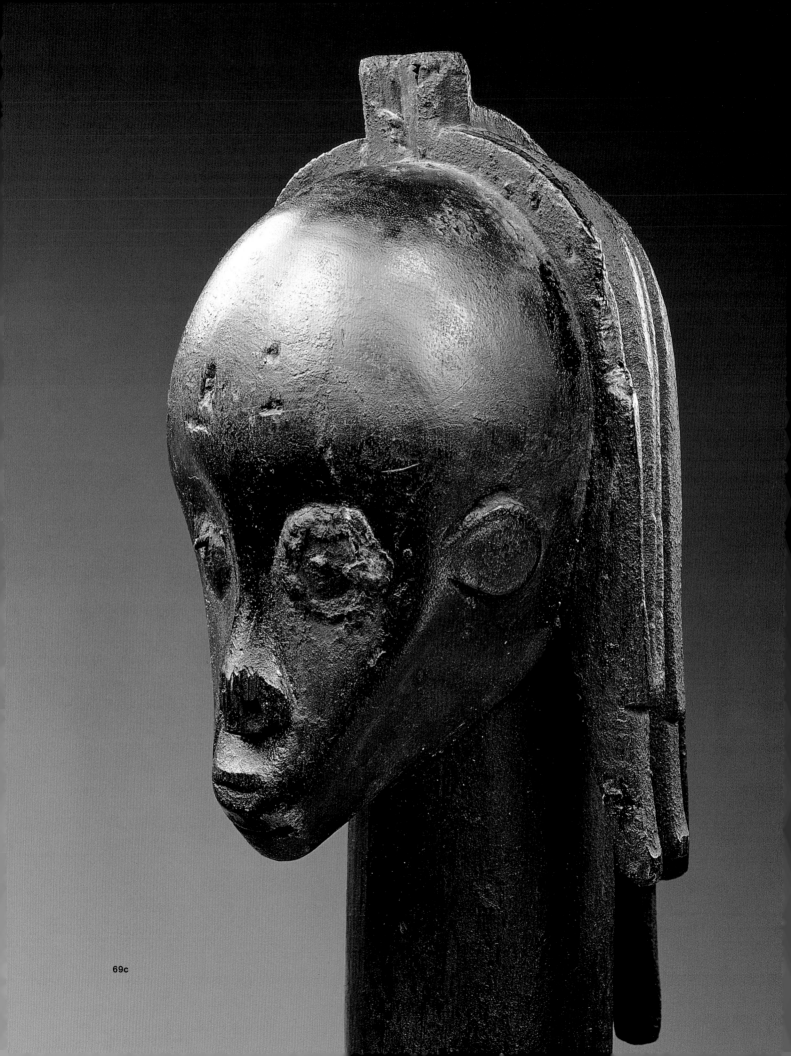

69c. Fang artist, Gabon
Reliquary figure *Nio Byèri*
Wood, pigments, 63 cm
Paris, Musée Dapper (inv. 2664)
Former Epstein Collection

The monumental purity, obtained using an extraordinary economy of means and great skill, is the quality which is most striking in this work, which belonged together with five other Fang heads, to the huge collection of the sculptor Jacob Epstein. It is one of the most famous works of African art, exhibited and published as far back as 1913, the year in which the English artist (of American origin) said that he had seen it at the famous Hungarian art merchant Joseph Brummer. Epstein rediscovered it in 1935 in the basement of a Parisian gallery owner and bought it to the great chagrin of the merchants who had been looking for it (Epstein 1940, 58).
The work was photographed by Geoffrey Ireland in Epstein's bedroom.

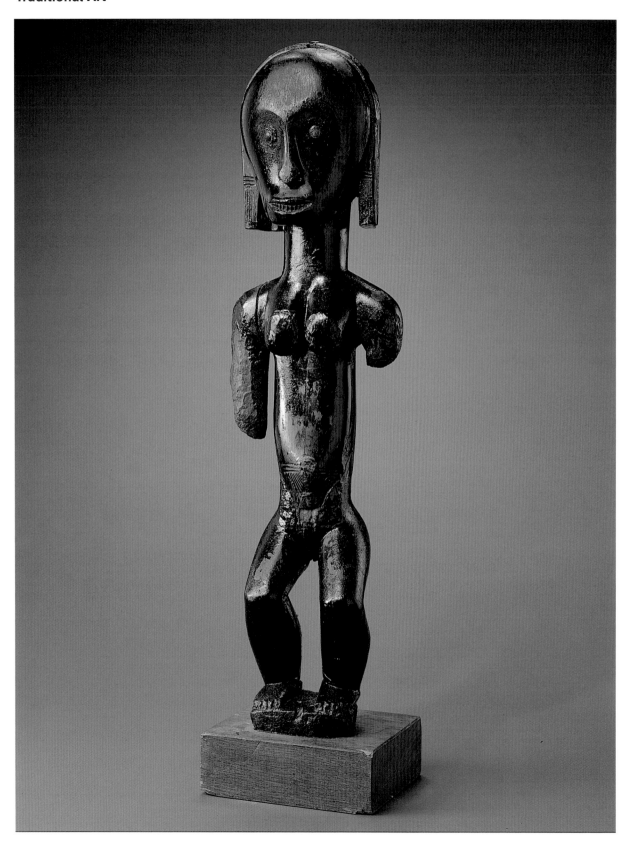

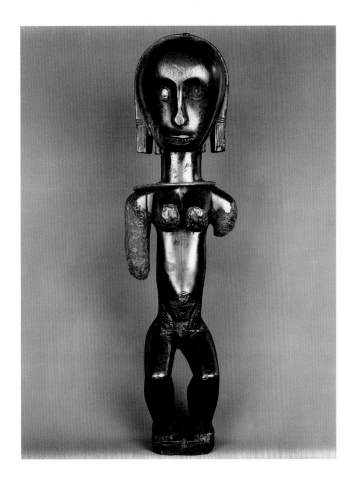

68c. **Fang artist, Gabon**
Reliquary figure
Wood with oily patina, metal eyes, 58.4 cm
Private Collection
Former Derain Collection

Fang sculpture has always enjoyed particular favour, by all means deserved, with collectors of African art. All the great historical collections, including those of famous painters and sculptors — the protagonists of the artistic revolution from the beginning of the last century — have had amongst their most important pieces one or more figures or heads, which the Fang placed on a cylindrical basket of bark containing the bones of their ancestors (see 48c and 49c).
This slender female figure, dominated by an imposing head, was part of the collection of the Parisian painter André Derain, and was photographed by Walker Evans in 1936.

BETWEEN THE FIN-DE-SIECLE AND THE ROARING TWENTIES

BETWEEN THE FIN-DE-SIECLE AND THE ROARING TWENTIES:

THE "DISCOVERY" OF AFRICAN ARTS

It is due to the most audacious of the artists who were working in the first ten years of the 20th century that the commonly held prejudices were dispelled regarding African idols, thought at that time to be hideous, even obscene, to be the dark aspect of degrading and absurd superstitions.

The "Discovery" of African Arts

1. Paul Gauguin, untitled, circa 1889
Two African statuettes in the kongo-vili style, slightly
modified and with Gauguin's monogram attached.
Wood, mother-of-pearl, glass, brass, oil pigments, 21 and 10.5 cm

Private Collection / Marc Felix Collection
© Archives Musée Dapper and Hugues Dubois.

2. Paul Gauguin, untitled, circa 1889
Statuette in the kongo-vili style
Wood, brass, dolls' eyes, oil pigments, 10.5 cm

Marc Felix Collection
Photography Hugues Dubois.

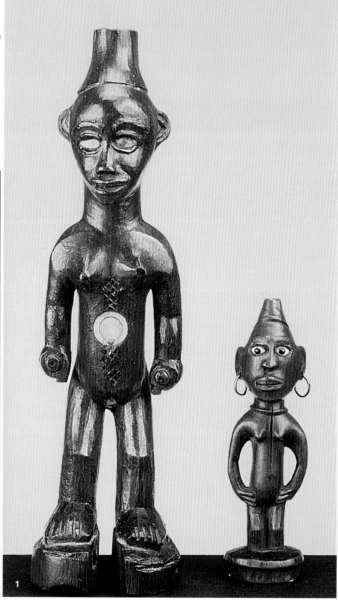

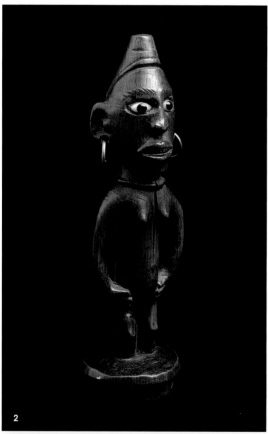

3. Paul Gauguin's monogram
painted on the base of the smallest of the kongo-vili
statuettes.

Photography Marc Felix.

Going against the values of Civilization and Progress which the proselytes of colonialism particularly extolled, the "primitive fetishes" aroused for a long time only arrogant disdain or, at best, amused condescension for the early stages of an art in its infancy. In order to emerge from the grip of a triumphant evolutionism, it took the clairvoyance of these creators who, according to diversified modalities, could discern the inventive resources of an art which, not subject to the realistic representation of the world, tried to formally construct the vision of it, rather than restitute the illusory reflection of it. Briefly evoked here will be a few of the most significant moments regarding the discovery of a model of transgression which was going to allow the artists to seize hold of a different kind of art. If a number of specialists agree today that the decisive encounter took place in 1906 in an artistic context which temporarily brought together Derain, Vlaminck, Matisse and Piccaso, there were however some foreshadowing signs before that. Thus, in 1890 a certain critic, summing up the annual Brussels Salon of the XX, harshly criticized the exhibits sent by the symbolist sculptor George Minne, "the man of primitive idols", which were judged to have been too inspired by the "fetishes of wild tribes." During this fin-de-siècle epoch which was that of the emergence of the Modern Style, a few of these initiators, such as Henry van de Velde, Paul Hankar, Gustave Serrurier-Bovy, and George Hobé, will contribute to the interior design of the Palace of Colonies at the 1897 Brussels-Tervuren International Fair, and to cite just one example of this, Hankar combined a whole procession of sculpted statuettes in the Kongo style with flowing volutes for the portal of the ethnography room. In Paris, the Maison Bing, which opened in 1895 under the banner of *Art Nouveau* with the aim of seeking a sophisticated integration of art and of decoration welcomed the expressions of a new art of living. One of those exhibiting, the painter Jacques-Emile Blanche remembered having seen "Negro masks" just next to those of the "Japanese theatre".

The mention of these few rare facts would not be enough to show that the process of recognizing the artistic dimension of African sculpture had begun before the end of the 19th century, if one did not evoke what seems to be the most striking forerunner. In 1889, two years before his departure for the South Sea islands, Paul Gauguin acquired at the "Loango village", recreated in Paris on the occasion of the World's Fair, two statuettes carved directly there in oak by sculptors who had come from the Gabon-Congo colony. Although these Kongo-Vili sculptures had no similarity of technique or style to his, Gauguin, after having added onto one a mother-of-pearl disc and onto the other, dolls' eyes and some vividly-colored highlights, attached his monogram to them. This singular appro-

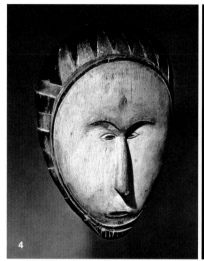

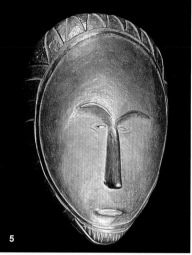

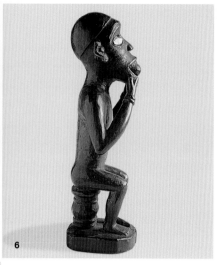

4. Fang, Gabon
Mask
Wood and pigments, 48 cm

Formerly in the collections of:
Maurice de Vlaminck, André Derain
Paris, Musée national d'Art Moderne, Alice Derain donation
Photography: Musée de l'Homme (1967).

**5. Bronze cast by Alexis Rudier
of Vlaminck/Derain's Fang mask**

Former Ambroise Vollard's Collection
Paris, Musée du Quai Branly.
Photography: Bouquignaud.

**6. Kongo-Vili, Democratic Republic
of Congo**
Statuette of an ancestor
Wood and glass, 24 cm

Former Henri Matisse's Collection.

**7. Henri Matisse, *Still Life
with Negro Statuette*, 1906-1907**
Oil on canvas, 105 x 70 cm

© Succession H. Matisse
Photography Archives Matisse (D.R.).

priation, by substitution of the author's identity, could very well constitute, outside of all complacent exoticism, one of the very first expressions of judgment by a Western artist, and not the least of them, regarding the plastic potential of African art. This isolated act remained, it seems, unknown to the artists who, familiar both with Gauguin's work as well as that of Cezanne's, were going to receive in 1906, according to Vlaminck, "the revelation of Negro Art".

The first acquisitions of African objects made by Vlaminck, Derain and Matisse can be dated to the last half of year 1906. Before that, in March, Derain wrote from London to Vlaminck and Matisse communicating his enthusiasm on seeing the British Museum collections coming from the borders of the Empire, calling their attention not to the strangeness of the ethnographic specimens exhibited but about the solutions which these seemed capable of bringing: "It is then understood that the relationship of volumes can express a light or the coincidence of light with such and such a shape". Therefore, the initial impulse should be attributed to Derain despite Vlaminck's reiterated declarations proclaiming himself, by deliberate antedating, to be the sole "inventor of African art". The so-called "discovery" which he announced in an Argenteuil café, according to the accounts — two or three sculptures from Dahomey and the Ivory Coast — certainly dates from the summer of 1906, and therefore a few months after Derain, having returned from England, had already gone all through the Trocadero Ethnography Museum several times together with him. In autumn, Derain got from Vlaminck "a large white mask from Gabon, the sight of which left him speechless". And according to Vlaminck again, "when Picasso and Matisse saw it at Derain's place, they too were in shock. From that day on, it was the hunt for Negro Art". The co-presence of Derain, Matisse and Picasso means this meeting would necessarily have had to be between the beginning of October and mid-November when Matisse, between two long stays in Collioure, came back to Paris for the Salon d'Automne. During this lapse of time, Matisse procured for himself his first African sculpture, a Kongo-Vili figurine, from Emile Heymann, a supplier of "curiosities and weapons of savages" and familiarly called "le négrier de la rue de Rennes". The very day of his purchase, he showed it to Picasso who was said to have been "very impressed" and Matisse added, "We talked a long time about it and this was the beginning of all of our interest in Negro Art — interest which we have more or less shown in our paintings".

"More or less"? In examining all of Henri Matisse's work, only two paintings show the clearly identifiable representation of African sculptures: the *Still Life with Negro Statuette* done soon after the purchase of the Vili statuette but left unfinished, and the triptych of the *Three Sisters* from 1917 whose left panel in-

The "Discovery" of African Arts

8. André Derain, *The Offering*, 1913
Oil painting, 116 x 89 cm

Bremen, Kunsthalle.

9. André Derain, *Woman with a Long Neck*, 1945-1950
Bronze, 32 cm

Private Collection, courtesy Pieter Coray.

10. André Derain, *Triangular Head*, 1945-1950
Bronze, 19.6 cm

Private Collection, courtesy Pieter Coray.

NEXT PAGES

11. Emil Nolde, *Man, Fish and Woman*, 1912
Oil on canvas, 71.5 x 57.5 cm

© Seebüll, Fondation Nolde.

12. Emil Nolde, *Man, Woman and Cat*, 1912
Oil painting, 67 x 53 cm

© Seebüll, Fondation Nolde.

cludes this Bambara statuette belonging to him, the bibelot set upon the fireplace mantle. The same year the photographic representation of the statuette appeared in the first book of *Sculptures Nègres* published with Apollinaire's help by the art dealer Paul Guillaume. Except for a few masks and statuettes which Vlaminck did late in life, with the skill and perhaps the intention of a forger, nothing in his production nor in that of Derain's, appeared to be strictly imitative of African art.

In contrast, the Fauves from across the Rhine, those artists who from 1905 until the disbanding of their group in 1913 placed themselves under the sign of the "Bridge" (Die Brücke) will refer in numerous of their paintings and sculptures beginning in 1908 to forms whose interpretation, sometimes passionate, nevertheless conceals the origin. Ernst-Ludwig Kirchner, Karl Schmidt-Rottluff, Max Pechstein, Erich Heckel, Emile Nolde in their quest for unadulterated real-life experience, and authenticity not stifled by a soulless civilization, will solicit, through the activating presence of "primitive" arts in their works, that "absolute spontaneity", that "intensive expression" which Nolde attributed to them. Beginning in 1910, while Kirchner was working on the Micronesian lintel-motif and palatial Benin plaques exhibited at the Dresden Ethnography Museum, Nolde, stimulated by the richness of the Berlin Imperial Ethnography Museum, filled his sketch books, exactly recording specimens coming from Africa, from the Indians of the Americas, from Oceania, from the Orient, both the Near East and the Far East. From these drawings came, not the illustrations for the essay which he had promised himself to write about *The Artistic Expressions of Primitive Peoples*, but a series of paintings dating from 1911 and 1912, such as *The Missionary* in which figures whose origins were easily identified were juxtaposed on a uniform background — Korean deity of the crossroads, Yoruba cup bearer, Bongo mask — such as *Man, Fish and Woman*, whose figures are mingled with two Yoruba figurines, or another one, *Man, Woman and Cat*, whose "man" borrows its forms and colors from one of the adjoining statues of the monumental beaded throne which the Sovereign Bamoum Njoya offered as a pledge of allegiance to Wilhelm II in 1908. Pechstein who, following the example of Nolde, will complete his museographical sojourns by a journey in the Southern Seas, will mix up the two continents in compositions at the end of the 1910s, compositions which by the dissonance of their chromatic contrasts accentuate the vigor which sculptures arranged properly as "still lifes" might have lacked.

If this expressivity which emanates from "primitive" arts is transcribed there in a strongly suggestive iconography, tending sometimes to the literal representation, it is not the case for the more toned-down version of French Fauvism. One can

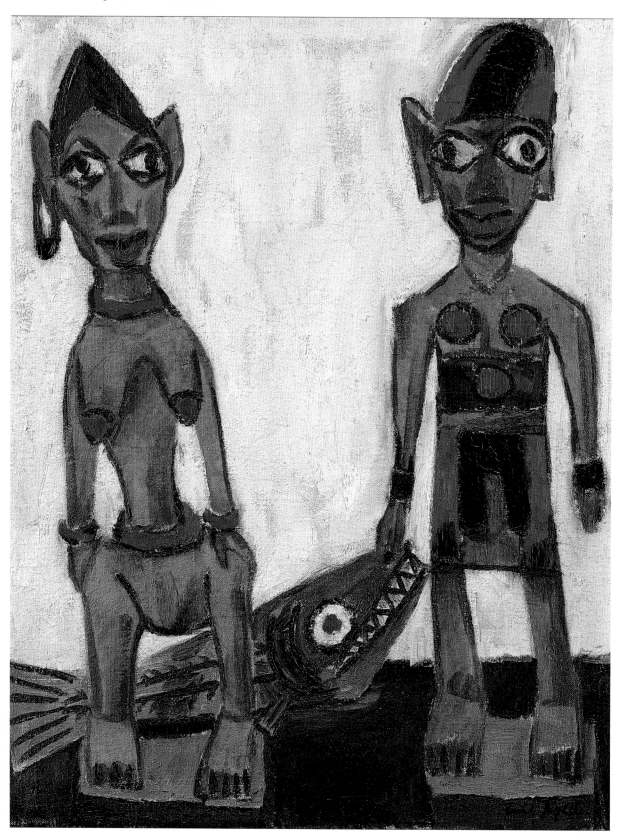

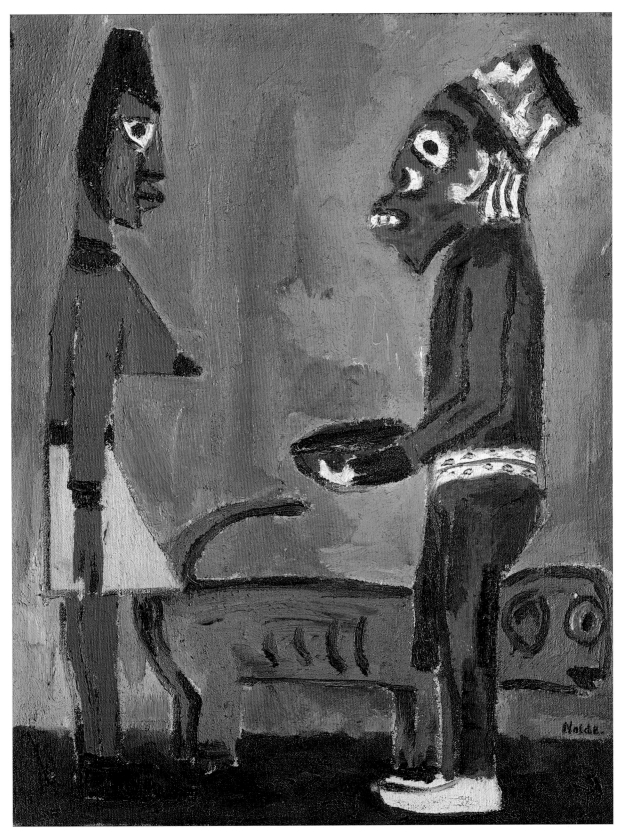

only suppose that in the aftereffect of Picasso's *Portrait of Gertrude Stein*, the abandonment of the realistic portrait and its conventional psychological features in favor of the face-mask would be reinforced by the expressionless facial aspect of Vlaminck/Derain's white mask or in the gaze without pupils of the Kongo-Vili statuette, and to credit these two objects for all these absent faces that Matisse gives to the visages with empty orbits of some of his "portraits", those of *Madame Matisse* (1913) or *Yvonne Landsberg* (1914), that which Vlaminck gives to his *Bathers* (1908) and Derain to the figures of *The Last Supper* (1911), to the *Portrait of an Unknown* (1913) or to the more modeled face of the bearer of the *Offering* (1913), for example.

Also, even if these artists, as numerous observers have testified, filled their studios at the time with African effigies, they avoided, however, the paralyzing "influence" that their admiring fascination could have produced. Examined in the same way as the work of Cezanne and Gauguin, "Negro Art" enters into this confluence as one of the elements of a plasticity sought after beyond the narrative and illusionary representation of a theme, of a subject or of a scene. As a proof of taking one's distance from too easy an Africanist reference, we have the famous paradoxical joke which Picasso told in 1920 despite being surrounded by innumerable masks and statuettes: "*Negro Art? Don't know it!*".

Fifty years later, Pierre Daix, one of the finest analysts of Picasso's work, with Picasso's implicit acquiescence, went even further. "*There is no 'Negro Art' in Les Demoiselles d'Avignon*". In fact, none of the sources invoked by art historians to try to show the close correlation between the faces of the *Demoiselles* and one specific mask or another have proved certain. Which doesn't exclude however that by a game of assimilations, transpositions and metamorphoses, the great painting of 1907 might condense the sense and the range of diverse personal experiences, of which the most crucial one was, by Picasso's own admission, what he experienced when he went alone through the crowded rooms of the Trocadero Ethnography Museum in the spring of 1907 confronted to the most surprising productions the human spirit had ever conceived. "*Les Demoiselles d'Avignon* must have come that day, but not at all because of the forms — because it was my first exorcism canvas, yes!" he confided to André Malraux. If one must object to the simplistic interpretation which would make of *Les Demoiselles d'Avignon* the figuration of a genre scene — a bordello on the carrer d'Avinyó in Barcelona — where the distortions which affect the prostitutes' bodies would have been imitated from the supposed exacerbated forms of "savage fetishes", one cannot prevent oneself from considering that this work is founded upon a plastic syncretism magisterially unifying the various iconic referents.

13. Emil Nolde,
Figure of a Man, 1911-1912
Based on a figure from Sultan Njoya's throne
Black lead pencil and color crayon,
27.9 x 21.8 cm

© Seebüll, Fondation Nolde.

14. Bamum, Cameroon
Sultan Njoya's throne
Wood and pearls, 175 cm

Berlin, Staatliche Museen, Preussischer Kulturbesitz,
Ethnologisches Museum
Photography Dietrich Graf.

15. Max Pechstein, *Still Life with Negro
Statue,* 1918
Oil on canvas, 67 x 90 cm

Stiftung Schleswig-Holsteinische Landesmuseen, Schloss
Gottorf. Dépôt coming from a private collection
Photography Claudia Franz.

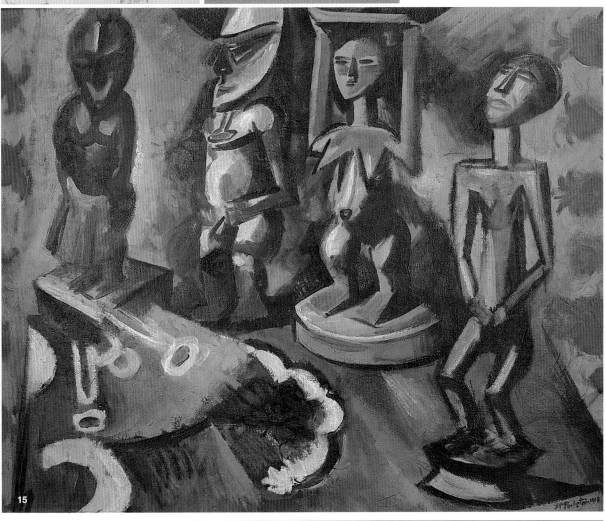

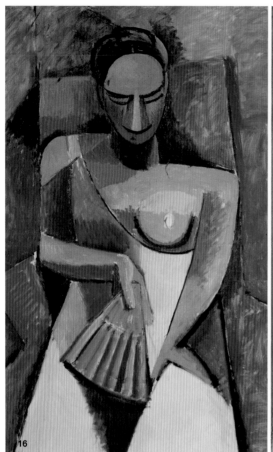

16

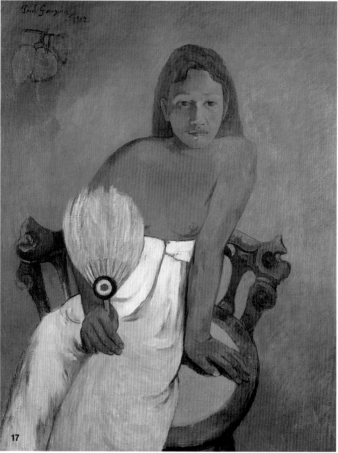

17

18

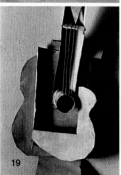

19

20

16. Pablo Picasso,
Woman with Fan,
late spring 1908
Oil on canvas, 152 x 101 cm

St. Petersburg, Hermitage Museum
Photography Bridgeman- Giraudon Agency.

17. Paul Gauguin,
Woman with Fan, **1902**
Oil on canvas, 92 x 73 cm

Essen, Folkwang Museum.

18. Pablo Picasso,
Head of a Man,
late spring 1908
Oil on wood panel,
27 x 21 cm

Berne, Kunstmuseum, Hermann und Margrit
Rupf-Stiftung.

19. Pablo Picasso, *The Guitar,*
winter 1912-1913
[replica in sheet metal of the Guitar
in cardboard, early October 1912]
Sheet metal and wire,
77.5 x 35 x 19.3 cm

New York, The Museum of Modern Art.

21. Kru-We,
Liberia or Ivory Coast
Mask
Bicycle seat, rams horns, metal,
wood, raffia, 24 cm

Max Itzikovitz Collection.

20. Kru-We,
Liberia or Ivory Coast
Mask (detail)
Wood, feathers, fibers, shells, 28 cm

Entered the Trocadero Ethnography
Museum in 1900
Paris, Musée du Quai Branly.

21

The *Woman with a Fan*, which dates from the end of spring 1908, is another example of this original syntax which reinvents the sources of its vocabulary. Without doubt its initial idea was taken from another *Woman with a Fan*, one of Gauguin's last paintings, done in 1902. But beyond numerous similarities, the differences are indeed as eloquent: the volumetry accentuated by the leveling of the shoulders and the division of the members, coming from Cezanne, the bulging forehead and the polyhedral nose coming from African masks and whose immediate echo is *Head of a Man*, in the Bern Kunstmuseum. And that leads back, through the alternating triangles of its coiffure, to the Vlaminck/Derain mask.

Certainly as much a deciding factor as the mask and the Kongo-Vili statuette, was the austere geometry of certain Kru masks — a flat oblong surface against which leans a perpendicular blade, two parallelepipedal volumes and two short cylinders — which led Picasso in the years before the First World War to a mutation of his formal language. Each of the constitutive elements of the Kru mask, in itself lexically neutral, draws its significance only from its relationship with the other elements to make a face. From this procedure, apparently simplistic but which revealed to Picasso the fertility of a montage of semantically limited fragments, stems the experiments in October 1912 with *The Guitar*. Cardboard sheets cut out, then folded to be superimposed upon in-depth space, one among them rolled to form a protuberant relief, and so, by the sole mode of their layout, leading to the recognition of the musical instrument. Daniel-Henry Kahnweiler underlines the stakes of this undertaking: "[…] *the cubist painters discovered, in certain Ivory Coast masks, signs which, abandoning all imitation, entrusted the viewer's apperception to imagine the face which these masks did not copy at all from 'real' forms. It was that, the discovery, I am sure of it, which enabled painting to create inventive signs, which liberated sculpture from the block, led it to transparency* […] *the fact is that Picasso owned a Wobe* [Kru] *mask and that it is the study of this mask which is at the origin of the upheaval which then took place*".

From 1912 to 1914, Picasso used partially or entirely in his papier collé "readymade" elements and sometimes even their painted imitation. Which does not contradict the experiment which came from the Kru model but prolongs it in inversing it. From unities semantically limited to their sole geometric properties, he went on to fragments borrowed from the reality and as such endowed with predetermined significance — musical partitions, wallpaper, tobacco packs, newspapers etc. — and, in assembling them, diverting them from their initial status all the while conserving it, thus playing on this double meaning. Picasso could not be unaware that the African artist does the same thing when, for

example, he inserts nails with big heads or cowries into orbital cavities, or when for the hair, usually sculpted, he substitutes "real" hair which, in its turn can be replaced by wooden plugs tightly studded, in imitation of hair. Or yet when, deliberately fostering the confusion on the sense of the referent, he multiplies on a same face one or the other of its constituents, or he articulates, without discontinuity, anthropomorphic and zoomorphic features.

In resonance to the combined forms of a Baga fertility mask, standing like a monument on the threshold of Boisgeloup chateau, and those forms, every bit as ample and generous, of Marie-Thérèse Walter's, Picasso's young friend, the heads and busts modeled in plaster from 1931-1932, vividly contrast with the *Head of a Woman* of 1929-1930. This "portrait" of the artist's wife — overhanging some diamond-shaped pillars, a plaque cut out of a metal sheet combined with, among other things, springs and sieves, is the reply to his image of an Ingres-like classicism in 1918 with *Olga in an Armchair*. The tri-dimensional assemblages which punctuate the journey of Picasso sculptor are founded on a creative approach which is not without analogy to that followed by his African colleague. And if it was necessary to attest again to it, *Head of a Bull*, this famous 1942 construction which combines handlebars and the seat of a bicycle finds its equivalent in a Kru-We mask, without our being able to suspect the one who conceived it of having known Picasso's work, associates a bicycle seat to a ram's horns to indicate its muzzle.

Among the sculptors who during the years 1910 to 1920 — following the examples of Ossip Zadkine, Henri Laurens or Alexander Archipenko — succeeded in liberating sculpture from its traditional religious, commemorative, decorative functionality, in affirming the autonomy in the tri-dimensional space and, through that, instituting within it the resolutely modern status, Constantin Brancusi, Jacques Lipchitz and Jacob Epstein, even though they challenged the direct influence of African sculpture, never denied the interest they had for it. If it is not sure that Brancusi owned some pieces, on the other hand, Lipchitz and especially Epstein will acquire many examples of them. The catalogue raisonné of the Epstein collection, established by Ezio Bassani and Malcolm McLeod itemizes not less than 430 pieces, among them more than ten incontestable chefs-d'oeuvres. The Lipchitz collection, begun upon his arrival in Paris in 1909 and, certainly more modest, nevertheless would contain a sufficient number for the New York Museum of Primitive Art to present a selection from it in 1960. With frankness, Lipchitz did not deny the diffuse presence of African art in certain of his works, but when he judged that presence too strong, he reproached himself, as is the case for *Mother and Child* (1913-1914), in front of which he admitted

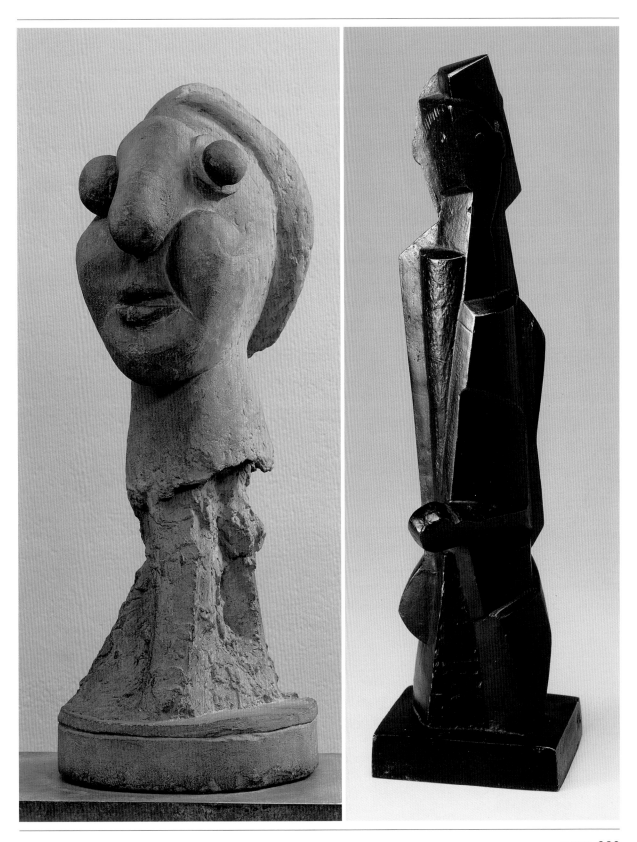

22

23

his dissatisfaction *"because of the specifically Negro quality of the figures and particularly of the heads"*. Even more firmly, Epstein contested the relationship too hastily established between his personal work and the sources upon which it was said to be too dependent. *"I have, because of my appreciation of and my enthusiasm for African work, been accused — as if it were a crime — of being largely influenced by it. That is not so"*. However, Alan Wilkinson detected a few revealing signs of this affinity for the period which preceded the First World War, among others in the drawings and wash drawings which were the prelude to the completion of the strange drilling humanoid, the *Rock Drill* of 1913-1914. *Totem* and *Study for The Rock Drill*, which harmonize the dynamism of their features to the energetic imbrications of the body caught in the sexual act could come from the "coupling" of the two figures of *Study for Man and Woman*, a watercolor drawing, undated, inspired by the top of a cenotaph from Sakalava (Madagascar), which in all likelihood Epstein made sketches of at the antique dealer Joseph Brummer's, before buying it ten years later. In his memoirs, *Let there be Sculpture*, published in 1942, Epstein, discussing the relationship of Brancusi's work to African art, wrote, *"African sculpture, no doubt, influenced Brancusi, but to me he exclaimed against its influence. One must not imitate Africans, he often said"*. In view of the *First Step* (1913) which, except for the head, he destroyed because of its aspect too obviously borrowed from a Bambara statuette at the Trocadero Museum, in view of the *Little (French) Girl* (1914-1918), where the first stage of its forms were refined for the same reasons, and the *Portrait of Madame L.R.* (1914-1918) which harkens back to the figures of Mahongwe or Kota reliquaries even to the detail of the triangular top of the coiffure whose origin can only be the Kota with the similar coiffure which was presented to the Trocadero in 1884 by the explorers Schwebisch and Thollon, one cannot consider, whatever have been the successive variations, that they come from slavish imitation. And not to be mistaken about a notion which oversimplifies, let us cite once more Jacob Epstein, *"The word 'influence', as I understand it, means more than a mere surface study, it means a full comprehension of both mind and technique, that go to the composition of a work, and a translation of that, according to the personality of the artist. A complete re-creation in fact through a new mind"*. Modigliani's relationship with African art must be seen in the same way. If we are to believe the first hand accounts by a number of his acquaintances, he defended that art fervently, for example in 1915 to Charles Douglas praising its over and above initial religious purpose, *"[…] what was at issue was an art in the full meaning of the word, and a conscientious research of a plastic language by genuine artists"*. Adhesion without ambivalence, but not complaisant adherence to

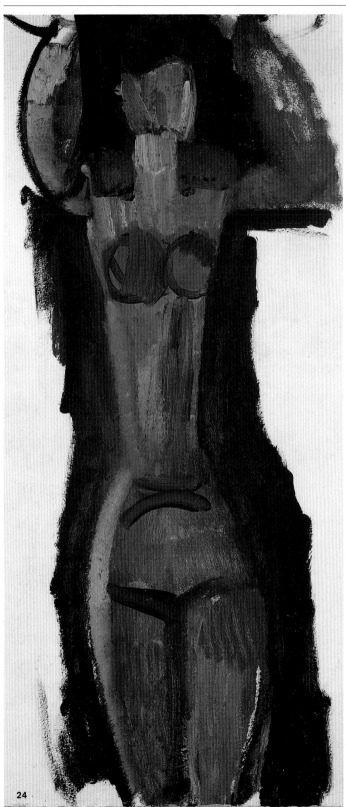

24

PREVIOUS PAGES

22. Pablo Picasso, *Woman's Head with big Eyes*, 1931-1932
Cement, based on the 1931 original in plaster and wood
94 x 36. 5 x 48.5 cm
Musée Picasso, Antibes.

23. Henri Laurens, *The Boxer*, 1920-1921
Bronze, 43.2 x 12.5 x 12 cm
Private Collection, courtesy Pieter Coray.

24. Amedeo Modigliani, *Study for a Caryatid*, 1913
Oil on cardboard, 81.5 x 51 cm
Private Collection.

25. Jacob Epstein, *Study for Man and Woman*, [1913-1915]
Black lead pencil and wash drawing,
61.6 x 41.3 cm
London, British Museum.

26. Sakalava, Madagascar
Top of cenotaph
99 cm
Formerly in the collections of: Joseph Brummer, Jacob Epstein, Carlo Monzino
New York, The Metropolitan Museum of Art.

25

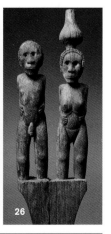

26

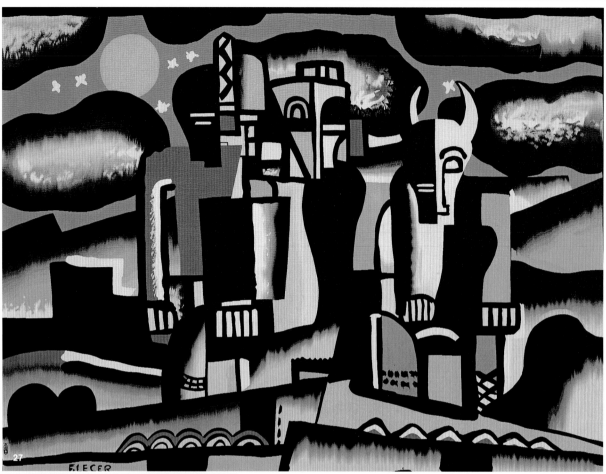

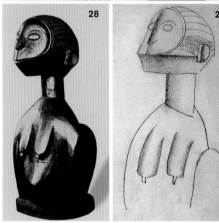

**27. Fernand Léger, *The Creation
of the World*, circa 1960**
Low-warp loom tapestry.
Based on a study in Indian ink
and gouache for the décor of *The Creation
of the World*
388 x 285 cm

Biot, Musée National Fernand Léger
Photography: RMN-Gérard Blot.

28. Baga, Guinea
Bust
Wood, dimensions and present location
unknown

Reproduced in Carl Einstein's work,
Negerplastik, Leipzig, 1915, pl. 44.

29. Fernand Léger, untitled, circa 1922
Pencil on paper, 27 x 21 cm

Biot, Musée national Fernand Léger
Photography RMN-Michèle Bellot.

supposed Baule, Fang or Luba models, as is evidenced by his sculpture in the round directly carved in the sandstone, such as his painted caryatids, or such as his graphic studies.

Beyond the circle of "discoverers", the number of "melanophiles" grew all during the years 1910s to 1920s, whether they placed themselves under the black flag of the avant-gardes — "Praise be to these cannibal gods who gave us the courage of salutary murders", according to the invocation proffered by André Salmon — or whether they gathered under the banner of the return to order — "Negro Art is the first of classicisms", André Derain and Paul Guillaume will say together. The commercial marketing of exotic curiosities and ethnographic specimens promoted to the rank of art objects opened the way to a collectionism which, increasing and diversifying, gave rise in turn to exhibitions and publications. And to rally the decoration, fashion and even political worlds to the cause of "Negro Art", even the means of the stage will be used. In 1919, in the huge rooms offered by the Devambez Gallery, Paul Guillaume organized the "First Exhibition of Negro Art and Oceania Art" with nearly one hundred and fifty pieces presented, and to assure the full impact of the event, he will produce the ballet *Fête Nègre* at the Champs-Elysées Theatre. Based on a libretto by Blaise Cendrars who will then continue the compilation of myths, tales and legends in view of publishing his *Anthologie Nègre*, and with the association of among others Arthur Honegger for the music, Van Dongen, Dunoyer de Segonzac, for the tattoos, decors and costumes, the dancers will mimic the ritual African gestural movements. On March 25th, 1920, in the same location, a sequence of choreographies using its own rhythms and putting into movement an African statuette, *Sculpture Nègre*, will be created by Jean Börlin, based on an idea by Carl Einstein and with music by Francis Poulenc and costumes created by Paul Colin. And then on October 25th, 1923, the Swedish Ballet Company will give the first performance of *La Création du Monde*, "a Negro ballet by Blaise Cendrars, music by Darius Milhaud, theatre curtain, decors and costumes by Fernand Léger, choreography by Jean Börlin". Among the many preparatory studies Léger will make, a series of sketches reveal that its initial documentation will have apparently been borrowed from the large iconography which he got from two works, *Negerplastik* (1915 or 1920 edition) by Carl Einstein, and *African Negro Art: its influence on Modern Art* (1916) by Marius De Zayas. None of which diminishes in any way the originality of the formal and chromatic stylizations which came from these drawings. Confronted by this infatuation which took hold of the cultural elite, nationalism grumbled. Through this "fetish mania" of the artists, the French palette was threatened with the loss of its patriotic colors, and Maurice Feuillet in *Le Gaulois*

artistique of June 25th, 1925 declared that "French art is in danger", warning his readers, "What kind of a victory would that be, to see us repudiating our Greco-Latin genius, lowering ourselves to adore like brutes the monstrous and lewd images inspired by Negroid art!". Without subscribing to these ill-considered remarks, one asks oneself: is this infatuation of the Roaring Twenties for the art of the "savages" only the taste of an epoch, a short-lived fashion? But, the power of renewal stimulated by the "primitive" genius since its "discovery" is in the tradition of a never-interrupted continuity. After having broken the reigning hierarchies and contributed to having definitively abolished the borders of Art, painters, sculptors and other creators have imposed the sincerity of their convictions, beyond all provocation, in such a way that the "first" arts have become an integral part of contemporary culture and of the universal artistic patrimony.

J.-L.P.

ETHNIC GROUPS

Foreword
The peoples mentioned in the brief notes which follow have experienced radical change, espe-
cially in the last half-century: changes in religion and in political and social organisation,
economic transformations and processes of migration. The information may therefore refer
to past situations which no longer exist. This also explains the frequent oscillations in the use
of present and past verb tenses in the notes themselves.

BAGA

The Baga are a small people of fishermen and farmers from Guinea. Their presence in the marshy region along the coast, where they are thought to have immigrated from Futa Djallon, was reported by Portuguese travellers as far back as the 16th century. Starting from the fifties, under the pressure of Islam (in Guinea over 70% of the population are now Muslims), traditional rites fell into disuse and the old worship instruments were destroyed or sold.

BAMANA

The Bamana are also known by the name of Bambara, 'non believers', the name given to them by the Arabs for the resistance they put up against Islamisation in past centuries. They are the largest ethnic group in the Republic of Mali, where they live in the northern regions through which the river Niger runs. The Bamana are above all dedicated to farming the savannah. Rites, aimed above all at encouraging fertility in the fields, involve the use of instruments which are often exquisite works of art.

BAMILEKE

People from the Cameroon savannah divided into small kingdoms which sometimes are a single village, but each of which has its own palace and celebration sculptures, usually portraits of kings and queens. The creation of commemorative figures and the ceremonial role of those, as well as their public exhibitions according to precise rituals, vary from one place to another.

BANGWA

A small Bamileke kingdom.

LOWER NIGER

This geographic designation — first used by William Fagg — refers to a civilization to which are provisionally attributed certain of the ancient Nigerian bronze works which differ stylistically from those whose origin is, in contrast, attested as such.

BAULE

The Baule are a part of the Akan ethnic group which in the 18th century left the lands of what is now Ghana to settle in the central regions of the Ivory Coast. They are one of the most important peoples in the country and live above all from farming. The sculpted figures and many masks are used to establish a relationship with the afterworld.

BENIN

Ancient city-state in what is now Nigeria inhabited by an Edo people. At the end of the 15th century, when the Portuguese arrived, it was the capital of a vast kingdom governed by an absolute sovereign, the *Oba*, who exercised his power assisted by a complex hierarchy of functionaries. The palace was luxurious;

there was a particular cult of royal ancestors with special altars. In 1897 the city was destroyed by a British punitive expedition.

BETE

Agricultural people from the Ivory Coast who live on the left bank of the Sassandra river. The Bete people have no centralized authority and they live grouped together according to lineage in relatively large villages.

BOYO

The Boyo or Buyu are a very small population related to the Luba. Decimated by Arab slave traders in the second half of the 19th century, the Boyo, dispersed in two groups — northern and southern —, live in small villages to the west of lake Tanganika, where they live above all from farming, hunting and fishing. They share many of their cultural features with the nearby Bembe.

BURA-ASINDA SIKKA

A necropolis in the Republic of Niger where more than four hundred funerary jars dating from between the 3rd and the 11th century AD were discovered.

CALABAR

A region of Nigeria where a number of earthenware objects dating from between 1000 and 1450 AD were found during the last quarter of the last century and which belonged to an ancient Bantu civilization.

CHAMBA

A small population (around ten thousand) living on the southern shore of the Benue river, governed by a king of divine origin, assisted by a council of lineage chiefs.

CHOKWE

Important people of farmers and small livestock breeders settled in Angola (above all) and in the Democratic Republic of Congo. They were organised in groups of villages subjected to the absolute authority of a chief, assisted by ancient wise men and functionaries. The cultural hero Chibinda Ilunga, who by marrying the Princess Lunda Lweyi started a new dynasty, occupies a dominant position in Chokwe mythology.

DAN

The Dan belong to the Mande linguistic group and live in the north-eastern regions of Liberia and the north-west of the Ivory Coast, where they arrived after being uprooted by the Malinke. They are farmers and renowned warriors. They have no central authority and live in villages made up of a number of clans grouped around a chief, whose authority is shared with a council of elders. The secret societies are important: among these there is the *Poro*, which is common to all the peoples in the region.

DENGESE

Very small Kasai people, politically linked to the Kuba, dedicated to farming, hunting and fishing. The *Ikoko* society, which oversaw hunting, formed the framework of social life. The statues are thought to be images of sovereigns or ancestors conserved in the tombs of the members of the *Ikoko*.

DOGON

The Dogon are a farming population living on the rocky plateau and plains of Bandiagara in Mali, south of the bight of the Niger, where they started to settle in the 15ᵗʰ century to escape from Muslim pressure, replacing or mixing with the existing peoples of the Djennenke and Tellem; these, in turn, had started to settle in the region in the 10ᵗʰ century. The politico-religious structure of the Dogon is based on a complex hierarchical system of parentage and age classes. The cult of the ancestors and initiatory rights are thus important and require many and various instruments. Their art offers great formal variety.

ESIE

A town in Nigeria where the present population, which arrived in the region at the end of the 18ᵗʰ century, found a thousand stone statues.

FANG

Important population which occupies a vast forest region extending from Cameroon to Gabon, including Equatorial Guinea. The Fang used to conserve the bones of family and clan ancestors in cylindrical bark boxes, surmounted by a head or a human figure known as *Byeri*.

FEN

The Fen, people of the Ewe group, now live in the Republic of Benin and in Nigeria; they represented the dominant class in the ancient kingdom of Dahomey before it was conquered by the French in the late 19ᵗʰ century. At the age of its greatest splendour, in the 17ᵗʰ and 18ᵗʰ centuries, the kingdom had an efficient military organisation. The accumulation of great wealth, encouraged by the slave trade, promoted the development of a flourishing courtly art.

HEMBA

The Hemba, farmers and hunters, live in the south-eastern region of the Democratic Republic of Congo crossed by the river Luika, an affluent of the Zaire. Until a few decades ago they were considered part of the Luba group. The Hemba are grouped into a dozen chiefdoms ("chefferies"). The cult of the ancestors, the source of authority, was extremely important and was the main driving force behind artistic creation. The possession of many figures of ancestors (*Singiti*) was a sign of nobility and confirmation of land rights.

IFE

Ancient religious and political capital of the Yoruba, seat of the *Oni*. Iron wor-

king has been dated back to at least the 9ᵗʰ century, but the period of Ife splendour is placed between the 12ᵗʰ and 15ᵗʰ century. In those years there were created the extraordinary sculptures in terracotta and bronze, produced using the lost wax technique, and destined for the sanctuaries.

IGBO UKWU
In the territory of the Igbo there have been found traces of a civilisation and of advanced metallurgy, dating back to around ten centuries ago.

JENNE-JENO
The name of a flourishing civilization beginning in the 12ᵗʰ century AD in the Niger river interior delta in Mali. The archeological excavations turned up a great number of works of art in earthenware, most of them illegally exported.

KONGO
Among the most important peoples in Central Africa, the Kongo live in the lower Congo (Cabinda, Republic of Congo and Democratic Republic of Congo); they are divided into various groups (Solongo, Vili, Woyo, Yombe and other related groups), each with their own structure according to a common cultural basis. The Portuguese, led by Diego Cão, first made contact with the vast kingdom of the Kongo in 1482.

KOTA
Group of peoples living in the north-east of Gabon where they emigrated between the 17ᵗʰ and 19ᵗʰ century, having been forced to emigrate by the Fang. Like the latter, they conserve the bones of their ancestors in baskets surmounted by sculptures of striking abstraction.

KWELE
People settled in the north-eastern region of Gabon along the river Ivindo. The Kwele were organised on the basis of lineage, and their chiefs ruled the villages according to a balanced rotation.

LEGA
The Lega lived in the Kiwu region, in eastern Democratic Republic of Congo. The village chiefs and the *Bwami* society ensured the political and social order. The masks express the social level attained in the society.

LOBI
Until the middle of the last century, the art of the Lobi was very little known. A series of exhibitions after that revealed the richness of this art, without however mentioning how old they were.
The dating of the female figure shown here which according to laboratory examination was shown to be about two centuries old, makes new investigations necessary.

LUBA

The Luba are a large people of farmers and traders. At present they live in the regions of Katanga, Upemba and part of Kasai in the Democratic Republic of Congo. In the 17th century they had a vast empire, or rather a federation of kingdoms under the protection of a central authority, in which power was exercised by a pyramidal structure. From 1860 onwards, the empire started to collapse due to the effect of the raids of the slave traders and subsequently Belgian colonisation. The cult of the ancestors represented the link between the various regions of the Luba empire; the secret societies exercised an important role in social control.

LULUWA

Farmers and hunters of Luba origin, inhabitants of the region of Kasai in practically independent villages under the authority of a local chief assisted by a council of elders. They share some cultural elements with the Kuba and Chokwe.

MAHONGWE

Situated between Gabon and Congo, the Mahongwe shared with the nearby Kota many elements of culture, including the practice of conserving the bones of ancestors in containers surmounted by an abstract figure covered in metal.

MBEMBE

Small ethnic group which settled in the region of Cross River in Nigeria, on the border with Cameroon. The members of the *Okwa* society exercise social control, choose the chief of the village and organise community life.

MBOLE

Hunters and farmers, they live in the centre of the Democratic Republic of Congo, in independent villages led by a chief chosen by the elders. The ritual activity was supported by the *Lilwa* society, with its rigid hierarchy.

MUMUYE

The Mumuye, of whom little was known until a few decades ago, live in the regions to the south of the river Benue where they fled to defend themselves from the invaders and slave merchants. They are farmers and hunters and live in villages divided into enclosures inhabited by people joined by family ties. Power, which is not centralised, is exercised by the chief of the village and by the council of elders. The age classes, whose members have buffalo masks as attributes, perform an important role in the life of the community.

NOK

Nok is the place on the edge of the plateau of Jos, in what is now Nigeria, where in 1943, the sculpture in terracotta which gave its name to the culture was found in a tin mine. This has since been followed by a vast number of other finds related to this people.

NUBIA

Ancient name of a region in the Nile river valley in the present-day Sudan Republic where complex societies developed beginning in the Neolithic Age and continuing for millenniums.

OWO

Ancient city-state in the southern region of what is now Nigeria, inhabited by a Yoruba people, founded, it seems, by emigrants from Ife. Owo was a centre of culture which produced fine works of art already in the 15th-16th centuries; subsequently it fell under the influence of Benin and this would explain the visible influences between the art of Benin and the art of Ife.

PUNU

The Punu live in the valley of the river Ngunie, affluent of the Ogowe, in central-southern Gabon. They share institutions and elements of culture with the Shira and the Lumbo, to whom they are related by language. They have no centralised political structure and their life is organised on a village level. The initiatory societies perform an important function in the therapeutic or judicial field. The "white masks" are an artistic creation common to these three peoples.

SAKALAWA

In past centuries, the powerful Sakalawa kingdom occupied almost the entire western part of the island of Madagascar. The presence of certain Indonesian elements (including the language), mixed with those from Africa, testifies the cultural contribution by emigrants from South-East Asia which took place at the beginning of the last millennium.

SAPI

Sapi (Sapes) is the name of the people from Sierra Leone and Liberia with whom the Portuguese first came into contact and had trading relations in the second half of the 15th century. They are the ancestors of the Bulom, the Temne and the Kissi, in whose lands, now inhabited also by the Mende (invaders who came from the East), there have been found small figures of humans and animals in soft stone, reused by the present inhabitants on altars for ancestor cults.

SONGYE

The Songye are a mainly farming people who live in the region through which the river Lomani flows in the Democratic Republic of Congo. Related to the Luba in terms of traditions and language and by a mythical ancestor in common, Kongolo, they reached the areas in which they at present live in a series of subsequent migrations. The Songye were organised into large chiefdoms which recognised the authority of a supreme chief who, in turn, exercised power assisted by councillors. The cult of the ancestors and initiation rites had great importance, as did the activity of the *Kifwebe* secret society.

SUKU

The Suku, hunters and farmers from the region of Kwango, are related in terms of language and artistic creation to the Yaka.

TOMA

Inhabitants of the dense tropical forest on the borders of Guinea Bissau, Sierra Leone and Liberia, the Toma are also known as the Loma depending on the region in which they live. The *Poro* society performs a fundamental role in their life.

TSOEDE

The legendary founder of the Nupe reign who, according to tradition, deposited the bronze sculptures now associated with his name in several places along the Niger river.

YORUBA

The Yoruba are one of the largest ethnic groups in Africa. They are above all farmers and most of them live in the south-western regions of what is now Nigeria and in those areas bordering on the Republic of Benin. All, however, acknowledge the religious authority of the *Oni* of Ife, the sacred city, and birthplace of the race. The Yoruba pantheon is extremely vast: with superior and inferior deities, deified kings and ancestors and the spirits of nature. The cult of these many deities explains the wealth of artistic creation.

ZANDE

Important ethnic group living in the regions straddling the Democratic Republic of Congo, the Central African Republic and Sudan. Until early in the last century, the Zande were organised into small kingdoms.

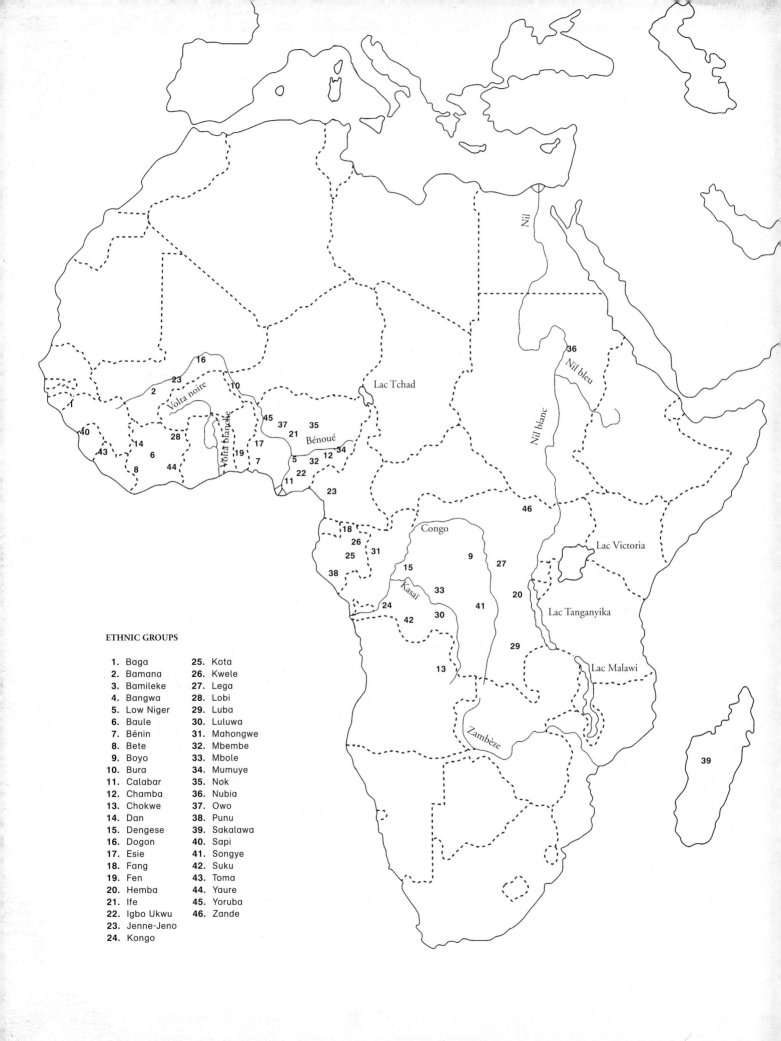

ETHNIC GROUPS

1. Baga
2. Bamana
3. Bamileke
4. Bangwa
5. Low Niger
6. Baule
7. Bénin
8. Bete
9. Boyo
10. Bura
11. Calabar
12. Chamba
13. Chokwe
14. Dan
15. Dengese
16. Dogon
17. Esie
18. Fang
19. Fen
20. Hemba
21. Ife
22. Igbo Ukwu
23. Jenne-Jeno
24. Kongo

25. Kota
26. Kwele
27. Lega
28. Lobi
29. Luba
30. Luluwa
31. Mahongwe
32. Mbembe
33. Mbole
34. Mumuye
35. Nok
36. Nubia
37. Owo
38. Punu
39. Sakalawa
40. Sapi
41. Songye
42. Suku
43. Toma
44. Yaure
45. Yoruba
46. Zande

Volta noire

Volta blanche

Bénoué

Lac Tchad

Nil

Nil bleu

Nil blanc

Congo

Lac Victoria

Lac Tanganyika

Lac Malawi

Kasaï

Zambèze

BIBLIO-
GRAPHY

Bibliography

GENERAL BIBLIOGRAPHY

Africa - Art and Culture-Masterpieces of African Art – Ethnological Museum, Berlin, H.-J. Koloss editor, Munich, Berlin, London 1999

Africa - The art of a Continent (catalogue of the exhibition, under the direction of T. Phillips), London 1995

Afrikanische Skulptur – Die Erfindung der Figur (catalogue of the exhibition, under the direction of S. Gohr), Colone 1990

Art et Mythologie – Figures tshokwe (catalogue of the exhibition, under the direction of Ch. Falgayrettes), Paris 1988

Art (L') sculptural nègre, (Art Style, vol. I), Paris 1962

Arts d'Afrique (catalogue of the exhibition, under the direction of Ch. Falgayrettes-Leveau), Paris 2000

Bamana – The art of existence in Mali (catalogue of the exhibition, under the direction of J.P. Colleyn), New York-Zurich 2001

ABIODUN R.O., "Ife art objects - An interpretation based on oral traditions" in Abimbola (ed.), *Yoruba Oral Tradition*, University of Ife, Department of African Languages and Literatures, Ife 1975.

ASHARA M.B., *The History of Owo*, 1966.

BAEKE E., BOUTTIAUX A.M., DUBOIS H., *Le sensible et la force – Photographies de Hugues Dubois et sculptures songye*, Tervuren 2004

BASSANI E., *Scultura africana nei musei italiani*, Bologna 1977

——, "Les sculptures Vallisnieri" in *Africa Tervuren*, M.R.A.C., Tervuren, a. XXIV, no. 1, 1978, p. 15-22

——, *La grande scultura dell'Africa Nera* (catalogue of the exhibition), Florence 1989

——, *Le grand heritage – Sculpture d'Afrique noire* (catalogue of the exhibition), Paris 1992

——, "The Ulm Opon Ifa (ca. 1650): A Model for Later Iconography", *The Yoruba Artist* (Acts of the study congress, Zurich, 1992), Washington 1994, p. 78-89

——, "Afroportugiesische Elfenbeinartbeiten und Elfenbeinarbeiten aus Alt-Owo (Yoruba, Nigeria)", in H.-J. Koloss, *Afrika und Kultur – Meisterwerke afrikanische Kunst - Museum für Völkerkunde Berlin*, Munich-London, New York 1999, p. 66-72

——, *Arte dell'Africa Nera – Una Collezione per in nuovo Centro delle Culture Extra Europee* (catalogue of the exhibition), Florence 2000a

——, *African Art and Artefacts in European Collections 1400-1800*, London 2000b

——, "Un grand sculpteur du Congo: le Maître de Kasadi", in B. de Grunne, *Masterhands – mains de maîtres* (catalogue of the exhibition), Brussels 2001, p. 163-177

——, *Africa Nera – Arte e cultura* (catalogue of the exhibition), Florence 2002

——, *Capolavori da un continente* (catalogue of the exhibition in Turin), Florence 2003

BASSANI E. and FAGG W., *Africa and the Renaissance-Art in Ivory* (catalogue of the exhibition), New York 1988

BASSANI E. and McLEOD M., *Jacob Epstein Collector*, Milan 1989

BASTIN M.L., *La sculpture Tshokwe*, Meudon 1982

BASTIN M.L., *Introduction aux arts d'Afrique*, Arnouville 1984

BOYER A.M., GIRARD P., RIVIERE M., *Arts premièrs de Côte d'Ivoire*, Paris 1997

BOULLIER C, *Les Sculptures en terre cuite de style Nok: approche pluridisciplinaire*, Mémoire de DEA, Université de Paris I / Panthéon, Paris 1995-1996

CHAFFIN A. et F., *L'art Kota- Les figures de reliquiare*, Meudon s.d.

CHRISTIE'S 2002, *African and Oceanic Art from the Estate of the Late Baron Freddy Rolin*, Amsterdam 2002

CHRISTIE'S 2003, *The Russell B. Aitken Collection of African, American Indian and Oceani Art*, New York 2003

CONNAH G., "The Archaeology of Benin" in *Journal of African History*, 1972, 13 (1), 25

CORNET J., *Art de l'Afrique Noire au pays du fleuve Zaire*, Brussels 1971

COSTA A., *Africa – La figura imaginada* (catalogue of the exhibition), Barcelona 2004

DAM-MIKKELSEN B. et LUNDBAEK T., *Ethnographic Objects in The Royal Danish Kunstkammer – 1650-1800*, Copenhagen 1980.

DELANGE J., *L'art de l'Afrique Noire* (catalogue of the exhibition), Besançon 1958

Dogon (catalogue of the exhibition, under the direction of Ch. Falgayretts-Leveau), Paris 1994.

DUCHATEAU A., *Benin – Royal Art of Africa from the Museum für Völkerkunde, Vienna* (catalogue of the exhibition), Munich 1994

DULON B., *African Art* (catalogue of the exhibition), New York 2004

EPSTEIN J., *Let there be sculpture – An autobiography*, London 1940

Escultura Africana no Museu do Ultramar (catalogue of the exhibition, under the direction of J. Dias), Lisbon 1968

EGHAREVBA J., *A Short History of Benin*, Ibadan,1968

EINSTEIN C., *Negerplastik*, Leipzig 1915

EYO E., "Sculpture Mbembe – Extremité de tambour", in *Sculpture Afrique Asie , Océanie, Amerique*, Paris 2000, 136-139

EKPO V.I., "Qua Terracotta Pottery", in *African Arts*, November, 1983

EYO E., *Two Thousand Years of Nigerian Art*, Ethnographica, London, 1977

——., "Igbo 'Laja, Owo" in *West African Journal of Archaeology*, 6, 1976, 37-38

——, "Reconsidering the Boundaries of Central African Ancestry: An Archaeological Perspective" in *Symposium on Reconsidering the Arts and Cultures of Central Africa* at Newberg Museum of Art, Purchase College, State University of New York in Purchase, New York 2000

——, "The First Annual Lecture of the Calabar Museum Society" in *Executive Travels Magazine* [Calabar (Nigeria)], 2004

EYO E., WILLET F., *Treasures of Ancient Nigeria*, Alfred A. Knoff, with the contribution of the Detroit Institute of Arts, New York 1980

EZRA K., *Art of the Dogon – Selection from the Lester Wunderman collection* (catalogue of the exhibition), New York 1988

EZRA K., "The initiation as rite of passage – Art of the Jo society", in *Bamana – The Art of existence in Mali* (catalogue of the exhibition, under the direction of J.P. Colleyn), New York-Zurich 2001, 131- 141

FAGG W., *The sculpture of Africa*, London 1958

——, *Cent tribus – Cent chefs-d'oeuvre* (catalogue of the exhibition), Paris 1964

——, *African tribal image – The Katherine White Reswick collection*, Cleveland 1968

——, *African Majesty- From Grassland and Forest*, Toronto 1981

FAGG W., *Nigerian Images*, London 1963

FAGNOLA F., "I legni scolpiti di El Hadjar", in E. Bassani, *Africa – Capolavori da un continente* (catalogue of the exhibition), Florence 2003, 95-105

FERNANDES V., *Description de la Côte Occidentale d'Afrique, (Sénégal, au Cap de Monte Archipels)* (under the direction of T. Monod, A.T. da Mota et R. Mauny), Bissau 1951

FISCHER E et HIMMELHEBER H., *Die Kunst der Dan* (catalogue of the exhibition), Zurich 1976

——, *The Arts of the Dan in West Africa*, Zurich 1984

GADO B., "Un village des morts à Bura en Republique du Niger", in *Vallée du Niger* (catalogue of the exhibition , under the direction of J. Devisse), Paris1993, 360-374

GILLON W., *Collecting African Art*, London 1979

GOLDWATER R., *Bambara Sculpture from the Western Sudan*, New York 1960

GRIAULE M., *Dieu d'eau. Entretiens avec Ogotemméli*, Paris 1948

GRUNNE B. (de), *Mains de Maîtres – A' la découvert des sculpteurs d'Afrique* (catalogue of the exhibition), Brussels 2001

GRUNNE B. (de), "Heroic riders and divine horses" in *Minneapolis Institute of Arts Bulletin*, Minneapolis 2001

——, *The Birth of Art in Africa: Nok Statuary in Nigeria*, SN Adam Biro, Paris 1998

HART W., *Continuity and Dicontinuity in the Art History of Sierra Leone*, "Quaderni Poro" no. 9, 1995

HARTER P., *Arts anciens du Cameroun*, Arnouville 1986

HEGER F. "Alte Elfenbeinarbeiten aus Afrika in der Wiener Sammlungen" in *Mitteilungen der Anthropologischen Gesellschaft Wien* (29), 1899, 101-109

Henry Moore at the British Museum, London 1981

JEMKUR J.F., *Aspects of the Nok Culture*, ABU University Press, Zaria 1992

Vallées du Niger, Paris 1993

JOUBERT H., "Mbembé", in *Arman et l'art africain* (catalogue of the exhibition, under the direction of A. Nicolas), Marseilles 1996, no. 111

KAMER H., *Ancêtres M'bembé* (catalogue of the exhibition), Paris 1974

KECKSKESI M., *African Masterpieces from Munich*, New York 1987

——, *Kunst aus Africa-Museum für Völkerkunde Munich*, Munich 1999

Bibliography

KERCHACHE J., PAUDRAT J.-L., STEPHAN L., *L'art Africain*, Paris 1988

KERVER T., *Horae Beatae Mariae Virginis*, Paris 1499

KOLOSS H.-J., *Africa – Art and Culture*, Munich 1999

KRIEGER K., *Westafrikanische Plastik II*, Berlin 1969, n° 236.

Kunst (Die) der Dogon (catalogue of the exhibition, under the direction of L. Homberger), Zurich 1995

LABURTHE-TOLRA Ph. and FALGAYRETTES-LEVEAU Ch., *Fang* (catalogue of the exhibition), Paris 1991

LAMP F., *Art of the Baga – A Drama of Cultural Invention* (catalogue of the exhibition), New York 1996

LAUDE J., *Les Arts de l'Afrique Noire*, Paris 1966

——, *African Art of the Dogon*, New York 1973

——, "Le sens de la forme – Un approche des arts Dogon", in *Dogon* (catalogue of the exhibition, under the direction of Ch. Falgayrettes-Leveau), Paris 1994, 169-220

LAWAL T., "Dating Problems at Igbo Ukwu" in *Journal of African History*, XIV, 1973, 1-8

LECOQ R., *Les Bamilekes*, Paris 1953

LEHUARD R., *Les Phemba du Mayombe*, Arnouville 1977

——, *Art Bakongo – Les centres de style*, 2 voll., Arnouville 1991

LELOUP H, *Statuaire Dogon*, Strasburg 1994

LELOUP H. and Ph., *Bambara* (catalogue of the exhibition), Paris 2000

——, *Feminité* (catalogue of the exhibition), Paris 2003

LEUZINGER E., *Die Kunst von Schwarz-Afrika* (catalogue of the exhibition), Zurich 1970

LEVEAU M., "L'epreuve du temps", *Dogon* (catalogue of the exhibition, under the direction of Ch. Falgayrettes-Leveau) Paris 1994, p. 243-248

"Magies" (catalogue of the exhibition, under the direction of Ch. Falgayrettes Leveau), Paris 1996

MARTIN J.-H., FEAU E., H. JOUBERT, *Arts du Nigeria – Collection du Musée des Arts d'Afrique et d'Océanie* (catalogue of the exhibition), Paris 1997

Masques (catalogue of the exhibition, under the direction of Ch. Falgayrettes-Leveau), Paris 1995

Masterpieces from Central Africa, Munich, New York 1996

McLEOD M., *Treasures of African Art*, New York 1980

Meisterwerke afrikanischer Plastik aus Schweizer Privatbesitz (catalogue of the exhibition), Zug 1995

MEUZE P., *L'art nègre – Sculpture*, Paris 1967

MULLIN VOGEL S., *African Aesthetics - The Carlo Monzino collection*, Milan 1985

NEYT F., *La grande statuaire Hemba du Zaïre*, Louvain-La-Neuve 1977

——, *Luba – Aux Sources du Zaire* (catalogue of the exhibition), Paris 1993

——, *Songye – La redoutable statuaire Songye d'Afrique C entrale*, Anversa 2004

NEYT F. et DUBOIS H., *Une effigie d'ancêtre Hemba d'exception*, Paris 2004

NEYT F. et de STRYCKER L., *Approche des arts Hemba*, Villiers-le-Bel 1975

NICKLIN K. (K.N.), "Trommel" in *Afrika – Kunst und Kultur* (under the direction of J. Koloss), Munich, London, New York 1999, no. 63

——, without title in *Africa –The art of a continent* (catalogue of the exhibition, under the direction of T. Phillips), London 1995, 370-371.

NOOTER M., *Secrecy – African art that conceals and reveals* (catalogue of the exhibition), New York 1993

NOOTER ROBERTS M. and ROBERTS A.F., *Memory – Luba Art and the Making of History* (catalogue of the exhibition), New York 1996

NORTHERN T., *The Art of the Cameroon* (catalogue of the exhibition), Washington 1984

Objetos – Signos de Africa (Recorrido iniciatico) (catalogue of the exhibition, under the direction of B. Dulon and L. Delediq), Zaragoza 2000

PALMENAER (de) E. (E.D.P), *Frans M. Olbrechts 1899-1958 – In search of Art in Africa* (catalogue of the exhibition, under the direction of C. Petridis), note cat. 38, Anverse 2001

PAUDRAT J.-L., "La sculpture africaine – Tradition et création", in *Sculpture d'Afrique* (catalogue of the exhibition of the Collection Barbier-Müller), Genève 1978, 11-24

——, "Résonances mythiques dans la statuaire du pays Dogon", *Dogon* (catalogue of the exhibition, under the direction of Ch. Falgayrettes-Leveau), Paris 1994, 55- 81

PERROIS L., *La statuaire Fan, Gabon*, Paris 1972

——, *Art du Gabon*, Arnouville 1972

PIGOUCHET Ph. for Simon Vostre, *Horae Beatae Mariae Virginis*, Paris 1498

Power of forms (The), African Art from the Horstmann Collection, Milan 2002

Primitivisme dans l'art du 20e siècle (Le) – Les artistes modernes devant l'art tribal (catalogue of the exhibition New York 1984, under the direction of William Rubin, French edition by J.-L. Paudrat), Paris 1991

Regards sur les Dogon du Mali (under the direction of R. Bedaux and J.D. Van der Waals), Gand 2003

READ C.H. and DALTON O.M., *Antiquities from the City of Benin and from Other Parts of Africa in the British Museum*, London 1899

RYDER A.F.C., "A Reconsideration of Ife-Benin Relationship" in *Journal of African History*, 6, 1 (1965), 25-37

SCHMALEMBACH W., *L'art nègre*, Bâle, Paris 1953

——, *Primitive Kunst*, Munich 1959

Sculpture Angolaise – Memorial de cultures (catalogue of the exhibition, under the direction of M.L. Bastin), Lisbon 1994

Sculptures – Afrique Asie Océanie Amérique, Paris 2000

SIEBER R. and WALKER R.A., *African art in the cycle of life* (catalogue of the exhibition), Washington 1988

Signes du corps (catalogue of the exhibition), Paris 2004

SHAW T., *Igbo Ukwu*, London 1970, vols. I-II

——, *Unearthing Igbo Ukwu*, Oxford University Press, Ibadan 1977

SWENEY J.J., *African sculpture*, Princeton 1970

TAGLIAFERRI A., *Stili del potere – Antiche sculture in pietra della Sierra Leone e della Guinea*, Milan 1989

TESSMANN G., *Les Pahouins – Monographie ethnologique d'une tribu de l'Afrique de l'Ouest*
THOMPSON J.L., VOGEL S., *Close Up – Lessons in the Art of Seeing African Sculpture from an American Collection and the Horstmann Collection*, New York 1995

Tour (Le) du monde, Utotombo – L'art d'Afrique Noire dans le collections privées belges (catalogue of the exhibition), Brussels 1988

Vallée du Niger (catalogue of the exhibition, J. Devisse General Curator), Paris 1993

VEIGA de OLIVEIRA E., *Escultura africana em Portugal* (catalogue of the exhibition), Lisbon 1985

VOGEL S., *African Aesthetics – The Carlo Monzino Collection*, Milan 1985

Voie des ancètres (La) (catalogue of the exhibition, under the direction of Ch. Falgayrettes), Paris 1986

WASSING R.S., *L'art de l'Afrique Noire*, Freiburg 1969

WELSH J., "A voyage to Benin beyond the country of Guinea mabe by Master James Welsh, who set forth in the yeere 1588" in *The Principal Navigations, Voyages, Traffiques and Discoveries of the English Nation*, R. Hackluyt (ed.), London 1904

WILLET F., *Ife in the Art of West Africa*, text on cd-rom, updated on 2003

Yoruba – Art and aesthetics (catalogue of the exhibition, under the direction of Abiodun R., Drewal H.J., Pemberton III J.), Zurich 1991

Printed in July 2005